Art of Celebration
CHICAGO & THE GREATER MIDWEST

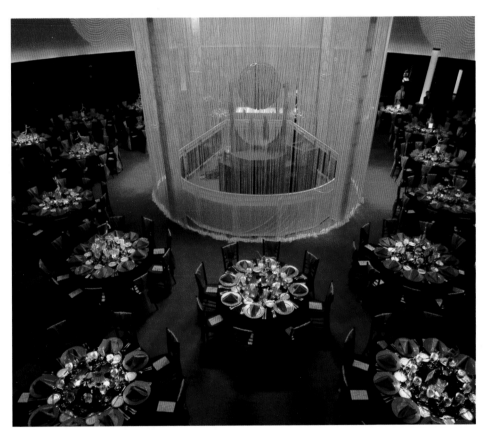

Published by

PANACHE
PANACHE PARTNERS

Panache Partners, LLC
1424 Gables Court
Plano, TX 75075
469.246.6060
Fax: 469.246.6062
www.panache.com

Publishers: Brian G. Carabet and John A. Shand

Printed in Malaysia

Distributed by Independent Publishers Group
800.888.4741

PUBLISHER'S DATA

Art of Celebration Chicago & the Greater Midwest

Library of Congress Control Number: 2010930001

ISBN 13: 978-1-933415-85-7
ISBN 10: 1-933415-85-1

First Printing 2010

10 9 8 7 6 5 4 3 2 1

Panache Partners, LLC is dedicated to the restoration and conservation of
the environment. Our books are manufactured with strict adherence to an
environmental management system in accordance with ISO 14001 standards,
including the use of paper from mills certified to derive their products from
well-managed forests. We are committed to continued investigation of
alternative paper products and environmentally responsible manufacturing
processes to ensure the preservation of our fragile planet.

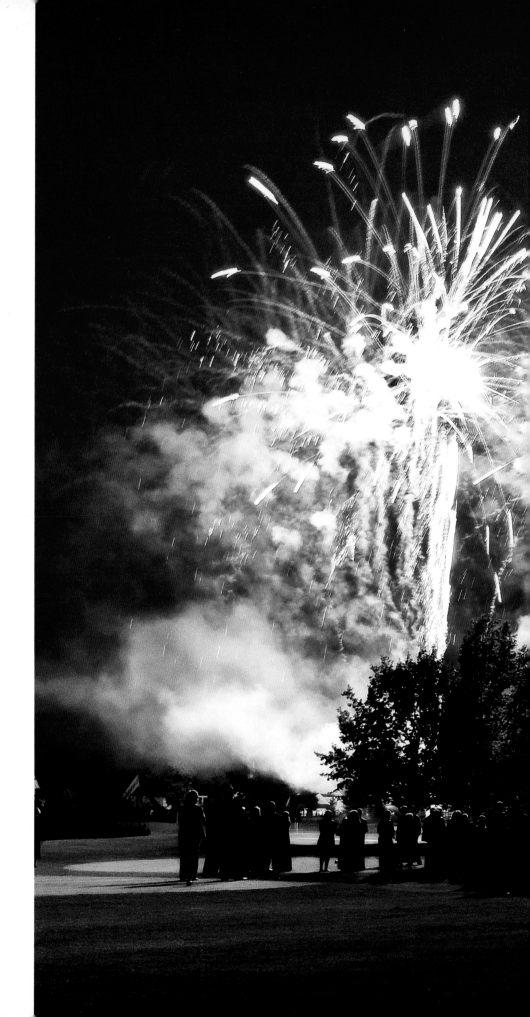

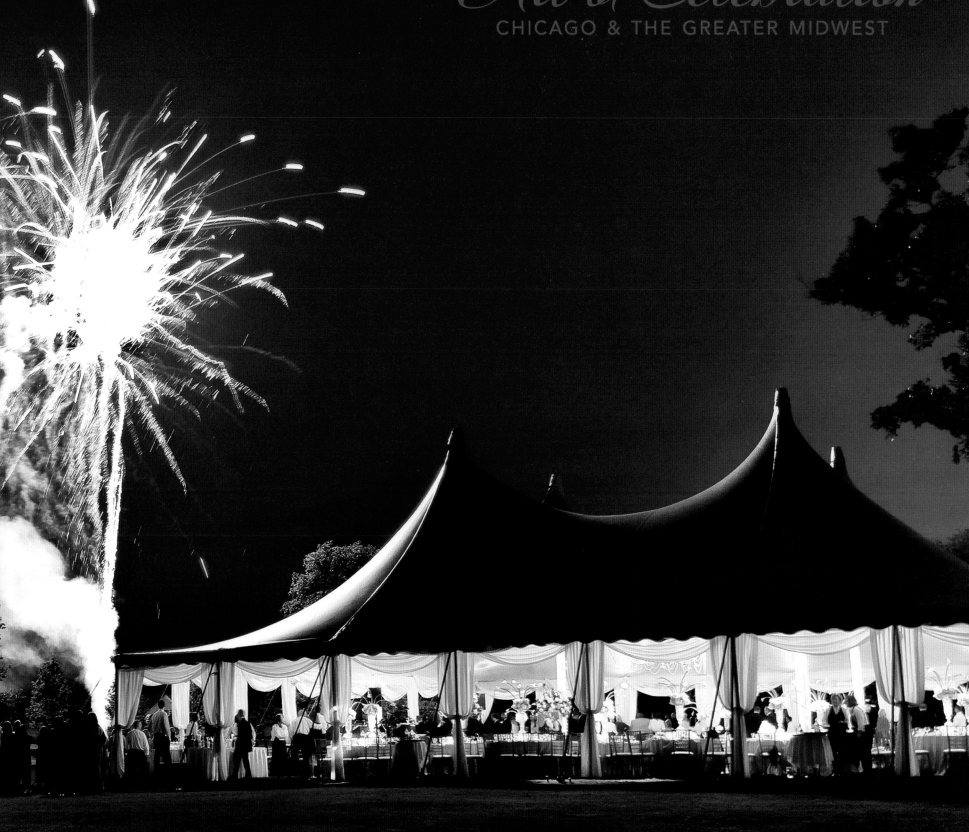

Art of Celebration
CHICAGO & THE GREATER MIDWEST

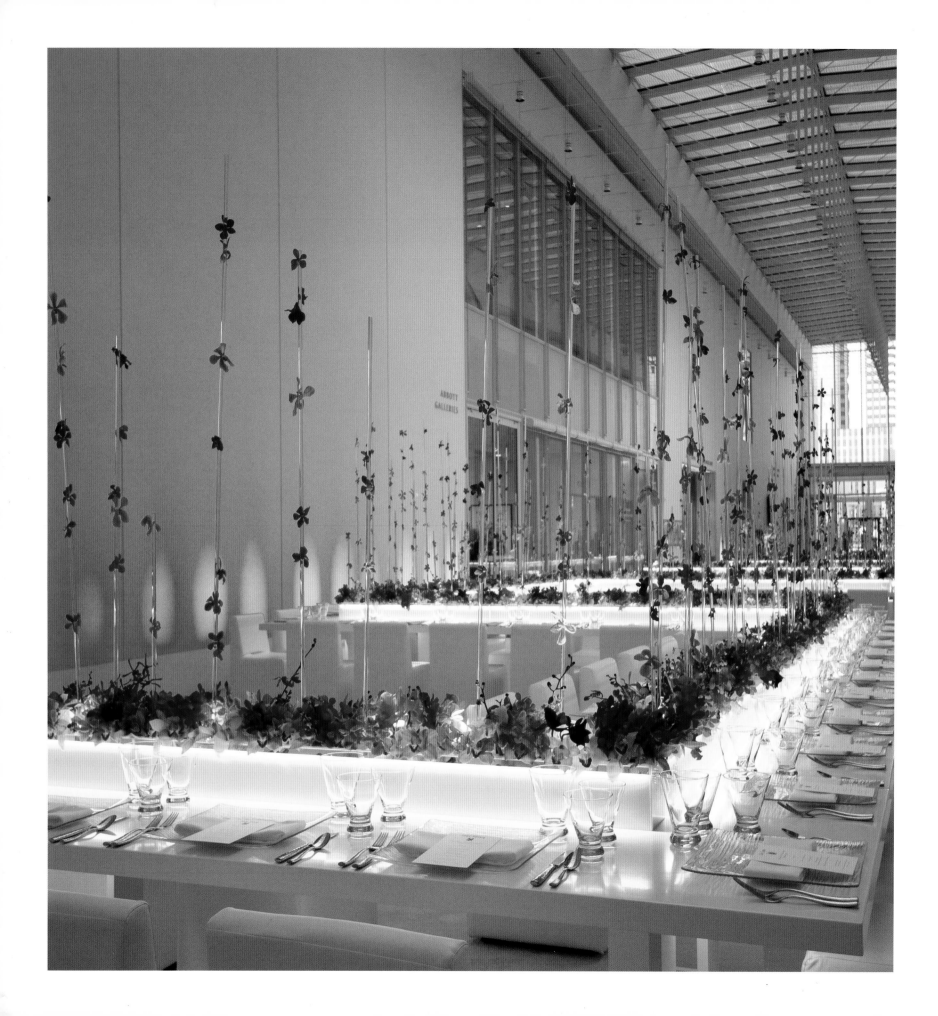

INTRODUCTION

Celebrations are woven into our lives from the moment we are born; we pave our long and winding road with fun and revelry. Cultures are identified by their milestones, rites of passage, and faiths. From the grand visions of a select few, through the work of many, and motivated by all, our celebrations are truly universal.

In *Art of Celebration Chicago & the Greater Midwest*, we chart Chicago and other Midwestern cities' modern-day visionaries who mastermind remarkable events, creating everlasting memories.

The magic of a phenomenal celebration is achieved with great collaboration. This book will take you on a voyage, sharing the insights and creations of the gifted. We begin this journey with event planners and designers—the directors, producers, and creative geniuses—who formulate, synthesize, and execute the visions from behind the scenes through EVENT PLANNING and VISIONARY EVENT DESIGN. And because once you've set the date, the next step is LOCATION, LOCATION, LOCATION, we turn our focus to the Greater Midwest's most incredible venues, which become inspirational backdrops.

The event, floral, and lighting designers are true connoisseurs of CREATING AN AMBIENCE; these artists are responsible for the endless ideas and boundless efforts, and are often the heart and soul of an unforgettable gala. Then EAT, DRINK & BE MERRY in the culinary world of caterers, whose works of art and ingenious creations delight the palate and astound the mind. From there, IT'S ALL IN THE DETAILS, as print shop proprietors, calligraphers, and graphic designers share insight into how breathtaking invitations and other printed materials set the stage for what is in store for the guest and offer a glimpse of what's to come. Through the amazing talents of musicians, entertainers, photographers, and videographers, CAPTURING THE MOMENT will forever keep alive the experiences of life's ritual—the art of celebration.

Art of Celebration Chicago & the Greater Midwest will inspire, inform, and just might take your breath away. Go ahead, let the magic happen—and celebrate!

Behind the Scenes Event Planning

Visionary Event Design

Location, Location, Location

Creating an Ambience

CONTENTS

Eat, Drink & Be Merry

It's All In the Details

Capturing the Moment

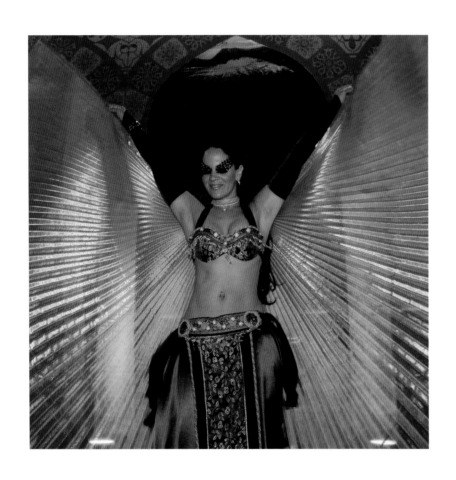

Behind the Scenes

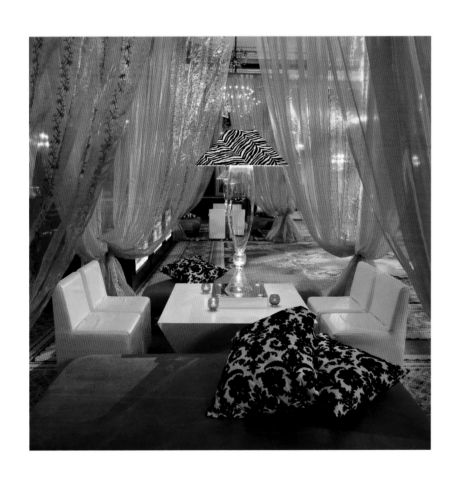

Event Planning

BIRCH DESIGN STUDIO

MARINA ALEXANDRA BIRCH
CHICAGO, ILLINOIS

For a designer who earned a degree in art history from Princeton University and a BFA in interior design from the Harrington College of Design, the career options are almost limitless. When Marina Alexandra Birch chose to open Birch Design Studio more than seven years ago, she knew that event design offered a creative outlet like no other. To her, it is a form of self-expression combining theater, dining, entertainment, and spatial analysis with the rarely realized fun of delving into the absurd. Art, fantasy, and organization merge—which just so happens to suit the way she is wired.

For Marina, every fête, party, or gala is a fantasy come to life, sparked by a grain of inspiration from the host. Keeping a close eye on fashion, interiors, and global trends, she works to envision the ideal event for each of her clients, and collaborates with the region's top creative forces to bring that vision to life. Constantly searching for new inspiration, Marina travels to less-frequented locales around the world for an influx of fresh ideas. Visiting foreign cultures offers a heightened sense of awareness and an open mind that only comes with unfamiliar surroundings. Taking in the sights, sounds, and flavors, she absorbs these many elements that can be later woven into her inspired events. These experiences allow Marina to push the envelope and explore new possibilities—a practice that has made her studio one of the hottest names in the event industry.

We pulled out all the stops for a theatrical, over-the-top private party with a 300-plus guest list. Using our office décor as the inspiration, we duplicated our studio's draped ceiling and chandelier to heighten the glamour of the Peninsula ballroom. Built on-site, a series of tufted walls gave the room a rich, textural appeal. We also had a speakeasy-style bar built to match the custom walls. An explosion of French tulips at each table underscored the dramatic, anything-goes feeling that pervaded the night.

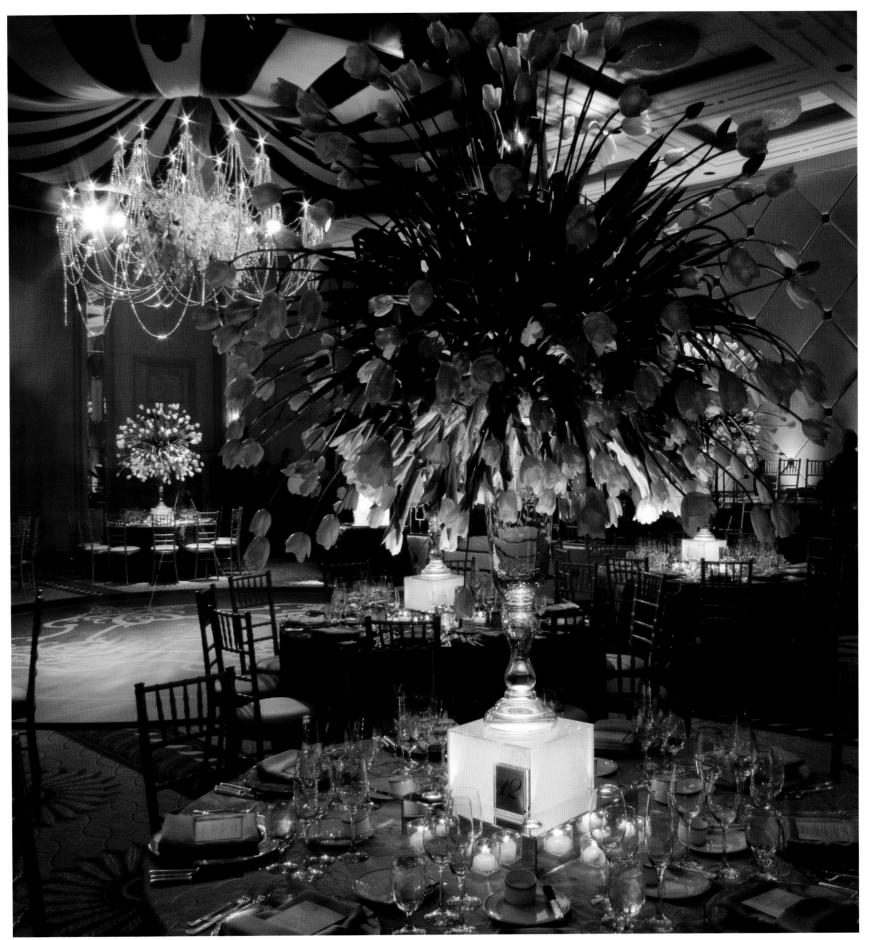

Photograph by Krista Wortendyke

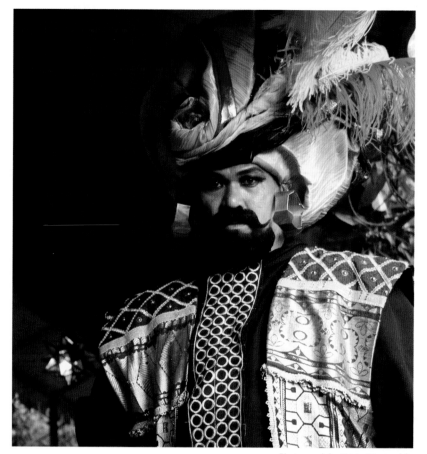

Photograph by Krista Wortendyke

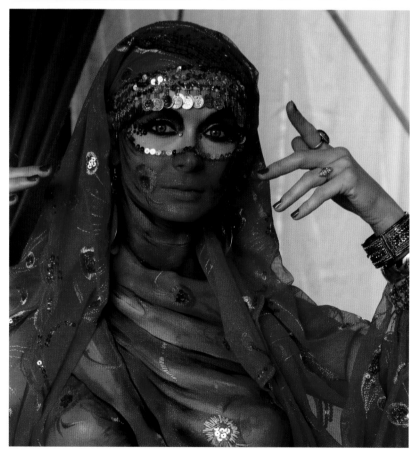

Photograph by Krista Wortendyke

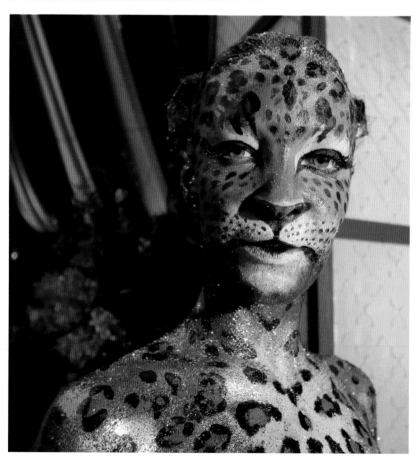

Photograph by Anna Kuperberg

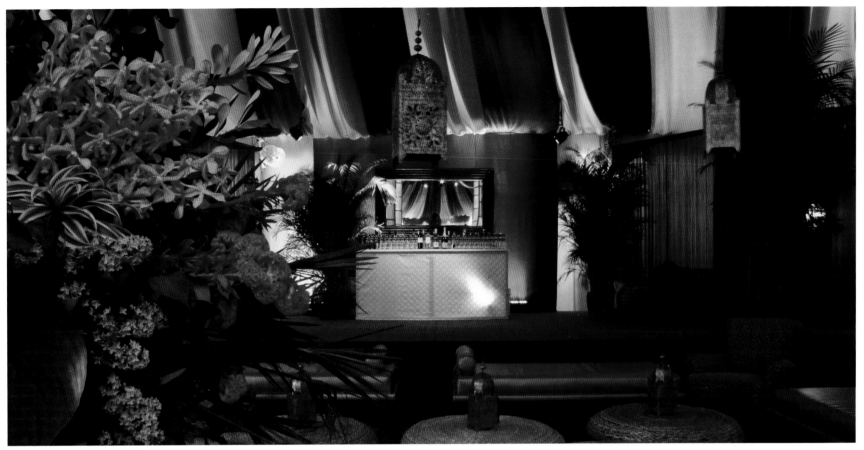

Photograph by Krista Wortendyke

For a Moroccan-inspired party, we designed a cocktail tent to have the energy of a bazaar—visually chaotic, bustling, and a little bit crazy. The tent was filled with hanging lanterns, thousands of orchids, trees, and chaise lounges, and fortune-tellers and portrait painters offered their talents to guests. As everyone entered the party, a myriad of costumed hosts welcomed guests. Outgoing and charismatic, the greeters—including a sultan on stilts—served Moroccan-spiced cocktails as guests arrived. Meanwhile characters like a cheetah and a harem princess, wearing only body paint, tempted the guests into the cocktail tent.

"The fantasy of an event begins the moment guests walk through the door, so it is imperative to create an immersive atmosphere upon arrival. Events should also evolve as they progress, offering a bit of surprise and interest as they unfold."

—Marina Alexandra Birch

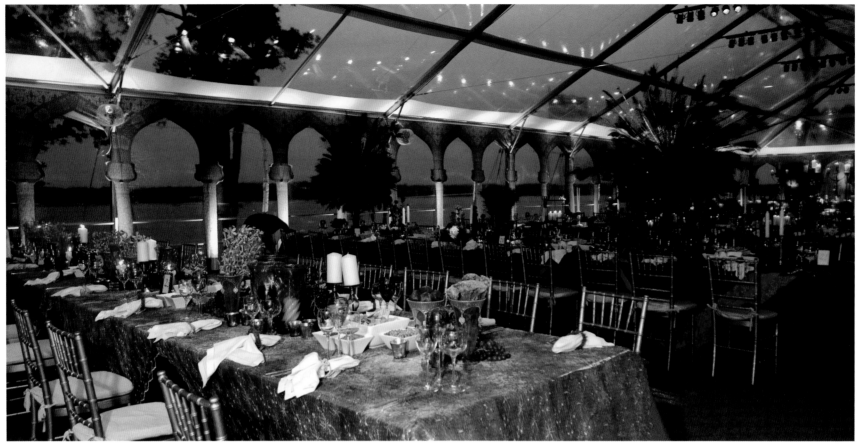

Set in a clear tent alongside the Atlantic Ocean, dinner was served in a space we designed to look beautifully eclectic and continue the Moroccan theme. We designed a custom-built and painted colonnade to give the impression of dining within an arch-enclosed courtyard. The opposing colonnade wall revealed a desert scene at sunset. The Moroccan-inspired menu featured food served in individual tagines that we later presented to guests as souvenirs—a distinct favor to remember the night. After dinner, themed performers wowed the guests, including a self-igniting fire artist, a highly skilled aerialist, a bird-wielding magician, and a belly dancing troupe. The crowd was completely entranced as each new experience was revealed.

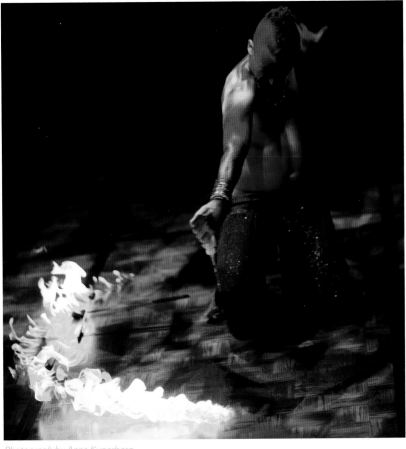

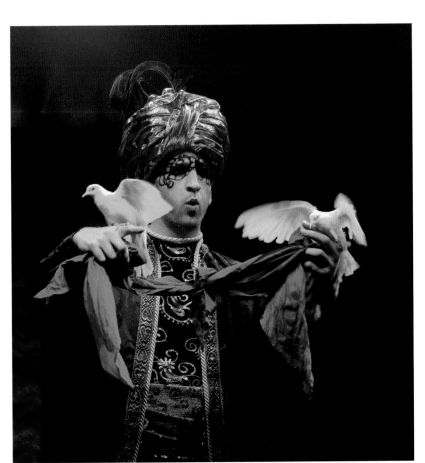

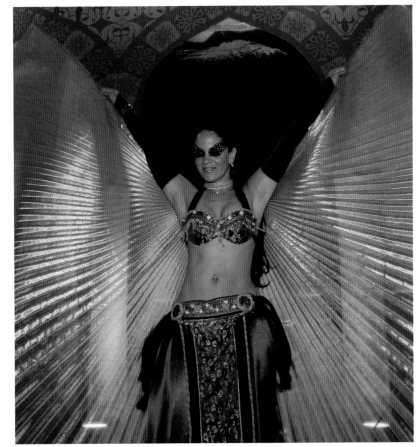

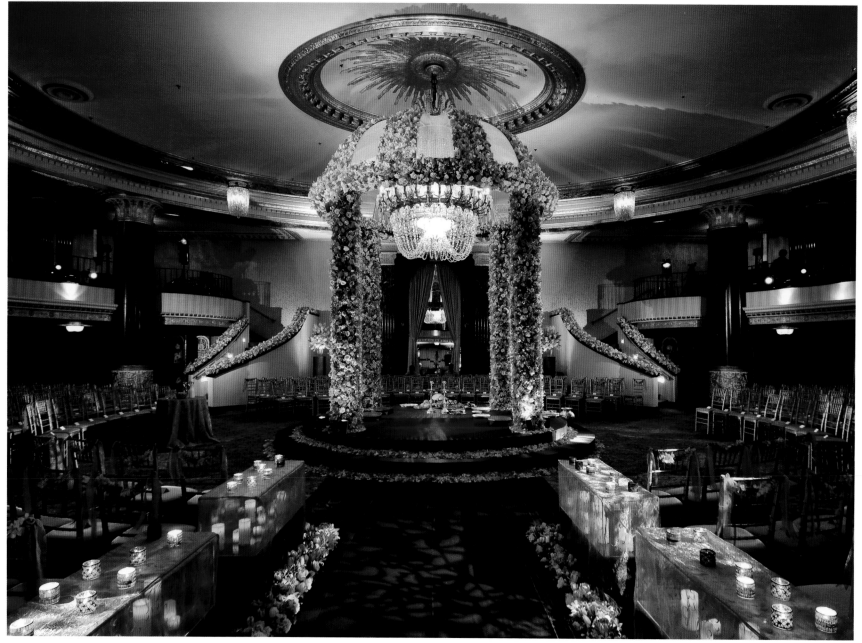

"Whether it is over-the-top or simple, an event has to be elegant, warm, and welcoming, never stuffy."

—Marina Alexandra Birch

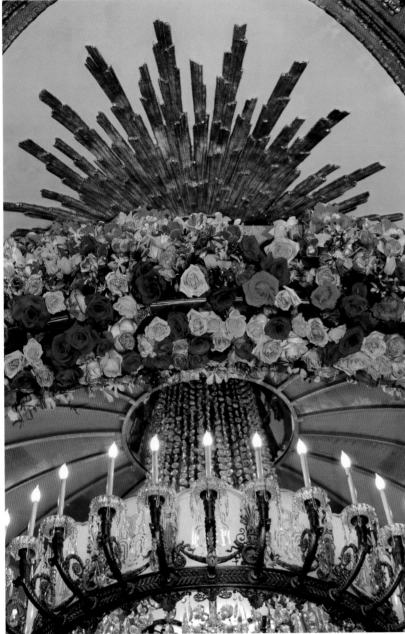

Photograph by Cara Garbarino, Garbo Productions

Photograph by Cara Garbarino, Garbo Productions

When we decided to use the Intercontinental Hotel's prized chandelier as the centerpiece of a custom mandap for a Hindu wedding, everyone was a little nervous. We carefully designed the mandap in two semi-circular shapes that closed within inches around the antique chandelier—you could hear a pin drop during the final moments of assembly. All the tension paid off and the ceremony was stunning. A profusion of flowers added a lush feel to the intimate circular space. Hedges of orchids, roses, tulips, and peonies encircled each step of the mandap, swept up the staircases, and lined the aisles. Lucite boxes with sheer golden slipcovers gave the candlelight a radiant glow of red and orange hues.

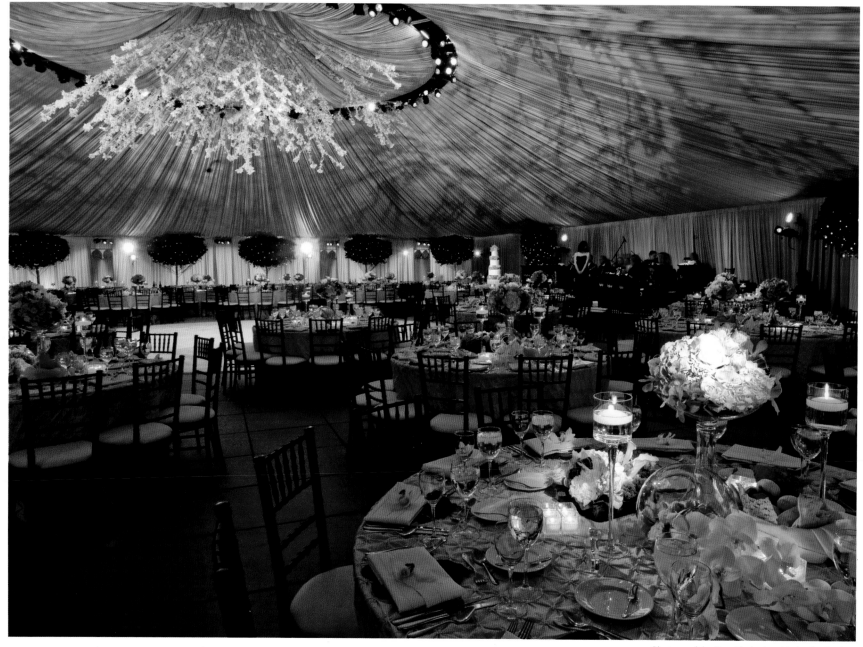

"Lighting is the single most powerful aesthetic element of an event. With simple lighting changes, the same space can shift from cozy to avant-garde, romantic to sexy, and static to dynamic."

—Marina Alexandra Birch

For a dinner-dance reception, the bride wanted to capture the feeling of an outdoor garden but with a dramatic and imaginative twist, something a little different. We created a magical environment that fit her vision. The ceiling and walls were draped with soft textured fabric; trees were disassembled and rebuilt on-site to fit in the tent. Meanwhile, we spent months designing and perfecting the jaw-dropping centerpiece. Measuring 32 feet in diameter, the crystal and orchid-encrusted chandelier floated above the dance floor in the center of the tent. We used the reflective nature of the fixture to emphasize the evening's overall lighting scheme which mimicked the natural cycle of light from dusk to dawn.

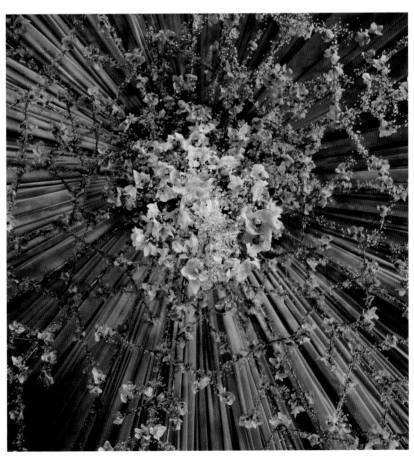

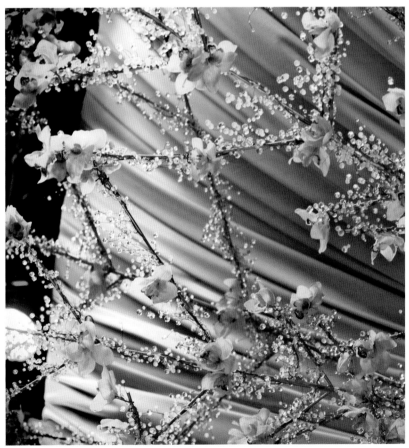

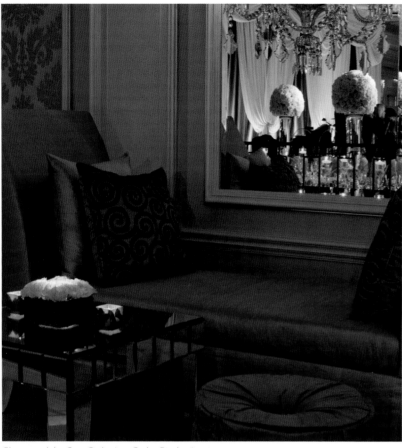

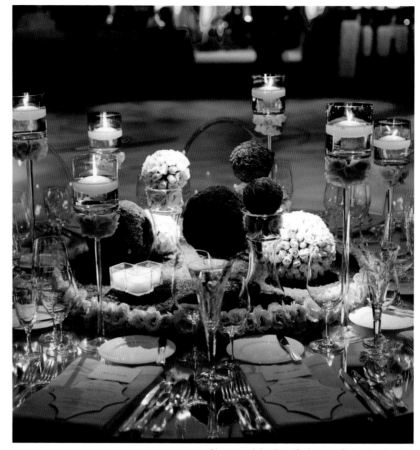

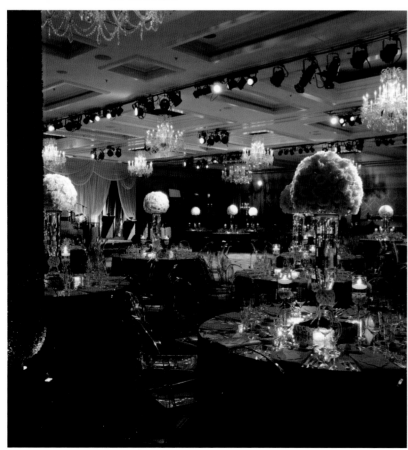

Our goal was to create something distinctly Italian to celebrate the family's heritage, while infusing the family's eye for contemporary fashion and design. We loved the idea of manicured cypress trees, as they are classically Italianate, yet possess a modern architectural form. A cypress-lined allée led guests to framed mirrors holding placecards and into the reception space. At each table, mossy landscapes, surrounded by a hedge of tiny sweetheart roses, held towering glass vases topped with pavé domes of roses, while the play of light and shadow gave the ballroom a dramatic elegance. As a surprise to the bride, we orchestrated a Jersey Boys tribute that kept the ecstatic guests dancing well into the morning.

Photograph by Cara Garbarino, Garbo Productions

views

Your event has to resonate with your personality. If caviar and foie gras aren't your style, then don't force it. Think of your event as an extension of yourself and your home; you want to be completely comfortable and for your guests to feel the same. Create fun and fantasy without betraying your taste and style. The host sets the tone for the entire evening, so be yourself and, above all, have a fabulous time!

THE WEDDING GUYS®

MATTHEW TRETTEL | BRUCE VASSAR
MINNEAPOLIS, MINNESOTA

Just as museums rely on curators to select the exhibit collections, both engaged couples and wedding specialists depend on Matthew Trettel and Bruce Vassar to showcase stunning event ideas and untangle the mysteries of etiquette surrounding that auspicious day in a couple's life. Matthew and Bruce both have extensive experience in the special event industry. Their unique backgrounds and skills—Matthew with fashion, video, and print communications and Bruce with marketing, catering, and music—make their collaborative venture, The Wedding Guys®, capable of taking on anything.

Through phenomenal wedding planning events, select signature weddings, and their TrendSpot blog, Matthew and Bruce love to fast-track the trends and bring new concepts to the forefront. Their innate ability to envision the undiscovered allows them to creatively make an impact and guarantee that guests will walk away with a one-of-a-kind experience. From something as simple as the unique placement of flatware to the more complex art of combining a modern art gallery wedding with the classical sounds of cathedral bells and organ music, Matthew and Bruce know just how to tweak the traditional.

Even considering their eye-popping work, Matthew and Bruce both agree that the personal relationships are what matter the most. Regardless of the exact design, their happiness lies in creating something truly personal for the soon-to-be-married. For The Wedding Guys®, the nuptial weekend should tell the family's story, incorporate individual personalities, and help guests learn something new about the couple.

Each year we design our signature Trend Wedding Giveaway where lucky couples in markets across the country win the nation's largest wedding giveaway. In 2009, we focused on a contemporary ambience with clean lines for a mod event. The dining space included three long tables featuring muted colors and sleek accents. Dendrobium orchids softened the modern groupings of mercury glass vessels and the acrylic runners. Slender black lamps added height for an intimate feel.

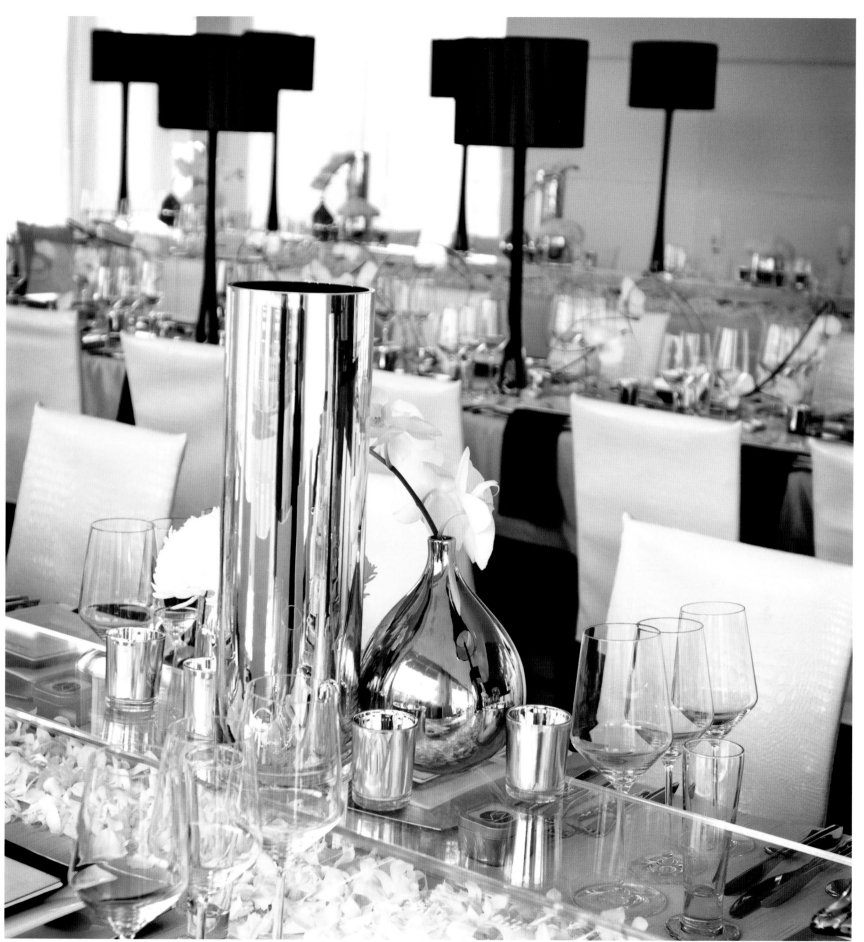

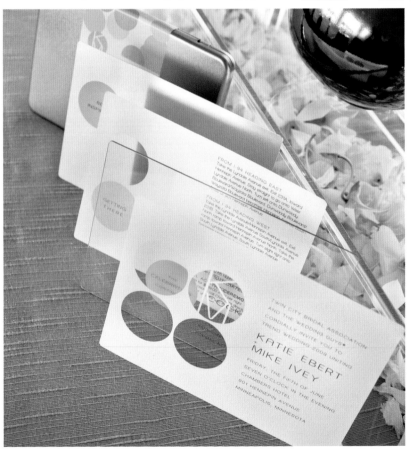

Right: After dinner, guests moved to a dance lounge that was created in the hotel's courtyard and enhanced by large cabanas featuring interactive stout tastings. These upscale "beer tents" were draped with muted yellow canvas to enhance the comfortable seating areas. Centerpieces mirrored the dinner accessories and featured metallic orbs and clear vases.

Facing page: To maintain the art theme of the signature wedding, we incorporated clean lines and polka dots throughout the event. Acrylic materials offered an immaculate base, from the multilayered invitation to the acrylic and glass art-sculpture altar created for the ceremony, and even the menu that doubled as a placecard. The dot pattern that acted as a modern aisle runner and was sprinkled on various elements mimicked the color palette revealed throughout the wedding. Personalized laser-cut monograms and other artistic touches, such as multiple flatware patterns at each place setting, capped off the event's theme.

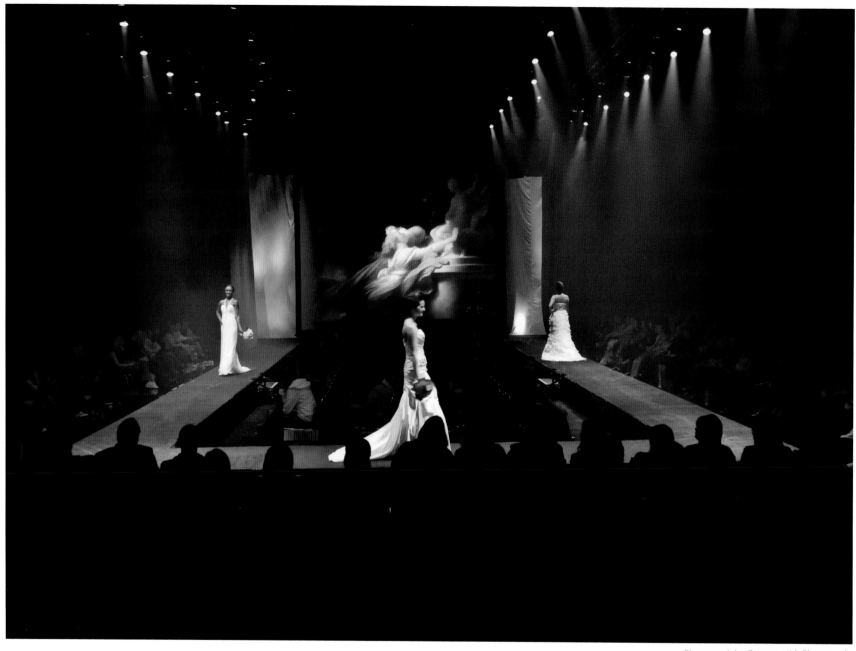

"Inspiration is everywhere and can reveal itself in the oddest places. Look for something that brings excitement, and then reinterpret it for the event."

—Matthew Trettel

The fashion within weddings is so important that we place ourselves in the epicenter by producing the Bridal Fashion Week shows for the press and fashion buyers at New York's Couture Bridal Market as well as bringing these high-fashion experiences to brides throughout Unveiled—The Ultimate Wedding Planning Event. Each fashion show can be challenging because we want to feature the latest couture design styles. We use lighting, video, and music to create the mood and place the focus on fashion.

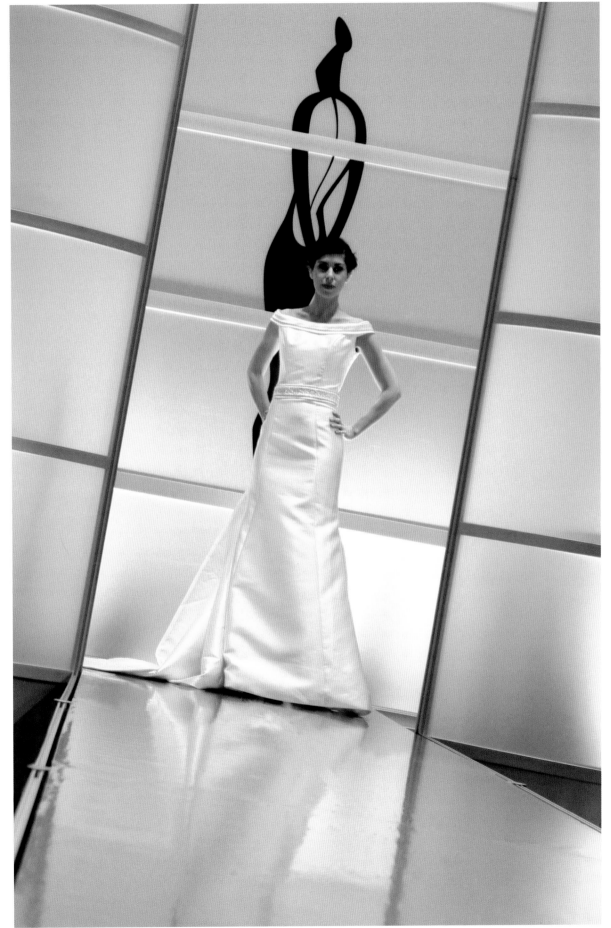

Photograph by Jenn Barnett Photography

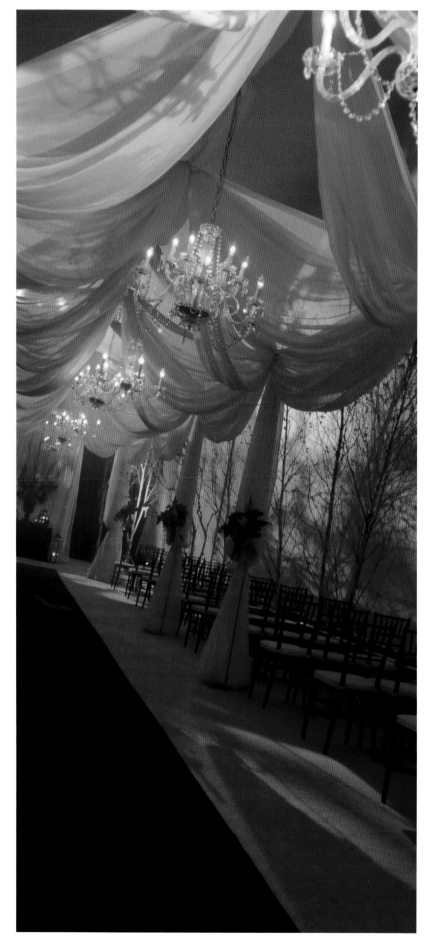

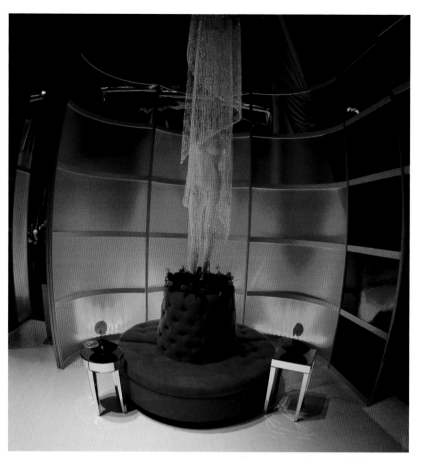

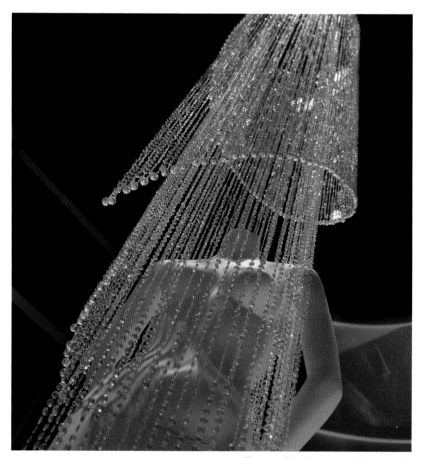

Photograph by Coppersmith Photography

Above: To create a seductive, passionate ultra-lounge, we used bold colors, sleek lines, and uplit acrylic walls. Vertical buffets on both sides of the circular bar kept guests moving and afforded the opportunity to pop the environment with gloss-white accessories.

Facing page left: We wanted to create a glowing ceremony experience but were challenged by high ceilings and stark-white surroundings. We brought out an autumnal theme with warm lighting and 30-foot-tall birch trees. By combining those elements with low-draped fabric, gobo patterns on the walls and floors, and elegant chandeliers, guests stepped into a luxurious forest.

Facing page right: The glowing red room highlights how the appropriate use of dramatic colors and lighting creates a mood. By adding the texture and comfort of a red velvet settee to the elegance and interest of a chandelier draped around a nude mannequin silhouette, we took the ambience to an entirely new level of passion and sensuality.

"Event ideas should inspire a vision for the designer to run with, not prompt an exact copy that lacks a personal connection."

—Matthew Trettel

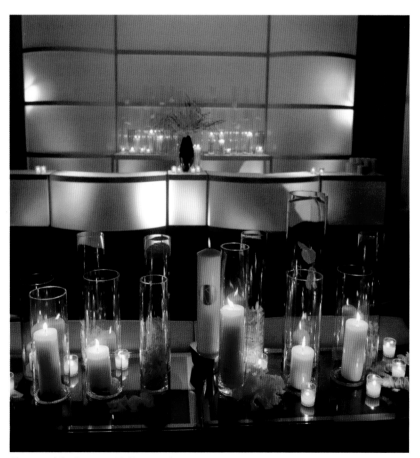

"For artists to achieve a noteworthy creation, freedom in design and execution is essential. The same applies to event professionals."

—Bruce Vassar

Left: To top off the Trend Wedding, guests mingled at the afterglow party amid white leather seating accented by retro contemporary lamps and tables. Continuing the dot pattern, gobos focused on the walls enhanced the curve of the chairs. The backlit bar provided a stunning impact piece behind the candle-covered sofa table that featured monogrammed drink coasters and DVDs of the couple's childhood.

Facing page: In revealing the music box cake room, guests were delighted by a fanfare confetti blast announcing the opening of the stunning red velvet-lined space. The reveal showcased the tiered chocolate cake and dessert buffet as music box tunes filled the room.

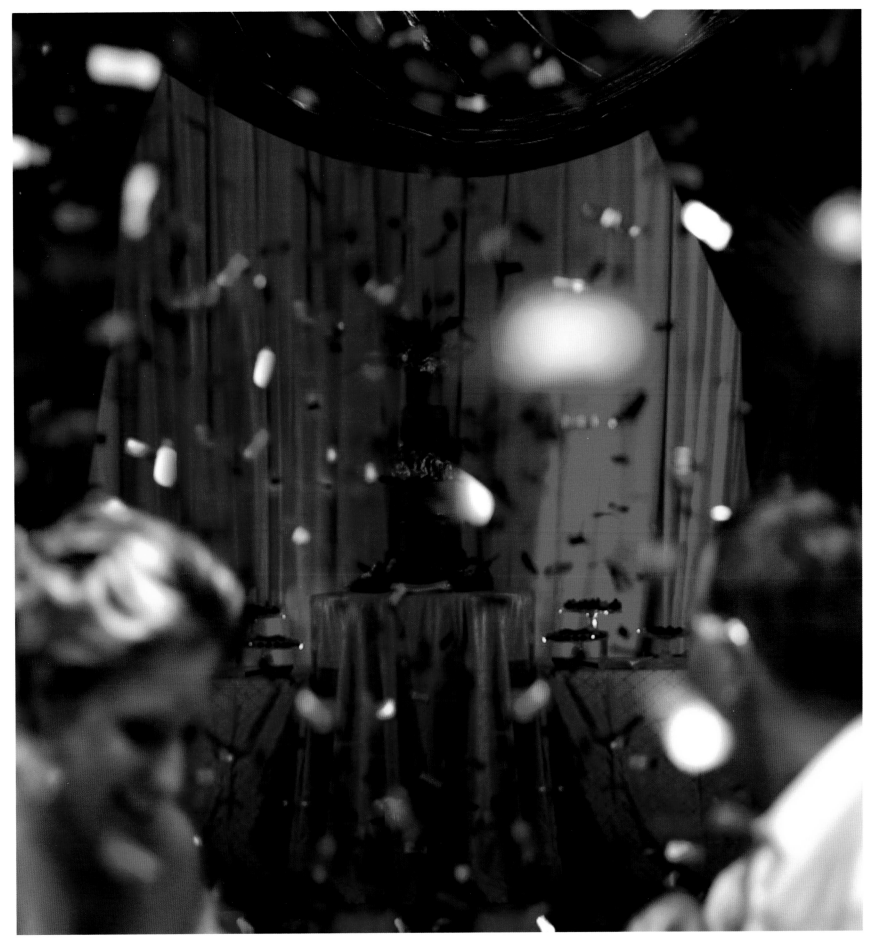

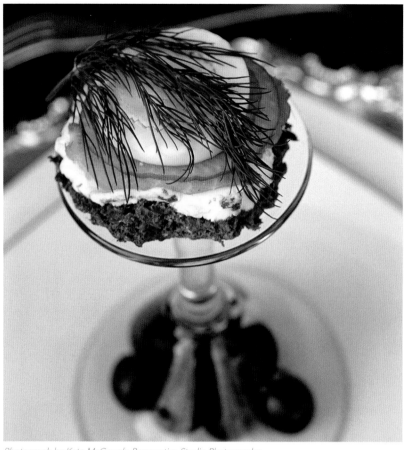

Photograph by Kate McGough, Perspective Studio Photography

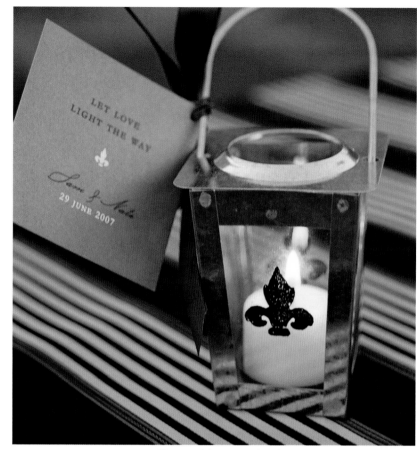

LET LOVE
LIGHT THE WAY

Sara & Nate
29 JUNE 2007

Photograph by Kate McGough, Perspective Studio Photography

Photograph by Coppersmith Photography

Photograph by Jenn Barnett Photography

"A complete understanding of the etiquette rules must first exist before they can be appropriately modified."

—Bruce Vassar

Right: An eight-course dinner for 75 guests with individual wine pairings for each course and more than 3,000 pieces of china, crystal, and flatware requires a highly detailed design. We utilized U-shaped seating with an opulent table that merged traditional baroque silver chargers with contemporary china for a blended vineyard feel.

Facing page: In every event, the details create the impact. We ensure that everything from the appetizer to the favors meshes with the overall design concept and speaks something about the hosts. Presenting food as highly stylized art incorporates the sense of sight into the culinary experience. Another unique touch is usable favors, such as a candle lantern that guests can use as the wedding couple departs.

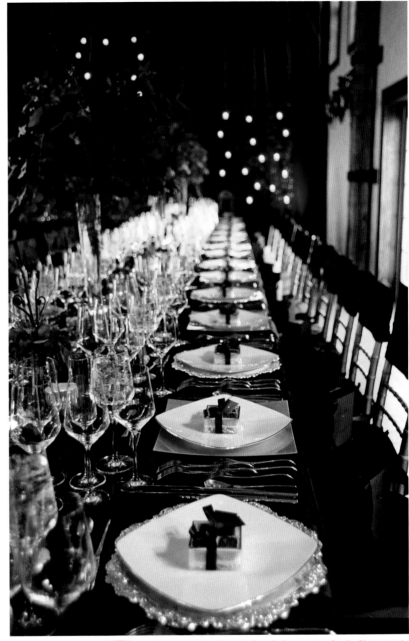

Photograph by Kate McGough, Perspective Studio Photography

views

To help generate new ideas when planning an event, use a technique called branching. Start with one element, like a daisy, and write down all of the aspects of that element—white, yellow, round, oval, leaf veins, green, fresh scent. Then take some of those aspects to bring in other design components that might not have been considered before—an oval for the invitation or the leaf vein pattern on the menu, for example.

EVE EVENTS

EVE DEIKEL WENDEL
MINNEAPOLIS, MINNESOTA

Creative, insightful, and undeniably organized, Eve Deikel Wendel brings pure elegance to every event. Belonging to a philanthropic family, her event planning began with nonprofit galas, charity benefits, and silent auctions that helped her develop a highly structured approach. She learned that planning and preparation are the fundamental elements of a successful celebration, but her creative side yearned for a broader outlet. After designing her own lavish wedding, husband's 60th birthday bash, and daughter's bat mitzvah, her talents were apparent.

Eve Events opened in 2006 and quickly established itself as a design firm that focuses on individuality and sophistication. With co-designers Sarah Wendel and Stephanie Lutz, Eve creates events with remarkable cohesion and spot-on accuracy; each celebration fits the personality of the host or hostess to a T. What's her secret? She writes the story before it happens, literally. With an English literature background, Eve understands the level of nuance and subtlety that words can convey and uses that as an effective means of communication. With text in hand, the host and hostess have full access to how the evening will play out. The result: a seamless production with no surprise endings.

Planning a bride's ceremony while she's serving in Afghanistan proved both challenging and rewarding. Her style? Simply elegant with a touch of spice. We went with a Hollywood Regency design at Windows on Minnesota, choosing a mixture of glamorous elements: crystal and white floral centerpieces, chunky candles, and elegant tableware. Combining the simplicity of color with the complexity of textures gave us the look we wanted.

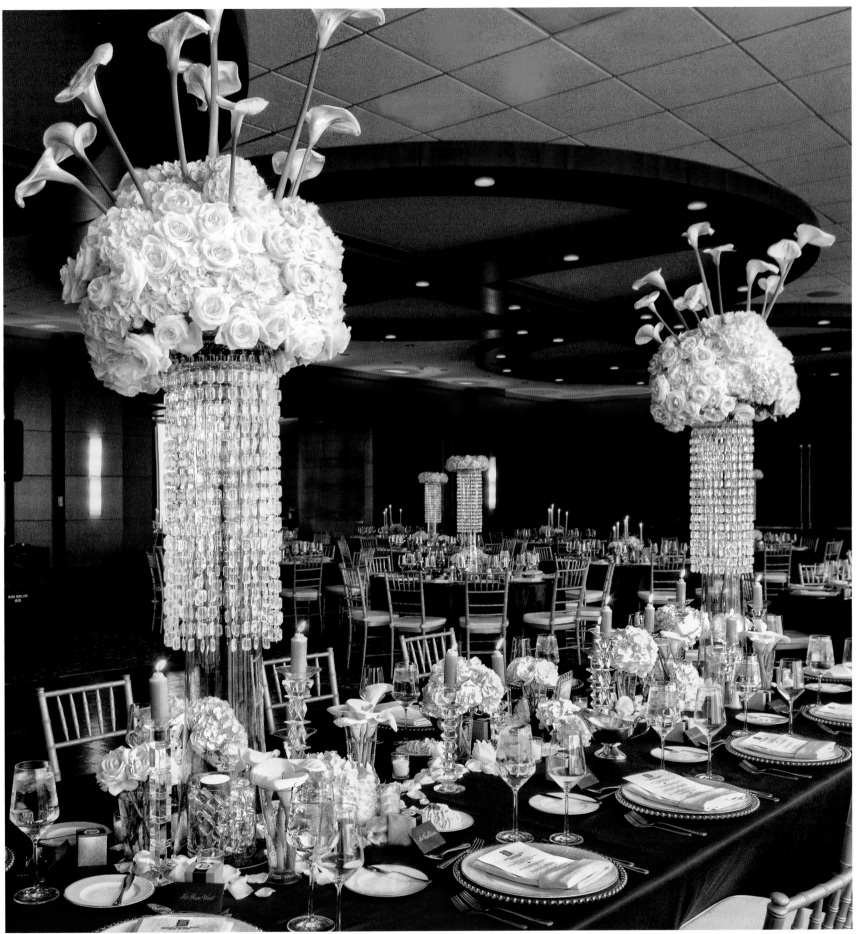

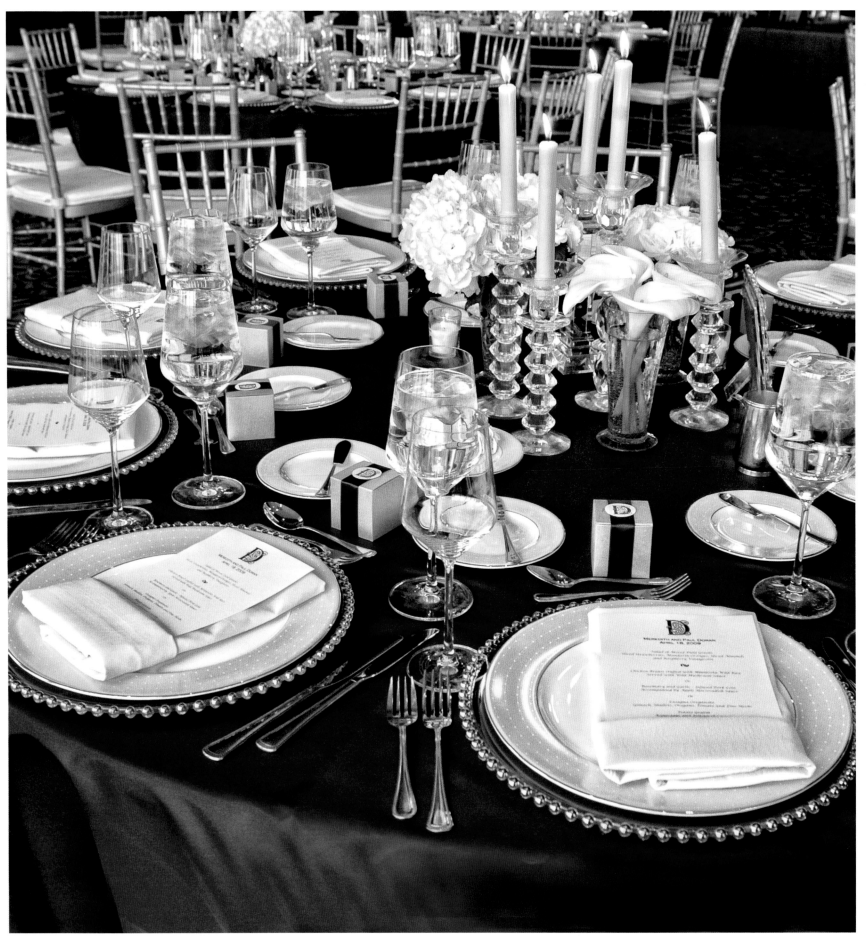

Photograph by Priscilla Wannamaker Photography

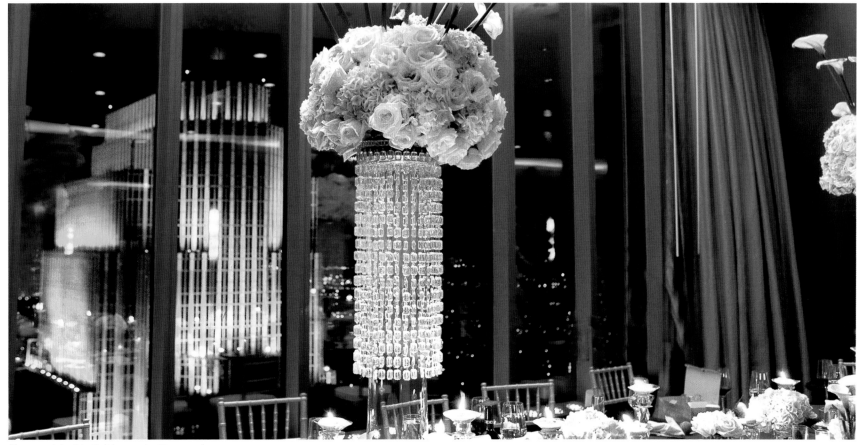

Photograph by Priscilla Wannamaker Photography

Above and facing page: Set atop one of Minneapolis' tallest buildings, the venue revealed wraparound views of the Minneapolis skyline, adding a dream-like allure that played well against our color scheme of blues and white. Custom-designed menus and specialty china from Monique Lhuillier's Etoile Platinum collection revealed the attention to detail. From the repetition of the monogram on the invitation suite, menus, and other printed materials, to the carefully chosen amenities, everything tied together beautifully.

Right: How do you improve a ceremony at the Four Seasons Lana'i? By enhancing the existing elements. With such a breathtaking setting, we used the periwinkle and yellow theme to improve upon the Hawaiian backdrop. By simply adding golden flowers to the fountain, we brought out the natural blue tones of the water.

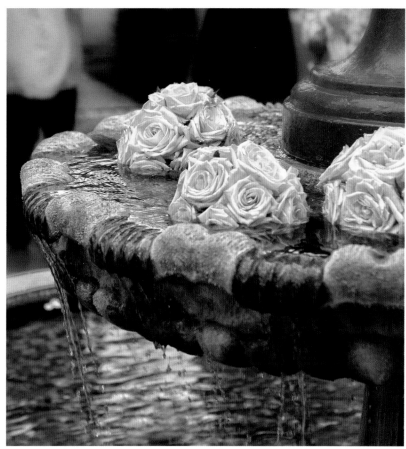

Photograph by Priscilla Wannamaker Photography

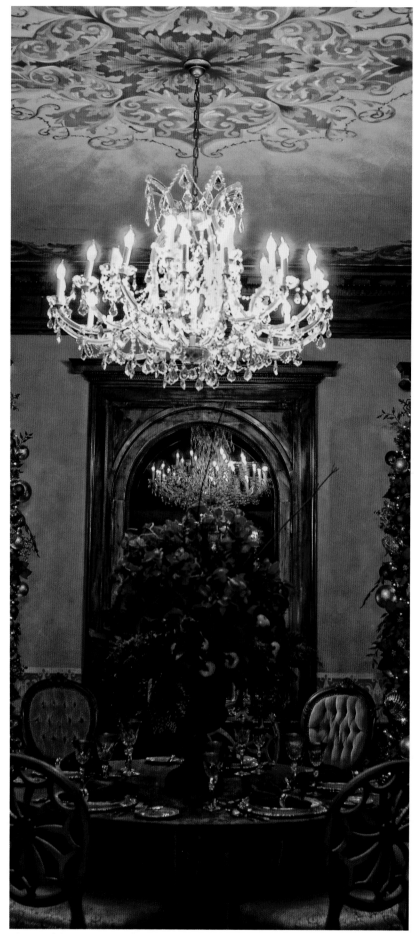

"A good event is like a well-executed play. The drama, excitement, and details all come together."

—Eve Deikel Wendel

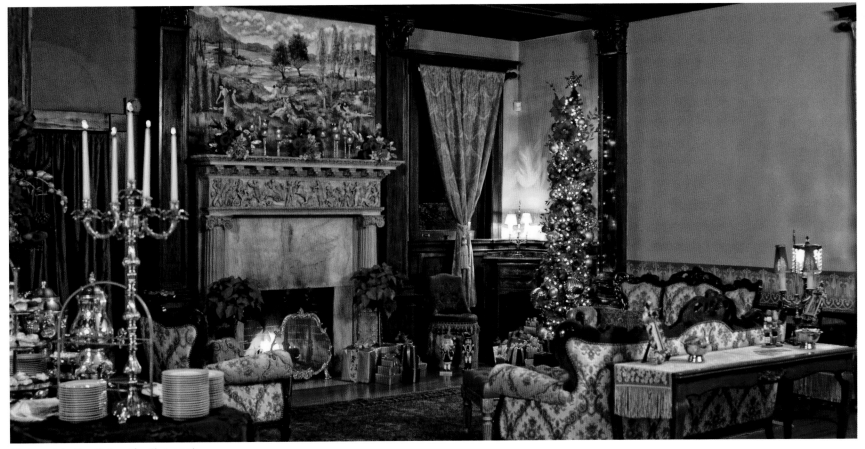

Photograph by Happily Ever After Photography

Pulled from the pages of a Dickens classic, a Victorian Christmas party let guests feel like they had stepped back in time. We staged the whole event, setting up furniture, rugs, linens, and lamps that suited the period. Choosing the venue carefully, we found a flexible and creative space that offered painted ornamental ceilings, crystal chandeliers, and stunning frescoes. Hours and hours of research allowed us to duplicate a 19th-century British home—authenticity was crucial. Menu items reflected the traditional fare of the time and were displayed in the most beautiful arrangements: peppermint sticks, marshmallows, and cinnamon accompanied hot chocolate and spiced apple cider. Warm and nostalgic, the room's composition gave a storybook feel.

Photograph by Happily Ever After Photography

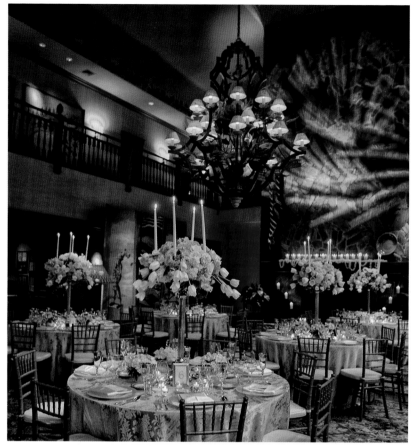

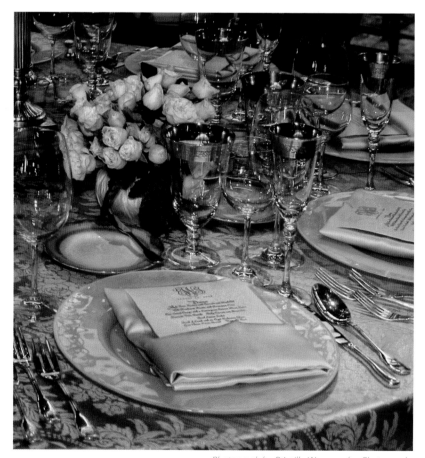

"The art of event design is in orchestrating a wide range of elements, textures, and colors to harmonize perfectly."

—Eve Deikel Wendel

Right: Set on a lush golf course, a rehearsal dinner at Manele Bay in Hawaii featured specialty linens. It was important for us not to compete with the vibrant colors of the background but rather to highlight them. The linens' hues allowed us to do so, with the rust color picking up the ruddy rock tones and the periwinkle augmenting the color of the water and sky. To maintain full focus on the amazing scenery, no flowers appear on the table; simple pillar candles grace it instead.

Facing page: When an English Country-themed wedding in Hawaii took place in a "touch-of-Colorado" venue, we knew that the combination would have to be seamless. The ceremony itself took place outdoors beneath a century-old banyan tree, providing a naturally romantic canopy. Pristine lawns and amazing gardens of the Lodge at Koele became views during dinner, as one entire side of venue opened to the outdoors. Soft and subtle, the lighting included candlelight, sconces, and intricate candelabra centerpieces for the tables. To enrich the English Country elegance, distinct stemware, china, and silver mingle with the gold, silver, and ivory hues.

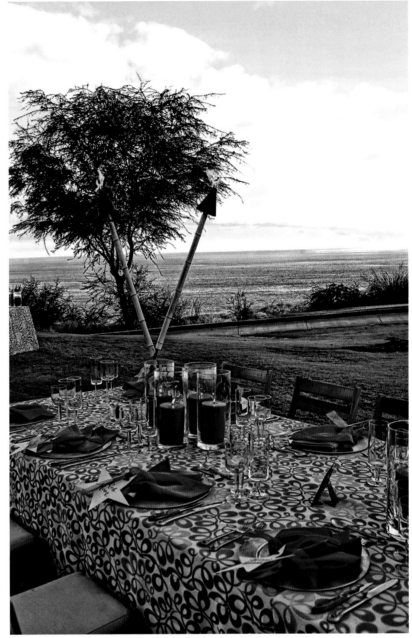

Photograph by Priscilla Wannamaker Photography

views

When working with an event designer, don't be afraid to hand over full control. Trust that you've properly conveyed your thoughts and ideas. Our job is to make sure the host and hostess are completely happy; take advantage of that. Enjoy the process and the experience of seeing your vision come to life. For many people, it's a once-in-a-lifetime opportunity.

Event Lab

BECKY HARRIS | JACK NOBLE
MINNEAPOLIS, MINNESOTA

Picture a virtual laboratory of event experts that synthesize their efforts seamlessly to concoct brilliant productions, and you've got Event Lab, one of the Twin Cities' premier party producers.

The company is the result of the collaboration of two great minds—founder Becky Harris and management head Jack Noble, who joined in 2006. Each oversees different components for an integrated vision that allows for a larger scope of capabilities, including an in-house staff of designers and florists and two huge on-site warehouses full of décor and linens.

Event Lab's designers dig deep into what the hosts hope to accomplish and then custom-build the party to their specifications. Each event is wholly unique and fully tailored to the host's needs and tastes. Final proposals are ingeniously tactile experiences that prove irresistible for potential hosts, who are invited to tour a showroom virtually decked out with components of the future event. This allows them to touch, hear, and feel the sensibility of the design vision—and really get excited about their upcoming celebration. The day of the event, Event Lab staff locks all the logistics and preparation down so hosts can rest at ease and enjoy their night. After all, the team is always striving to hear those magic words of feedback: "That was perfect!"

The abstract prompt for the theme—"Be Amazing"—really allowed us to let our imagination run wild. We devised a totally white palette, and the monochromatic approach let us play with shapes, textures, forms, and lighting—the incredibly tactile table coverings are a perfect example. Hundreds of five-foot orbs hung at varying heights, soft drapery panels, centerpieces of LED lighting, and fresh flowers contribute to the immersive sensory experience.

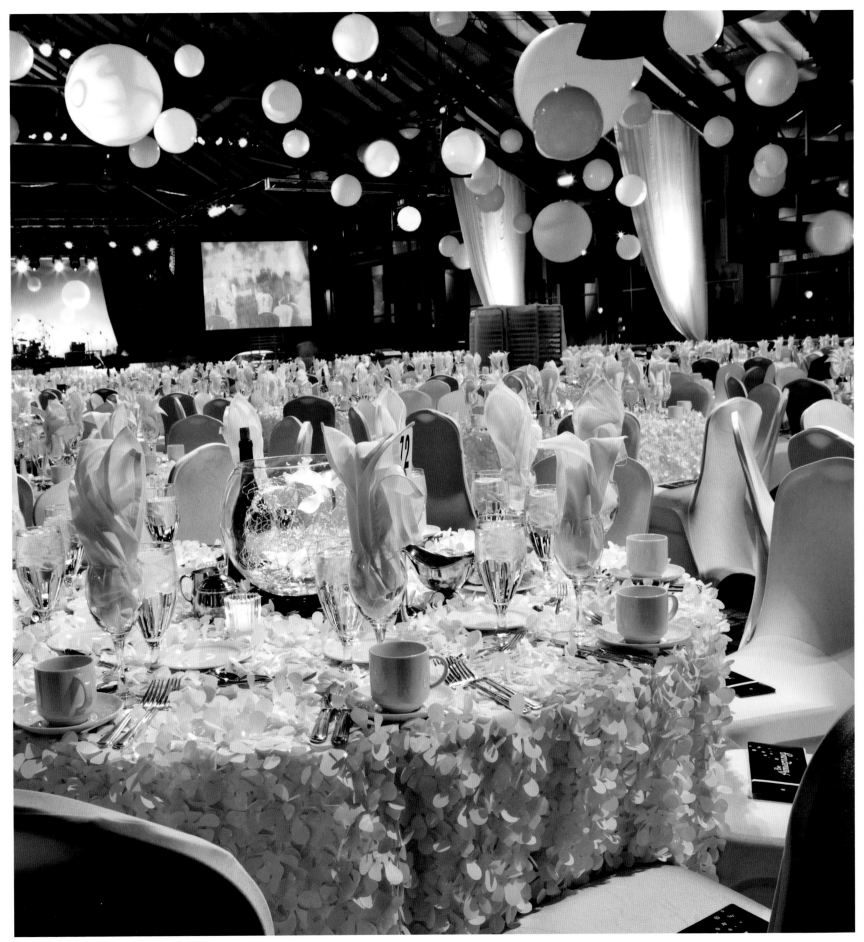

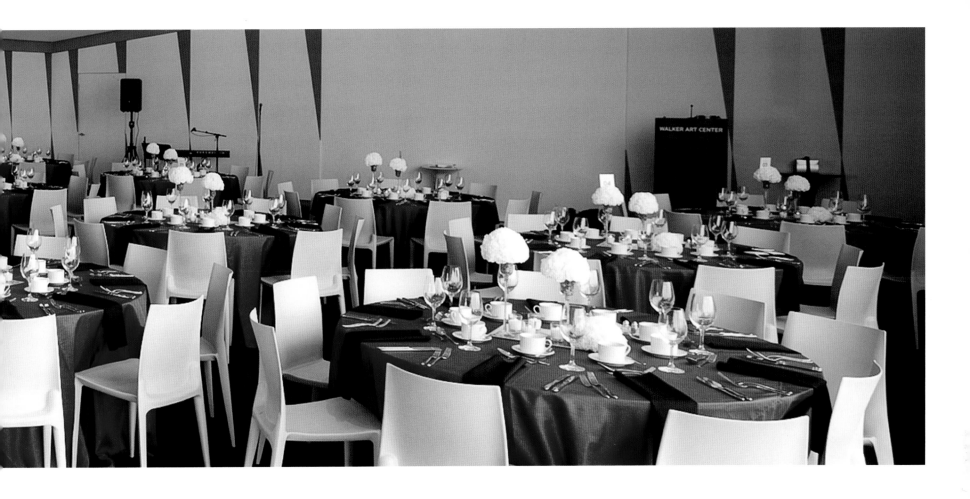

05.11.02
AN EVENING TO HONOR
STEVE G. SHANK

02 ENTREE

03 DESSERT

RASPBERRY CHEESECAKE BITES | FRESH
FRUIT AND MASCARPONE TARTLETS |
CHOCOLATE TRUFFLE CAKES | RHUBARB
CAKE WITH CRÈME FRAÎCHE | WILD
STRAWBERRIES | CHOCOLATE MINT PIE

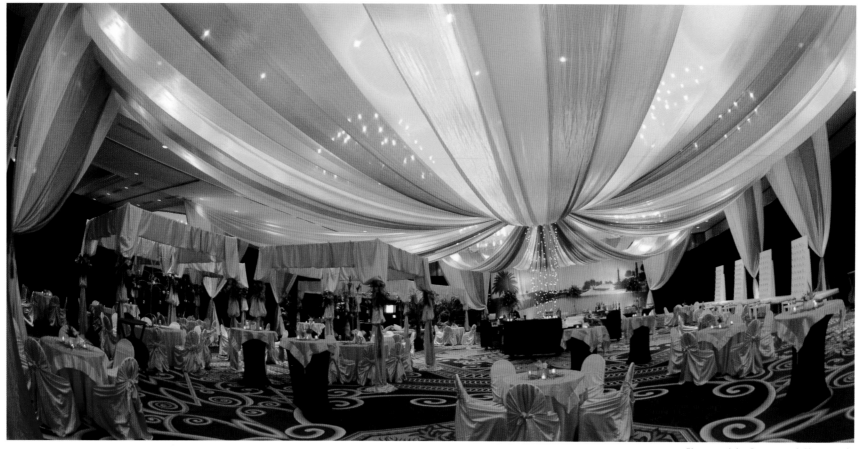

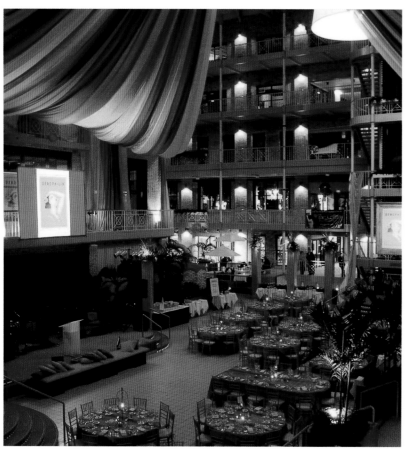

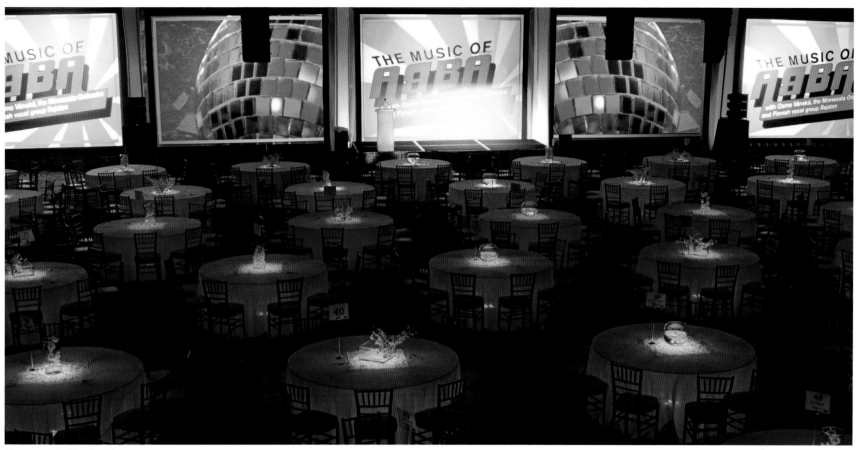

Photograph by Matt Porath

Above: A fun, vibrant fundraising event with a '70s theme featured a modern twist—acrylic tables lit from underneath that changed colors throughout the night.

Facing page: We're all about commitment to a total recreation of the venue. A Moroccan-style event boasted a dramatic draped ceiling glowing with warm hues and golden accents. Hanging floral balls, satin fabric tents, and a multitude of pillows punctuated by stunning floral votive trees contributed to an intimate environment.

Previous pages: At a retirement party for a heralded CEO, modernity and clean lines were a priority. The venue, an art museum, inspired us to emphasize and incorporate the guest of honor's favorite artworks. What's especially fun is when the graphics—the menus, the placecards—tie in seamlessly with everything else, and here we were given the control that let us bring together the flowers, the chairs, and the printed media for a fully synthesized design.

"A Mardi Gras fête can delve beyond masks and feathers. Innovative twists lend any tired theme fresh perspective."

—Becky Harris

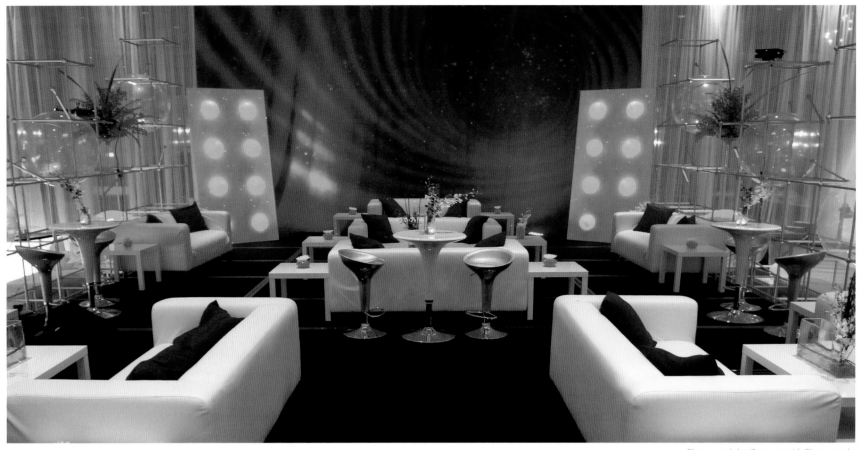

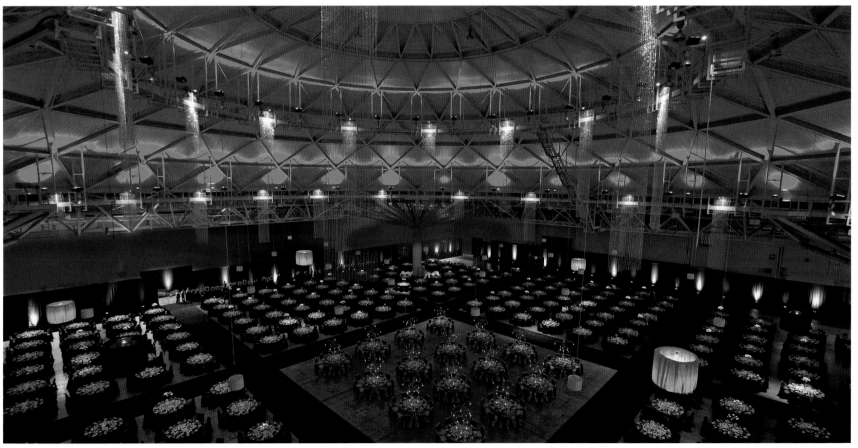

"You know a party is done right when the guests walk in and say 'Wow, I haven't seen that before!'"

—Jack Noble

Right and facing page top: A client appreciation night at a Minneapolis hotel included families and children as guests, so we split the room into an adult portion and a kids' area, each with its own activities and food. The vibe was modern, sleek, and industrial, with lots of contemporary LED lighting for a high-tech experience.

Facing page bottom: A dinner for 3,500 scrapbookers in the convention center's exhibition hall proved quite a challenge, but everybody loved it. To pull off an elegant evening in blue, we dressed the tables in azure linens and sheer overlays, and lit the room with hundreds of candles and blue LEDs in the form of hanging crystals and lamps.

Photograph by Coppersmith Photography

views

The best way to pull off a seamless event is to ensure that every detail is well-planned—coordinate and execute not just the décor and the look but also how things like valet parking and the bar will work. View the event through your guests' eyes to ensure every person involved is focused on that singular vision.

AFFAIRS WITH LINDA

LINDA ALPERT
CHICAGO, ILLINOIS

Long before women were welcome in the event planning business, Linda Alpert began making a name for herself in Chicago's competitive market. In an industry where word travels fast, she established a reputation for designing the finest, most distinctive events. Starting with her stepson's bar mitzvah nearly 30 years ago, Linda has acquired the finesse and expertise that have placed her at the center of Chicago's elite; city officials, movie stars, and CEOs populate her extensive clientele.

Her namesake company, Affairs with Linda, has become prominent due to a skill that she's turned into an art form: listening. It is at the heart of her mission to create the perfect celebration. Hosts become members of the family and in a short time, she has absorbed everyone's tastes and personalities, which ensures an event that is simply stellar.

Linda knows that she is only as good as her last event, which is why every party is just as impressive as the one before.

For a ceremony at the Harold Washington Library, we captured the personalities of the bride and groom. Vibrant, elegant, and exciting, the space came together with the creative insight of Kehoe Designs, BBJ Linen, Tablescapes Party Rentals, and Entertaining Company, with lighting by Frost Lighting.

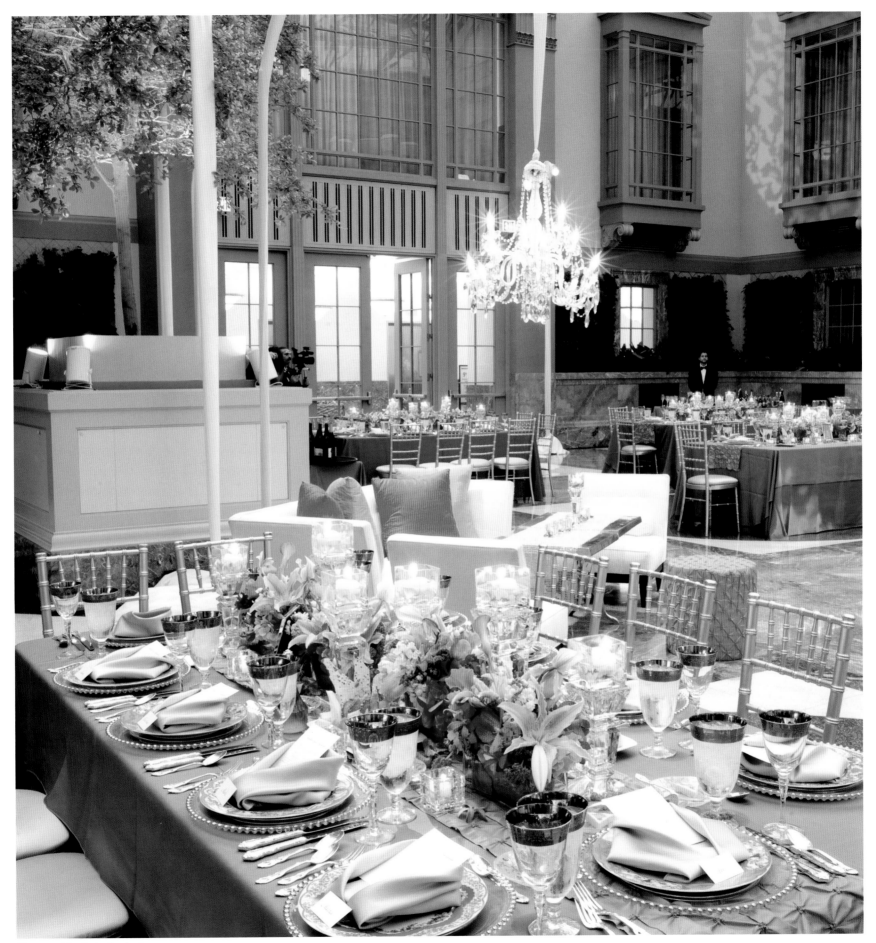

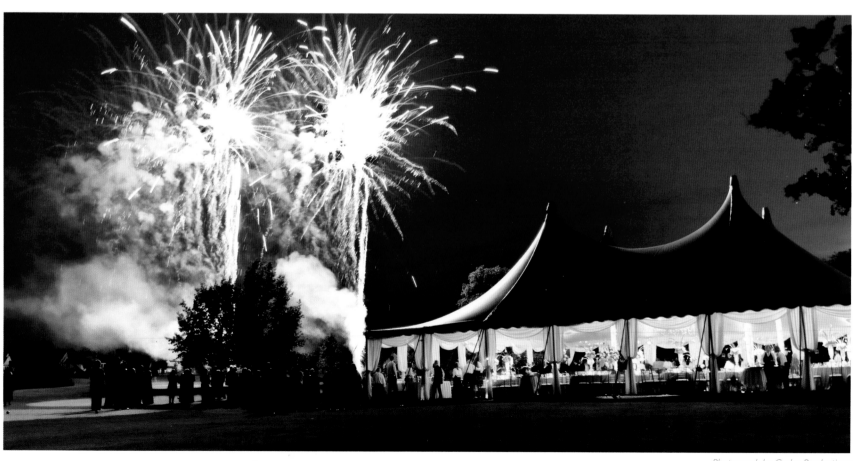

"Events are unique in the sense that they have the ability to bring a dream to life. Few things have that much power."

—Linda Alpert

Right: Some events exude pure energy, and the event I designed for a couple who wanted to capture the spirit of Carnival did just that. Bright colors, a variety of shapes, and well-crafted lighting made for plenty of visual stimulation and fun. Lynne Jordan and the Shivers gave a crowd-pleasing performance. Amy Crum from Blumen and BBJ Linens helped create a stunning space, with lighting by Frost Lighting.

Facing page: When I planned a ceremony and reception for two childhood sweethearts, I knew it was going to be something special. Held at the Conway Farms Country Club, the event took place in the neighborhood where both the bride and the groom grew up, Lake Forest. I brought their vision to life and used fireworks for an exciting, dramatic touch that everyone loved. The event was a resounding success thanks to my collaboration with Tablescapes Party Rentals, Orchestra 33, Partytime Productions, Kehoe Designs, and BBJ Linen.

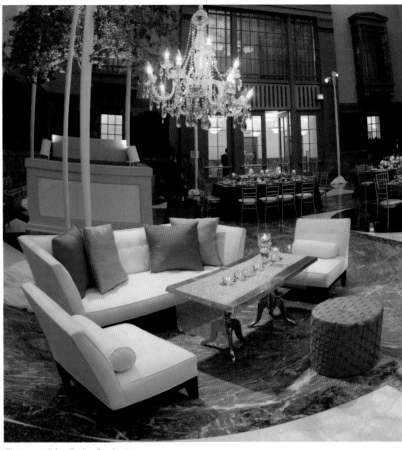

Photograph by Garbo Productions

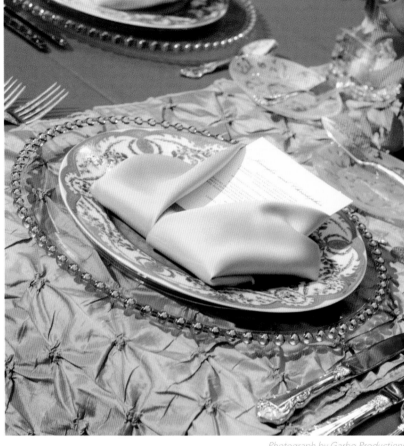

Photograph by Garbo Productions

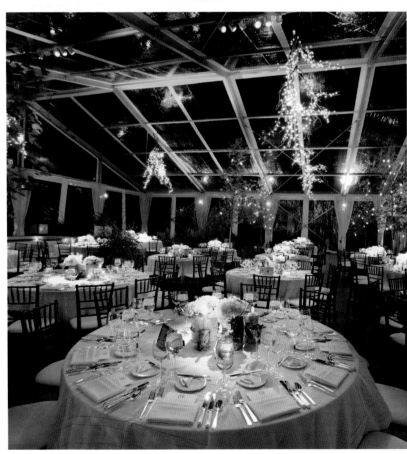

Photograph by Heather Kingen-Smith

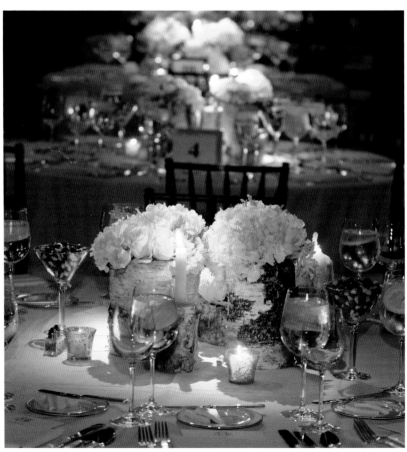

Photograph by Heather Kingen-Smith

"This isn't about me and it isn't about my company. This is someone's big night—I'm there to make it flawless."

—Linda Alpert

Right and facing page top: The more options, the better. When I design an event, there's no shortage of variety for hosts to choose from. Intense colors and brilliant flowers made for a hot space to complement the ceremony at Harold Washington Library. We strategically placed furniture around the dance floor to give guests a comfortable resting place without missing all the fun. Limoges-like plates and chargers show off the attention to detail and overall elegance of the event.

Facing page bottom: With flowers from Craig Bergman, catering from Designed Cuisine, and tent design from Partytime Productions, we turned a Lake Forest home into a fairytale. The mother of the bride is a well-established antiques dealer so the setting reflected an appreciation of time-honored beauty. Set on a ravine, the estate is a rehabilitated Cyrus McCormick stable that wowed the guests. We tented a long expanse in the courtyard with cobblestone floors and traditional table settings to achieve a classic, romantic feel.

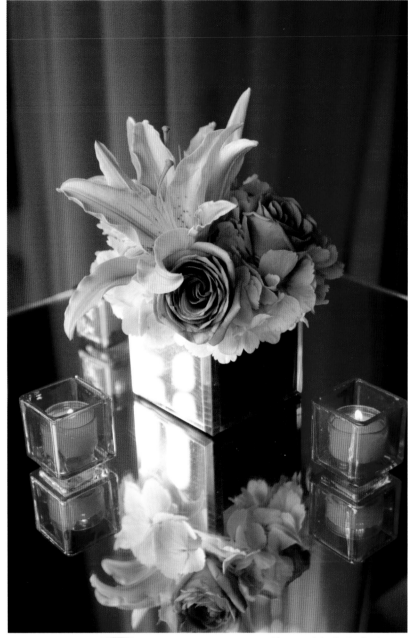

Photograph by Garbo Productions

views

Music can make or break the night. And your best bet is live music. If a band can engage the audience and get people onto the dance floor, then the party is a success. People want to relax and cut loosé—music provides the best outlet for that. Don't hold back on this portion of the budget; it's worth every penny.

COLEMAN MASON EVENTS

COOKIE COLEMAN | CHAR MASON
MINNEAPOLIS, MINNESOTA — ST. PAUL, MINNESOTA

An event is an extension of the hosting organization, family, or company. More than just a one-time party, a celebration is a way to communicate ideas, goals, vision, purpose, and mood. Cookie Coleman and Char Mason, owners of Coleman Mason Events, use their combined years of experience to bring the vision and goals of the host through to each part of the event.

Before combining forces to create Coleman Mason Events, Cookie provided consulting and management services to businesses and nonprofits to develop events such as fundraisers, galas, and conventions. As an award-winning singer, she brings music and theatrical knowledge and excitement from that perspective.

Char has marketing and event directing experience, including directing festivals, managing galas, and copywriting. She opened her own communication and event business before partnering with Cookie. Char's talent for producing events allowed her to naturally gravitate toward helping others throw spectacular celebrations.

At Coleman Mason Events, Cookie and Char bring a strategic, big-picture approach to the planning process with a global look at the purpose of the event, the mission of the host or organization, and what will create a lasting positive memory for the audience. Pulling from their long list of independent contractors and talent pools, Cookie and Char use their combined creativity and areas of expertise to bring in just the right team for each event.

The Minnesota Institute of Arts gala opening provided a unique challenge to host a swank event for 900 people in a tent while still creating a seamless feel from the new galleries in the museum into the event space. The hand-cut centerpieces created movement with the swirling lighting and changing colors for a stunning effect.

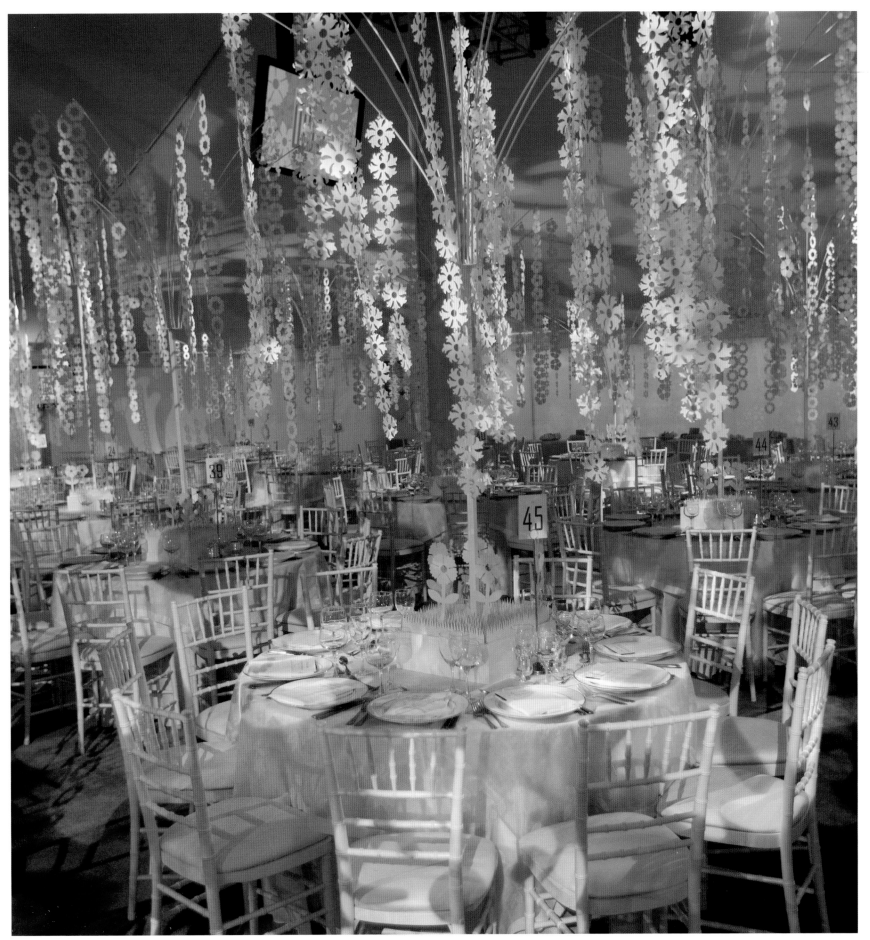

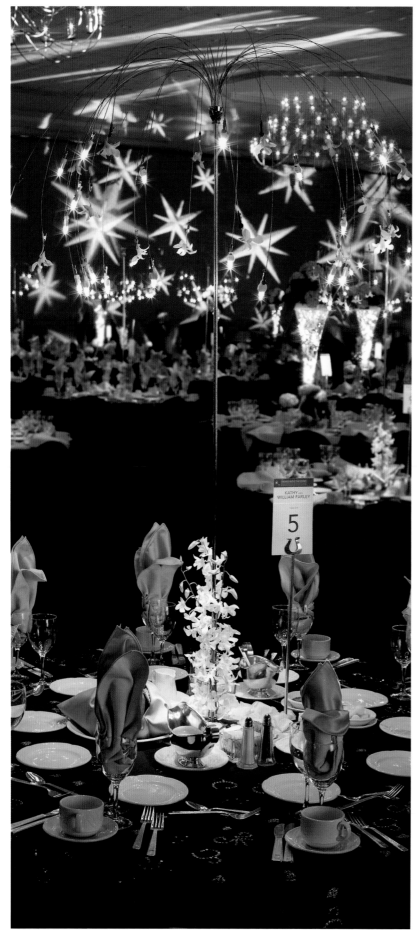

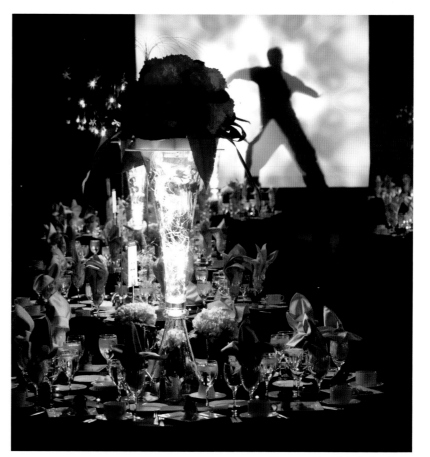

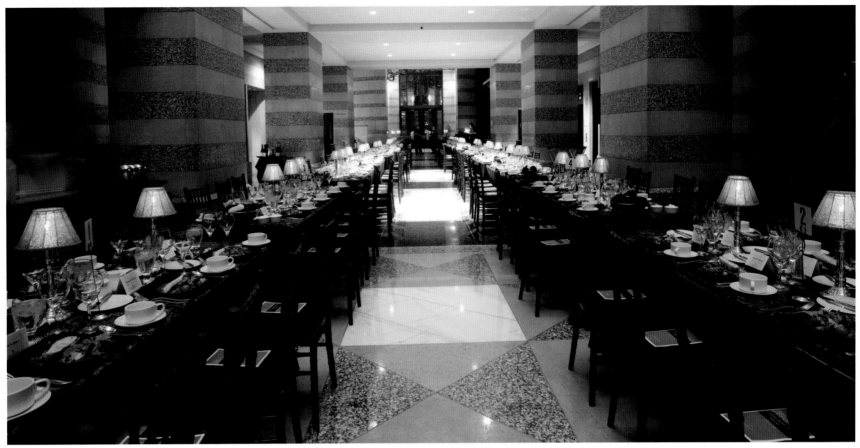

Above: Long, narrow hallways and an adjacent rotunda made for a challenging seating and viewing space. We created a layout the facility hadn't used before, augmented the program with video support, and used rich but minimal décor to better highlight the beauty of the event space.

Facing page: At a "Dance with the Stars"-themed gala, we focused on making the hotel ballroom disappear and on transporting the guests into a virtual constellation of moving stars. We used dramatic table settings, intelligent lighting, a fantastic performance, and a stage with a runway to bring the audience closer to the action.

"When orchestrated correctly, the mixture of elements will align with the goal of the event and the mission of the organization so attendees walk away with the desired message."

—Char Mason

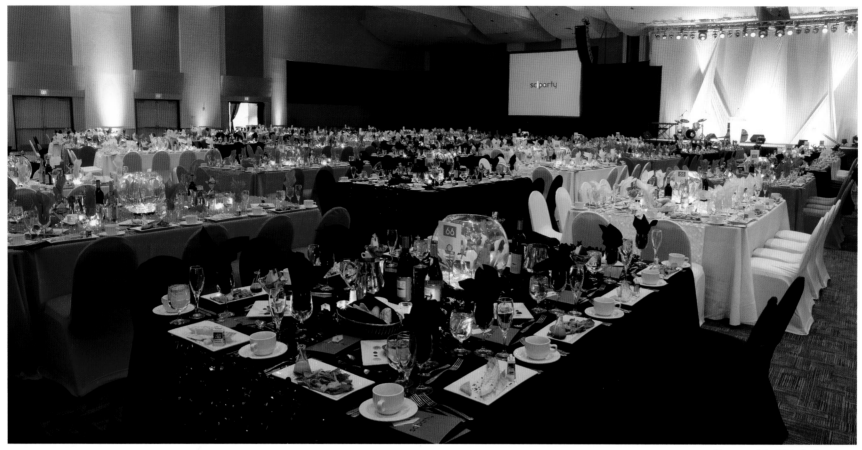

Photograph by Michelle Gunderson

Photograph by Michelle Gunderson

Photograph by Michelle Gunderson

"Keep guests interested and engaged by building surprises into the event and breaking up the traditional DNA format of silent auction, dinner, live auction, then dancing."

—Cookie Coleman

Right: The unique element of sound was woven through the Minnesota Public Radio gala to help showcase the new building. Because the building itself wasn't large enough to seat the 500 guests, the adjacent parking lot was tented for the dinner. We then connected the mission of the organization with the musical entertainment. Each corner in the theater-in-the-round setting provided unique music. When heard together, all of the entertainers coordinated their individual music for one complete sound.

Facing page: After the party, no one connected science with the word "boring." For the science museum's 100th anniversary, we brought science into every aspect of the event. Each course of the meal incorporated squash grown from 100-year-old seeds found in Native American pottery. We used sound and added a visual element of sound into the entertainment. The Sci-Lounge, an after-event cabaret decorated like a test tube, featured music by jazz trombonist Delfeayo Marsalis and encouraged people to stay long after the formal program was complete.

Photograph by Beth Kost

views

Begin the event planning process with a review of the event's purpose before moving on to the "fun stuff." Then, don't forget to orchestrate a perfect ending. Guests should remember the event itself, not a frustrating or overlooked detail such as a long wait for the valet.

Contemporary Events

STEVE SCHANKMAN | SAM FOXMAN
ST. LOUIS, MISSOURI

When you've built up a rich and storied history of producing major concerts and legendary shows, expanding into similarly unforgettable event design is only natural. Uniquely suited to produce celebrations of the highest caliber, Contemporary Events has evolved into a true full-service event company with customers worldwide.

Senior partner and creative director Sam Foxman joined Contemporary in 1994, and has kept the company's event design side focused on consistently solid, artistically fresh work—he knows a good track record matters just as much as a good concept. The company invests serious time in listening to its hosts to help them lay out core objectives for the event and then interprets them, letting creativity blossom along the way. The result is a customized celebration that fits the host's needs like a neatly tailored suit.

Contemporary is passionate about live entertainment, so it goes without saying that if the design can incorporate live performance to enhance an event, it will. In the Midwest, live entertainment is the company's exclusive niche—and its event designers take full advantage of their knack for connecting the right performers with audiences. Guests that are fully engaged and immersed through a real connection to a live show are going to walk away thrilled and awed, and that's exactly the reaction that retains the company's loyal following and keeps its heritage alive.

When we were called on to help design the Missouri Botanical Garden's 150th anniversary event, our concept was to make the "Garden Come Alive" by using unique entertainers, elegant structures, and stunning lighting. A large clear-span tent was erected over the garden's famous lily ponds, creating a green, magical environment that brought the outdoors in and encouraged guests to linger amid beautiful gardens. Floral patterns cast by a battery of moving lights slowly morphed into vines and flowers as the world-renowned Climatron, a geodesic domed greenhouse, glowed through the clear tent wall.

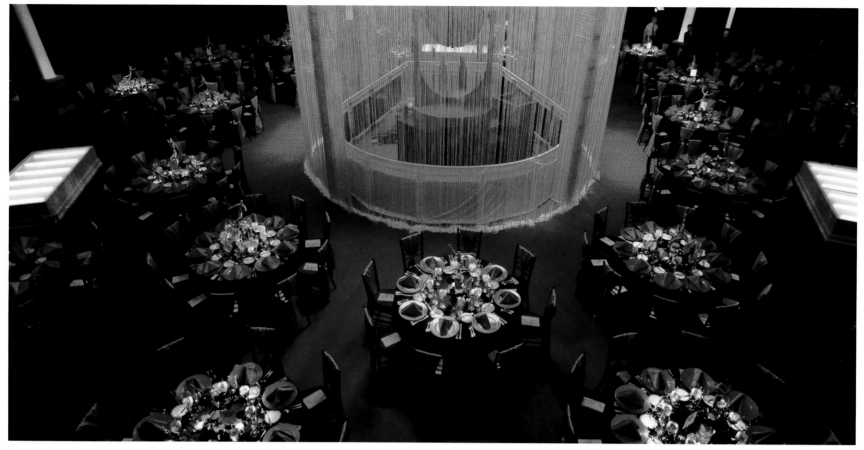

Photograph by Christopher Ryan Photography

Photograph by Guillermo Gomez

Above: We enjoy tailoring celebrations to the needs and personalities of guests of honor. For a vibrant family man's 40th birthday, we seated guests at super-long tables for a chic, family-style meal. For a debutante party—produced in conjunction with Cosmopolitan Events—honoring a young lady who loved the South American rainforest and indigenous cultures, we completely transformed a country club into a veritable maze of jungle foliage and ancient ruins. A tent connected to the back of the club featured a masterful orchestration of staging, audio-visual elements, and the dance floor—all adorned with vines, ancient temple walls, and a stunning three-dimensional carved backdrop.

Facing page: We relish the chance to bring unexpected elements into our designs. For a St. Louis Science Center gala held at the James S. McDonnell Planetarium, our challenge was to artfully disguise the giant star projector in a fresh way. To do this, we used a circular truss, spandex fabric, string curtain, and an array of moving lights to create a round focal point orbited by uniquely decorated tables. We produced an outdoor music festival inside a nationally accredited sculpture park that featured blues legend B.B. King, and for a hospital foundation event we dreamed up a fusion of Chinese New Year and Mardi Gras for a night we called "Mandarin Mardi Gras."

"There needs to be at least one magical moment that people share during the evening. Flashy décor and pretty flowers do not matter if the event lacks human connection."

—Sam Foxman

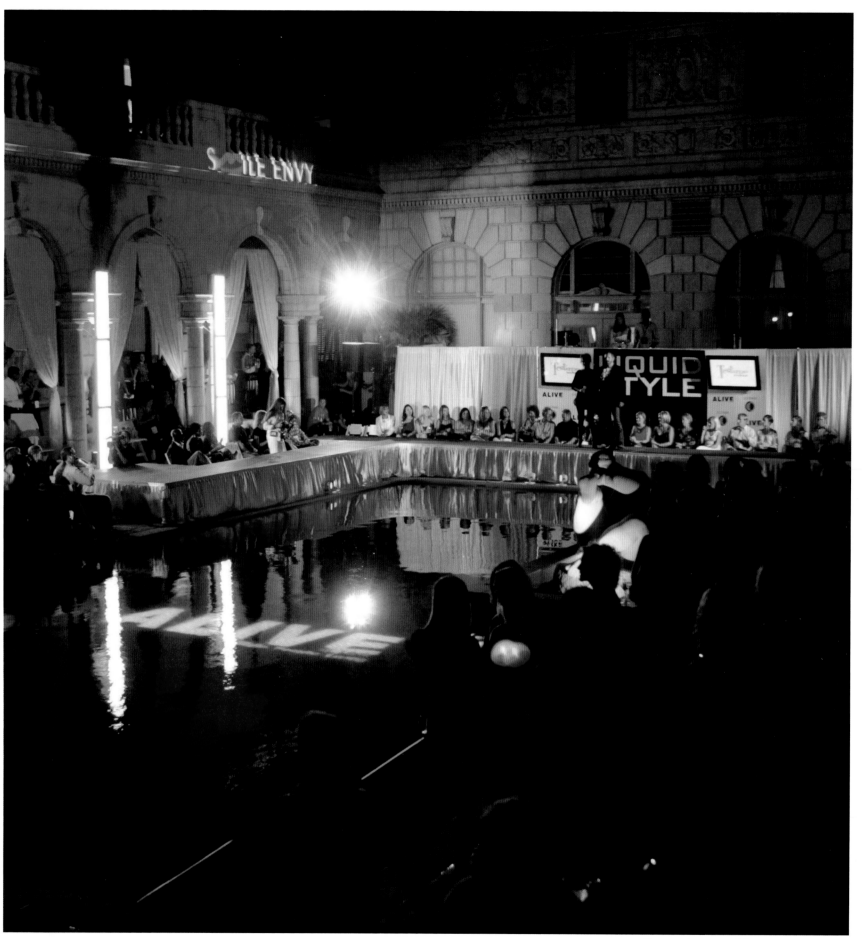

"The feedback you crave is not only 'We couldn't do this without you!' but also 'We won't do this without you!'"

—Sam Foxman

Right: In collaboration with executive producer Attilio D'Agostino, we created an extremely stark, bright environment for Saint Louis Fashion Week. Lighting sculptures crisscrossed the ceiling above the runway to fill the entire room with intense white light.

Facing page: The first major public event to happen poolside at a historic St. Louis hotel, Liquid Style—a show sponsored by Ecco Domani and *ALIVE* Magazine—allowed our creativity to run free. We erected giant towers of light along the historic columns and used fabric to create VIP cabanas in the archways. For an added bit of drama, the runway ran snugly alongside the pool as we took advantage of the pale stone surfaces to project sponsor logos. The show was a sellout and the premier fashion event of the year.

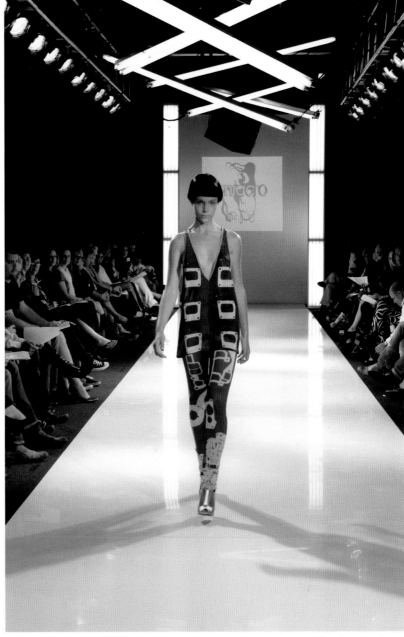

Photograph by Signature Studio

views

❖ Seek an event planner who will pull you out of your comfort zone and stretch your imagination.

❖ The right designer will make both the party and the entire process fun.

❖ Take advantage of the opportunity to incorporate live entertainment—you won't regret it.

DYNAMIC EVENTS

DAVID CARUSO
MILWAUKEE, WISCONSIN

Traditional costumes. Multiple spotlights. Elaborate sets. Sometimes an event can seem more like a large-scale theatrical production than a simple gathering. But hosts who collaborate with David Caruso often appreciate that dash of drama, especially when the man directing the show continually synchronizes all the elements into a crowd-pleasing hit.

David's entire life has been about telling stories and creating impressions. A background in theater and time spent studying television broadcasting and visual communications at Marquette University translated into valuable people skills and incredible grace under pressure. After a marketing detour in Chicago, where he organized store openings and corporate and community events, David returned to his hometown of Milwaukee, ready to combine his passion and experience into his ideal job. He started Dynamic Events in 2002, originally working as a one-man operation and relying on business advice from his father. Now David operates a studio space in downtown Milwaukee and plans about 25 high-profile events a year, including galas for the American Red Cross, the Milwaukee Youth Arts Center, MillerCoors, the American Cancer Society, and the YMCA of Metropolitan Milwaukee.

Putting his college training to good use, David is a familiar presence in local media and print, dispensing advice and offering up tips for planning the perfect celebration. His signature style is all about creating highly personalized events that provide an experience unlike any other.

The Milwaukee Art Museum is one of the premier event spaces in the city. We kept the lounge area décor sleek, modern, and in line with the museum's white Italian marble floors and Calatrava-designed architecture. Bright pops of color from the flowers and pillows added vivacity.

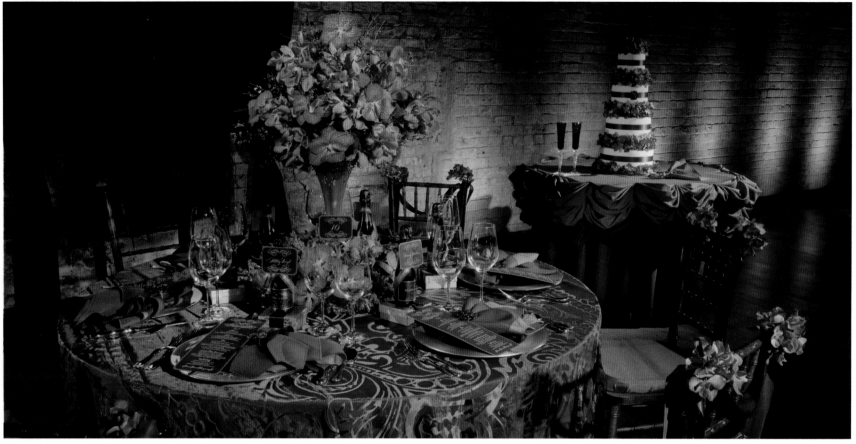

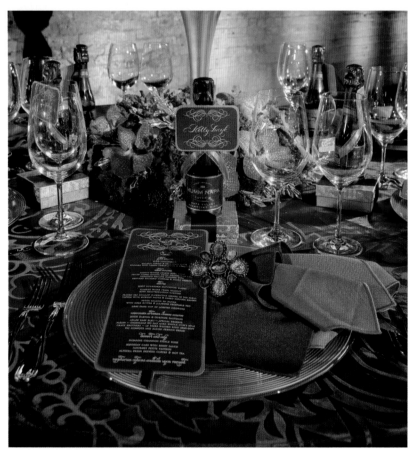

Above and left: I love customizing place settings so that guests feel special and taken care of. Beautiful, hand-picked favors such as a mini bottle of champagne, and little details like a fashionable brooch instead of a napkin ring all let your guests know that you put a lot of thought into welcoming them to your event.

Facing page left: For a corporate executive's retirement dinner, co-workers shared with me some of the boss's best attributes and I researched their meaning. Words like "beloved" and "inspirational" ended up translating into "sapphire," and that became the event's theme. About 20,000 rose stems went into the three-tiered centerpieces, with swags of crystals and faux sapphires dripping everywhere you looked.

Facing page right: An effervescent paisley print, lacquered black accents, and saturated colors nod to Indian culture and heritage without going over the top.

"The magic is in the details."

—David Caruso

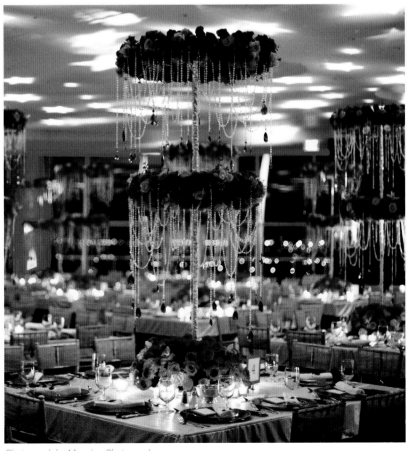

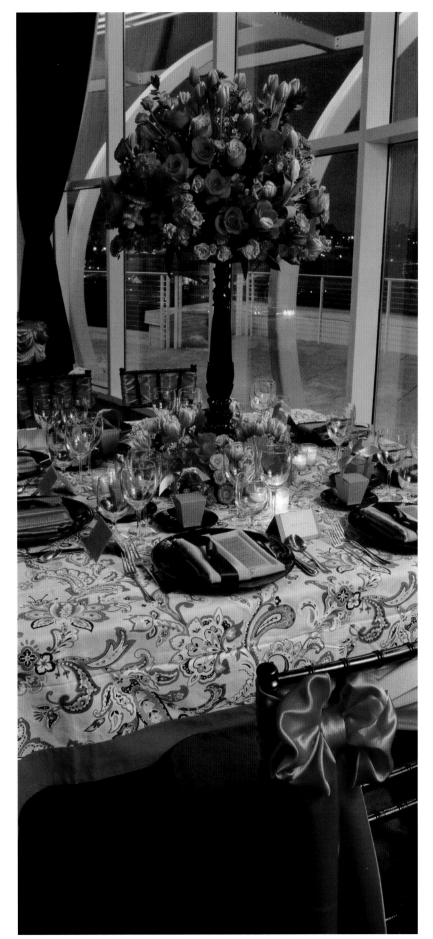

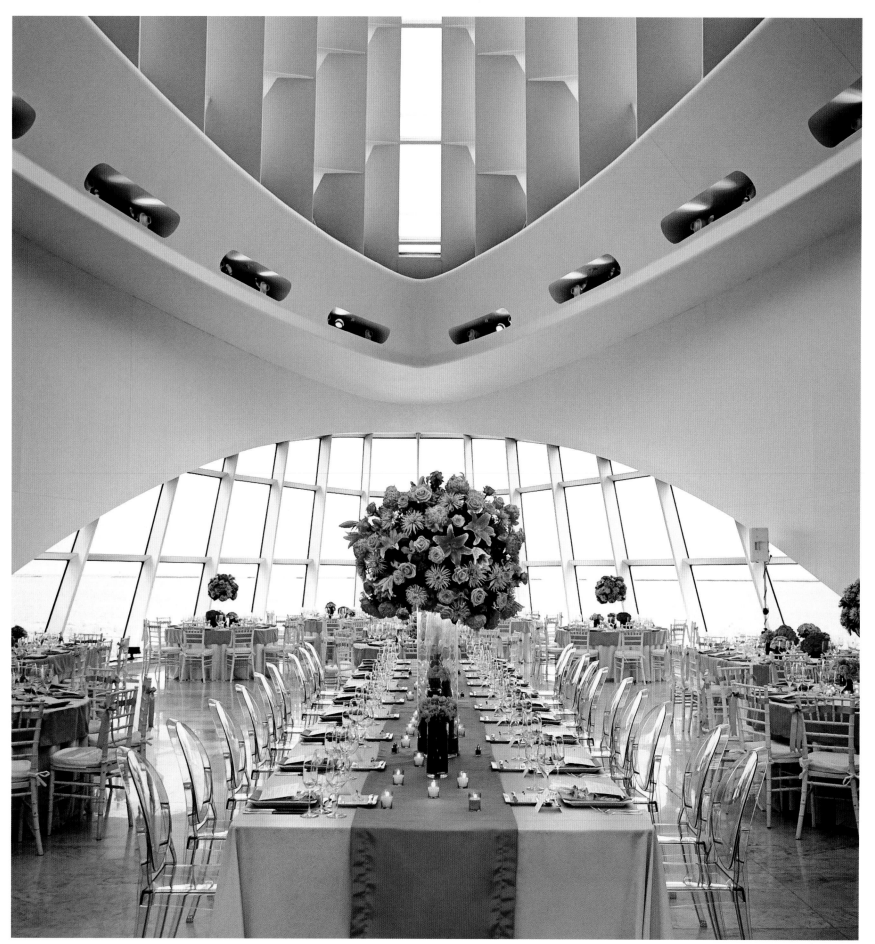

Photograph by Front Room Photography

"Concentrate on what is unique and special about you. That's how people will remember your event."

—David Caruso

Right: I illuminated an architectural centerpiece comprised of lilies and orchids with canary-yellow pillar candles, a modern alternative to the more standard votives.

Facing page: As a way to blend modern and classic styles, I used simple décor elements in a big way. The head table featured Lucite chairs and enormous centerpieces, and the familiar colors of green and pink were tweaked to elicit a fresh, vibrant, and fun atmosphere.

Photograph by Scott Patrick Photography

views

When you start to plan an event, keep your eyes and ears open to find inspiration in everyday life experiences. Don't confine your suggestions to only what you think an event idea should be. Be personal, be unique, and enjoy yourself!

ENGAGING EVENTS BY ALI, INC.

ALI PHILLIPS
CHICAGO, ILLINOIS

Unlike Jennifer Lopez's character in "The Wedding Planner," Ali Phillips did not grow up marrying her Barbie dolls and daydreaming about veils. It was her previous career in financial and project management that gave her the foundation to become one of Chicago's most sought-after event planners. While attending a networking event, Ali met another wedding planner and eventually became her assistant. After working for only one successful summer, she knew she had found her calling.

Ali's personal history plays a significant part in her easy rapport with hosts and vendors. As a Chicago native, Ali grew up appreciating the myriad of magnificent venues the city has to offer. From traditional hotels to modern airy lofts to cultural institutions, the sheer amount of places to hold an event is staggering. That insider knowledge, combined with her positive approach, paved the way for her to open Engaging Events by Ali in 2001.

Known amongst Chicago's vendors as the woman who always provides the information, tools, and communication necessary to make an event perfect, Ali counts her business background as a large part of her success. It may not sound glamorous, but being a whiz with timelines and schedules has averted many a near-catastrophe and calmed numerous jittery hosts. The immense amount of trust Ali cultivates with her hosts also helps ensure a stress-free, enjoyable day. The fact that she packs a bigger emergency kit than the one in "The Wedding Planner" certainly helps too.

Holding an event at the Trump International Hotel and Towers Chicago automatically inspires a certain aesthetic. Old Hollywood glamour was the theme for the night, complete with a red carpet to welcome guests.

Photograph by Becky Hill Photography

Just as people have many different sides, so can events. A color scheme of soft, girly pinks and ivories welcomed guests to a refined sit-down dinner, only to morph into vibrant, juicy colors and graphic black-and-white prints for the hip afterparty.

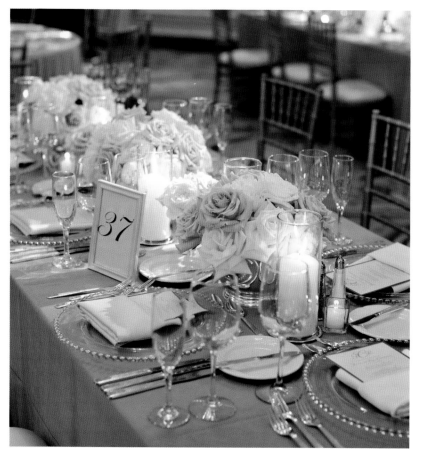

Photograph by Becky Hill Photography

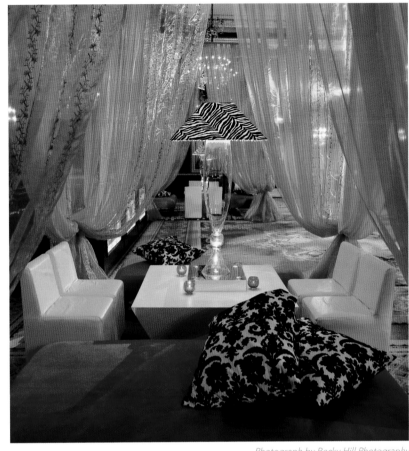

"I love it when all the elements fit together in a beautifully orchestrated schedule."

—Ali Phillips

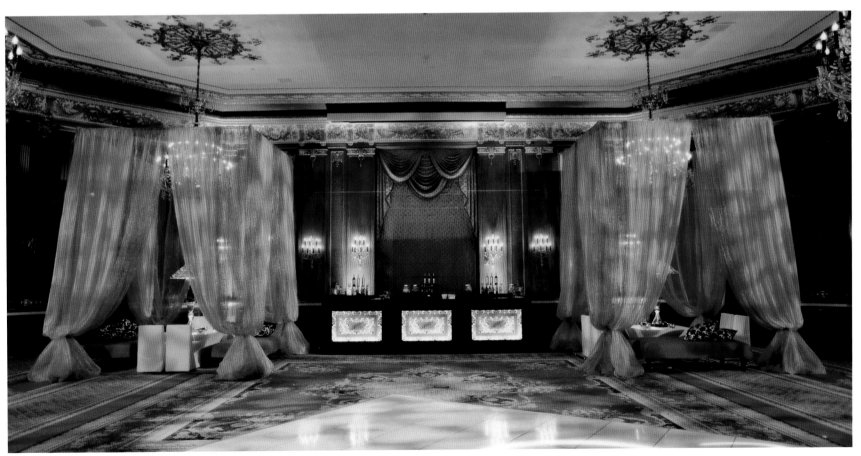

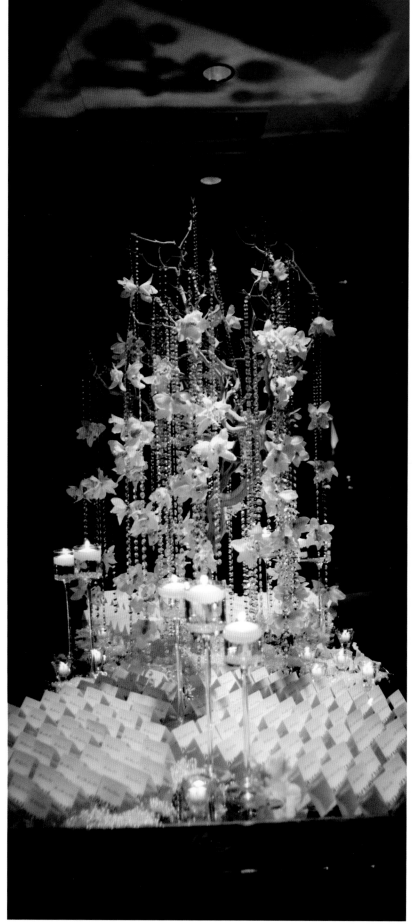

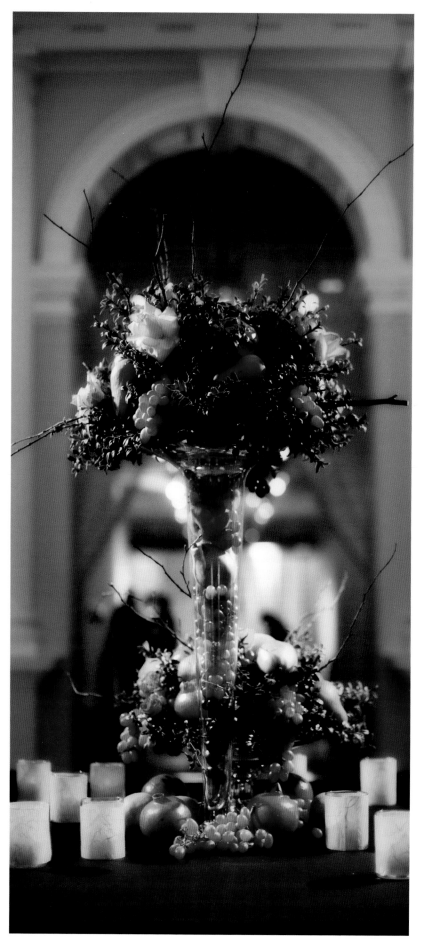

"To make an event feel like it happened organically is the goal, but to achieve that involves lots of behind-the-scenes planning."

—Ali Phillips

Right: Going off the bride's preferences—gold and bright colors—I put together a stylish event in the Drake Hotel's Gold Coast room in less than a week.

Facing page left: Every aspect of an event is a chance to up the drama. A spotlight in an otherwise dark outer room highlighted the miniature tree made of orchids and dripping crystals, enticing guests to come and find their table assignments.

Facing page right: I'm very fond of things making sense and fitting together, and a wine and cheese pairing with an actual sommelier explaining the chosen wines amid a backdrop of grapes, pears, and pomegranates is a perfect example of that.

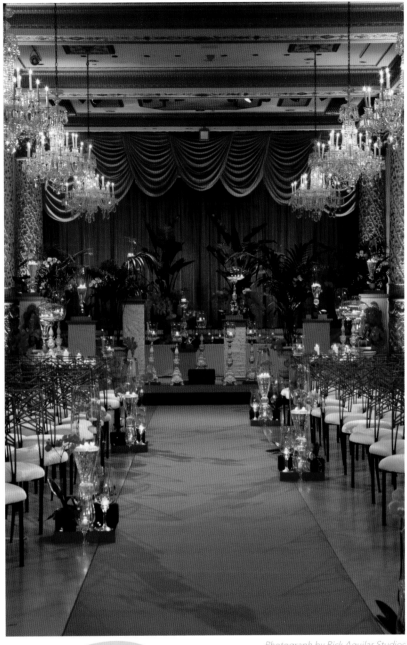

Photograph by Rick Aguilar Studios

views

When you're just entering the planning stages, a helpful exercise is to sit down and figure out your top three most important elements. Does exquisite food matter more than flowers? Is having a packed dance floor a must? Of course you want everything to be perfect, but narrowing it down to your absolute must-haves gives your event planner a better idea about who you are and what you want.

TOTAL EVENT RESOURCES

KATHY MILLER
CHICAGO, ILLINOIS

The elephant in the room isn't proverbial in the case of Total Event Resources. The studio's repertoire includes programs that called for live elephants in a ballroom and helicopters dropping confetti onto crowds below. Kathy Miller, who founded Total Event Resources in 1995, thrives on this exciting variety of event management. With humble beginnings in the spare room of her home, Kathy exceeded her goals in the first year by nearly 250 percent, which isn't surprising considering her passionate attitude and significant experience in the sales, marketing, and production of events.

Since then, Total Event Resources has continued to provide solutions for meetings and events for the Fortune 1000, major trade associations, and not-for-profits throughout the world. The wide range of partners presents a unique work environment that increases Kathy and her team's passion for their work. Corporations tend to think more with their head—the bottom line—with social and not-for-profit events focused on the heart. Associations, on the other hand, emphasize the destination of the event and education of the attendees.

This diversity of goals ultimately transfers to a plethora of drastically divergent programs, making the team's inspiration essential in creating unrivaled events. With as much information and research as possible, including dutifully testing the related products—even if it includes vodka for a product launch celebration—Kathy and her team go the extra mile to help inspire, motivate, educate, and celebrate.

At the grand opening of a Rush Truck Center, the service bay was transformed into an industrial luxe dinner and reception with inventive lighting and a sea of shining chrome. From a backdrop wall of tractor trailers and hood ornaments for centerpieces, to a vivid array of gobos that resembled trucking parts, the décor incorporated company products into the theme in a way that truly celebrated the space.

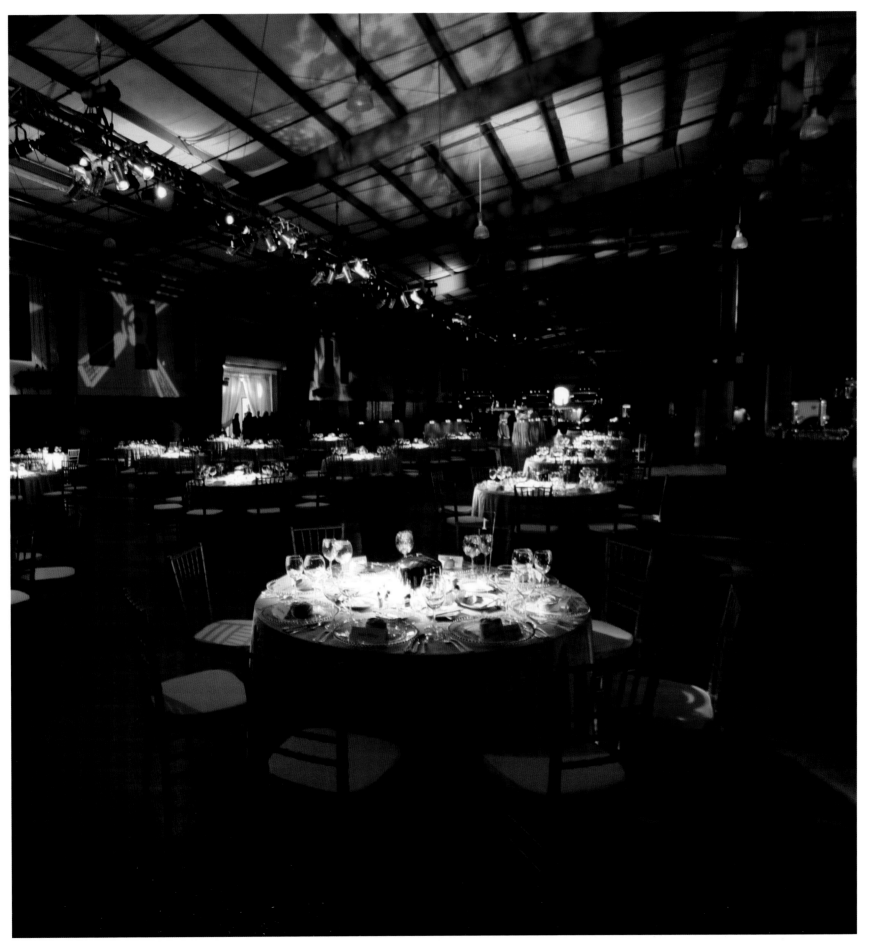

"The infamous who, what, when, where, and why are critical in creating the perfect production."

—Kathy Miller

Left: Even the smallest details of the Rush celebration, such as a custom ice sculpture in the shape of a 259 Peterbilt truck, reflected the company and its goals. The focus rested on celebrating the pristine industrial space in all of its size and glory and showcasing the drama of the scale from the first site tour to the last bite of dessert.

Facing page: A three-day expo for a truck manufacturer featured a "Crunch Time" theme that incorporated the construction of a truck that literally burned a mock competitor's truck in the closing session. Owners of the Cantera Choppers Garage hosted each general session with additional entertainment including a garage band and professional grinders who created the company's logo onstage amid a shower of sparks.

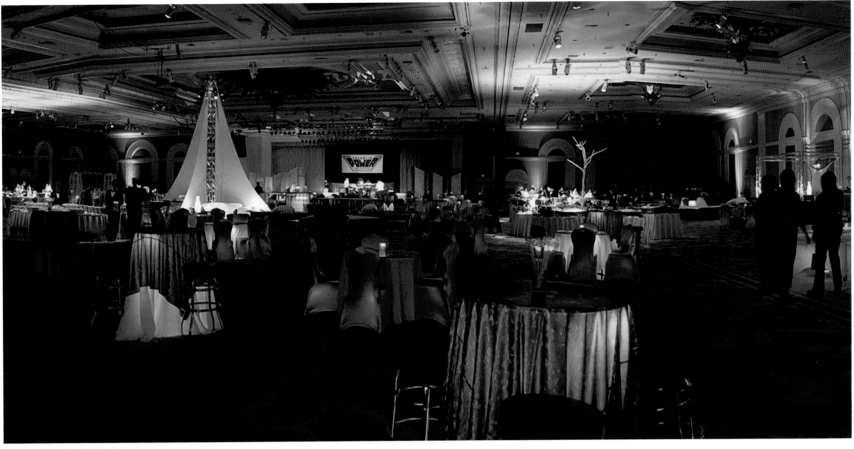

Photograph by Paul Cichocki

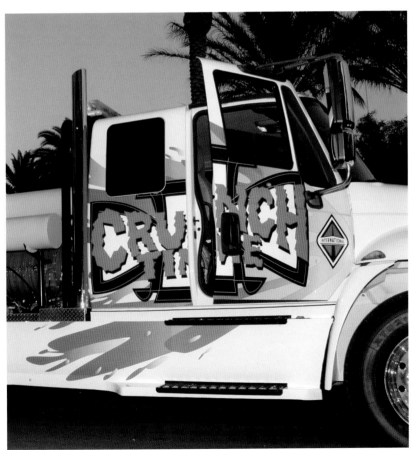

Photograph by Paul Cichocki

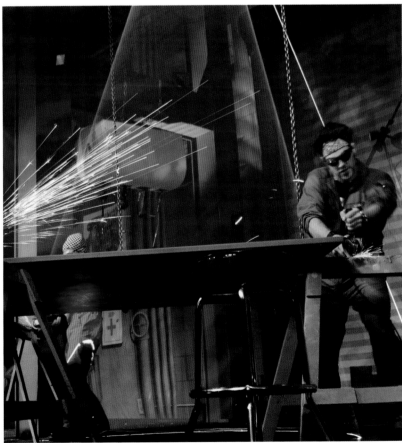

Photograph by Paul Cichocki

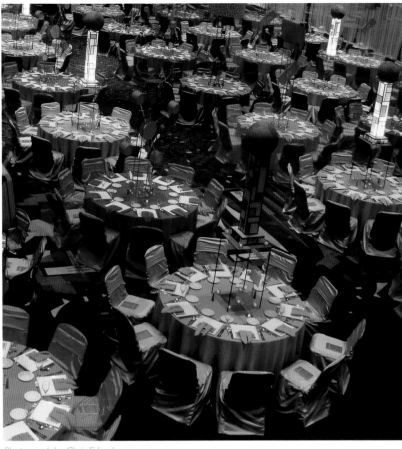

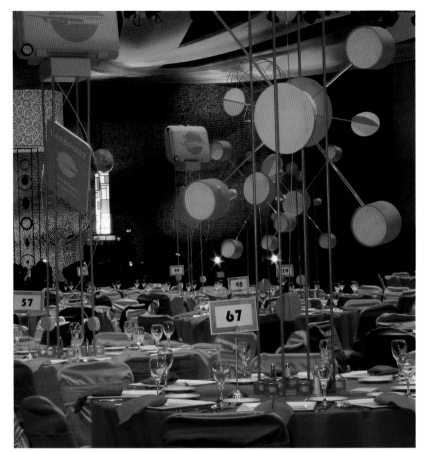

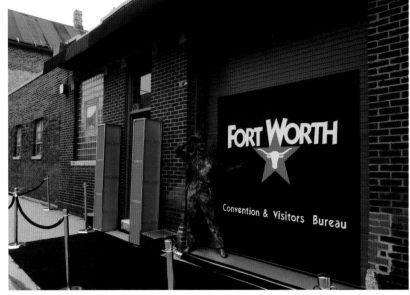

"Repurpose everyday objects and spaces to rediscover their intrinsic beauty and elegance."

—Kathy Miller

Right: The private, cleverly designed residence of a well-known Chicago designer served as the venue for the Fort Worth Convention & Visitors Bureau event. A stately black awning and red columns defined the entrance, as a customized art gallery of city photos and a living cowboy statue at the base of a waterfall curtain highlighted the spacious layout inside.

Facing page: The 1960s airline theme at the Design Industries Foundation Fighting Aids Chicago Gala demonstrated both the past accomplishments and the future needs in the fight against AIDS. Brilliant colors, chiffon control towers, retro luggage centerpieces, passports, and globes decorated the ballroom. The stage, which mimicked a runway with search lights and clouds, featured theatrical dancing pilots and flight attendants.

views

The stress level of projects ebbs and flows, but at the end of it all, helping educate people, launching new products, creating an experience, celebrating successes, and motivating others are the reasons we love going to work each day.

BRIDE'S VISION WEDDINGS AND EVENTS

ELLEN GUTIERREZ
ST. LOUIS, MISSOURI

Creating beautiful memories every bride and groom will remember and cherish years after their special event is what defines Bride's Vision Weddings and Events, led by owner Ellen Gutierrez. As someone always interested in entertaining, parties, and events, Ellen began her meeting and event planning career as both a volunteer and a paid professional who organized large conventions and corporate affairs. She then worked in the hotel industry as a sales manager responsible for corporate meetings, special event parties, and weddings. She especially enjoyed the hotel wedding business: being responsible for representing the venue, working with the bride to decide what particulars were needed for the event, and miraculously making everything come together with ease; Ellen loved every minute of it. Her work culminated with planning her older daughter's wedding—the springboard, the final impetus that motivated Ellen to launch Bride's Vision.

Needless to say, Ellen has found her passion, lives it daily, and enjoys it immensely. She is highly organized, extremely detail-oriented, genteel and graceful, always creative, calm, experienced, and has unsurpassed diplomacy. Most importantly, as a trademark of Bride's Vision, Ellen respects her hosts' wishes and vision. She works closely with them, always seeing they get more than they ever expected—unforgettable service and impeccably designed, well-executed events.

For their wedding reception at the Missouri History Museum, the couple wanted a very elegant, traditional feel without being boring or stuffy. With limited set-up time in the public venue, we dressed the room with draping, specialty lighting, and lanterns provided by Exclusive Events, along with floral arrangements, linens, china, and silver glass chargers. Silver accents ran throughout the stunning event, and the Charles Lindberg airplane was perfectly integrated.

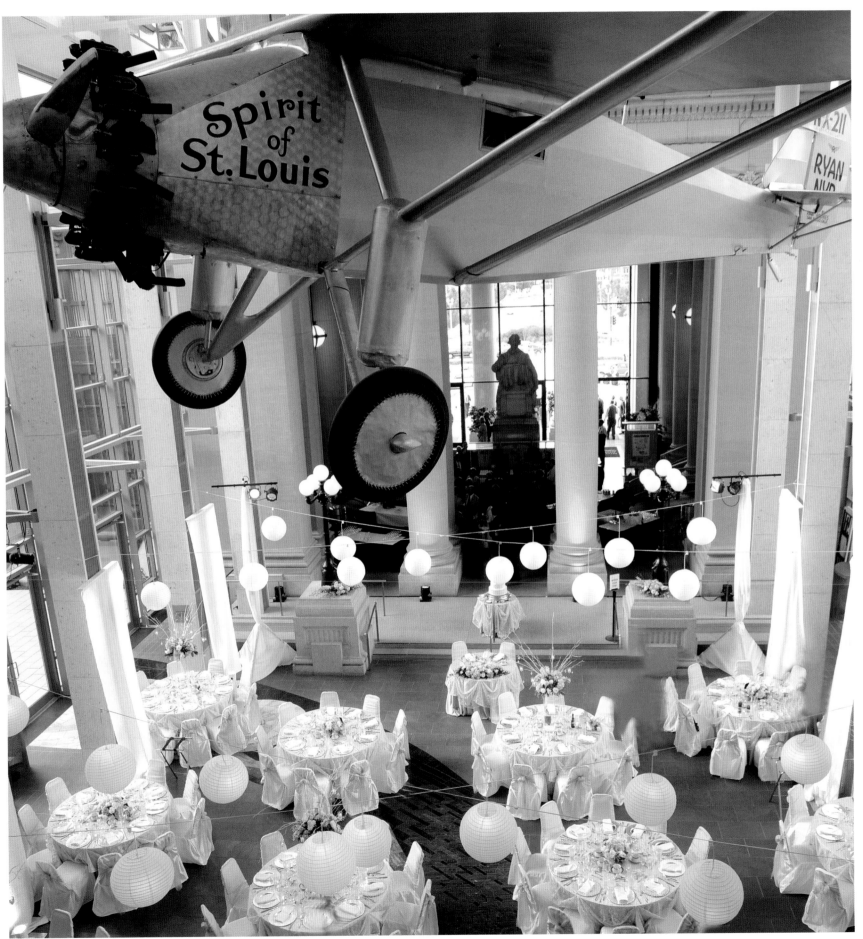

Photograph courtesy of Exclusive Events, Inc.

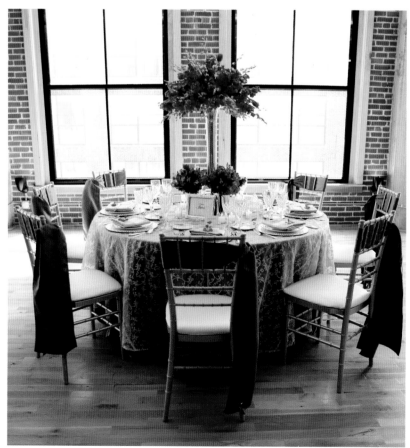

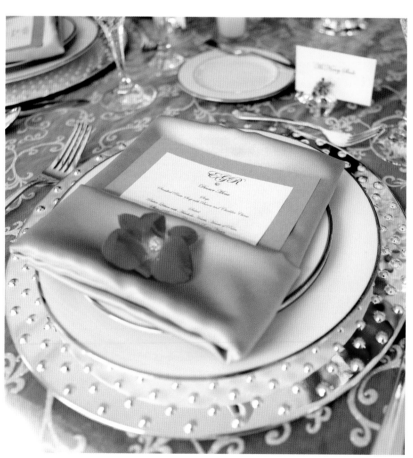

Photograph by Liz Reiffe Sloan, L Photographie

Photograph by Liz Reiffe Sloan, L Photographie

"The most successful events are those that reflect the host's personality. It's the planner's responsibility to figure out if that happens through grand gestures or subtle details."

—Ellen Gutierrez

Right: Beautiful fruit and floral centerpieces with votives hanging from the branches complemented the garden setting of the summer wedding reception. The coolness of the pale pink and light greens added much needed relief from the July heat of St. Louis. The Dale Chihuly glass sculpture in the background added stunning drama to the reception room.

Facing page top: The wedding reception was held at a lovely private country club with beautiful traditional décor. The couple wanted to add some excitement to the room and create a look not previously seen in the space. We had the entrance and the fireplace draped by Exclusive Events with beautiful sheer ivory fabric to add drama and cover the black hole of an out-of-season fireplace. Each guest table had a trio of tall pilsner vases, with submerged mokara orchids and floating candles, surrounded by three short cylinder vases, each with a single flower pavé of Esperance roses, lavender, or pink hydrangeas, and deep purple dahlias.

Facing page bottom: For a traditional wedding reception, I used an elegant spring table design of silver, purple, and fuchsia pink. Ornate details such as a tiny silver elephant holding the guest's placecard and small crystal details on each of the menu cards were added for whimsy and decoration. Elegant spring table designs were created to be detailed without being cluttered. Hundreds of orchids made up the tall Petals Galore arrangements.

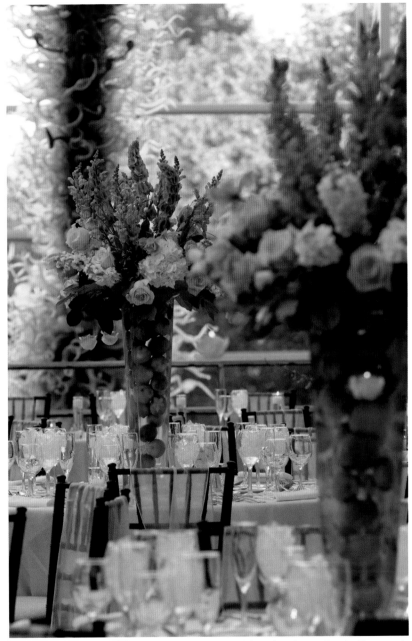

Photograph by Robert George Fine Art Photography

views

I view myself as the designer and producer of the event. My job is to make possible what the bride and groom envision, with design elaboration on my part. If they have an idea for something, I will be on the phone until I can make it happen. Sometimes they have a good idea that is not practical. I carefully explain why it is not practical but always suggest how to make it happen in a way that works with their event.

COSMOPOLITAN EVENTS

JOSIE LITTLEPAGE
ST. LOUIS, MISSOURI

The best event planners strive so much for nothing less than ecstatic happiness from hosts and guests that not one detail is left to chance, and St. Louis is lucky indeed to have Cosmopolitan Events. Whether an intimate gathering or a grand gala, the company brings innovation and style to every celebration.

Proprietor Josie Littlepage thinks of herself as an employee of a company she just happened to found. This team of event experts features members from every niche of the industry who collaborate on weddings, fundraisers, and corporate celebrations. The welcoming manner of skilled event planners like sales head Chasley Bradbury puts brides and other social hosts at ease. The entire process is meticulously detailed without sacrificing one drop of creativity or originality. After meeting with the hosts to develop the concept and theme, freestyle brainstorming sessions evolve into a complete visual design presentation that the entire family, nonprofit organization, or business group is invited to view and further refine to everyone's tastes. The firm's fresh ideas and savvy logistics guarantee a success each time.

For Cosmopolitan Events, personalizing every element of the celebration is of paramount importance. Getting to know the host intimately results in beautiful events rich in details that truly reflect personal tastes: from a cocktail stirrer featuring a favorite symbol to an ice sculpture carved into a meaningful shape. The team enjoys immersing themselves in people's personalities to discover an inner cosmopolitanism that results in completely unique, transformative events that will wow everyone.

To bring life and color to an older room darkened by stone interiors, we mixed a vintage feel with a contemporary motif. Rich jewel and floral tones, dramatic centerpieces, and a linear table design vivify the space.

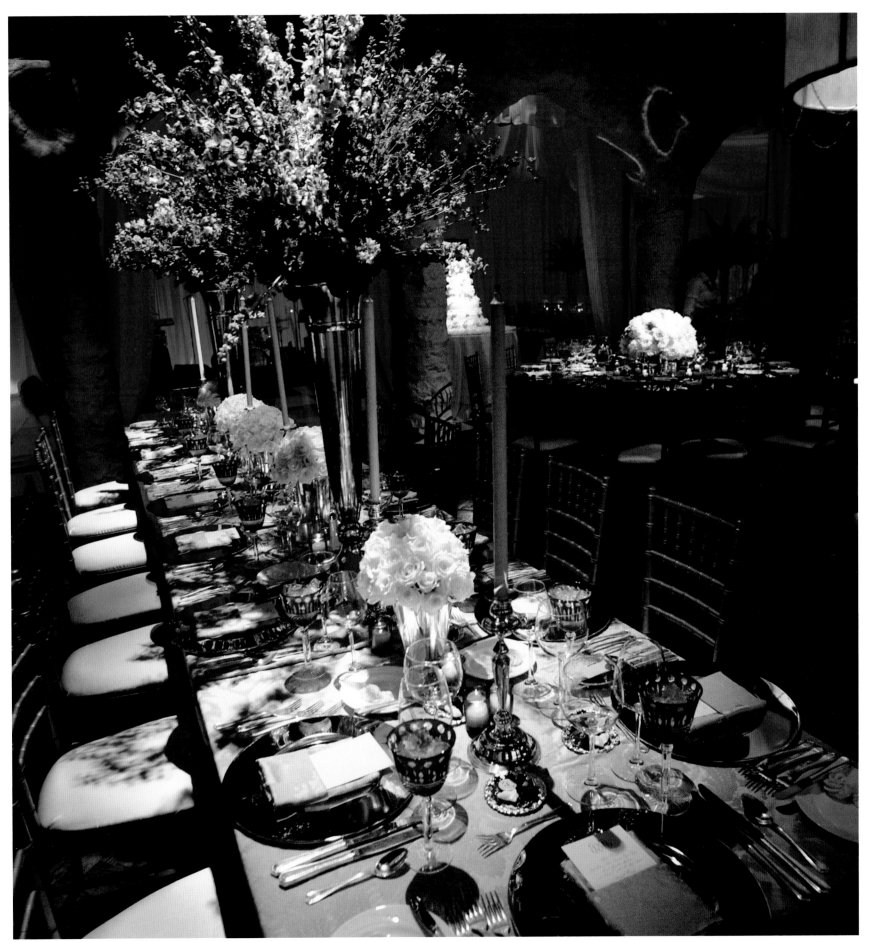

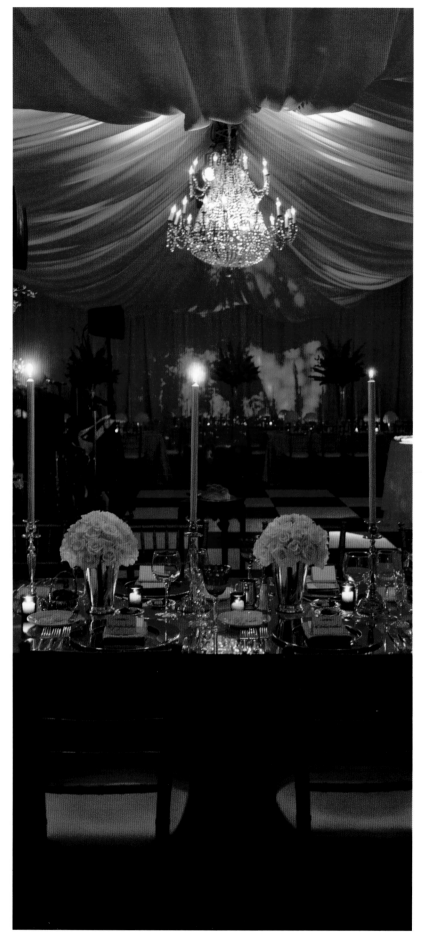

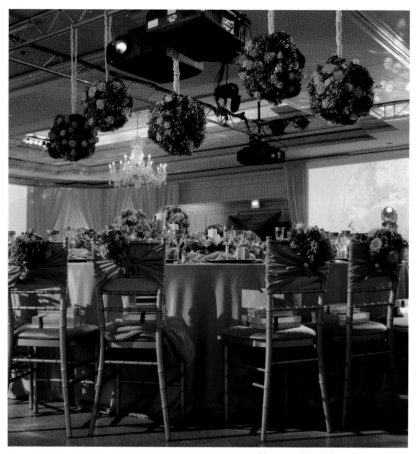

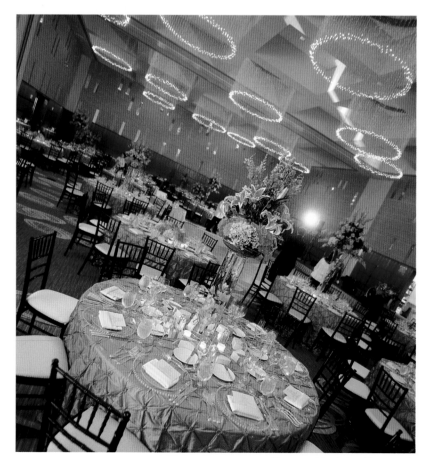

"It's all about how you redefine and reinvent the space. We've taken venues from preppy pinks and greens to electric purple city chic. The possibilities are limitless."

—Chasley Bradbury

Right: A Mardi Gras Brazilian Carnaval-themed event fabricated in conjunction with fellow producer Contemporary Productions allowed us to focus on the visual elements such as orange, gold, and hot pink tables topped with spandex centerpieces. With the addition of their live entertainment, the event truly immersed guests in the exotic celebration.

Facing page: We take advantage of bright and bold colors, dynamic lighting, and manifold textures to totally reinterpret venues to fit each event's theme—we want these rooms to transport guests to another world. Whether we aim for high drama, whimsical fun, or classic elegance, we strive for originality.

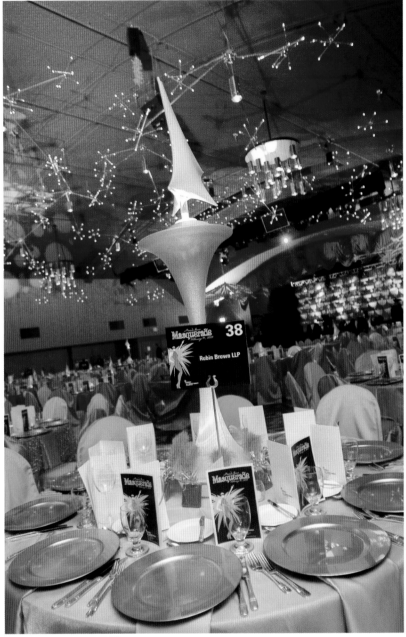

Photograph by Alisha Clark Photography

views

Don't leave anything to chance. Create timelines, schedules, and design schemes. Once we've put everything to paper, we highlight the gaps and work with hosts and vendors to finalize details. The day of the event we have itineraries, checklists, emergency kits, and staff on-site to ensure that it all goes off without a hitch.

PARTY PARTNER

CHRISTINA CURRIE
BARRINGTON, ILLINOIS

When Christina Currie was 16, she decided to throw a party for her friend who was moving out of state. She invited the entire sophomore class to her home and organized everything—invitations, a local band—prepared the food, and added personal touches with homemade décor. The successful party gave Christina her first taste of what would eventually blossom into a fantastic career organizing themed events, staging outdoor fêtes, and creating memorable weddings.

Bringing her energy into a party so the host isn't exhausted and stressed out by the time the affair begins, Christina ties up all the loose ends. She uses effortless approaches to a non-stuffy atmosphere by going back to the basics: simple recipes, sexy drinks, and lively décor. Christina believes mixing the host's style with her style will create a unique and successful occasion for all.

Christina feels that the people of Chicago have a festive spirit. They see a party as a chance to unite with friends and family. They call on her to take care of the important details and to add style. She has access to the best chefs and bartenders, entertainers, florists, lighting companies, and rental companies for everything from tents, tables, and chairs to exquisite bars and water fountains. Christina's base philosophy is to create a stylish welcoming environment so that guests feel comfortable enough to hold conversations and to have an impromptu dance they'll remember long after the party is over.

The charming garden affair was brought to life to celebrate an important birthday in the harsh month of November. Utilizing the host's natural grass as the floor and incorporating her favorite pear tree helped make the outdoors event both unique and enchanting. When combining structures of gable tents with cathedral ceilings, dramatic amber lighting, fresh flowers, warm linens, chandeliers, and candles—all with an 1890s stone house and pear tree inside the tent structure—you cannot help but to feel as if you stepped into a fairytale.

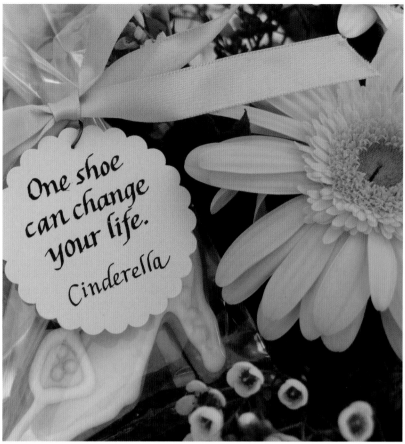

"Conversation, laughter, and some impromptu dancing—that's when you can sit back and know the party is successful."

—Christina Currie

Right and facing page bottom: To celebrate joyous milestones, a combination party for a high school graduate and his dad's 50th birthday was celebrated in their backyard. Inspired by pictures of the two men, I created an affair with vibrant floral arrangements and elegant linens. For an original presentation on the buffet tables, I decided on an assortment of colorful and inexpensive fruits and candies. Adding cabaret tables to the patio helped set up a whole new atmosphere. I dressed the tables with sophisticated white linens and blue wraps inspired from certain photographs featured at different tables—pictures providing two nostalgic timelines that converged into one memorable event. To top off the party, a colorful signature martini was passed to guests as they arrived at the joyous occasion.

Facing page top: Everyone loves a bit of glamour at a bridal shower. For an unforgettable and trendy bridal shower, I wanted to remind guests what it would be like to be a little girl dreaming about getting married someday. To help capture the lavishness of the scene, I began the palette with pastel cascades of Gerber daisies and faux jewels. Personalized fancy and edible favors were placed around the centerpieces—cookies shaped as Cinderella shoes with a calligraphy note attached by an elegant bow. The chic lunch menu was elaborate enough for a princess with simple hors d'oeuvres, gourmet pasta salads, and decadent desserts.

views

❖ Select the menu, draw inspiration from foods you're selecting, and then plan it out.

❖ Personalize your event with simple calligraphy notes and labels.

❖ The mere act of holding a glass, even if it's lemonade, puts your guests at ease—in other words, have your signature drink waiting at the entrance of your affair.

PAULETTE WOLF EVENTS & ENTERTAINMENT

PAULETTE WOLF | JODI WOLF
CHICAGO, ILLINOIS

Paulette Wolf, as one of the most sought-after event planners in the country, is known for her creativity, innovative ideas, and attention to detail. Her firm incorporates her signature style to create one-of-a-kind happenings.

Paulette Wolf Events & Entertainment is a cutting-edge national firm renowned for its unique combination of creative design, event management, and entertainment production. For over 35 years, the firm has created exclusive, memorable, and dynamic special events for high-profile hosts in the worlds of fashion, lifestyle, film, and entertainment—taking all of the principles from experience with complex events like the Olympics and major corporate celebrations and applying them to special occasions of all kinds.

Paulette's team does extensive research, so they know who the audience will be and how to best appeal to them. They're always looking for new inspirations in terms of fashion and design, something clever or different—a linen, bowl, or painting—that sparks an entire environment. They design and orchestrate the event, then bring in the right players to make it happen. Most importantly, they are able to capture a dream and take it through all of the steps to make it a reality.

The 70th birthday celebration was the social event of the year, featuring all of the birthday boy's favorite things: a beautiful evening in Millennium Park, sushi and sake from Nobu Matsuhisa and 22 of his chefs from all around the world, a Neil Diamond cover band, and a performance by his favorite comedian, Jerry Seinfeld.

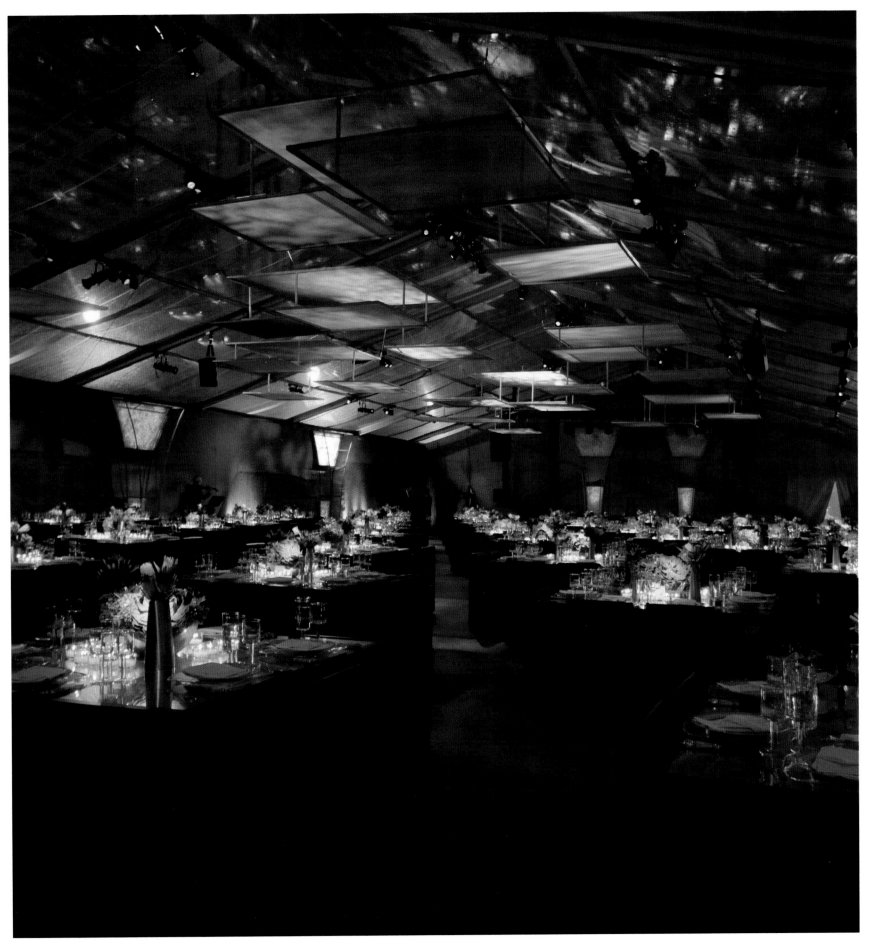

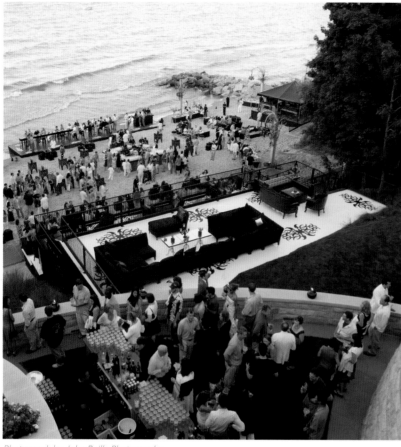

Photograph by John Reilly Photography

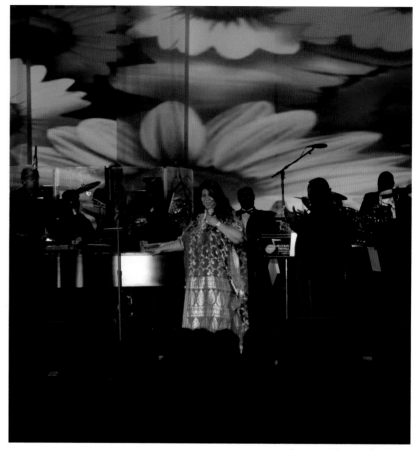

Photograph by Jennifer Gerard

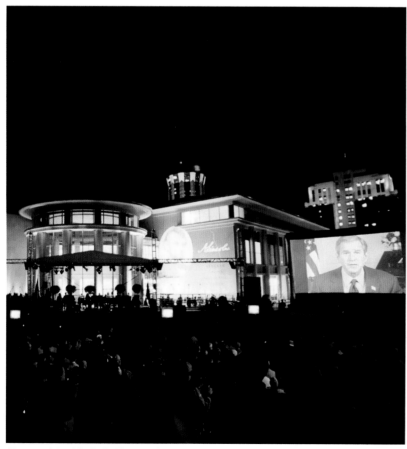

Photograph by John Reilly Photography

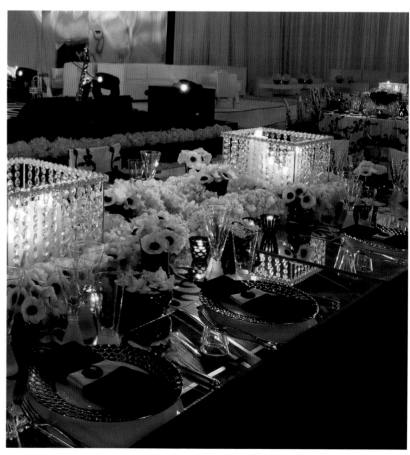

Photograph courtesy of Design Fusion

Right: Tapping into the bat mitzvah girl's interests for inspiration, we came up with a chocolate lounge sophisticated enough to appeal to the teenager yet fun enough to appeal to the kid in her. We started off with a Neopolitan Pucci print linen and built the look from there. The fabric influenced every element of the evening, including this entrance piece—an actual bustier surrounded by hanging crystal beads, flowers, and feathers.

Facing page top left: The 10-year corporate anniversary celebration can best be described as "goth meets organic." Gothic design and organic materials combined with elaborate lighting transformed the beach into an outdoor lounge-club complete with an exclusive performance by Bon Jovi.

Facing page top right: The grand opening campaign for the Prentice Women's Hospital culminated with a series of events that celebrated various sects of the hospital community. All events incorporated tours of the new building, food and beverage, elaborate floral and décor, and diverse entertainment. The building dedication incorporated Maya Angelou's poem "Phenomenal Woman"—read by many of the donors and staff—representing the strength and character of women. The black-tie gala featured Aretha Franklin as the headliner.

Facing page bottom left: Abraham Lincoln is the most researched and written about historical figure. To capture his legacy at the Abraham Lincoln Presidential Library grand opening, we arranged an F-16 flyover, fireworks, and a full illumination ceremony. The event was emceed by Bernard Shaw, Miss America '03 sang the national anthem, and many political figures attended.

Facing page bottom right: We designed a South Beach wedding with an updated Art Deco look. The festivities began on Friday at the Versace mansion then moved to the pools of the Setai Resort for cocktails, and the rest of the evening was held in a tented ballroom that we created, appointed with a variety of custom details.

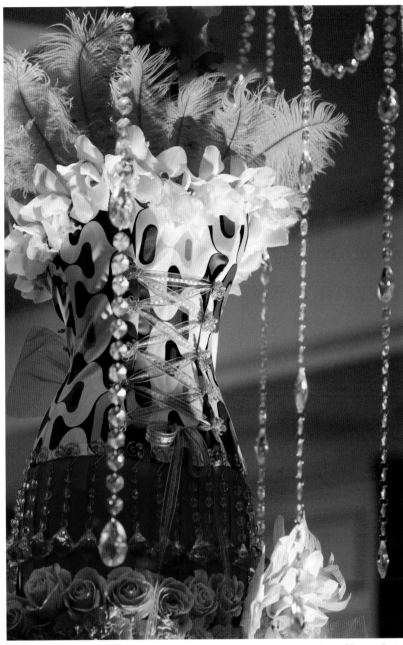

Photograph courtesy of Design Fusion

views

❖ Determine the who, what, when, where, and how much.

❖ Build a project blueprint that shows the goals of the event.

❖ Try to create an environment that is conducive to the event's purpose.

❖ Make sure all the pieces work together when designing your event.

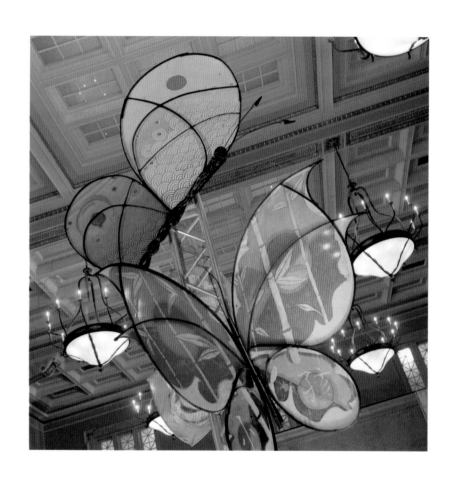

Visionary Event

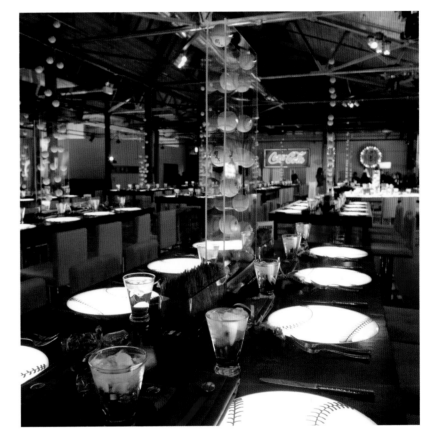

Design

Heffernan Morgan Event Design

ROBERT MERTZLUFFT
CHICAGO, ILLINOIS

In a city where glamorous parties seem to happen almost nightly, there is one company that has distinguished itself as the champion of jaw-dropping design. Heffernan Morgan, famous for its imaginative and opulent environments, regularly crafts displays that are "often imitated, never duplicated."

What was started by current creative director Bill Heffernan as a weekly residential floral service nearly 30 years ago has since blossomed into one of Chicago's most sought-after event design firms. Robert Mertzlufft, who joined the company 20-some years ago as technical director, saw that florals could be more than just beautiful centerpieces, and that every event could do with a dash of theatricality. Now, as owner, Robert and his savvy design team—John Hensel, Nikki Lee, and Erin McDonald—oversee scores of weddings, galas, birthday bashes, and corporate gatherings every year, directing a staff of up to a hundred dedicated people who make flawless service their priority. Those ready to plan a memorable event usually come to Heffernan Morgan with high expectations and an open mind.

As a true Chicago devotee—he even loves the winters!—Robert uses the rich cultural and architectural history of his adopted city as inspiration and motivation for his company's creations. The incredible diversity of venues in the city, from classical ballrooms to trendy lofts to outdoor gardens, presents boundless opportunities to design for varying tastes. The importance Robert and his team place on listening ensures that while Heffernan Morgan is the driving force behind many of the city's most magnificent events, each host is guaranteed to feel like the company's most prized VIP.

When you start out with a location like The Peninsula Hotel, known for its understated elegance, it's always smart to accentuate the remarkable beauty that already exists. Simple gold, cream, and black table décor coordinates with the carpet, walls, and ceiling, allowing the focus to remain on the starburst-shaped flower arrangements. Approximately 300 stems of creamy white French tulips went into each centerpiece, which balanced atop custom illuminated pedestals, a clever alternative to a pin spot.

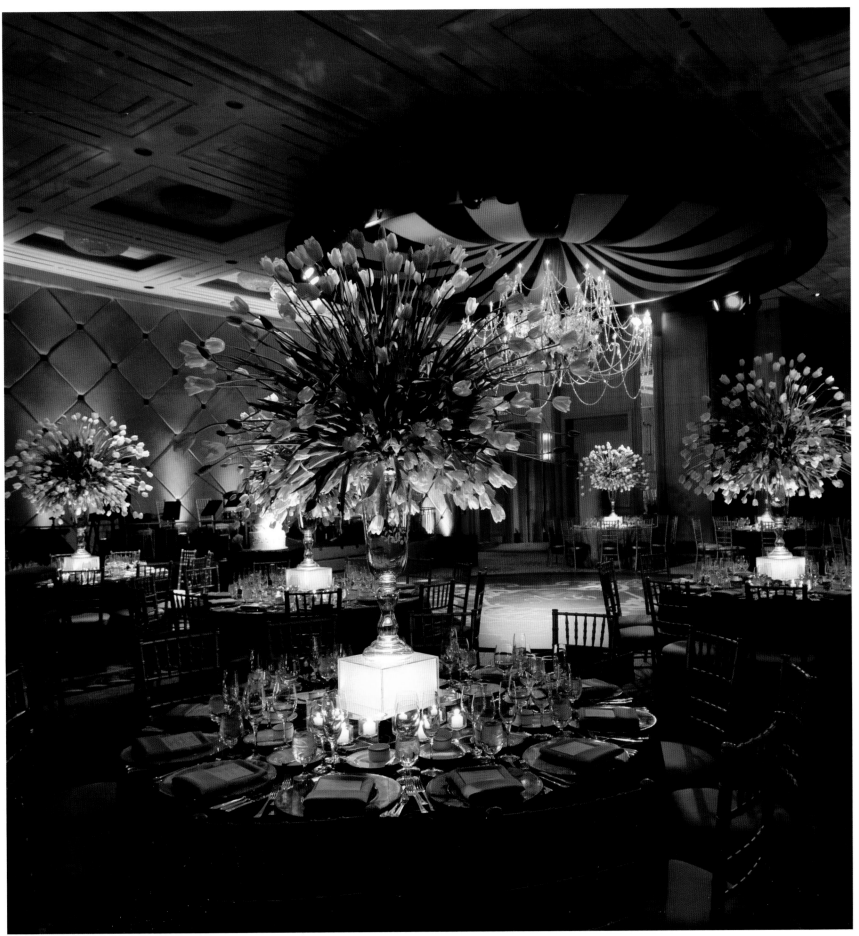

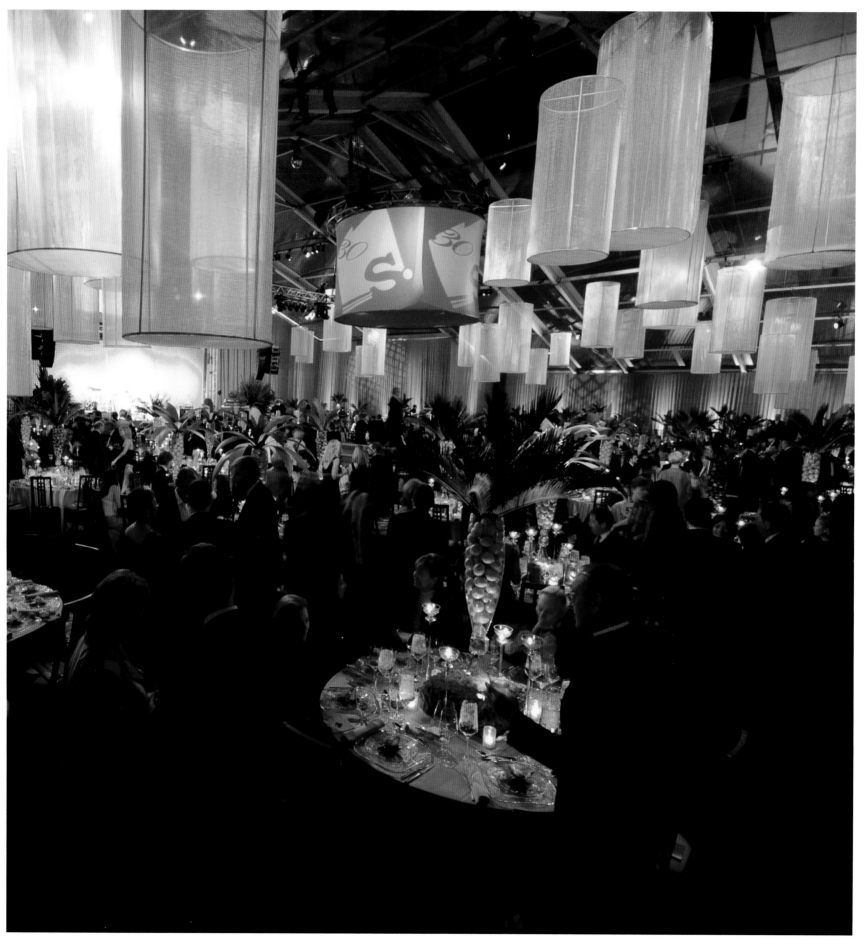

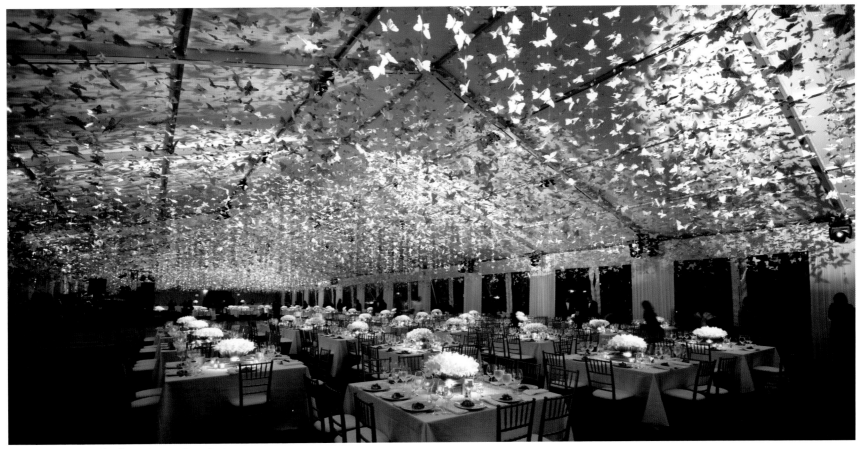

Above: At a fundraiser for the Harris Theatre, held on the Chase Promenade at Millennium Park, we "dropped" the tent's ceiling by creating a field of fluttering butterflies. We hung over 40,000 feather butterflies within eight feet of the tables, on monofilament threads interspersed with mirrored discs. Automated, colored lighting continually swept over the butterflies, and combined with the natural movement of a bustling room, they seemed to be flying. Centerpieces consisting of amaryllis blossoms in hammered steel dishes were lit from beneath, giving the effect of candlelight, only more powerful.

Facing page: Every year, Chicago's critically acclaimed Steppenwolf Theatre Company plans its anniversary gala around a featured play from the season. For the first time that year, the company built its season around entirely new plays, so the gala's theme evolved into just a fun, upbeat tropical party. To give the room a vibrant foundation, we upholstered the walls in various hues of orange, violet, and hot pink. Sheer, custom-designed, iridescent chiffon cylinders hung from the ceiling and were lit with automated lighting. For a funky twist on the traditional centerpiece, we constructed "palm trees" out of vases filled with lemons, limes, and oranges and topped with palm fronds. These rested on a carpet of spray roses and lighted pedestals—the first time we used what has now become a signature technique of ours.

"How an event functions is just as important as how it looks."

—Robert Mertzlufft

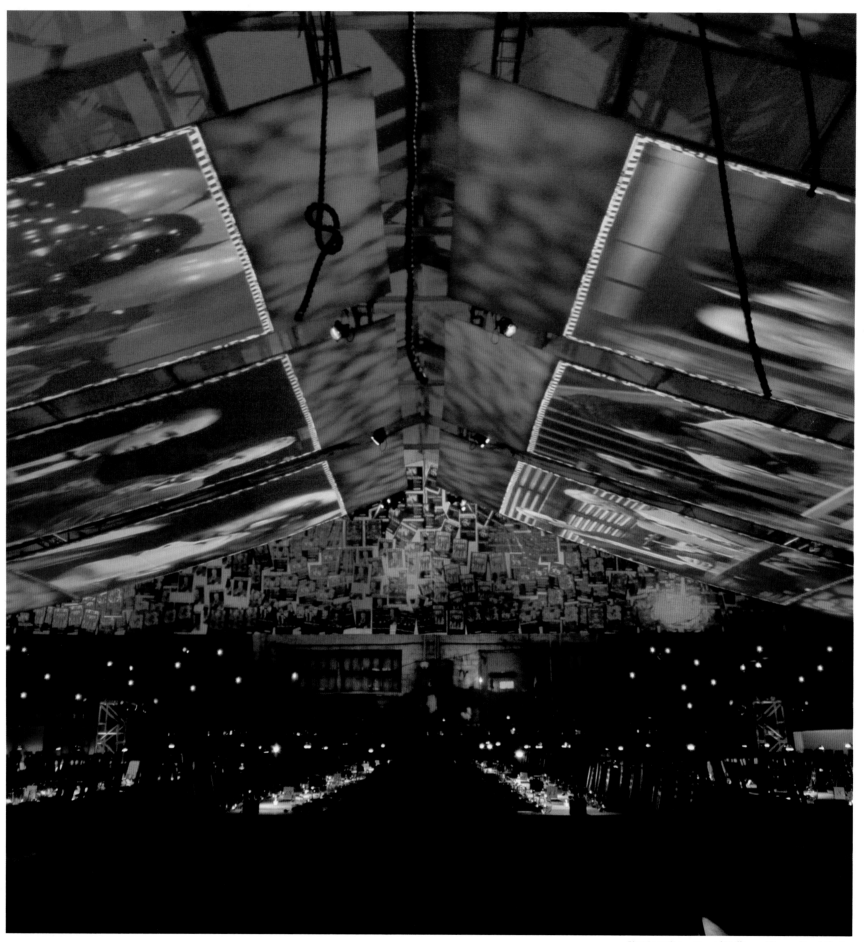

Photograph courtesy of Heffernan Morgan Event Design

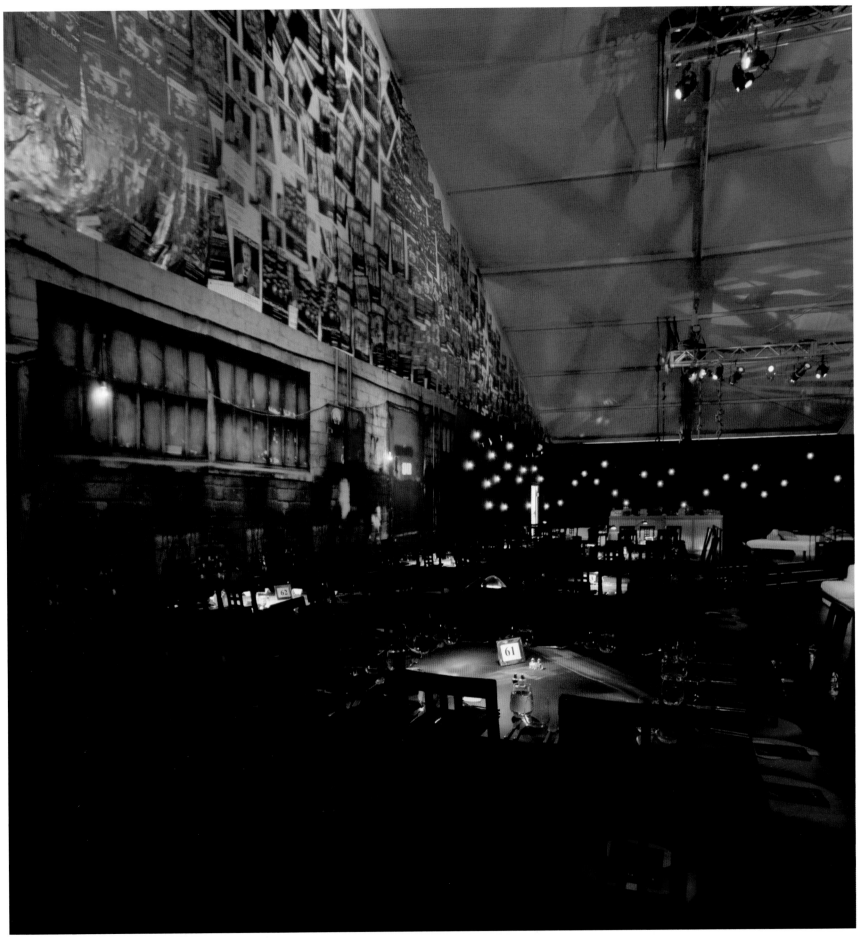

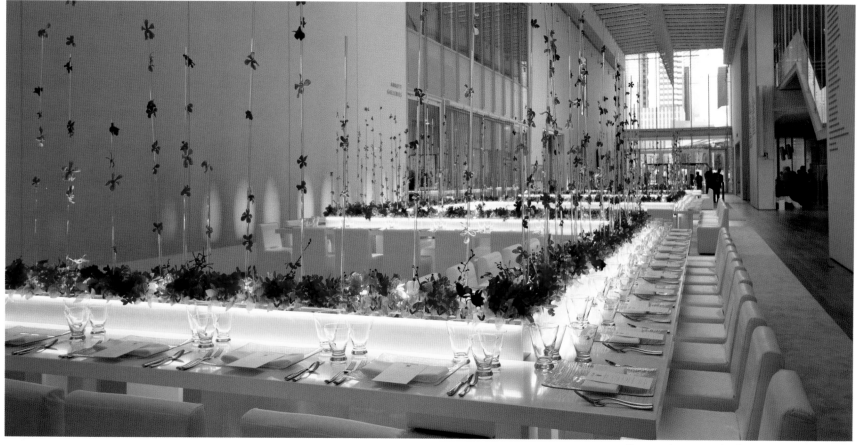

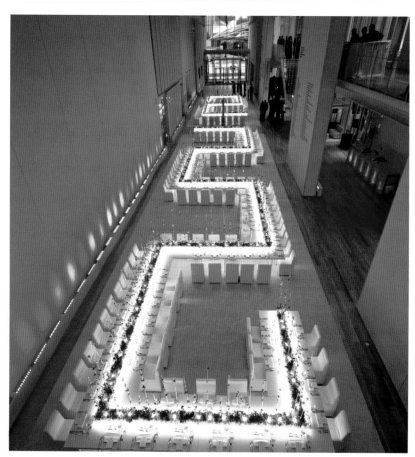

Above and left: To celebrate the long-awaited opening of the Art Institute of Chicago's Modern Wing, the prominent Chicago philanthropist family for whom Griffin Court was named hosted an event designed to showcase the newly displayed artwork. Working with a predominantly white palette, we had to adhere to the strict museum guidelines: no candles were allowed, white carpets were brought in so dark beverages could be served, and there was a very tight timeline for set-up. White lacquer tables were specially designed to fit quickly together like a puzzle, giving a modern outline to the overall table shape. A profusion of candy-colored orchids sprang from tabletop floral containers and scaled Lucite rods of varying heights, lit from beneath with rechargeable LED batteries.

Facing page: The Standard Club is another example of working with existing beauty. To play off the crystal chandeliers and gleaming wood floors, we created "rose wallpaper," completely upholstering wall sections in a seamless layer of richly hued roses. Mirrored pedestals and fluted glass vases framed the bride as she entered the ceremony area; the same room was then transformed for the reception during cocktails. Rose balls 30 inches in diameter were placed atop the tables, and their large size was a stunning surprise to the guests. The secret element in constructing these astonishing rose displays? Exercise balls!

Previous pages: It's truly mission accomplished when guests feel like they have literally stepped into another world. For Steppenwolf Theatre Company's 2009 gala fundraiser, attendees were invited after the play to cross the stage and venture "backstage"—really a decorated tent erected behind the theater. A very realistic mural, tables and chairs flecked with bits of paint, exposed lighting and rigging ropes, and a collage of past program covers furthered the illusion. To showcase the company's season, DL3 projectors ran photographic stills from the plays on six enormous ceiling panels. As a special treat, Steppenwolf co-founder Gary Sinise entertained the crowd by performing with his Lt. Dan Band.

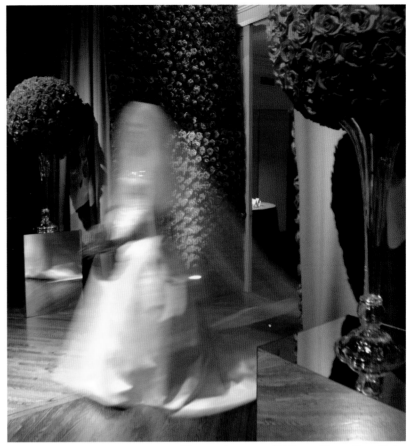

"Part of the fun of this job is seeing all the different skill sets you can use to put an event together."

—Robert Mertzlufft

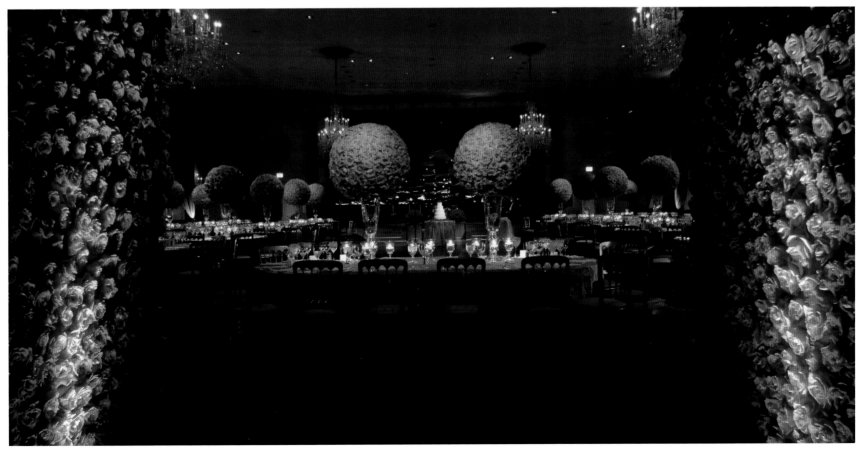

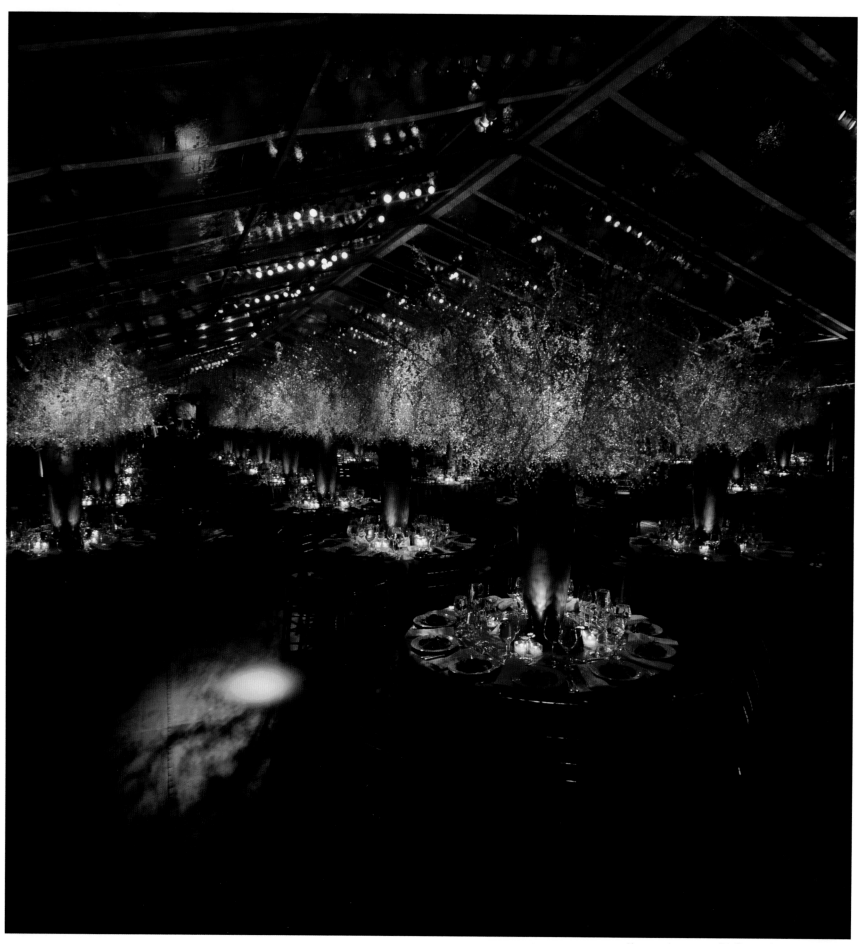

Photograph courtesy of Heffernan Morgan Event Design

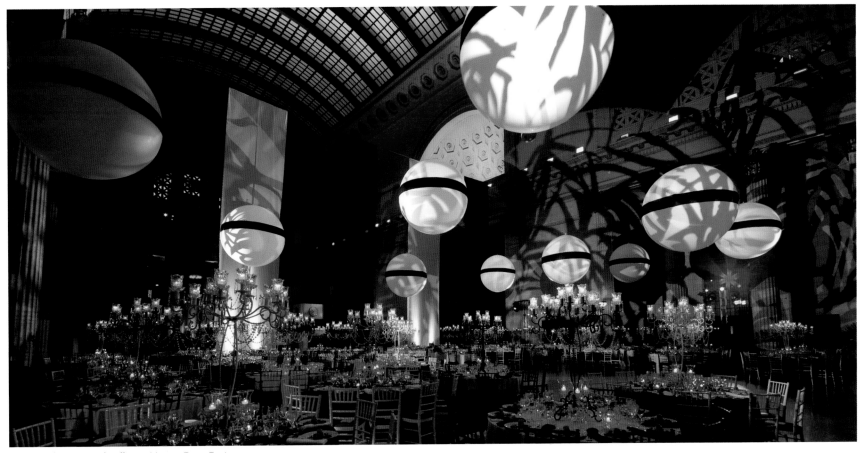

Photograph courtesy of Heffernan Morgan Event Design

Above: Some venues, such as the Great Hall at Chicago Union Station, can seem intimidating at first because of their size, but really it's just an invitation to design decorations on a grander scale. Iron-scrolled candelabra in alternating black-and-white lacquer finishes, completely swagged in Swarovski crystals and topped with cut crystal votive cups, made a commanding presence on the tabletops. Mammoth white balloons encircled with wide black satin ribbon danced above the space, giving the classical room a fanciful yet refined feeling.

Right: Designing within a tent presents both challenges and opportunities. A jewel-box tent, with its glass side walls and clear ceiling, reflected perfectly the light from the 32 Sputnik lamps hung at another party for the opening of the Art Institute's Modern Wing. To help separate the space and infuse even more modernity into the design, 16-foot pipe groves and angled fabric walls with door cutouts made the tent feel more like a piece of art itself. Rather than use projections, the fabric walls were lit from within, rotating between indigo, violet, and white. It was a hoot to see men in tuxedos waving their hands around, trying to find their shadows.

Facing page: Metal branches beaded with lavender, hot pink, orange, and light blue crystals were a dazzling alternative to flowers, but they also weighed in at well over 150 pounds. Each centerpiece had to be lifted onto the table with a forklift! The design originally called for glass vases, but there was a worry the glass might break. Custom-made resin urns resembling the originals were made, and due to the time crunch, were spray-painted metallic gold at three different car painting facilities simultaneously in order to be done in time.

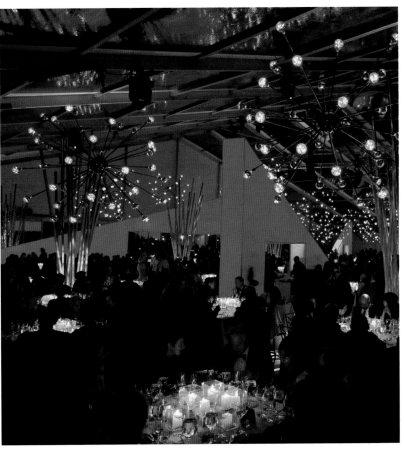

Photograph courtesy of Heffernan Morgan Event Design

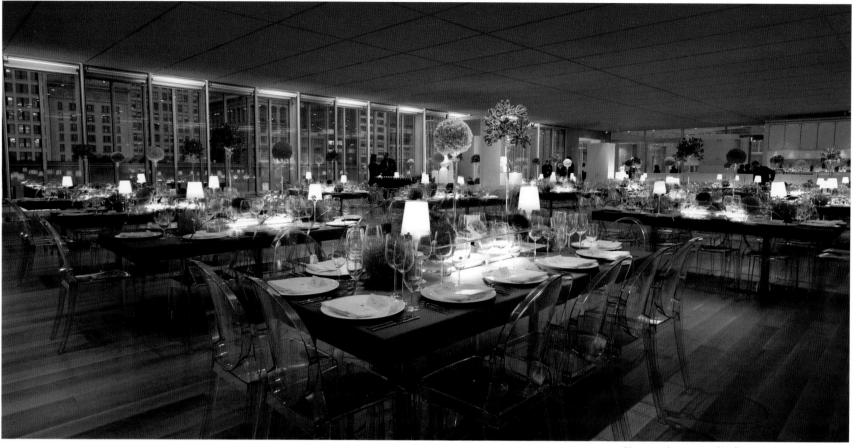

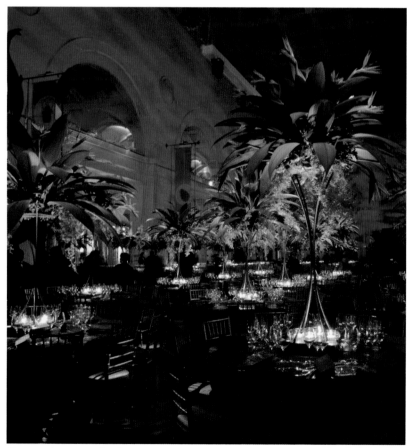

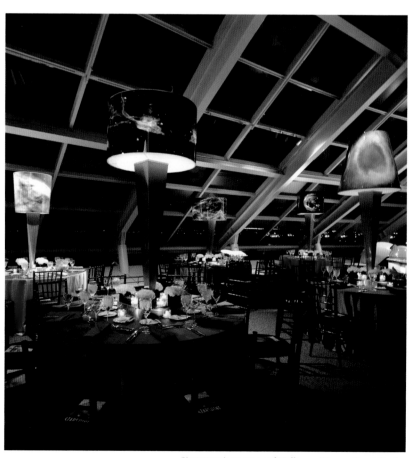

"Nothing is impossible with enough time and planning."

—Robert Mertzlufft

Right: By manipulating the placement and direction of each strand, we created a seemingly solid vase out of yards of hand-strung Swarovski crystals. Each riser was nearly five feet high, and combined with the flowered cuff, base, and abundance of smaller bouquets, the result was a dream white wedding, Heffernan Morgan style.

Facing page top: Clear Lucite slabs, LED bistro lamps, and a wide variety of playful flower balls instantly took Terzo Piano, the third-floor café in the Art Institute's Modern Wing, from museum restaurant to chic private party. Museum policy states that nothing can be removed from the room, so we accommodated the host's request to seat 10 to a table by designing linen-covered, hinged tabletops that could be placed over the existing ones.

Facing page bottom left: The opening of The Aztec World exhibit at The Field Museum offered us the chance to not only bring a tropical rainforest indoors, but to work with the museum for an 18th consecutive gala.

Facing page bottom right: By taking photographs of nebulae from the Hubble telescope and installing them as lampshades atop angular stainless steel risers, we stayed true to the Adler Planetarium's theme for its annual Celestial Ball while remaining sleek and stylish.

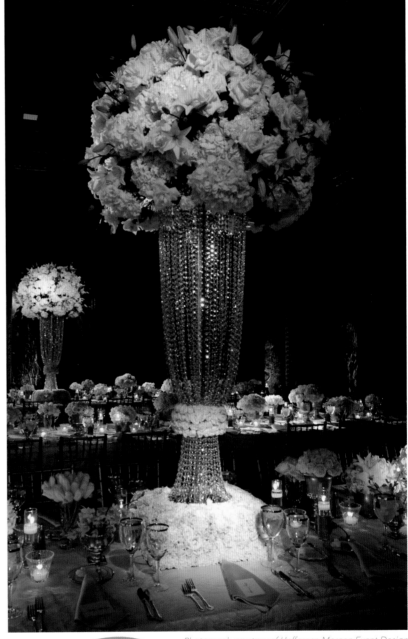

Photograph courtesy of Heffernan Morgan Event Design

views

The key to a successful event is the ability to adapt. By ensuring that everyone involved shares a common perception about what can be accomplished within a specific timeline, not only will an event run smoothly, it will exceed all expectations.

BeEvents

RYAN HANSON
MINNEAPOLIS, MINNESOTA

Lasting impressions aren't made memorable by cocktails and caviar, but rather by something much more intimate: guest experience. When Ryan Hanson founded BeEvents in 2007, he brought that experience-centered concept to the forefront of the event design conversation. Ryan understands that community and interaction are the commanding forces behind successful, purpose-driven events, and his strategic approach has attracted the attention of corporate and social event hosts alike.

A thought-leader in the events industry, Ryan has been crisscrossing the country designing and producing projects that are redefining event design and integrated production. These events are strategically created, value engineered, and designed with the audience in mind to define brands and create authentic experiences, one guest at a time. Because he knows without a doubt that the design of a space can facilitate and contribute to the dialogue that happens in that space, Ryan and his team focus on strategic messaging and brand value. It's their mission to make events matter and create designs that inspire.

Sometimes literal works. For a charity gala, event chairs sought an Asian-infused event that celebrated the organization's iconic butterfly. These giant butterflies fluttered above a four-sided lit bar for a bit of playful whimsy. We commissioned a local artist to construct the colorful insects from renewable resources, including bamboo rods and hand-dyed silk wings.

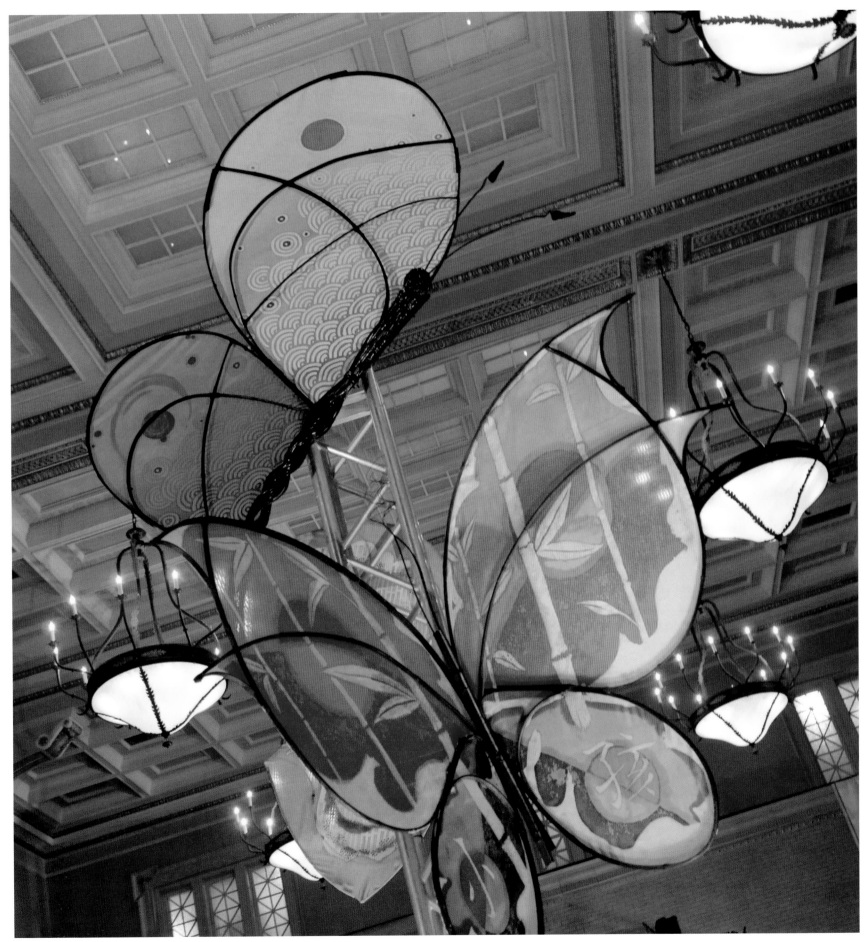

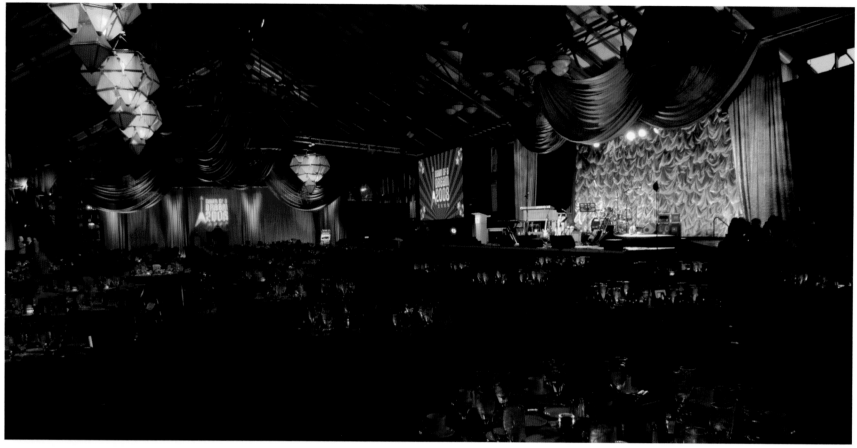

Photograph by Stephen Geffre

Above and left: First impressions are everything, so go big. At an annual dinner, giant swags of fabric stretched up to the iron scaffolds of a train depot-turned-event venue while industrial chandeliers served as bold focal points drawing guests into the space. Additional décor integrated graphic elements from the event collateral into the room so the message would be seamless. As a unique twist on the lounge trend, we built a 16-foot glowing pool with four fountains and pillow seating on all sides. The point: create maximum drama with a single, unexpected piece.

Facing page: Seven-foot-tall lamps atop every table at a corporate luncheon made for a big impact upon entering the space, without detracting from any guest's view of the stage. The color-changing LED lamps branded with the organization's logo were synched with an animated video presentation on-screen to reinforce the company's message. As the screen depicted the company's purpose—connecting talent—the lamps turned on one by one, linking the tables of guests, until the entire room illuminated the story.

Photograph by Stephen Geffre

Photograph by Stephen Geffre

"Great event design gets people talking. When you create the design, you define the dialogue."

—Ryan Hanson

the journey begins.

Photograph courtesy of Freestyle Productions

"When guests attend an event, they know instinctively if it's done right or done wrong, even if they can't articulate why. Cohesive, integrated design ensures a worthwhile experience."

—Ryan Hanson

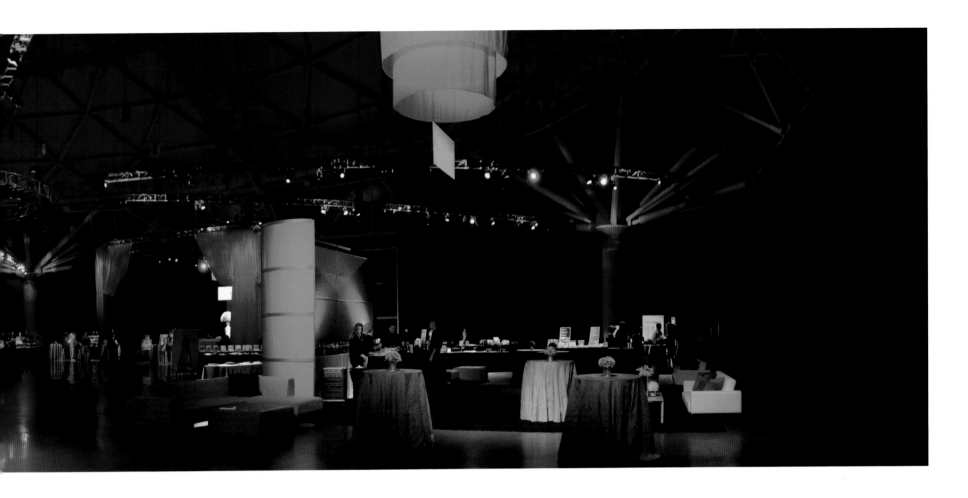

Above: To reimagine a silent auction, our hosts and their production company invited us to produce a fully functional space. The result of our teamwork was a design spiraling out from a 16-foot-tall, color-changing X-shaped acrylic bar in the center of the room toward four color-branded lounge spaces. The larger-than-life décor transformed the giant expo hall, established its purpose, and became such a hit guests were slow to leave the auction for dinner.

Right and facing page bottom: To lend a rock and roll edge to a multilevel VIP lounge for a nonprofit gala, we focused on bold colors in complementary hues. Orange couches, purple pillows, and green gladiolas fit the bill. Candles were barred, so we got creative and presented calla lilies as taper candle stand-ins with flat silver candelabra on illuminated acrylic side tables.

Photograph by Stephen Geffre

Photograph by Stephen Geffre

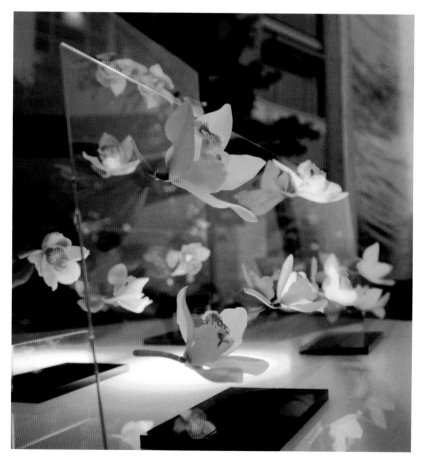

"What I love about events is the same as what I love about theater and film—it's storytelling at its best. I believe strongly that when you bring people together, great things happen."

—Ryan Hanson

Right: Innovation can happen anywhere. What do you do with a bin of leftover electrical housing units for hanging lamps, a spool of wire, and a bucket of eggshell French tulips? Fashion inventive chandeliers, of course.

Facing page: We love taking smart risks to try the unexpected. For a corporate hospitality event during the Republican National Convention, we integrated a 24-foot pool into the floor of a clear-span tent populated by acrylic furniture for a transparent, open-air feel. Inverting the expected, we put the flowers inside the table and crafted centerpieces of chic colored glassware atop each table. Acrylic side tables supported clear panels holding white and green orchid blossoms, while tanks of live koi swam on either side of a custom bar. Though it took 16 hours, we hand-tiled the floor of the structure, creating a white path woven through a gloss-black floor. LED lighting below acrylic floor tiles set the tent aglow as the evening progressed, while 20 modern chandeliers illuminated the space.

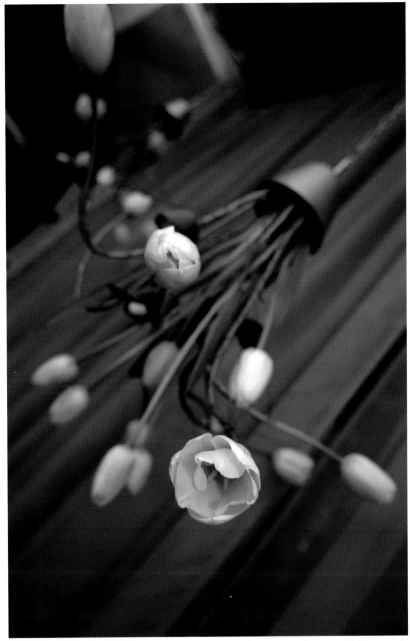

Photograph by Coppersmith Photography

views

Great designers devise events that keep guests engaged. Be aware that every detail, from a simple napkin fold to color choices of linen, draping, flowers, and lighting to your stage design and entertainment, has to play its part. Everything must function together; these elements combine to shape the experience of the brand, the celebration, the event.

Oeu'Vre Creative Services

MICHELLE KRAEMER-HOGAN
MINNEAPOLIS, MINNESOTA

True design engages all the senses for a fully engrossing experience. Events that completely shock and awe you with an undeniable creativity and commitment to a theme linger in the memory. For unforgettable experiences, hosts in Minneapolis and nationwide turn to Oeu'Vre Creative Services, a company that certainly lives up to its name—taken from *œuvre*, the French term meaning "the complete body of an artist's work." Indeed, each spectacle owner Michelle Kraemer-Hogan produces is a work of art, another stunning entry in her *œuvre*.

Since 1996, Michelle has been striving to top herself with each new design she invents. That's when she took her full-service event production business from California to Minneapolis and incorporated it as Oeu'Vre. It had begun as a way to blend a bit of event design into catering—like a mariachi band to accompany Mexican food—but soon morphed into full-scale production. Today Oeu'Vre handles everything from stage set design to technical coordination to prop fabrication. The combination of two teams—a design team of sculptors, seamstresses, carpenters, painters, and more, and a technical team of video producers, editors, photographers, and so on—can implement anything that's designed.

Though the company is based in Minneapolis, a majority of its productions are staged nationwide. Michelle, a real visionary, enjoys designing themes complementary yet original to the location, such as a blues theme for an event in Georgia, or an oil-money Old West twist for one in Texas. Elements of the site or venue often inspire the team—such as a waterfall outside a Hawaii resort leading Michelle to design an on-stage waterfall that parted for the arrival of each speaker. It's also common for designers to play off the richest highlights of what each city possesses, or the best of its history. Oeu'Vre truly sets the stage for fascinating, committed design.

To forge an intimate, monastery-like setting for a unique corporate dinner in Scottsdale, we used stacks of leather-bound books as centerpieces, candles and tassel-clad votives in abundance, and violet and russet tones. The lovely sounds of an a cappella boys' choir merged with crushed velvet and sheer linens to heighten the antique mission feel of dining with the priest.

Above and right: In order to energize a sales team on the first day of a weeklong seminar, we splashed the stage with vibrant colors, projected moving light textures with patterned logos, and brought out dancers to truly vivify this mambo-themed corporate affair. The interactive stage set changed throughout the course of the week for a fresh look with every new phase of the meeting.

Facing page: A stunning desert set the perfect backdrop for an elaborate outdoor soirée, but the addition of fire, water, music, and lighting to the mix took it to a new and wonderful level. For an elegant and comfortable vibe casual enough for lots of mingling and dining, we arranged areas of soft lounge furniture, utilized subtle yet purposeful lighting, and hired an electric cellist to infuse the night with ethereal sounds.

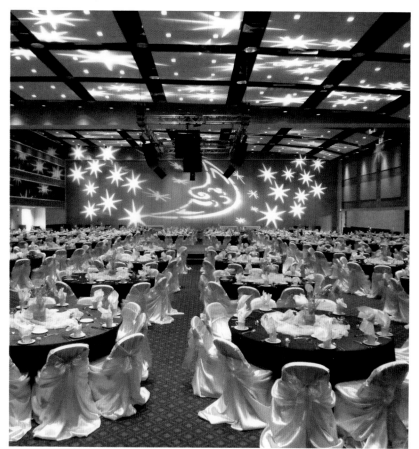

"Carte blanche creative freedom isn't something you can demand. You have to earn it."

—Michelle Kraemer-Hogan

A neon-hued South Beach feel with glowing lounge furniture and live palm trees; a moon-and-stars celestial celebration; a sleek, clean Asian-inspired atmosphere that evoked a restaurant environment within a hotel venue through chocolate, gold, and olive tones, foliage, and modern centerpieces atop unique square tables—the possibilities are endless.

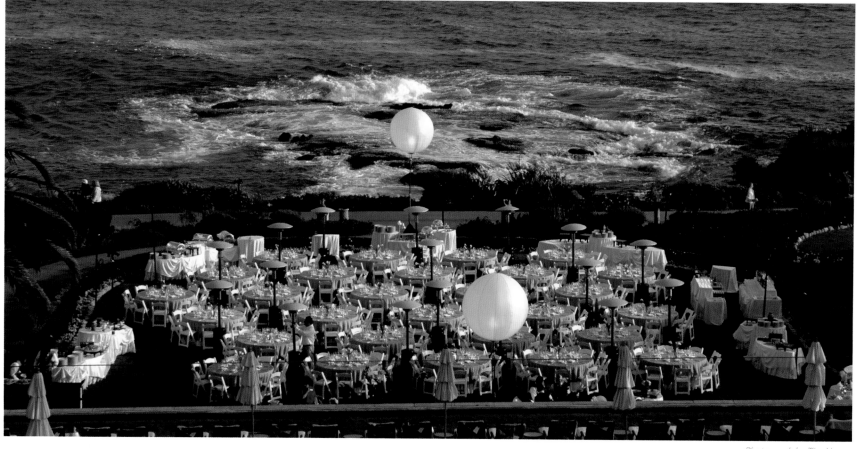

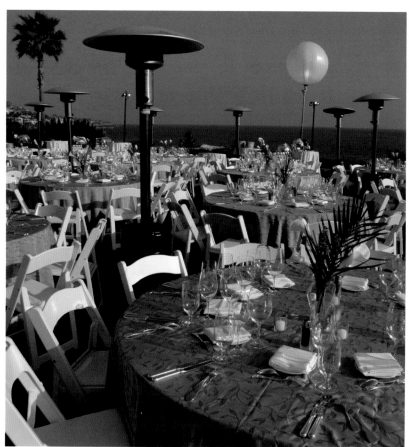

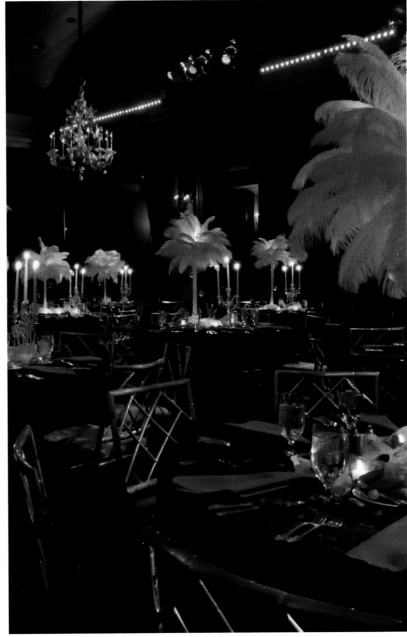

"Experiential design engages all of the senses for a full, multifaceted environment."

—Michelle Kraemer-Hogan

Feathers, candelabra, organza fabric, pearls, rose petals, and scarlet shades brought to life a stunning Roaring '20s ambience, while a Southern California alfresco dinner right next to the ocean and the waves featured a classic white palette and giant statement-making Air Star globes that imbued the night with an understated radiance.

views

When an event addresses and balances all of the senses—not just the visual, but the aural, tactile, gustatory, and olfactory as well—you have the perfect combination. Hosts and guests will be completely immersed in an entirely new world.

ELLYN BOLD EVENT DESIGNER

ELLYN BOLD
KANSAS CITY, MISSOURI

For someone who absolutely loves the element of surprise and whose fondest childhood memories are of attending exquisite parties with her family, the role of professional event designer is not only perfect but also a privilege. Ellyn Bold enjoys designing events of all sorts: large or small, in the Midwest or on one of the coasts, dramatically colorful or elegantly understated. Regardless of the event's scale, Ellyn advocates superior quality and value, designing the full scope of elements from menus to music. She sets the bar high for all of her vendors and works exclusively with those who share her appreciation of ingenuity and perfection.

Ellyn's background as the longtime executive director of Kansas City's Country Club Plaza—where she honed her strategic thinking skills and produced countless events—has been invaluable in her independent ventures through her firm Ellyn Bold Event Designer. An expert at envisioning a space's potential, Ellyn is known for orchestrating impeccably timed events that engage guests from the moment they arrive.

Humbly noting that there is no such thing as a truly unique look, she favors personalized designs that embody the host's sense of style. In order to create such an effect, she begins the planning process with an in-depth conversation to uncover what kind of party the host wants to have and then develops a special theme filled with meaningful design details. While hosts are intimately involved in the planning process, Ellyn always makes a point of incorporating at least one surprise— revealed the day of the event—to underscore how well she knows them and how much she cares.

The leaf motifs on the 30-foot fabric panels gave the room warmth and intimacy, while the pinwheel motif on the floor created texture on the dance floor. Our timeless design transformed a blank theater stage into a stunning garden, demonstrating that design and lighting are the cornerstones of a successful event.

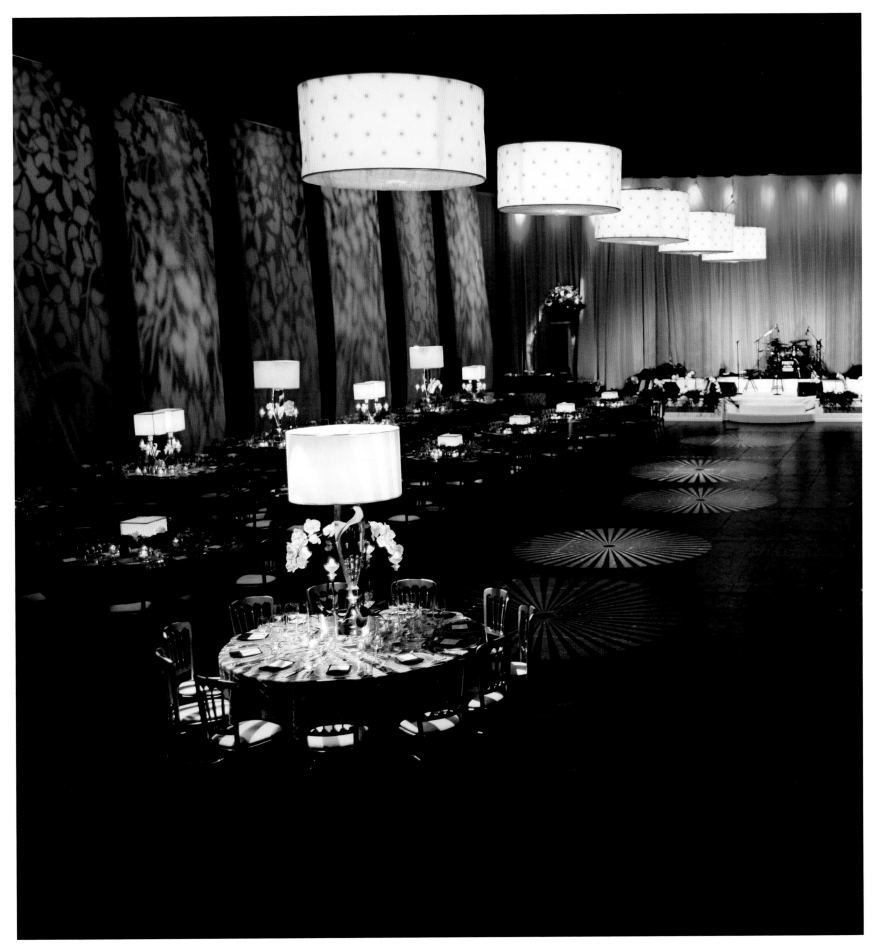

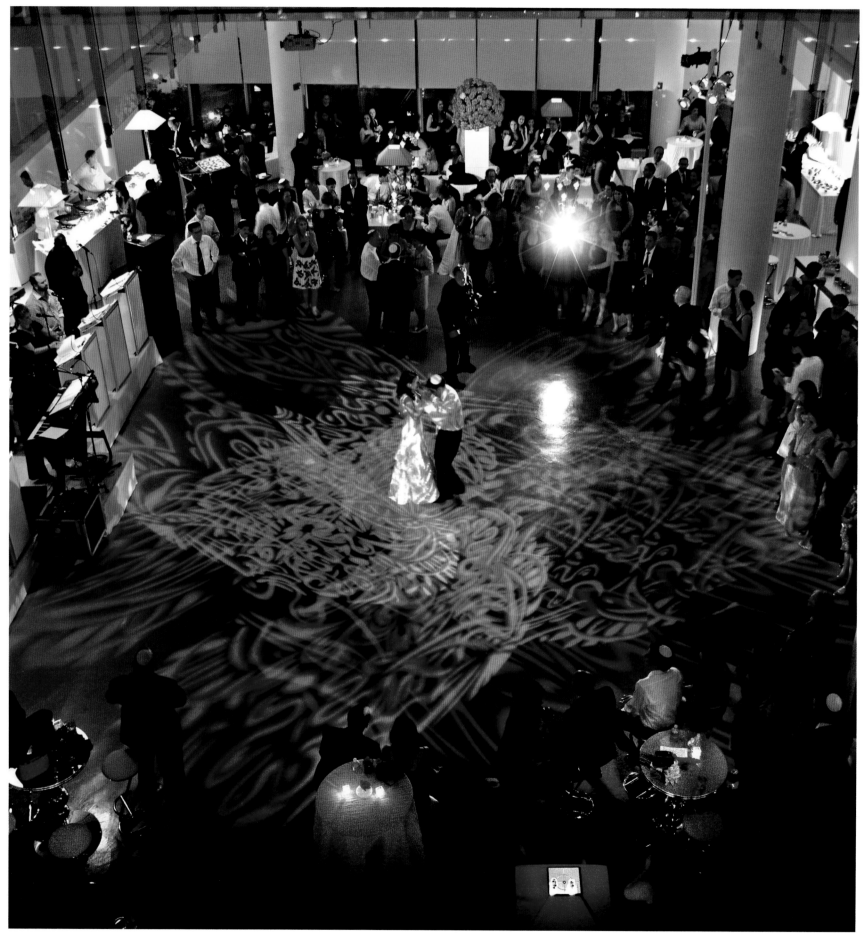

Photograph by Wirken Photography

Photograph by Wirken Photography

Photograph by Wirken Photography

I selected the multilevel museum in Chicago because it had the potential to afford all 300 invited guests a front-row view of a Jewish pre-ceremony wedding tradition: After being carried downstairs by his brother, the groom veiled his beautiful bride. Everyone's position was planned well ahead of time, but to the guests, the moment was spontaneous and something they'll never forget. After the ceremony, loved ones once again closely surrounded the couple as they danced and mingled.

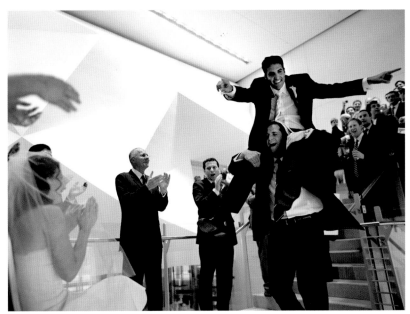

Photograph by Wirken Photography

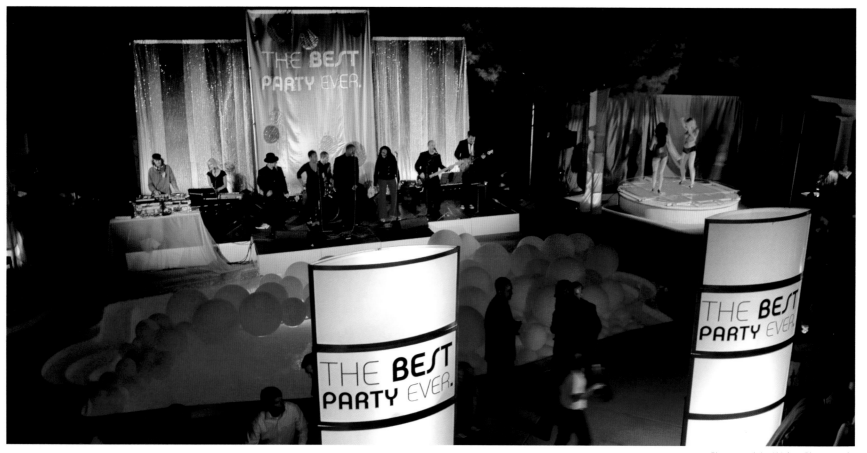

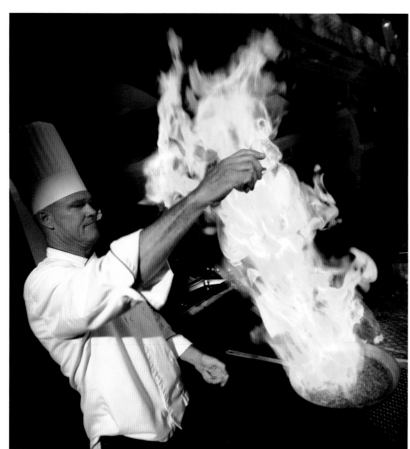

"Events are like live movie premieres."

—Ellyn Bold

Right: Every huppah is special, and I've designed some exquisite pieces—one made exclusively of crystals, others pavéd in flowers. The ribbon concept is one of my favorites, incorporating varied widths and hues of cream and pink ribbons for an elegant effect. The lightweight composition allowed us to use the huppah during the ceremony and then easily move it to the reception, where it framed the bridal couple's table; it now serves as a canopy in the bride's childhood bedroom to enjoy during visits home.

Facing page: Lights! Camera! Action! A CEO wanted to have the best party ever, so I took him at his word and designed "The Best Party Ever," stylized after a Las Vegas nightclub and branded to perfection. Guests enjoyed cocktails indoors, and once the sky darkened, LED lights lit up the backyard and the band came to life. Continuous music, bodypainted dancers, and chefs preparing various savory small plates—including rack of lamb, sautéed scallops, Mexican tamales, and fresh bananas foster—proved a recipe for a fabulous event. Studio Dan Meiners and Harvest Productions collaborated on the event.

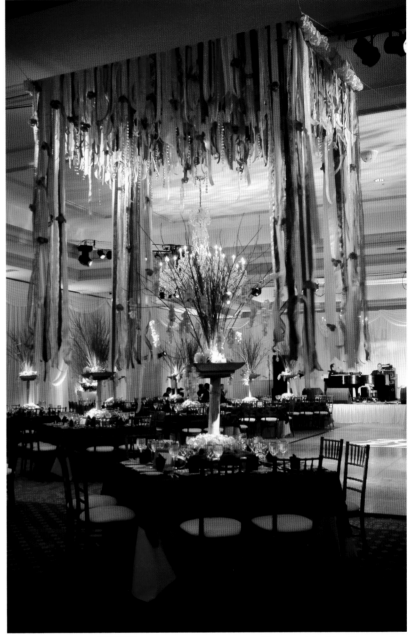

Photograph by Kdog Photographers

views

In order to be successful in this industry, you have to really love working and be willing to give every event all you've got. My dad was always the life of every party, and throughout the later years of his life he became a sounding board for my creative pursuits. It's because of him that I'm so driven and determined to remain on the cutting edge of event design—a constantly evolving quest, a wonderful challenge.

KEHOE DESIGNS

TOM KEHOE
CHICAGO, ILLINOIS

Tom Kehoe continually pushes the limits of unconventional, modern, and elegant event décor design. He established Kehoe Designs™ after years spent honing his creative vision in floral design, luxury hospitality, and small business entrepreneurship and today is one of the most highly regarded event specialists in the United States. Kehoe Designs has been transforming the realm of possibilities for weddings, corporate affairs, and social events since 1995.

The range of services is impressively broad—beyond floral and graphic design, the company can provide fabric décor, custom furniture, interior plantscape design, and specialized artwork. Its multifunction design house includes numerous artisans such as florists, fabric technicians, visual artists, graphic designers, upholsterers, carpenters, and landscape experts. The environments they create result in luxury, from lush upholstered lounge groupings to custom-built bars to tailor-made fabric over pergolas. The effect is unmistakably haute.

The senior team is composed of high-level creative professionals from a diverse array of backgrounds comprising interior design, visual merchandising, hospitality, sales, and event production. In-house brainstorming sessions are collaborative efforts allowing each member's forte to shine. Often one designer knows what will look great in a particular venue, while another has a certain sense for styling a period piece and can emulate it into a themed design. The dynamic collaboration of the entire team results in Kehoe's signature upscale, contemporary, and inimitably original style.

Taking our host's unique vision of Africa, we transformed The Field Museum of Chicago into a bright, magical world populated by exuberant color, oversized dome lamps, art installations, extravagant draping, comfortable lounges, and rustic tables. There were four motifs at play: jungles of the Congo, Egyptian artifacts, Moroccan textiles, and tribal masks. Each furniture collection received custom fabric treatments ranging from bright orange and hot pink Moroccan square banquettes to tribal fabrics covering hundreds of ottomans. Oversized, handmade tribal masks served as stunning accents to every buffet table. Our challenge came in designing props large enough to make an impact in the museum's massive atrium. Huge Moroccan dome lamps hung in certain sections, creating a more intimate lounge space.

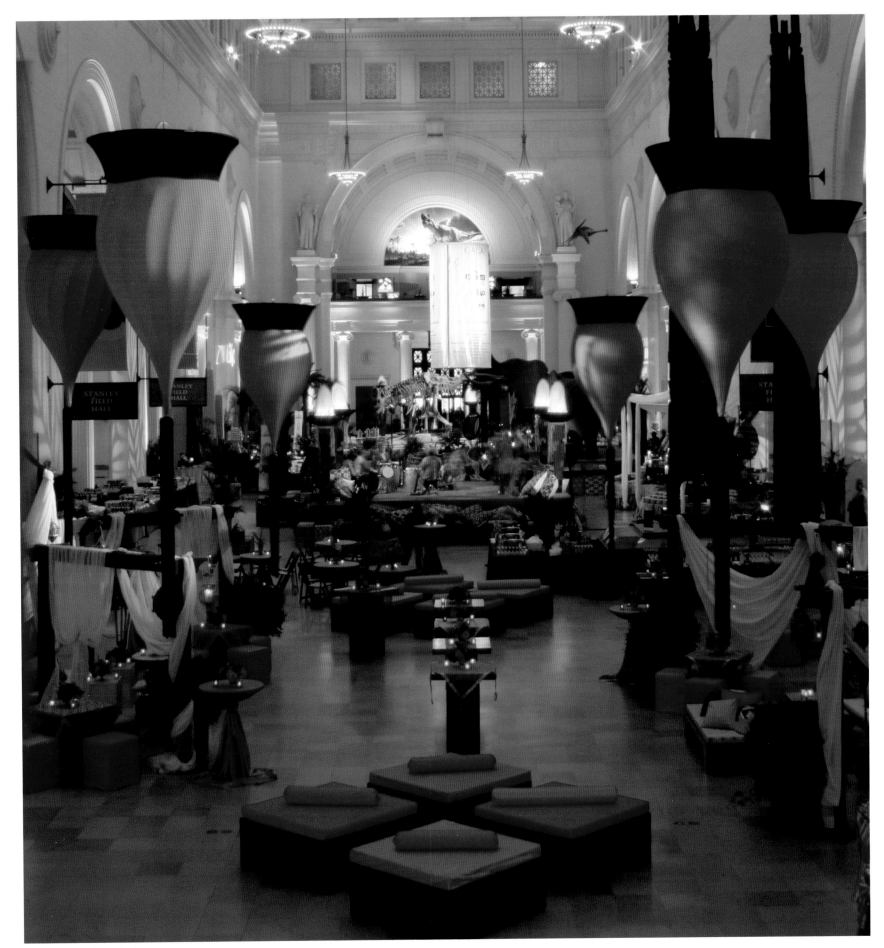

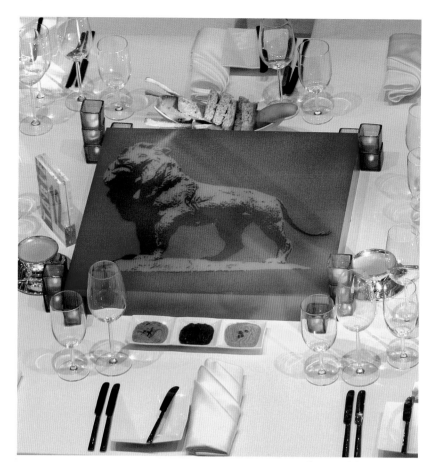

Above and left: A gala celebrating The Art Institute of Chicago's new Modern Wing and its 35th anniversary was characterized by a clean, symmetrical design inspired by the new wing's architect, Renzo Piano. We created a unique environment using aluminum frame tables with stretched artist canvas tabletops to give a lightweight, almost floating appearance. Images of interpreted artwork displayed at The Art Institute were printed onto 24-inch display boxes, as a refreshing twist on the traditional floral centerpiece. Our favorite tabletop featured one image of the iconic Art Institute bronze lions statue by sculptor Edward Kemeys. Silver chairs and white ottomans rounded out the contemporary and simplistic yet artistic feel.

Facing page: Our inspiration sprang naturally from the Garfield Park Conservatory where our corporate host held the affair. We wanted to emphasize the natural canvas of lush foliage and stunning architecture, so we created custom eco-friendly décor that would blend into the surroundings for a cohesive flow. We drenched the room in candlelight and strong fuchsia illumination for a sense of warmth. Recycled birch formed our highboys, low tables, and wood pedestals, while a latvassa korkealla pattern covered pillows, which were perched atop crisp white lounge groupings. These custom-made elements were chosen specifically to coincide with the conservatory's pre-existing artifacts, highlighting facets of the venue such as a detailed mosaic wall.

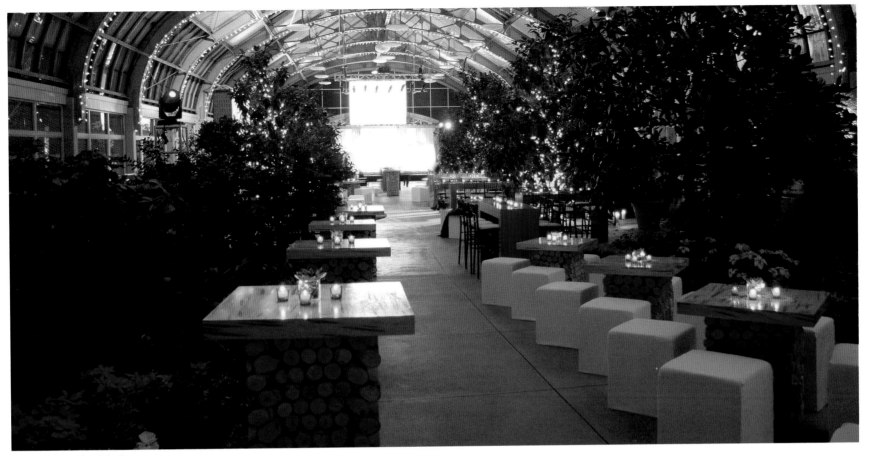

Photograph by Chris Erbach

"Be true to yourself, keep evolving, and don't limit yourself to one look."

—Tom Kehoe

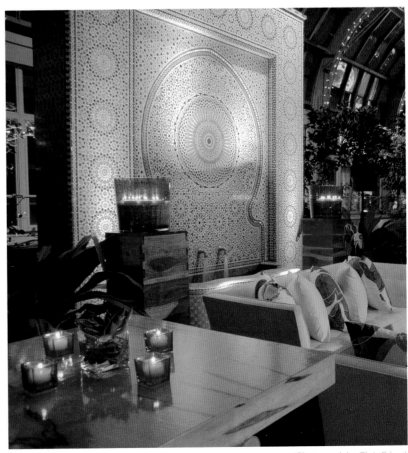

Photograph by Chris Erbach

Photograph by Phil Farber, Photo Images Inc.

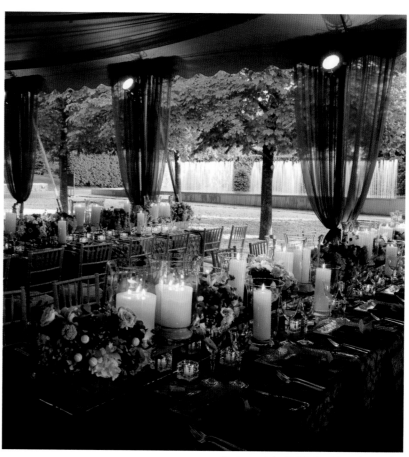

Photograph by Phil Farber, Photo Images Inc.

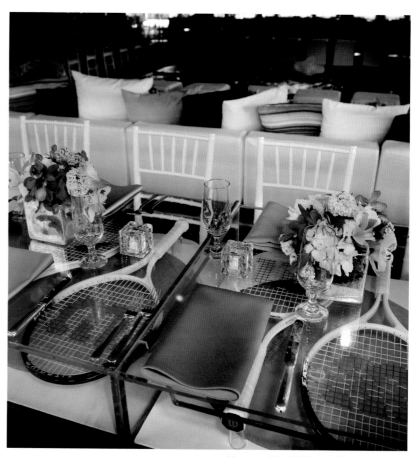

Photograph by Phil Farber, Photo Images Inc.

"The essential element of any event is not a thing, but a spirit, the emotion it conjures up."

—Tom Kehoe

Right: Designing this spectacular event was a unique opportunity to play off The Field Museum's masculinity with a balance between that and femininity. Our design incorporated a strong furniture collection underscored by soft, fashion-forward colors in the pillows and floral design. The midnight black Baroque-inspired lounge grouping was offset by subtle components such as champagne, beige, and pale gold accent pillows and stylish centerpieces consisting of golden compotes overflowing with coral peonies, sherbet ranunculus, peach amaryllis, gloriosa lilies, and trailing smilax.

Facing page: A bat mitzvah held at the Chicago Botanic Garden merged a daughter's love of tennis with her mother and grandmother's elegant style, making tennis passionate and feminine. We incorporated various shades of green to neutralize the bright citron hue of a tennis ball. The lush tabletop design included long sleek mirrored vessels containing green viburnum, mokara orchids, cymbidium orchids, bupleurum, hydrangeas, and spray roses, all accented by petite yellow tennis balls—a subtle, sophisticated nod to the athletic theme, which did not detract from the rich violet and green floral design. Candlelight in varying shapes and sizes completed the unique design. The children's tabletop design became more of an art installation featuring sporting equipment and original graphics within a Lucite table. Whimsical centerpieces featuring pretty and playful flowers mixed with sporting elements to give depth and sophistication to the event.

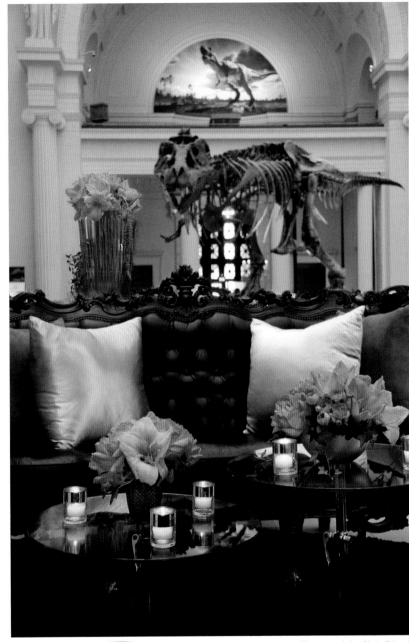

Photograph by Chris Erbach

views

❖ Choose a design company capable of delivering décor concepts that are original and unique, yet faithful to your vision.

❖ Experience, imagination, and professionalism are key traits to seek in your event designer.

❖ The best firm will collaborate with hosts to produce an event of the utmost elegance, sophistication, and creativity.

EVED SERVICES

CHICAGO, ILLINOIS

Coordinating a multiday program for 4,000 attendees with transportation each day—including one evening to over 25 of Chicago's favorite restaurants—and creating a large event with product branding seems quite daunting. But not for Eved Services with its one-stop-shop approach, efficient technology, and innovative culture.

Co-founder Talia Mashiach opened Eved Services in 2004 as a year-round resource for event and destination management needs with no request too small and no event too large. Eved also partners with over 30 hotels and venues in the Chicago area as their in-house event management team of experts.

With such a wide range of tasks and events, what makes Eved Services successful? The unique technology designed by Talia and her associates plays a huge role in their accomplishments. The exclusive web-based software allows vendors—who must maintain a certain rating to remain a vendor—to upload and manage a list of inventory and availability. The Eved team can then peruse the virtual list to find the best resources for an event without calling numerous vendors to determine availability and cost.

The efficiency of the system is amazing, with automated orders and updates in real time for both Eved associates and vendors. Talia and her team are then free from wading through piles of paperwork to focus on designing and orchestrating spectacular, one-of-a-kind events.

Lucite chairs and the king-style translucent table, which change color from the lighting elements suspended above, illustrate the use of event technology to color and brand events. Swan entertainers add movement as they gently glide through the space.

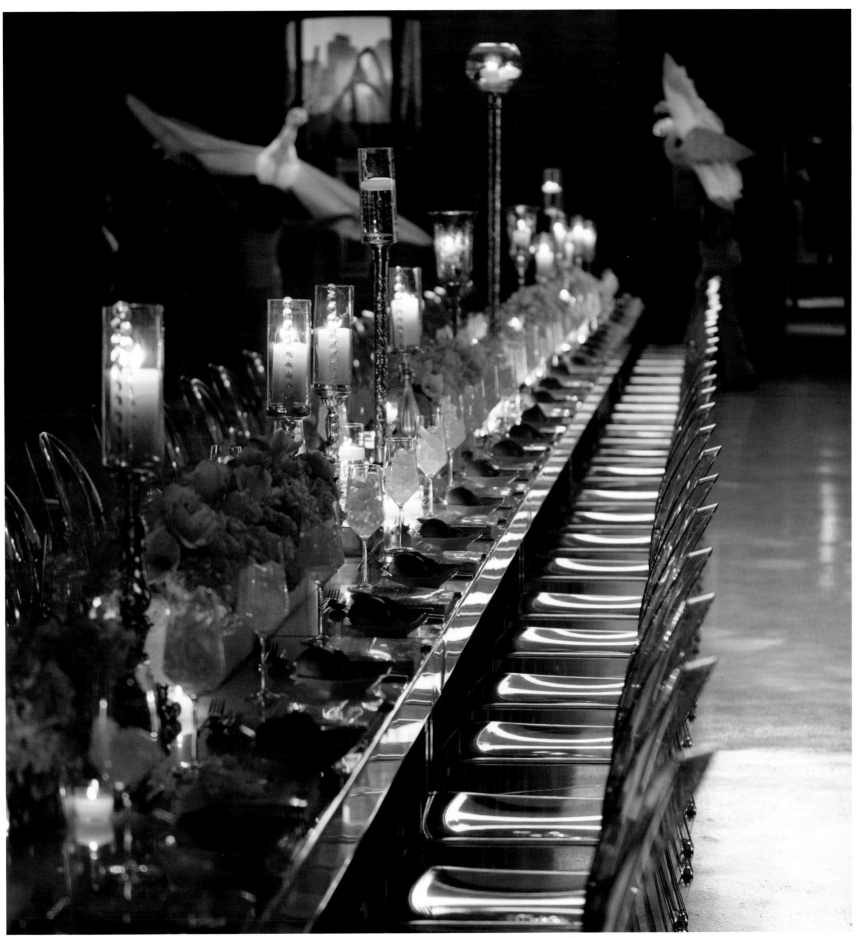

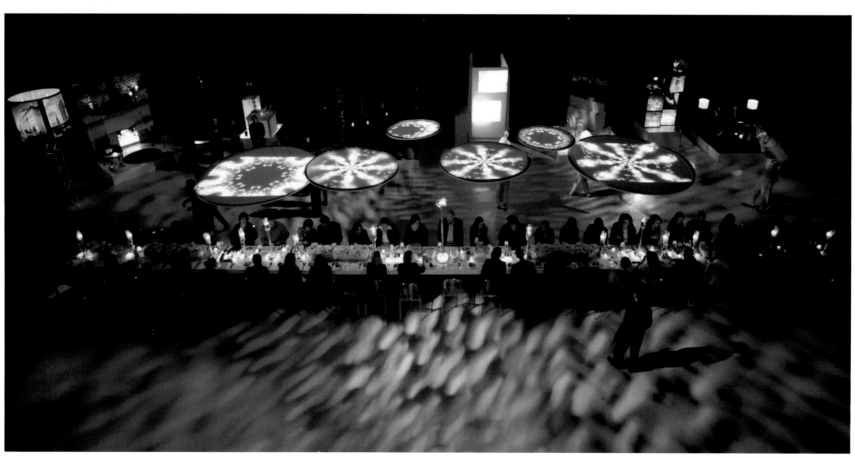

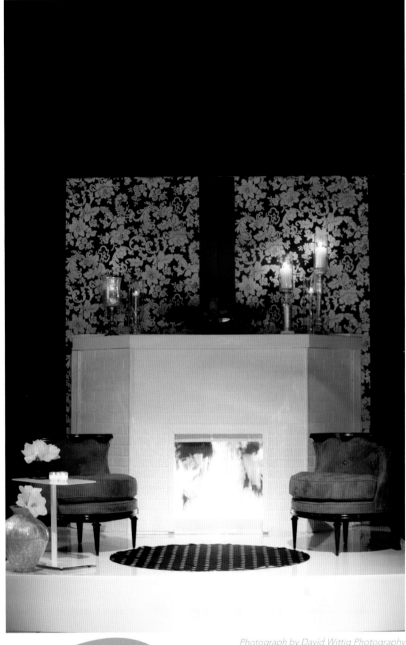

"Innovation is indispensable when orchestrating events."

—Talia Mashiach

Fresh color mixed with antique or elegant elements, such as candles, a fireplace, a velvet couch, and black-and-white décor, create a vibrant contrast. With event technology, a dramatic, modern kaleidoscope dances on nylon draped above the table. Each component stood out just enough to add interest, yet they still exhibited a cohesive feel throughout the event.

views

Consistency through each planning process is crucial to ensure each event host feels at ease. A structured proposal, similar ways to handle unique situations, and even a company uniform provide stability and ensure quality.

EVENT CREATIVE

SEAN CANNON | LIONAL RIVERO-CANNON
CHICAGO, ILLINOIS

When undeniable creativity and impeccable planning come together, anything is possible. That's what the dynamic partnership of husband-and-wife team Sean Cannon and Lional Rivero-Cannon bring to Chicago with their event production business Event Creative. When your event design firm is headed by a CEO *and* a CCO—Chief Creative Officer—that's when you know it's going to be an amazing event no one will ever forget.

Sean Cannon has been involved in the special event industry since the age of 18 in New York City, where he worked for some of the most prestigious companies in the business. In 2004, he was ready to open his own business and began Event Creative with his wife and partner Lional Rivero-Cannon, the creative head. As a full-scale, full-service production company, Event Creative's facilities encompass a generous 40,000 square feet. The space houses over 30 full-time employees ranging from carpenters, seamstresses, furniture artisans, florists, creative and production staff, and audio-visual-lighting specialists to graphic designers and video editors.

Every member of the company contributes to an overall design. It's not rare to see the florist and the lighting technician in the same room discussing how they will join forces to pull an event together, and this ensures that technology will be woven seamlessly into the décor, which allows for fewer snags and snafus along the way and up to the day of the celebration. With so many creative forces together in one building, it's no wonder Event Creative earns its name on a daily basis.

We always strive to marry technology with décor. We created a 450-square-foot, four-level Indian-themed lounge and wanted to incorporate a koi pond within the room. Instead of bringing in live fish, we fabricated a stonework pond and projected virtual fish into it from a video projector. Our brightly colored floral arrangements surrounded it and a series of iconic images from India ran on the far wall.

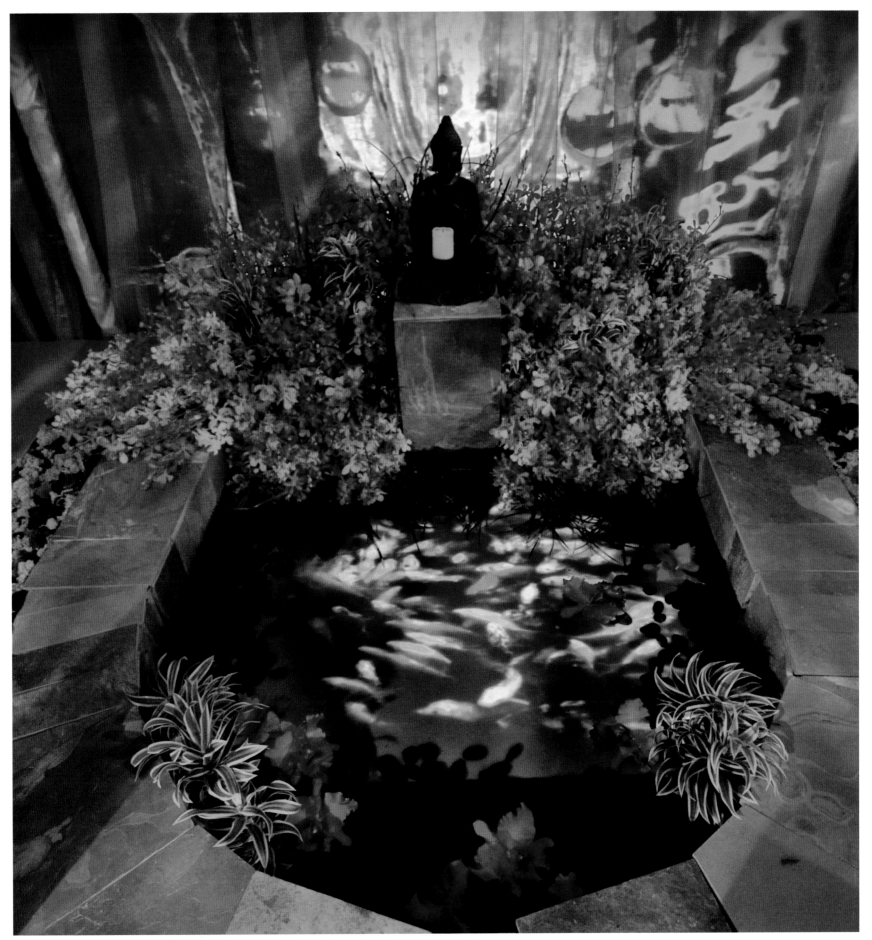

"Designing events is about creating lifelong impressions."

—Sean Cannon

Right: We can go from transforming a space to enhancing it depending on the needs of the location. Many of those we work with are nontraditional—including the Chicago Board of Trade trading room floor and even an airport runway. At a filming studio at Columbia College Media Production Center, we chose not to hide the soundstage equipment inhabiting the room, but rather to employ all of it to design the event. We crafted furniture out of lighting gear and really played up the existing setting. In this way we proved to our hosts that we could utilize elements already present in the room. After all, the fundraiser hosted there was all about saving money—so we showed them how it's done!

Facing page top: At a baseball-themed bar mitzvah held in the vintage car warehouse Ravenswood Event Center, we came up with a nontraditional seating arrangement involving tailor-made leather-stitched vases to mimic baseballs. Footage we shot and edited ourselves of iconic baseball images played in the background.

Facing page bottom: For a Las Vegas-themed wedding, a giant "PLAY" sign and lounges with overhanging white feathered lamps played up the glamorous ambience. As the venue was the Museum of Contemporary Art Chicago, all components had to be freestanding and could not be attached to the walls.

Photograph by Jared Kelly

views

❖ Look for a team that's creative, flexible, and highly collaborative.

❖ Be prepared—test and build components before the on-site installation occurs.

❖ Maintain control over every component for a cohesive, smooth job.

EXCLUSIVE EVENTS, INC.

ERIN SCHULTE
ST. LOUIS, MISSOURI

It's rare to find an event design company that also houses an in-suite studio staff of designers, carpenters, costumers, and scenic artists—just for starters—but that's exactly what Exclusive Events, Inc. prides itself on providing. It's a true one-stop shop capable of pulling off elaborate, exceptional events.

When Erin Schulte and her husband moved from Los Angeles to St. Louis, she never dreamed an event design industry was waiting to be born there. She started out designing and producing theater, then began planning high-end social affairs, and eventually branched out into full-blown event design—while still approaching every party as a theatrical production. Now she's at the forefront of the St. Louis event industry as the owner of Exclusive Events, and a key figure in the scene. In fact, the company has had to move three times because its giant warehouse and workshop keep expanding!

The events team loves to think outside the box and dig deep into people's personalities to enable fun, authentic parties with pieces dreamed up just for them. From lighting a planetarium ceremony in black light to pioneering a new St. Louis event trend of custom-built and painted elevated platforms to house head tables and ultra lounges, the firm is at the vanguard of every aspect of event production, lending theatrical flair to every celebration.

We love when hosts are just as excited as we are to totally transform venues. One bride let us take the country club ballroom she had grown up with and turn it into an entirely fresh environment for her reception. The event coordination was by Bride's Vision.

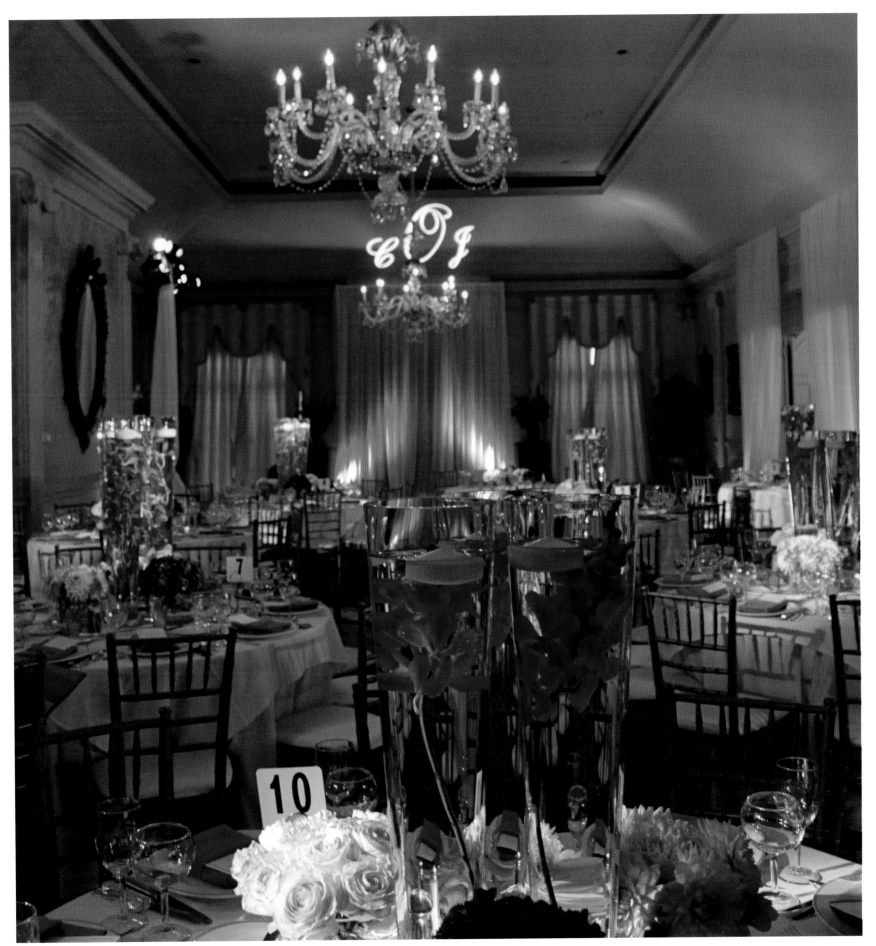

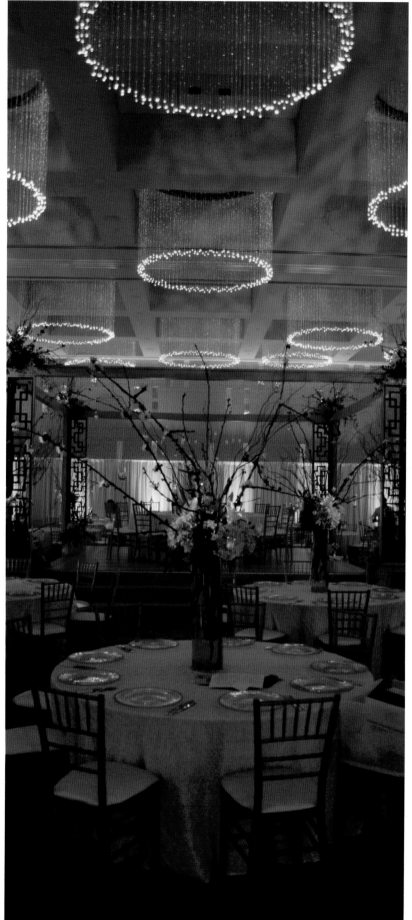

"Inspiration can come from something as abstract as rain drops hitting a puddle or as routine as a piece of tile. If you open your mind to whatever you come across in everyday life, insight will follow."

—Erin Schulte

Right: It's fun to make it so guests don't know where they are. In conjunction with fellow designer Contemporary Productions, we covered an old, bookcase-lined library with lighted fabrics to fashion a room-within-a-room look that was intimate and a little bit outside the ordinary—and redone so completely that even regular patrons didn't recognize it.

Facing page: Each event gives us the chance to utilize different facets of our imagination. For one event where half of the family was Asian, we created a subtle, contemporary elevated head table drawing on Chinese architecture and the five Chinese elements. For a tent installation soirée, we played shades of blue and white and different types of light off each other to form dimensions on the ceiling. We took our creativity to the limit when we made Phillies baseball player Ryan Howard a mirror lounge for a party during his All-Star Game, incorporating mirrors into the rugs, tables, and wall decorations to generate a masculine yet contemporary ambience that was truly inventive.

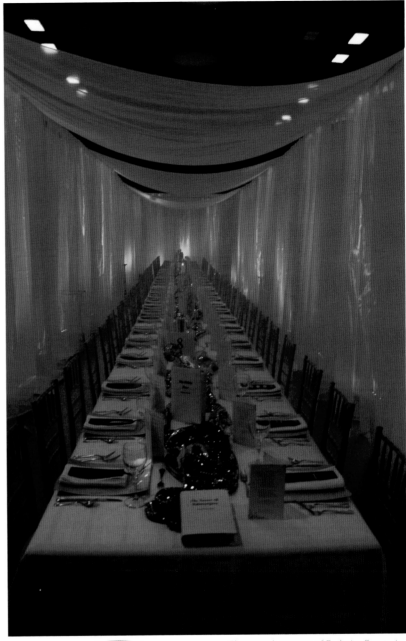

Photograph courtesy of Exclusive Events, Inc.

views

When planning parties, know that you don't have to settle for what has been done many times over, and that there are options to make an event special and unique to you. Be imaginative and create something personal and meaningful—let the night be a reflection of your personality.

RONSLEY SPECIAL EVENTS

MICHAEL LEVENTHAL | KATHARINA LEVENTHAL
CHICAGO, ILLINOIS

How do delightfully over-the-top celebrations come together? Like most design and production companies, Ronsley Special Events starts with the host's vision—a few ideas loosely strung together or a vivid vision of how the décor should look and the evening should unfold. But then the team takes the typical process about 10 giant leaps beyond what any host would expect. An all-out creative brainstorming fest ensues. Bringing in artists, graphic designers, carpenters, and designers of floral, fabric, lighting, and sound, the project manager leads an animated discussion about special designs and effects that would make the event totally unique and unforgettable. Ideas turn into well-thought-out plans and ultimately a three-dimensional stage is mocked up for the hosts to experience a slice of the real thing. In this preliminary phase, as during the event itself, people are absolutely mesmerized and find themselves wondering what's real, what's rendered or projected, and how on earth the designers pulled it all together.

It comes as no surprise that owners Michael and Katharina Leventhal have deep passions for set design and interior design, respectively, and spent quite a bit of time on the West Coast, soaking up the sun as well as the Hollywood magic. Bringing their international flair back to the Midwest in the early '60s, when they acquired 1913-established Ronsley Special Events, the Leventhals set about quenching an insatiable thirst for creating celebratory fantasy worlds. They have applied their creativity for projects social and corporate, across the United States and as far away as Japan. When they're not designing, Michael and Katharina can usually be found road-rallying on a scenic highway in one of their vintage racecars—enjoying the calm and, of course, gleaning inspiration and restoring energy for their next big event.

We've worked with such an array of organizations, from virtually all of the major professional sports associations to entities like Harpo Studios, Walt Disney, Dr. Pepper, Alfa Romeo, and Bvlgari. We were on set for "My Best Friend's Wedding" and "The Fugitive" and intimately involved in the events surrounding Princess Diana's trip to Chicago in 1996. Just when we feel like we've done it all, a new creative challenge presents itself.

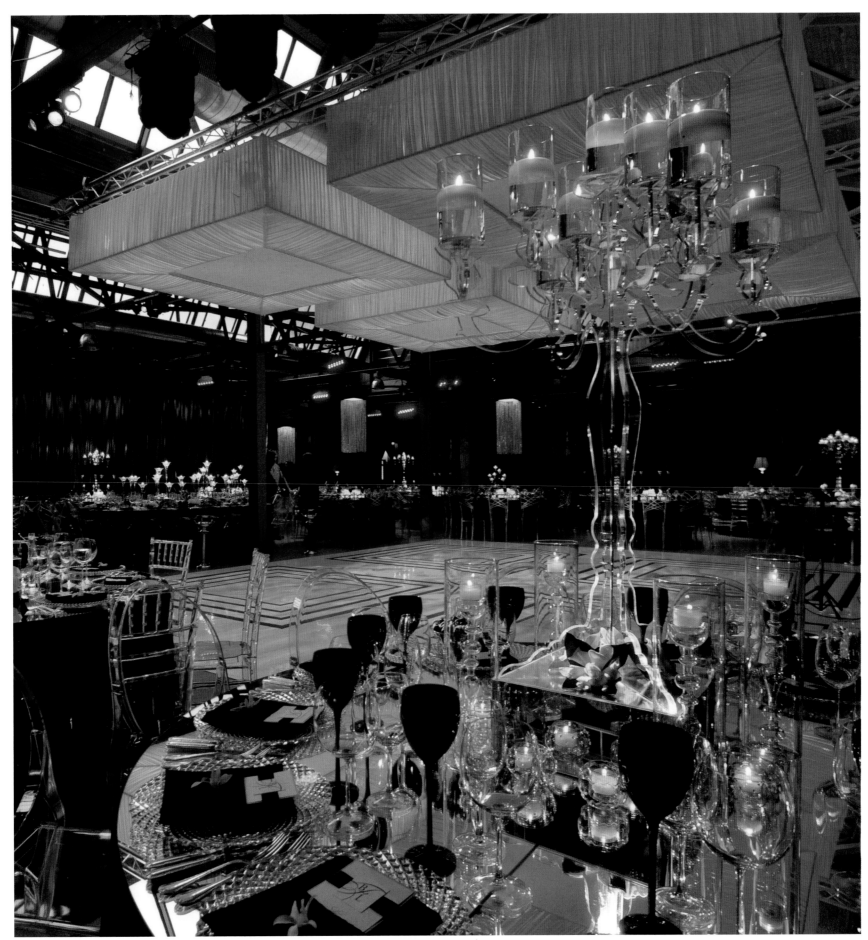

Photograph by Phil Farber, Photo Images Inc.

Photograph by Phil Farber, Photo Images Inc.

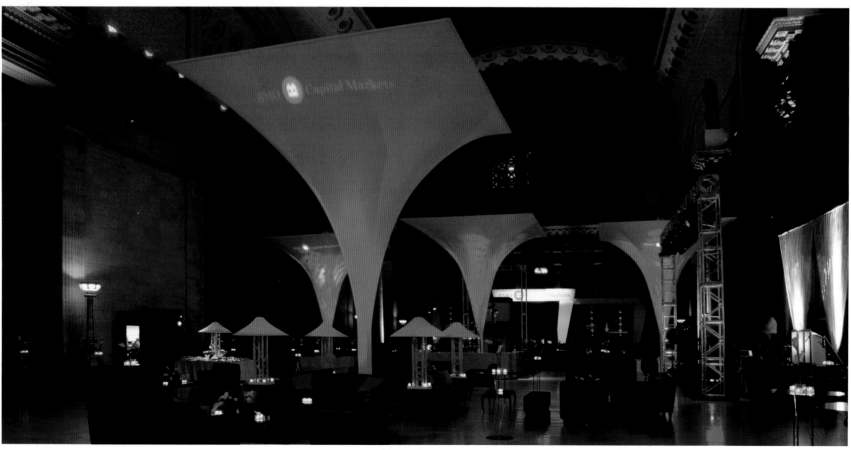

Art of Celebration | 158

Photograph by Larry Shapiro

"You know you've outdone yourself when guests dream about the party in color."

—Michael Leventhal

Among other things, we're pretty well-known for our fabric department and its ability to create completely custom ceiling treatments, wallcoverings, and other textile elements. For a Mad Hatter private party, we built out the ballroom from top to bottom. We used green screen technology and beautiful artwork to allow guests to enter the party in true Wonderland style: through a swirling rabbit hole. From grand gestures like the fields of 15-foot-tall mushrooms to themed details like the hat stands beside each dinner table, we really created a three-dimensional set, an experience that will never escape even the most gala-experienced of guests.

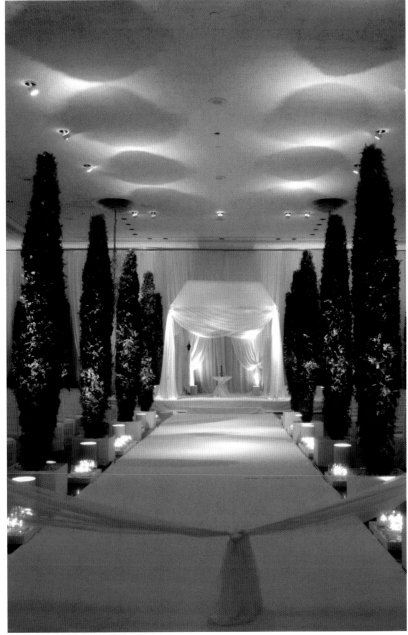

Photograph by Phil Farber, Photo Images Inc.

views

One of the secrets to planning a great event is asking the right questions of the right people at the right time. Closing off major streets for weeklong festivals is completely within the realm of possibilities; it just requires good planning and clear communication among everyone involved.

Studio Dan Meiners

DAN MEINERS
KANSAS CITY, MISSOURI

Dan Meiners combines the expertise of an art director with a love of flowers for a truly all-inclusive event design experience. He has transformed the realm of possibilities in Kansas City.

It happened quite by accident. Dan, a trained graphic designer, was a visual director for store window displays when he took on a side business, selling plants with a friend. Vendor interest took off, an official store opened, and Dan began receiving design requests. It wasn't long before Studio Dan Meiners sprang onto the Kansas City event industry scene in 1993, capable of handling everything from floral only to full event design. The studio sources the highest quality flowers for its arrangements and furnishes hosts with an array of themed centerpieces and custom-built props.

The pride of Dan and his team is the ability to envision everything the guests will experience from the second they arrive until the moment they leave. He formulates many of the ideas, and then team members strive to make them a reality—working closely with vendors to ensure the vision is executed perfectly, crafting props and flowers in-house, and keeping the ball rolling on momentum and energy. The studio's signature look is clean-lined, creative, and elegant, whether traditional or modern. The friendly yet persistent staff is highly effective, and the team relishes that moment when everything gels and the finished product is revealed to the host's thrilled amazement.

To enhance the curved room design inside a front lawn tent hosting 750 wedding guests, our understated floral designed included rings of orchids adorning the chandeliers and tall unobtrusive centerpiece arrangements alternated with smaller, lower displays.

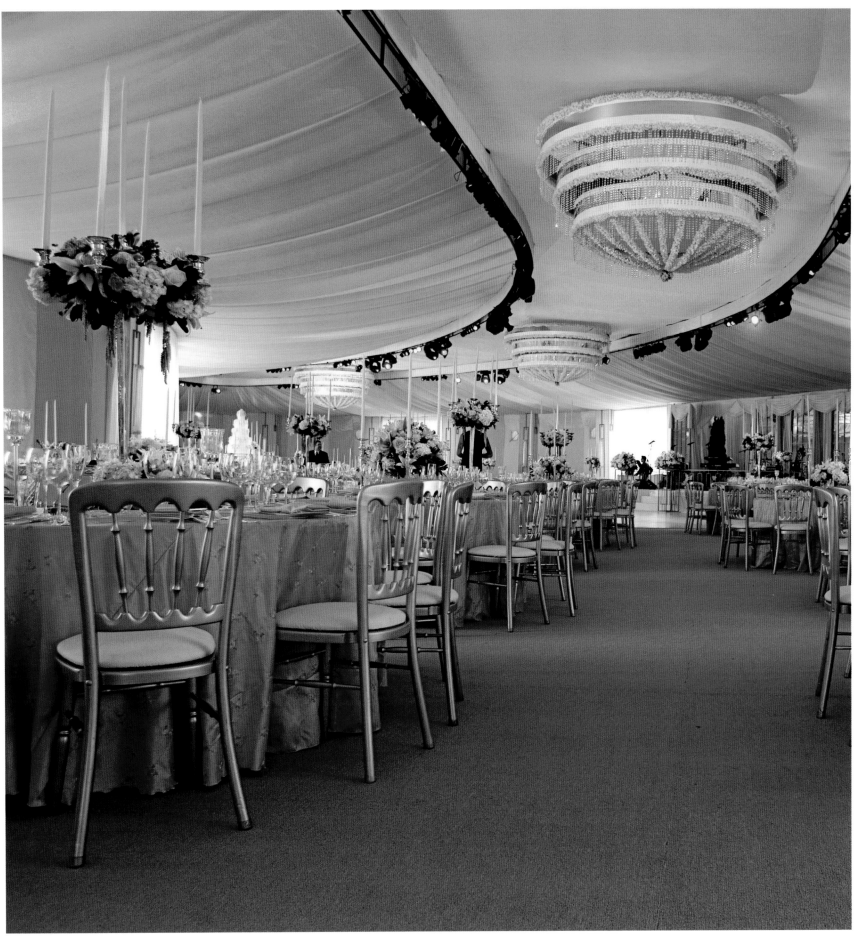

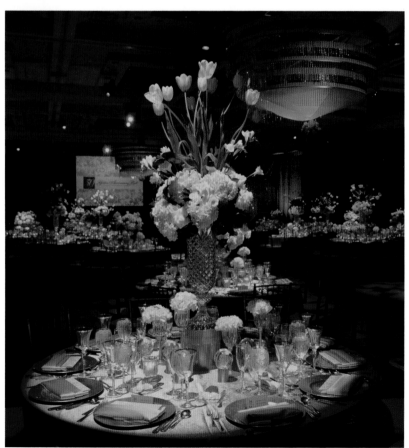

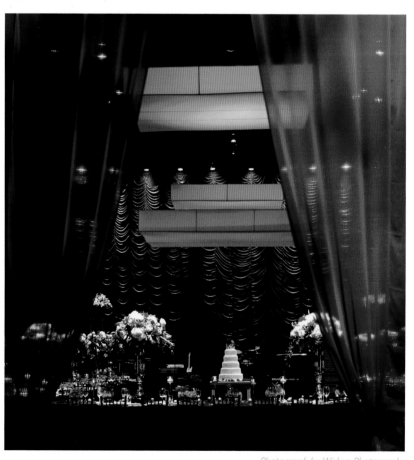

"I look at a party, and I see the whole vision—not just flowers and tables. I prefer aesthetics over convenience."

—Dan Meiners

Right: During the cocktail hour of a wedding reception, a spinning crystal ball glittered as brightly as our cut crystal hurricane glasses floating alongside rich red flower balls on Plexiglas tiers. Sparkling mirror garlands hung all around the giant stage house, which we transformed—ceiling, walls, floor and all—from an entirely blank canvas for the event.

Facing page top and bottom right: Under the creative direction of event designer Ellyn Bold, we helped to create a seamless ballroom effect inside a clear tent set up in the host's backyard and went all out for a lush wedding with giant florals, dramatic draperies, rich reds, and giant hanging light boxes.

Facing page bottom left: We love to let our imagination and creativity run wild, like when we forged a formal feel with cut crystal, numerous candles, custom-made linens, a dance floor 150 feet in length, and gold and turquoise hues for the Lyric Opera of Kansas City's 50th anniversary ball.

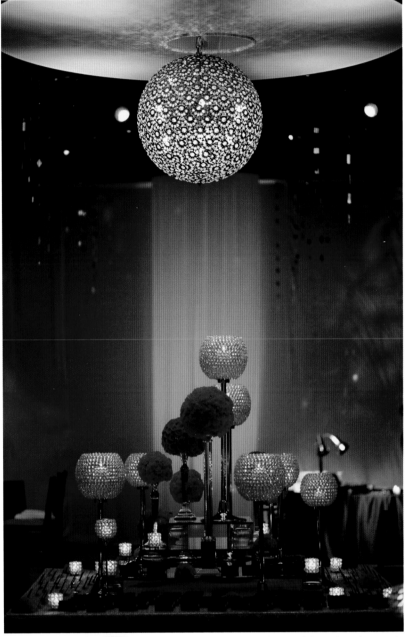

views

What's the key to a well-executed event? Planning, planning, planning. Don't forget the flexibility to adjust things last minute when things don't go smoothly. Our team keeps photos of the table design for reference and we leave ourselves a few hours' cushion. Before the event kicks off we like to be standing around long in advance tweaking, playing around, and doing little unexpected things.

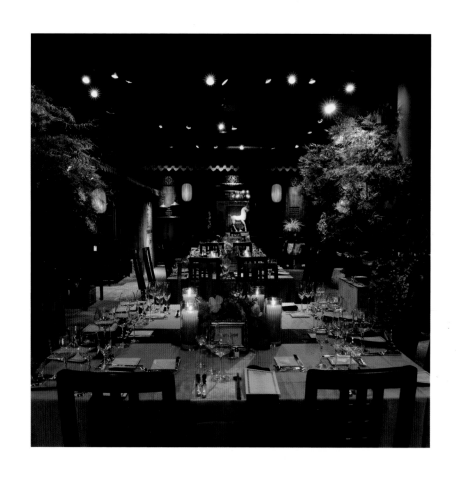

Location, Location,

Location

THE FIELD MUSEUM

MEGAN WILLIAMS BECKERT
CHICAGO, ILLINOIS

Imagine dining and dancing among the dinosaurs, celebrating in style surrounded by creatures that walked the earth millions of years ago. There's a thrill to having an event at The Field Museum in Chicago, the renowned historic landmark that overlooks the city skyline and shores of Lake Michigan. Viewing a portion of the permanent collection of archaeological artifacts and anthropological wonders is a privilege for partygoers. Events of unequaled sophistication can only be experienced in the awe-inspiring monument that has impressed visitors since its first opening for the World's Columbian Exposition in 1893, and then in 1921 when The Field Museum moved to its present-day location. Today it is an institution dedicated to research and education, while enticing visitors with its 35 permanent exhibits of the most important collections known to man.

Unforgettable moments are created every day at The Field Museum. Hosting formal galas, business meetings, fundraising dinners, annual corporate gatherings, and posh family weddings—for an intimate guest list of five to 15,000 invitees—is a dream come true whether throughout the full museum or in any one of 20 special event spaces. Each unique architectural space can be transformed into a customized look whether you choose Stanley Field Hall, a private meeting room, the East Atrium and Pavilion, James Simpson Theater, or other namesake auditorium theaters, galleries, or outdoor terraces. Exclusive vendor partners who understand the museum's layout and requirements, floral and décor designers, lighting experts, audiovisual specialists, and catering teams are ready to produce every celebration to perfection as guided by the talented hands of the museum's professional event managers. Planning more than 150 fabulous fêtes annually, the venue has garnered rave reviews from the local media, and is recommended by high-profile CEOs and award-winning event orchestrators from around the globe.

The largest, best-preserved T. *rex* specimen in existence, "Sue," stands in Stanley Field Hall presiding over hundreds of celebrations annually. A cocktail reception and formal seated dinner was held in the impressive hall. To creatively and tastefully divide the space, we suspended sheer panels featuring projections inspired by the "Maps" exhibition as stunning thematic décor. The florals were by Heffernan Morgan Event Design.

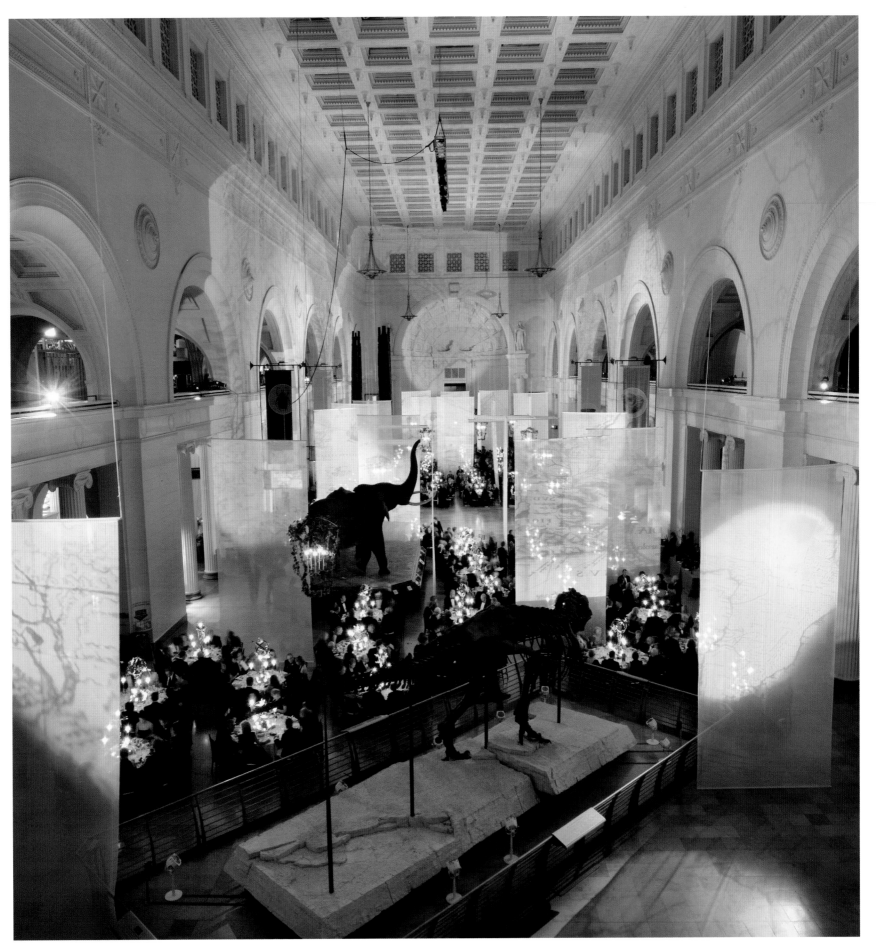

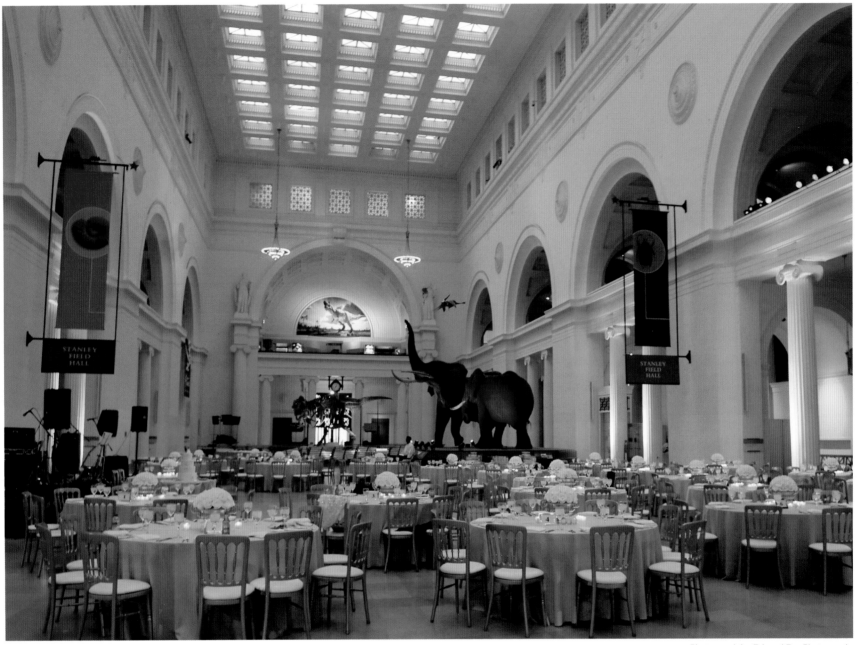

Above: Catered by Food for Thought and set for 350 guests with fresh, clean décor, pastel blue linens, and golden Versailles chairs, our summer evening wedding exuded a light and airy ambience. Stanley Field Hall provides an architecturally rich dining experience with two African elephants and "Sue" in the background.

Facing page: A tempting dessert buffet was designed by Jewell Events Catering with gold and amber tones casting a warm glow to the marketing event for 400 high-profile invitees. Votives illuminated round and bar-height tables for an elegant touch throughout the museum space.

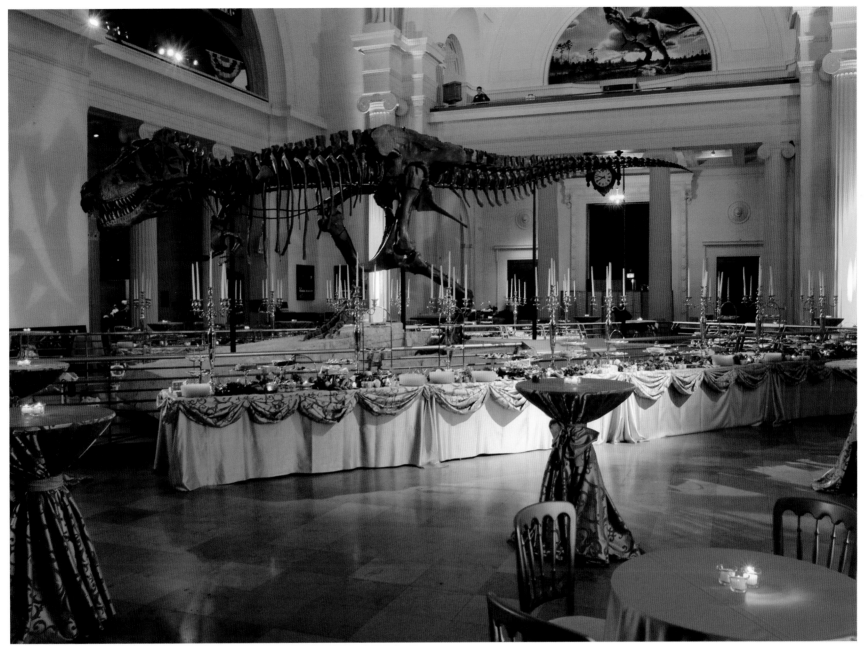

"When you host an event in a world-class venue, guests will remember the experience forever."

—Megan Williams Beckert

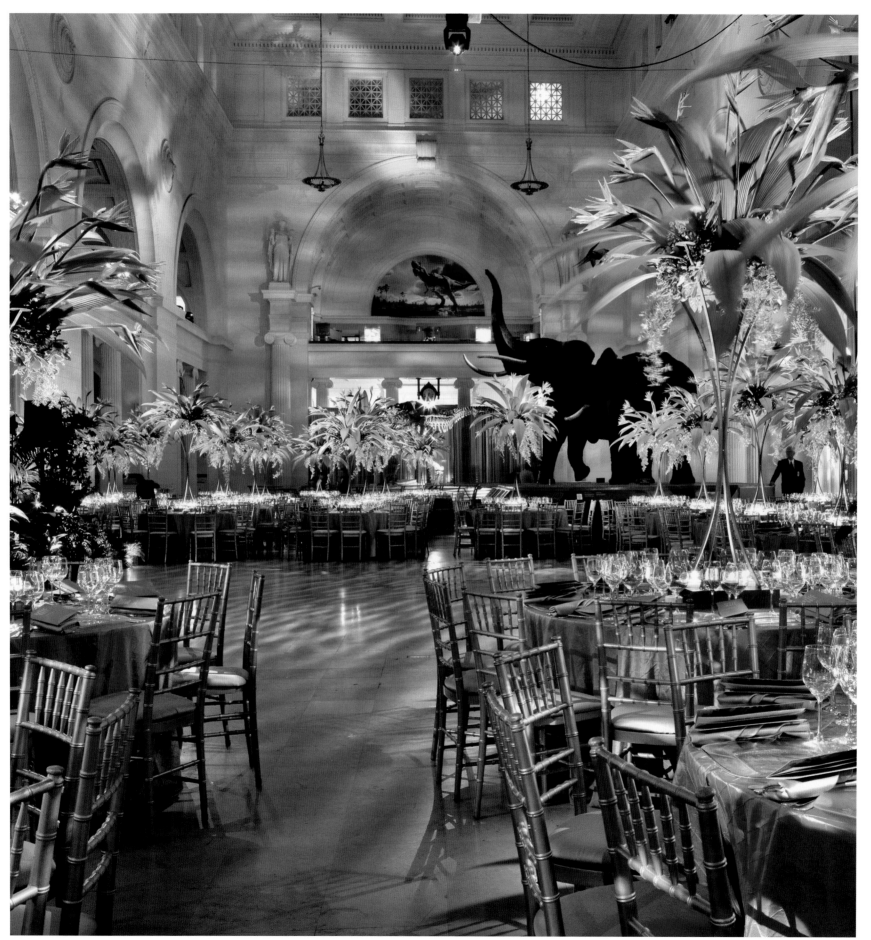

"Permanent museum exhibits often inspire the best party themes."

—Ellyn Nugent

Top right: For a holiday affair, we warmed up the space with golden light and luxurious striped linens, avoiding typical red and green color schemes. The formal seated dinner served 500 guests. Tall grass centerpieces adorned each table, while standard museum décor of classic holiday wreaths and icicle lights gave a hint of seasonal flair.

Bottom right: A large-scale corporate gala utilized Stanley Field Hall with balcony to accommodate more than 1,300 guests. Our events team set up a buffet reception flanked by dramatic uplit décor, further illuminated by vivid pink and orange washes from the dance floor up to the archways.

Facing page: Inspired by the special exhibition "Water," the design team transformed Stanley Field Hall into a rainforest-blue lagoon dinner party through projections and washes of light designed by Frost; the room's blue hues are accented by lush green foliage and birds of paradise florals. Blue Plate provided catering.

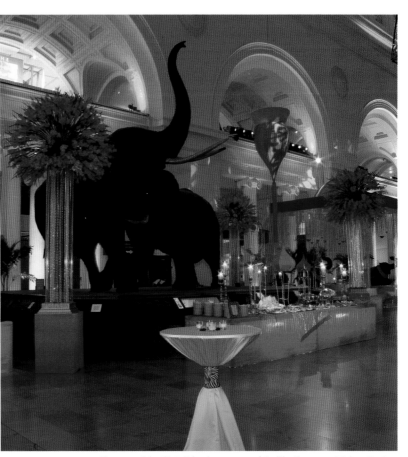

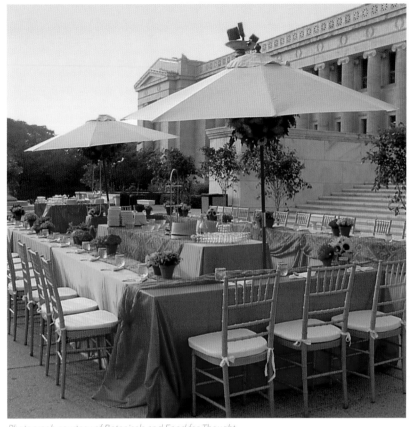

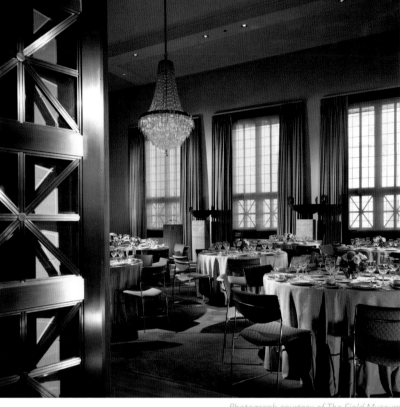

"As event specialists we don't live in the world of 'good enough.' Every party must be executed flawlessly."

—Megan Williams Beckert

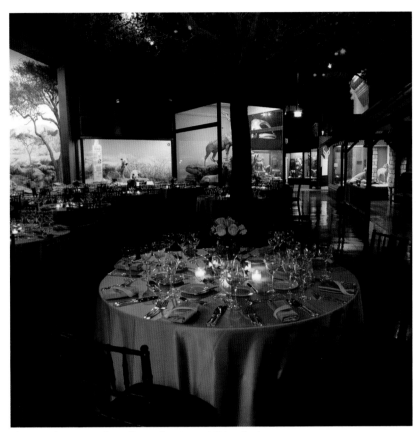

Photograph courtesy of Levy Events Catering and Kehoe Designs

Photograph courtesy of Jewell Events Catering

Above left: Rice Hall features Serengeti murals and wildlife displays, the permanent exhibit that inspired a corporate event for 150. We transformed the gallery into a seated dining experience. The event relied on exhibition lighting and we added twinkling lights on the central tree to create a nightfall ambience with the legendary Lions of Tsavo prowling nearby. Subtle earth-toned table linens and vibrant décor complete the mysterious look.

Above right: Opened in 2005, the versatile East Atrium and Pavilion is a long, gallery-style space with a glass atrium ceiling to allow for natural light. Permanent silk-screen murals and specialty uplighting create a clean, contemporary backdrop for parties up to 300. Our handsome marble coat check area can also double as a cocktail bar.

Facing page left: Celebrating summer, a corporate marketing breakfast was held on the Northeast Terrace for a sunny morning meeting catered by Food for Thought. Showcasing Chicago's amazing skyline and Lake Michigan, our terraces afford world-class views. Brilliant table centerpieces were created by Botanicals.

Facing page right: Dedicated to the generous donors of our museum, The Founders Room is our most intimate and historic event space. An exquisite crystal chandelier sheds light on seated dinners for up to 80 people, with decorative fireplace, full kitchen, coat check, and private restrooms. Many VIP receptions are hosted here to honor celebrities and dignitaries.

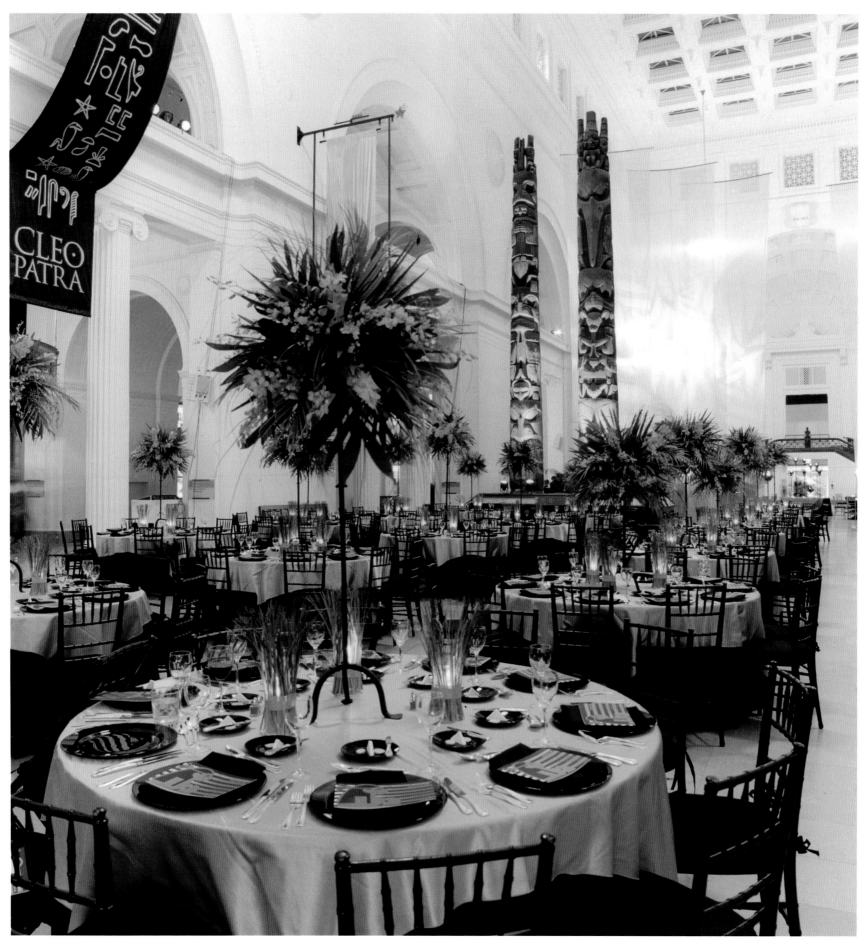

Photograph courtesy of Botanicals

"Be proactive, think ahead, and plan carefully, then let the event unfold like a blossoming flower."

—Megan Williams Beckert

Right: We served pre-dinner cocktails on the Northeast Terrace, and as wedding guests entered Stanley Field Hall, dramatic velvet theater curtains parted to reveal the elegant reception. Romantic opportunities abound: You can propose to your significant other by presenting the engagement ring in our Grainger Hall of Gems displayed with personalized placard, or feature a private showing of your love story in the Ernst & Young Theater.

Facing page: The opulent black-tie event was inspired by our "Cleopatra" exhibition of priceless ancient artwork. Hosted in Stanley Field Hall, the seated dinner boasted a golden, khaki, and black color palette to reflect the exhibit theme. Event designers integrated sustainable décor elements to complement the regal presentation. The Field Museum strives to be as environmentally friendly as possible.

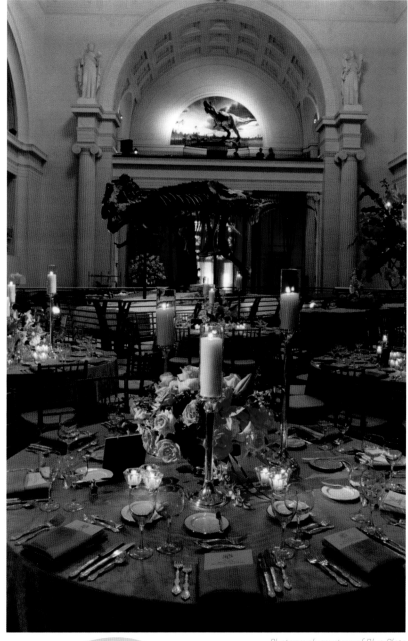

Photograph courtesy of Blue Plate

views

Decide on what you want to accomplish, and then choose the right venue partner. For example, if you need guests to focus on a silent auction, rope off permanent exhibits to encourage the fundraising aspect. Remember that every detail must be well planned. Most museum spaces require visitors to do a lot of walking, so be sure your venue is accessible to accommodate every guest.

MILLENNIUM PARK

CITY OF CHICAGO
CHICAGO, ILLINOIS

Since opening in 2004, Millennium Park has been the perfect setting for free concerts, tours, and open rehearsals, along with hundreds of exclusive private events. The result of a partnership between the City of Chicago and the philanthropic community, this 24.5-acre park features the work of world-renowned architects, artists, and designers. Located in the heart of downtown Chicago, it features the Frank Gehry-designed Jay Pritzker Pavilion; the interactive Crown Fountain by Jaume Plensa; the contemporary Lurie Garden designed by the team of Gustafson Guthrie Nichol, Piet Oudolf, and Robert Israel; and the monumental sculpture by Anish Kapoor, *Cloud Gate*.

This world-class collection of architecture, landscape design, and art provides a backdrop for more than 500 free cultural programs each year including concerts, exhibitions, tours, and family activities. It is also a partygoer's paradise and an event planner's dream. An event in Millennium Park is unforgettable, whether a lavishly tented celebration near *Cloud Gate* on the Chase Promenade or a black-tie ball overlooking the Great Lawn and the city skyline. Private social events, corporate gatherings, gala fundraisers, graduation ceremonies, and celebrations range from intimate dinner parties for 40 invitees to park-wide events accommodating thousands of guests.

The Jay Pritzker Pavilion's temperature-controlled environment allows for customized private events to be enjoyed year-round.

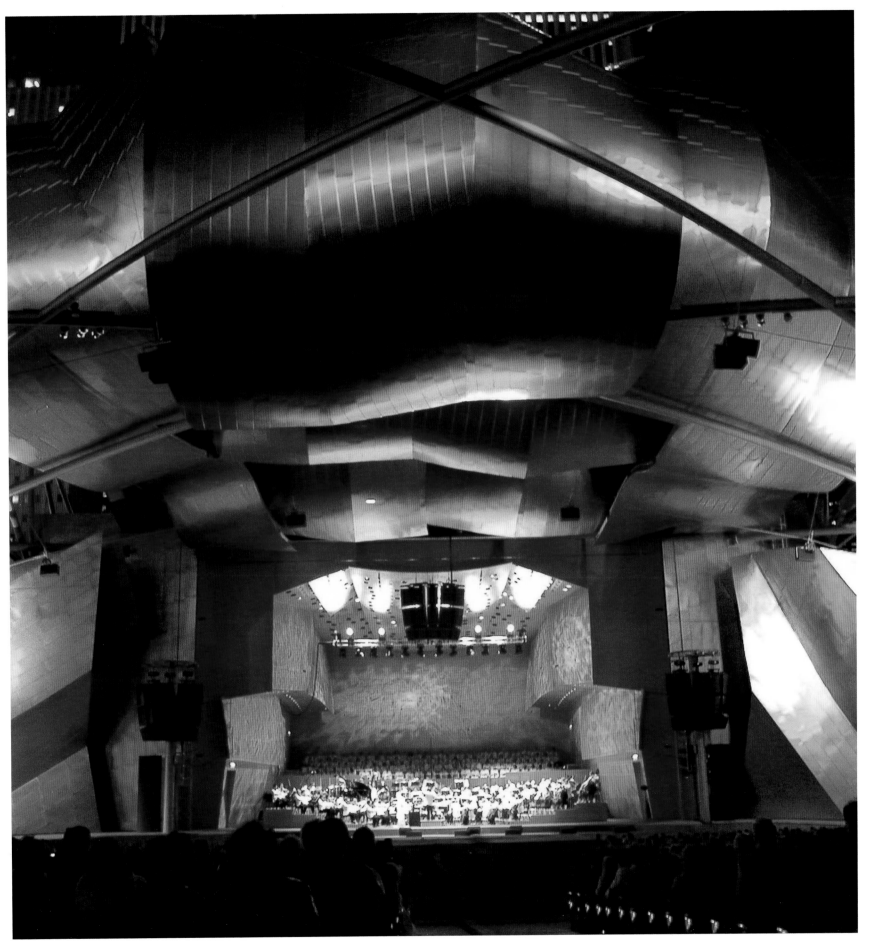

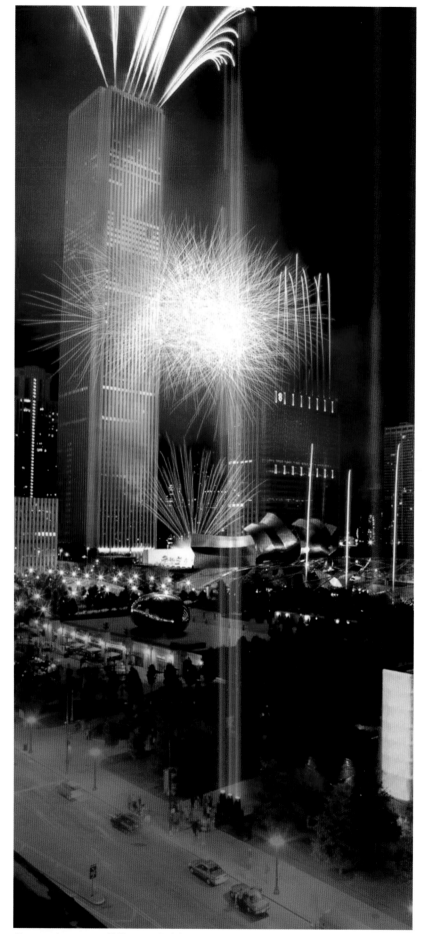

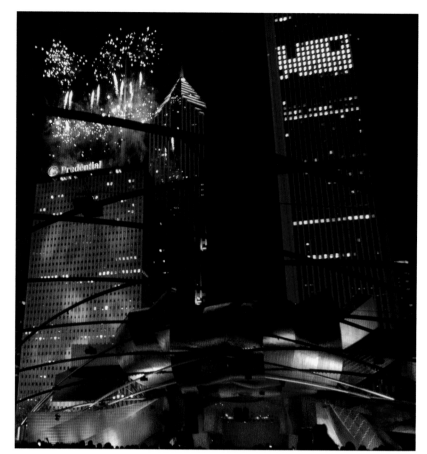

"A memorable venue has the power to reflect your identity, where you came from, and where you want to go in the future."

—David Ortega

Photograph courtesy of Millennium Park, Inc.

Above: A clear-span tent on the Chase Promenade was the perfect setting for a seated dinner extravaganza. The event designer punctuated the space with live trees and trellised ivy arrangements to bring the outdoors in. Antique gold Chiavari chairs and well-dressed tables create sophisticated elegance under the stars.

Facing page: Nothing can come close to hosting a spectacular dinner for hundreds in view of *Cloud Gate* with dazzling fireworks amid high-rise buildings; the feeling is awesome and photo opportunities are unmatched.

Photograph by Rick Aguilar Studios

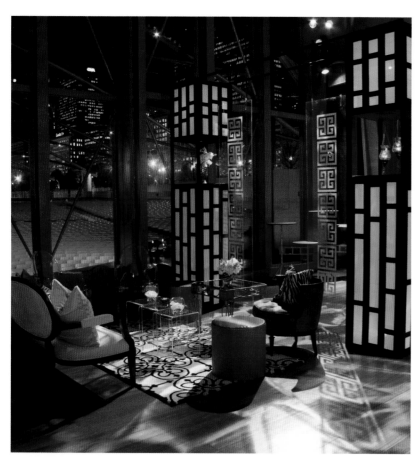

Photograph by Rick Aguilar Studios

Photograph by Rick Aguilar Studios

"Millennium Park is one of the most innovative urban parks in the world. Well-designed events are even more spectacular because of the venue's larger-than-life sensory experience."

—David Ortega

Right: The Jay Pritzker Pavilion stage and choral room is easily transformed into an exclusive cocktail reception space and can be configured to suit a dinner party for anywhere from 40 to 200 seated guests. The illuminated glass doors create an intimate event experience with an open view of Millennium Park's Great Lawn and the Chicago skyline.

Facing page: Vibrant lighting effects add passionate drama to the contemporary Jay Pritzker Pavilion stage. This VIP nightclub atmosphere was created featuring chic conversational seating and walk-up bars for serving catered hors d'oeuvres and drinks, accented by customized décor. Sheer fabric draperies define the red carpet walkway leading to lounge areas past golden sculptures. The architectural glass wall affords thrilling cityscape views while people sip champagne and mingle.

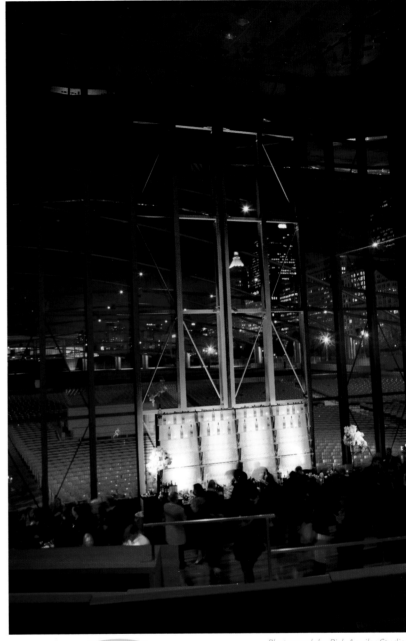

Photograph by Rick Aguilar Studios

views

When choosing an urban setting for your party, reserve city spaces months in advance to work around already scheduled public events. Be sure that the venue offers site coordinators and production personnel to make large-scale events run smoothly. Hire recommended caterers who are familiar with the venue and are able to prepare exceptional cuisine off-site. The right venue sets the tone, so be sure to find one that makes an impact and will wow your guests.

CAENEN CASTLE BY CHEF RENÉE KELLY

RENÉE KELLY
SHAWNEE, KANSAS

How many chefs purchase and begin renovating a historic castle at the age of 23? Renée Kelly is a pioneer in her field who is taking the Kansas City event venue and catering industries by storm. She combines fresh, local ingredients with a picturesque, unique castle location for an eye-opening venture that marries food with fortress.

A trained chef, for six years Renée had been musing over a dream of opening not a restaurant but an exclusive catering service in an architecturally significant private event space, though she had yet to find the perfect location. Slated to begin work in Arizona imminently, Renée happened to hear from a family friend about a 1907-built stone house known as Caenen Castle—and it was for sale. Upon walking four feet inside the front door, she knew immediately and instinctively that this was it. Eight months of demolition and renovation later, a deliberately small, intimate venue—the maximum occupancy is 120—emerged. Since its opening in 2004, Caenen Castle has held true to its historical standards while offering modern conveniences and timeless beauty.

Renée believes that the banquet cooking she practices—in keeping with the medieval-like setting—should involve basic, simple cuisine. Accordingly, the four rotating seasonal menus are kept intentionally minimal, ready to be embellished or trimmed upon request. Of course, Renée relishes custom-made menus, and considers that the culinary industry's form of artwork. She credits her inspiration to locally and seasonally available fare, magazines, travel, and her fellow chefs—and often attempts to bring the pieces of an experience home. Similarly, visiting the castle is an experience itself. Guests have free reign of the building, able to explore the main hall, wine cellar, manicured grounds, gated patio, and more. To come together and share a meal is a simple, often overlooked act greatly facilitated in this intimate space, and nothing makes Renée happier than to observe the culinary renaissance that takes place regularly in her castle.

A gorgeous tailor-made wrought-iron door welcomes guests to the outdoor patio, where overflow often spills out or cocktail hours happen.

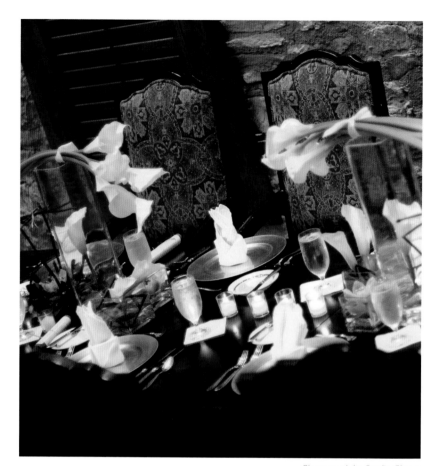

"Seeing the colors and breathing in the aromas of fresh ingredients are all the inspiration I need."

—Renée Kelly

There has not been one major event in my life that has not revolved around the dinner table—a lot of great things happen around food. I want to bring the focus back to the hearth and home, and I think of the castle as an extension of my home. I love to walk out into the dining area and see everyone full of joy, chatting and happy. Sometimes guests even get so excited they come back into the kitchen to tell us how pleased they are, and I love those moments. We place extra-special emphasis on the quality of our food—free-range food from local farmers, the majority of it organic—to ensure that these meals will facilitate that fundamental gathering around food. Whether a glass of wine to pair perfectly with the food, an artfully arranged table to complement the dishes, a fresh course like pan-seared sea scallops, or the flowers a June wedding brings to the premises, every component is vital to the experience.

Photograph by Studio Chyree

views

Frequent communication with our hosts is essential. Potential hosts are welcome to attend a tasting, visit the castle, and come for Thursday happy hour and Sunday brunch to get a feel for the castle when it's occupied and taste other food items as a virtual pre-event. In the days leading up to the event, we meet with the hosts to troubleshoot and run through our overviews, checklists, and schedules to tie up all the loose ends.

Chicago History Museum

BARBARA SISKA
CHICAGO, ILLINOIS

The colorful history of Chicago overflows with music, politicians, skyscrapers, civic leaders, innovation, gangsters, sports and, of course, two notable World's Fairs. It's no surprise, then, that the Chicago History Museum is the quintessential place to appreciate the Windy City's storied past while celebrating its vibrant present. Besides being the city's oldest cultural institution, the museum houses more than 22 million artifacts and documents relating to Chicago and U.S. history. In the "Crossroads of America" exhibition resides the first 'L' car that took guests to the 1893 World's Columbian Exposition, the Pioneer Locomotive, and a variety of artifacts from the Great Chicago Fire.

After a 30-million-dollar renovation in 2006, the current facility now features multiple event spaces that combine historic presence with modern conveniences. Entering through the stately Sanger P. Robinson Gallery, the versatile 4,850-square-foot Chicago Room lends its Georgian-style architecture and stained glass displays designed by Louis Comfort Tiffany to receptions and meetings of all types. Breathtaking views of Lincoln Park's gardens and the Gold Coast neighborhood reside outside of the Chicago Room, as does Uihlein Plaza, a 15,000-square-foot open-air court.

The event staff at the Chicago History Museum provides total event coordination. Just as Chicago was built, and rebuilt, from the hard work and ideas of its residents, the museum relies on each of its dedicated employees—from special events to security to building maintenance—to make each occasion a truly historic affair.

The Chicago History Museum provides some of the most versatile event spaces in the city, with both beautifully appointed indoor and outdoor spaces. We can also host daytime events, as the Chicago Room can be reserved during the day—something that most museums cannot accommodate.

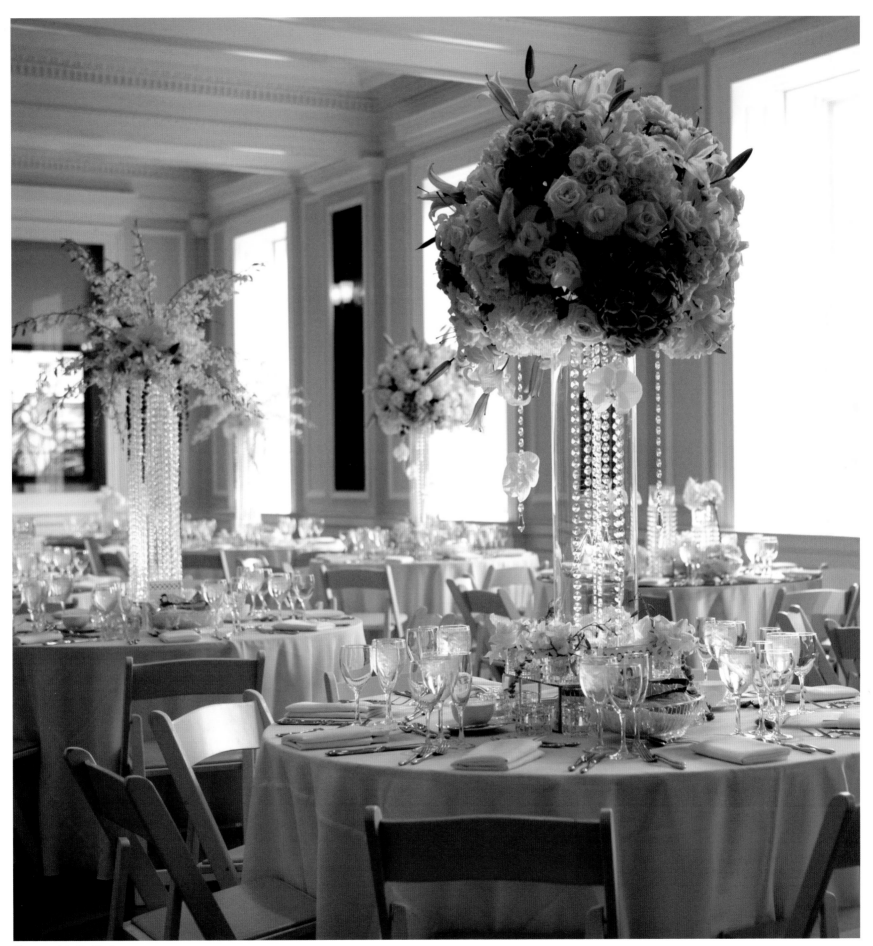

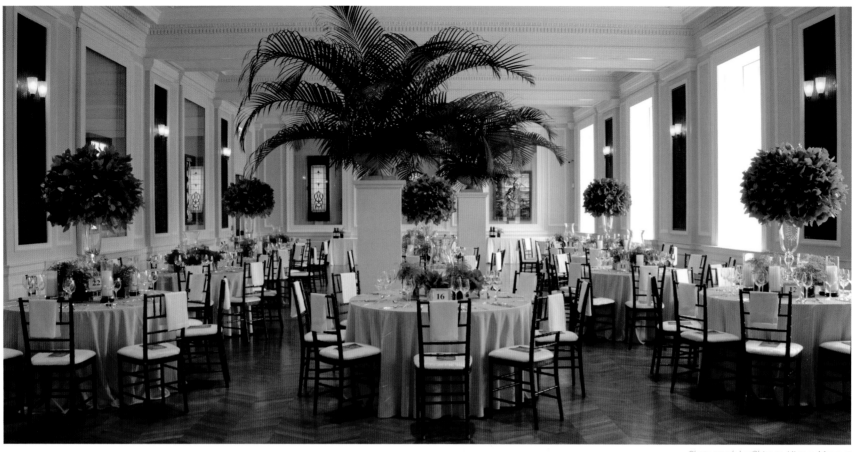

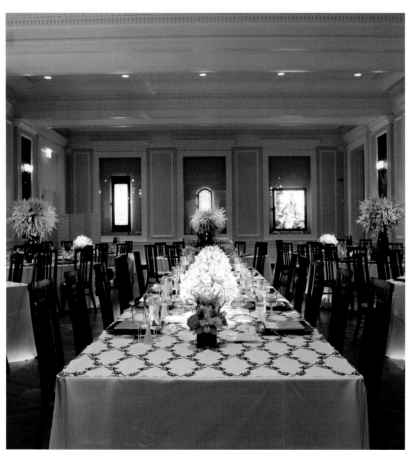

"This is truly the Chicago experience.
We *are* Chicago."

—Barbara Siska

Right: A sweetly ruffled wedding cake projects an aura of sophistication, elegance, and charm in the Chicago Room.

Facing page top: We hosted a fundraiser for the Bertha Honoré Palmer exhibition. Palmer was the queen of Chicago society and one of the most significant figures in America at the turn of the century. Serving as an ambassador for the 1893 World's Columbian Exposition throughout Europe, she was a force in her own right and a champion for women's rights.

Facing page bottom: The Chicago Room and the Robinson Gallery both project a regal atmosphere. The gallery was designed to resemble the interior of Independence Hall in Philadelphia, where the U.S. Constitution was drafted and the American flag designed.

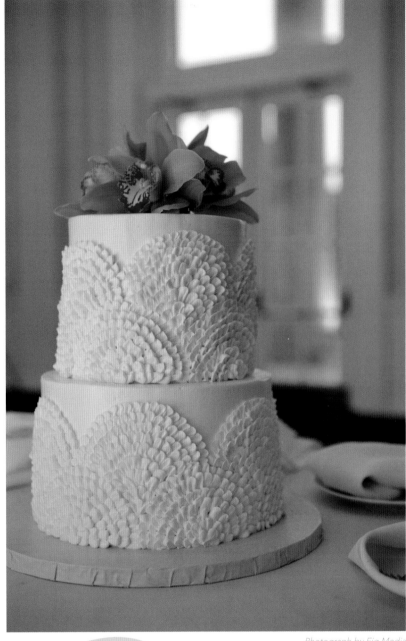

Photograph by Fig Media

views

First and foremost, we are a museum. When guests realize the magnitude of all that is included with their event—education, culture, an overwhelming sense of history—they agree that it makes the occasion even more memorable.

CORONADO BALLROOM
BY STEVEN BECKER FINE DINING

STEVEN BECKER
ST. LOUIS, MISSOURI

Sometimes the right look for your event is nothing less than the quintessential Cinderella ballroom. In those cases, there's the Coronado Ballroom, a venue that plays a much-needed role in St. Louis. Steven Becker Fine Dining exclusively manages the ballroom's mouthwatering fare, while remaining a preferred caterer at many of the city's finest establishments.

The Coronado building has a long and storied history, beginning life in 1926 as an elegant hotel frequented by local luminaries, with a ballroom added in 1933, then a university dorm patronized by law students. Finally, after lying dormant for many years, it reopened in 2003 with a lavish renovation as the Coronado Ballroom. The venue now features a grand ballroom, an Art Deco terrazzo dance floor with illuminated floor tiles, state-of-the-art kitchen facilities—including the oldest kosher kitchen in the city—a meeting room, and a grand lobby. The historic landmark is often a source of nostalgia for brides' grandmothers, who can remember staying at the former grand hotel.

The culinary experience is just as exquisite as the fairytale setting—and has just as much tradition. Second-generation restaurateur and caterer Steven Becker has taken his entrepreneurial roots to the next level with Steven Becker Fine Dining, which focuses on banquet and fine dining. Among his capable team is vice president Rob Schaefer, who has been planning weddings for 25 years and is the inaugural St. Louis Wedding Professional Hall of Fame inductee. Menus are a collaborative effort, changed every six months to offer twists on core items. Ideas come from travel to magazines, and much is customized according to what hosts need emphasized—a barbecue hors d'oeuvre station for a groom from the South, or a Yiddish dessert table for a Jewish host.

A December wedding in our grand ballroom aimed for a timeless holiday theme. While the Christmas greenery and white lights were retained, cream and gold hues, and Versailles chairs brought out the luxurious winter feel. Fur, evergreens, and all-white flowers—lilies, hydrangeas, and roses—completed the effect.

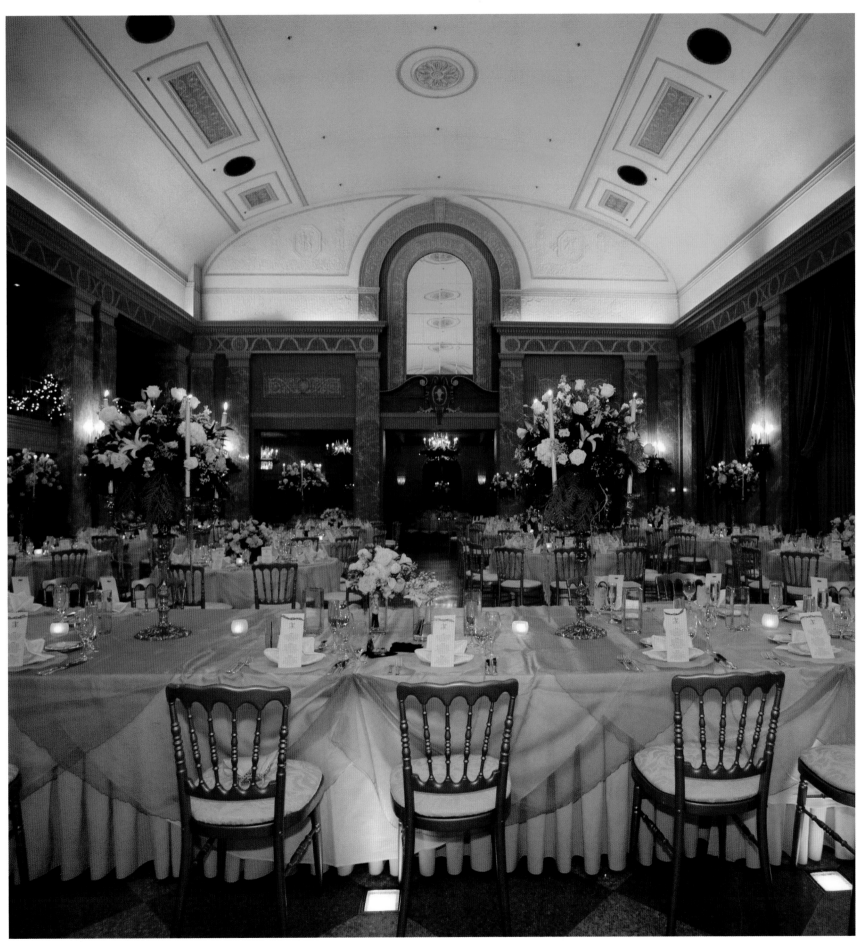

Photograph by Alise O'Brien Photography

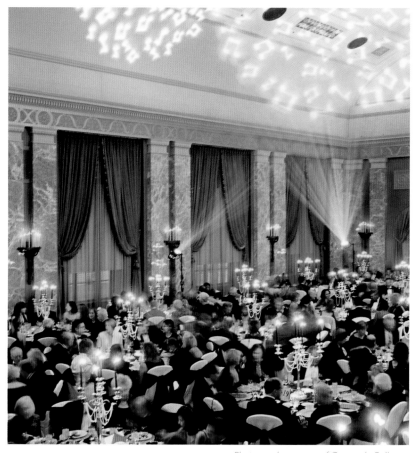

Photograph courtesy of Coronado Ballroom

Photograph courtesy of Coronado Ballroom

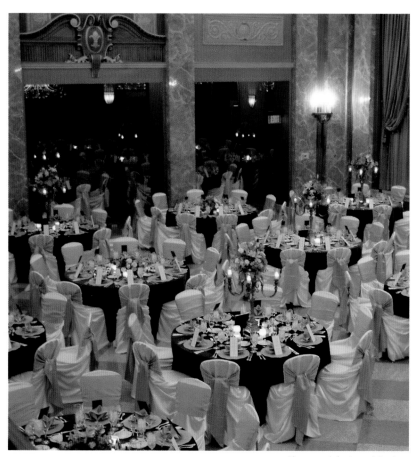

Photograph by Laurel Cochran

"The magic happens naturally when you fully embrace the life-changing element of the event you're celebrating."

—Steven Becker

Right: Bridal couples love to pose by our entrance, which features a sign lit up at night and a circle driveway to whisk guests to and from the soirée.

Facing page: From the grand lobby to the Art Deco ballroom, from black-and-white symphony galas to chocolate brown and champagne gold fall weddings, from cocktails to risotto trays, the Coronado can be dressed up any number of ways.

Photograph courtesy of Coronado Ballroom

views

By the time our hosts come to a tasting, we've prepared culinary, bar, and event timelines. Everything is detailed and locked down— there are no surprises. The night of, we're there the entire time to keep everyone focused and on-track. Our venue is the most heavily staffed facility in the city with the most extensive culinary offerings, and planning at all stages of the process ensures no sudden snafus and a flawless event.

THE GOLDEN TRIANGLE

DOUGLAS VAN TRESS | CHAUWARIN TUNTISAK
CHICAGO, ILLINOIS

Soon after opening in 1989, The Golden Triangle quickly became one of the largest stores in the country devoted to art, antiques, and home furnishings hand-picked from China, Southeast Asia, and Europe. Partners Douglas Van Tress and Chauwarin Tuntisak have a passion for authentic antiques creatively mixed with contemporary furnishings. Each item in the store exudes a comfortable luxury that, when merged with a unique ambience, creates a one-of-a-kind event location.

Built as a theater set of sorts to appropriately showcase the authentic treasures from other cultures, the store's central indoor courtyard with its 200-year-old terracotta floor is bounded on two sides by zones modeled after houses. The first zone steps onto a raised teak wood deck that leads into a British Colonial-style room. The second zone features an Asian influence with a grand soaring gate that welcomes guests into an elegant, more formal gallery. Each room offers a private entrance from the street, while a kitchen, serving area, and catering prep area are just steps beyond the gallery space.

The building itself is only the beginning of the unique atmosphere at The Golden Triangle. With artifacts such as ancient pottery that dates back 4,000 years, hosts have the ability to rearrange and create the perfect layout. And staff members can either be flies on the wall during the event or they can become an active part through roles such as costumed greeters or friendly docents to assist guests in discovering the authenticity and story behind the gallery pieces.

The central room, known as the courtyard, offers a warm, versatile area that can accommodate approximately 100 people for cocktails or 50 for dinner. The seamless mingling of the gallery and the event space gives guests continuous entertainment throughout the evening as they browse through the artifacts.

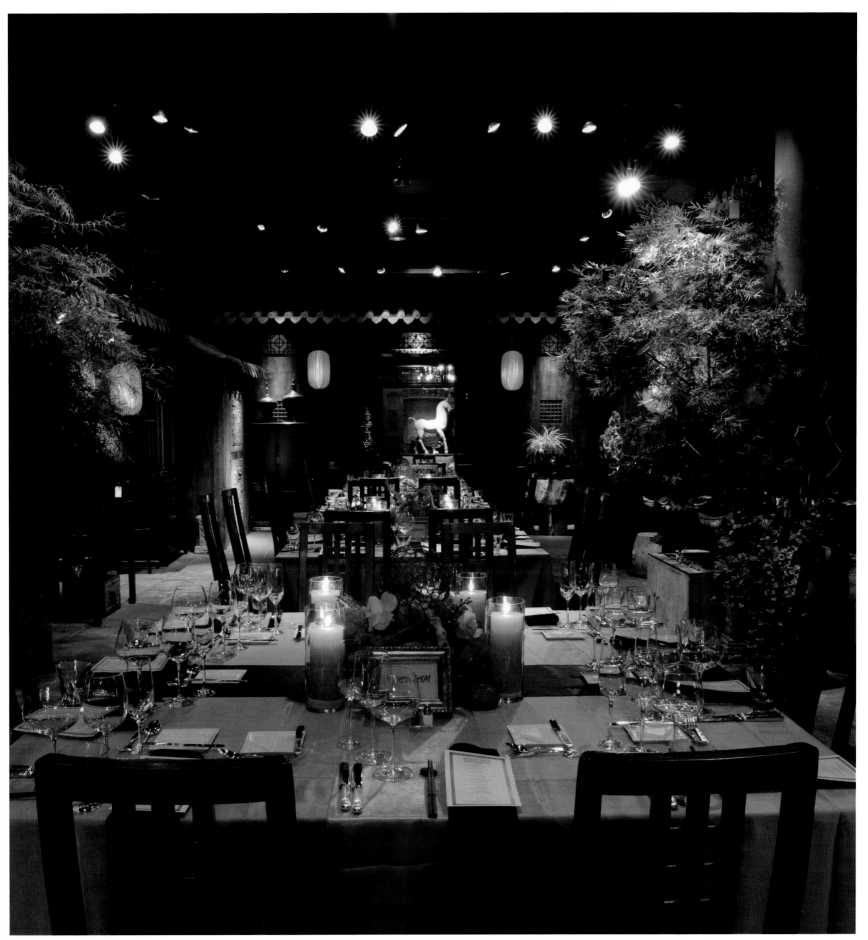

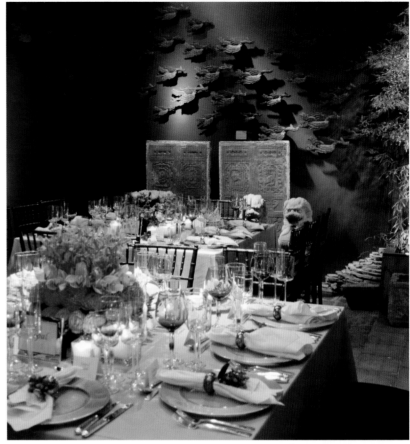

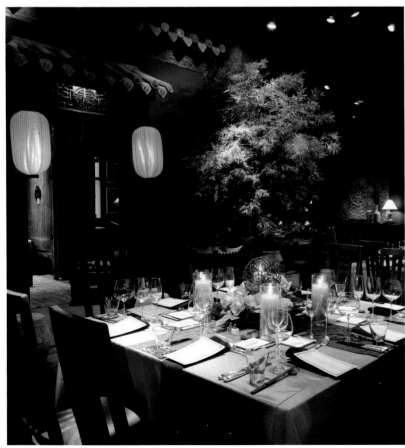

"There is nothing more soothing yet intriguing than being surrounded by authentic art and home furnishings and knowing a deep history lies behind them."

—Douglas Van Tress

Right: From the courtyard, guests can wander into the Chinese house through the gate with its weathered columns. A second entrance into the space from the street features a majestic architectural façade with bright blue doors.

Facing page: The versatility in space within the galleries offers unbounded opportunity to adjust for certain styles and goals. The exotic nature, which has become more appreciated in recent years as people travel now more than in years past, can be accentuated or toned down based on the chosen décor. Guests can even use the existing furniture in the galleries during the event to suit their needs.

Photograph courtesy of The Golden Triangle

views

Look for a venue with a good flow to the space. Separate areas for the guests to move through as the event progresses can be a great way to keep things interesting. To encourage conversation, provide little nooks and crannies in which guests can mingle away from the crowd and noise.

Le Méridien Chambers Minneapolis

RICHARD D'AMICO
MINNEAPOLIS, MINNESOTA

Art museums and galleries are popular event spaces; they are, after all, already decorated. No wonder that a hotel combining well-appointed guest suites with beautiful works of art would be such a hit with the elite set. That's exactly what Le Méridien Chambers, a luxury boutique art hotel, brings to Minneapolis. Perfectly complementing great art is great food, both at in-house restaurant D'Amico Kitchen and in the hotel's private events spaces, provided by D'Amico Catering.

Opened in 2006 by prominent art collector Ralph Burnet, the art hotel and hot nightlife venue had been making waves in Minneapolis when Richard D'Amico of D'Amico & Partners stayed at his friend Ralph's hotel. Richard had long been fond of the concept of a joint restaurant and catering venue, and Chambers offered a ready-made location. It turned out to be a perfect match. Richard D'Amico designed the signature restaurant D'Amico Kitchen, a casual, contemporary space offering urban Italian fare. In addition, D'Amico is the exclusive caterer for events at the hotel and has developed and customized several new menus specifically for the venue. Popular Italian dishes from the restaurant merge with contemporary American and steakhouse offerings, and more—all types of cuisine are represented. While custom menus are *de rigueur*, the house menu is also one-of-a-kind.

Such delectable fare highlights the signature spaces within the hotel: the Burnet Gallery, Sid & Nancy's Rooftop Lounge, the three ART dividable rooms, the Boredroom boardroom, and an outdoor grotto-style courtyard, Eden, which also connects to the restaurant. Each space has its own perk to offer, from Burnet Gallery's constantly rotating art collection to the lounge's 360-degree skyline vista visible via floor-to-ceiling windows, Eden's pool table and fire pit, and the Boredroom's plasma screen television.

The hotel's 60 guest rooms compose two buildings joined by a glass walkway that is wonderfully illuminated at night. Large glass windows allow for spectacular skyline views.

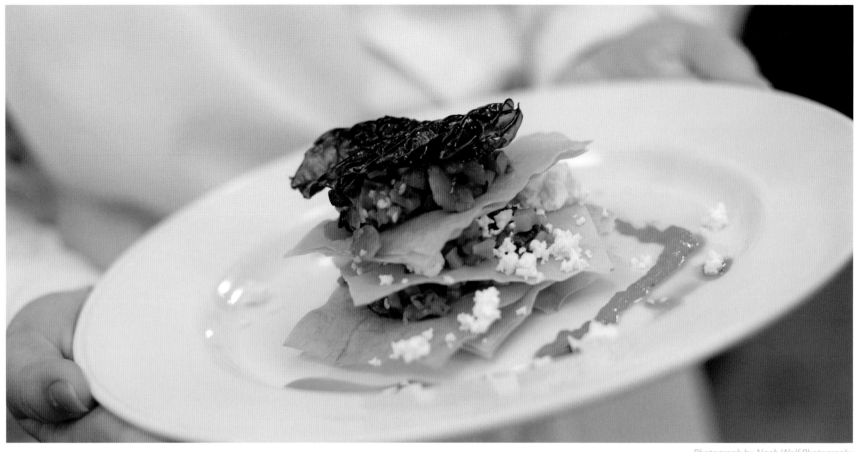

D'Amico at Chambers encompasses artistic grace from top to bottom—including rooftop lounge dinner settings, delectable dishes like Napoleon of Ratatouille, balcony areas mingling with gorgeous views, and an open-air, veritable grotto-style courtyard with private cabanas and lush greenery.

Photograph by Noah Wolf Photography

views

❖ Custom-created menus make every event truly distinctive.

❖ Adjoining rooms that can be divided or opened offer endless possibilities.

❖ Guests enjoy exploring fun, interesting spaces containing numerous things to do, see, and experience.

PALLADIUM SAINT LOUIS

ST. LOUIS, MISSOURI

Intriguing, fresh, yet timeless: Palladium Saint Louis is one of the city's most innovative and elegant spaces. An unusually accommodating venue—there's room for up to 700—located in the heart of downtown, Palladium offers modern amenities set against a historic backdrop.

Built in 1937 as the laundry facility for City Hospital, the 6,500-square-foot site had been vacant since 1985. The beautiful architecture, impressive capacity, and prime location make it one of the most interesting spaces in downtown St. Louis. The name Palladium takes its cues from the many theaters of that name throughout the United States and Europe—after all, with the myriad theatrical lighting and presentation options, the location does indeed possess a dramatic flair. Palladium is also a metal similar to platinum—in fact, the venue's logo is inspired by the image of its chemical composition, and the sparkling metallic chairs and ceiling beams tie into that as well.

Palladium Saint Louis truly is a theater stage, a backdrop that allows hosts to set the scene for any of thousands of different possible looks. There are graceful fabric room dividers, dubbed "petals," that can be raised or lowered to divide or open the space as necessary. It's entirely feasible to have cocktail hour in one part of the room, then draw the petals apart to reveal a stunning array of dinner tables laid before your guests. The space can also project images or presentations, incorporate a color-changing LED lighting system, and engage state-of-the-art audio and visual capabilities. Gorgeous cityscape views and seamless catering options round out the services to make this glamorous locale the ideal place for distinctive weddings, social gatherings, corporate functions, and galas.

For the inaugural night of a nonprofit gala celebrating the revitalization of historic downtown buildings, Palladium Saint Louis—a historically renovated venue itself—was a perfect fit. Hanging from the ceiling are the venue's signature petals, custom-designed fabric screens that act as room dividers, projection screens, and lighting elements.

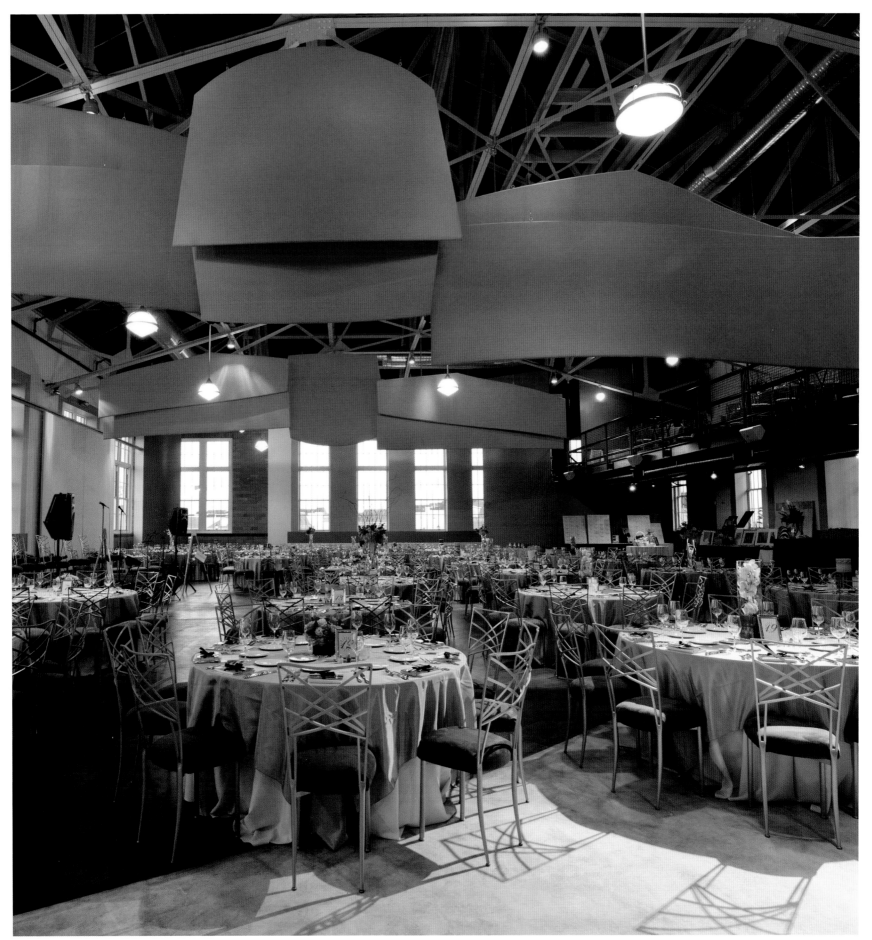

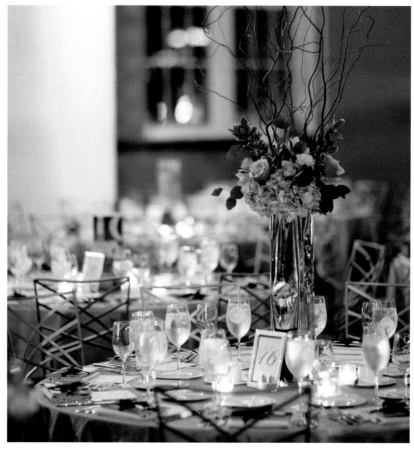

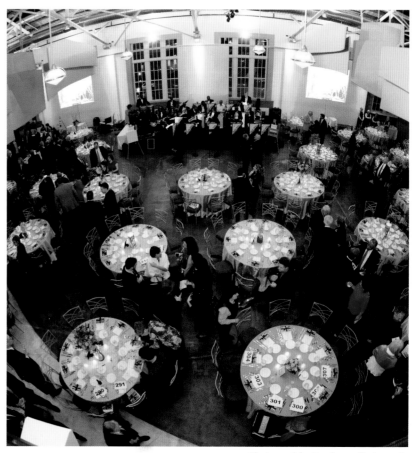

Right: While the interior has been brought into the new millennium, the classic façade remains true to its history. To celebrate the grand opening and gala event, an elaborate fireworks display erupted from the roof of the building.

Facing page: From our signature chocolate torte—featuring a white chocolate garnish stamped with our logo—to our specialty contemporary yet elegant place settings and metal chairs to dishes like crayfish and edamame salad amuse-bouche to the venue's ability to accommodate 350 seated dinner guests along with a 16-piece jazz band and 200 silent auction items, the possibilities are endless.

Photograph by Nordmann Photography

views

An excellent venue needs flawless service capabilities. Seek a place that has not only a full-service kitchen on property for your catering needs, but multiple preparation areas to ensure your food is presented perfectly in line with your theme. And make sure your venue, especially one downtown, possesses safe and easily accessible parking—secure, on-site, and valet are three good keywords.

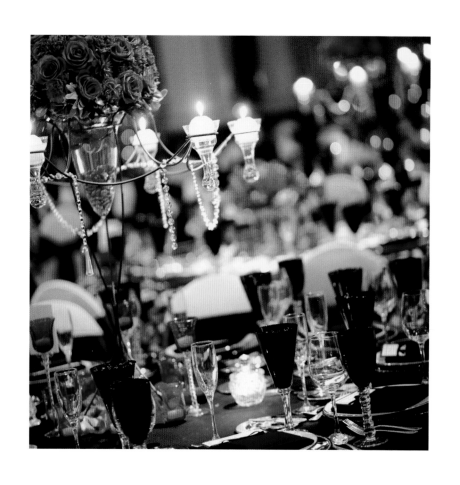

Creating an Amb

WISTERIA DESIGN STUDIO

RUSSELL J. TOSCANO
MINNEAPOLIS, MINNESOTA

Minneapolis-based floral design informed by New York City couture and experience—how many florists can claim that? Wisteria Design Studio certainly can, and its unique perspective has garnered acclaim and an excellent reputation. Today, still very much on the innovative cutting edge of the field, it stands as the exemplification of chic Midwest floral design.

Russell Toscano had spent years in New York in the drama and art fields before he decided to try his hand at flower arranging for a creative outlet—he'd loved flowers ever since he was a child. As he apprenticed under a series of mentors, he found that he was soaking up the tenets of floral design and style like a sponge and discovering a very real natural talent. Finding it hard to break into northeast markets, he was convinced to move his business to Minneapolis. Christening his company with the name of a favorite flower, Wisteria Design Studio was born in 1986.

Since arriving in Minneapolis, Russell has transformed the floral design scene by pushing for a wider variety of flower availability and offering dramatic, distinctive arrangements. He's an unwitting trendsetter—the types of arrangements Russell has always done are popular now, though they were unevenly received when he first started. And the Minneapolis flower market has almost quadrupled in size since his arrival, largely thanks to his demand for more unusual-looking blooms. Russell's bold signature look is now a regular fixture in floral design—proving that Wisteria has had a major impact on the Midwest.

At a cross-cultural Persian-American wedding, we placed the head table arrangement on Plexiglas boxes illuminated from below. The tallest, most dramatic arrangement in the room highlighted this table's importance—a large square in a sea of long rectangular tables. The reception flowers were all deep reds: roses, dahlias, and jamestory orchids, accented by green amaranthus. The cream and white blooms on the chair backs hail from the ceremony aisle décor.

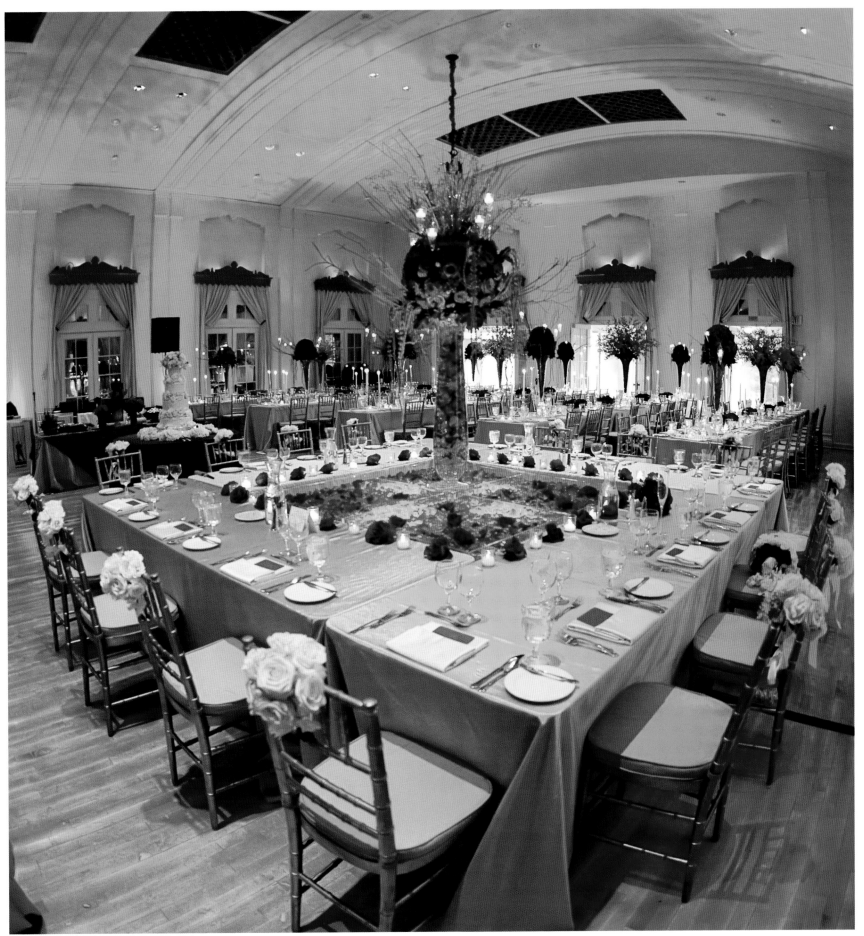

"An unusual bloom, a jewel, or a feather can take a bridal bouquet beyond classic romantic to something spectacular."

—Russell Toscano

Above: A fun, contemporary display set up outside a wedding reception ballroom entrance foreshadows the interior décor and sets the design tone. The series of flower balls echoes the bridesmaids' dress colors with a more dynamic palette.

Facing page: We love to come up with fresh and different table design looks at special events, especially when the theme is atypical, fun, and colorful—yet sophisticated. Sometimes we'll juxtapose a taller design on certain runs of tables with a look more balanced in height on others—the taller look employing narrow oncidium orchid vases alternated with low rectangular vases of cactus dahlias, and the balanced one featuring submerged orange mokara orchids for every papaya-toned miniature calla bunch. We'll carry the elements from the guest tables into accent areas too, such as a Plexiglas box cocktail table filled with floating cactus dahlias, or a square corner table using a tall cylinder as a pedestal for a flower ball.

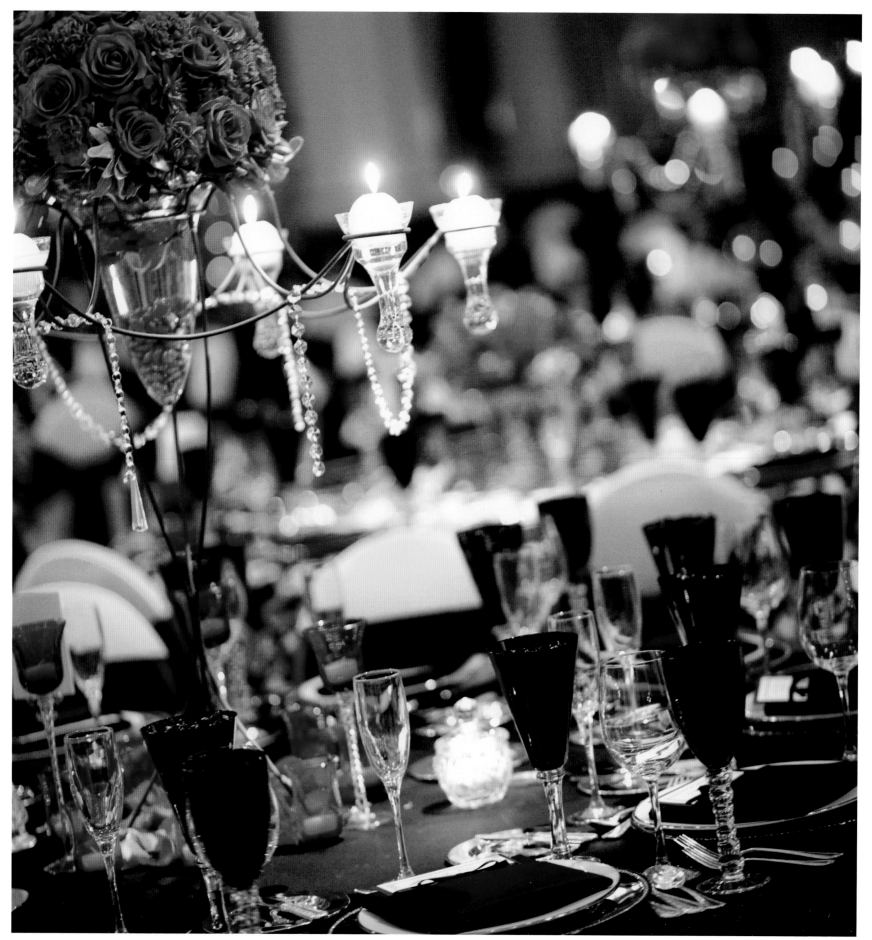

Photograph by Olive Juice Studios

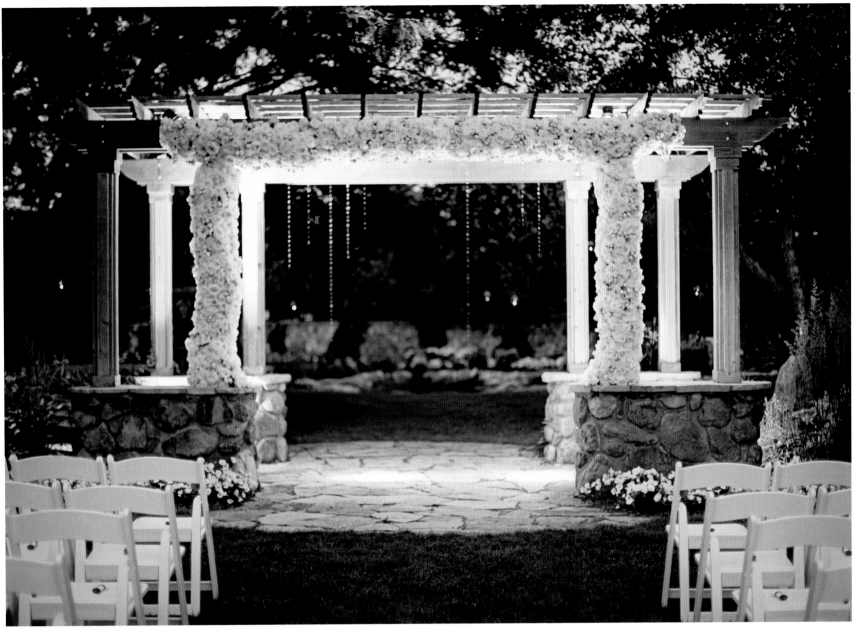

Photograph by Olive Juice Studios

Above: A pergola was dressed for a unique post-reception outdoor evening wedding ceremony in masses of polar star and cream majolica spray roses and faux hydrangeas. In order to accommodate the bride's desire for an evening wedding in July and the need to have the pergola decorated before the reception after hours of full afternoon sun, we brought in an unorthodox faux element—fortunately, it was completely imperceptible. We mounted a series of two-foot linear units of flowers to the pergola on-site to create a floral design that would be very present without the benefit of much overhead lighting.

Facing page: Baseball player Justin Morneau—one of Minneapolis' local celebrities—and his bride wished for a design in deep reds that would be arranged against black-and-white linens to forge a stunning yet not ostentatious effect.

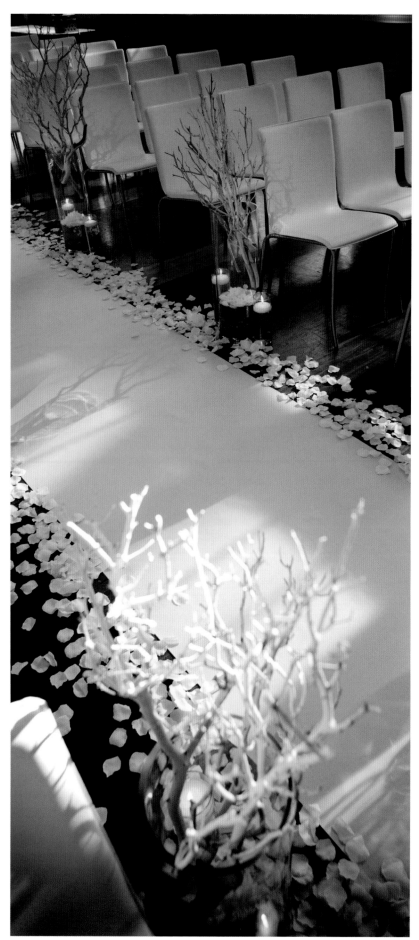

"Event floral design is theater, it's setting the stage—and that's my background so it comes naturally to me."

—Russell Toscano

Left: White rose petals and bleached manzanita branches in cylinders with floating candles set a Hollywood glamour tone with a contemporary twist, forging a clean-lined, understated bridal aisle.

Facing page: We choose colors and textures for the effect they will have against their surroundings—flowers for us are a cohesive part of the event, more than an accessory. Whether it's brown cymbidium bouquets to stand out against black bridesmaid dresses, a yellow mini cymbidium boutonniere with grasses for a natural air, green pomander balls of Kermit mums to fit with the simplicity of a romantic, rustic vibe, or a cocktail table arrangement full of varied textures and shapes, our flowers make a clear statement and suit the look of the design.

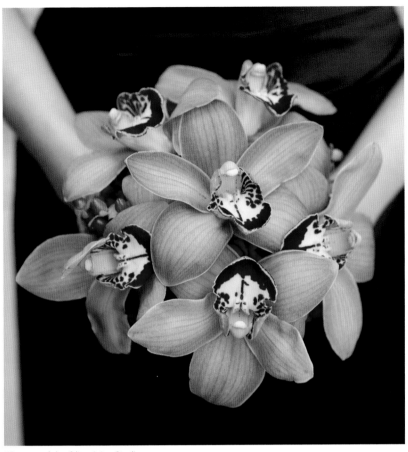

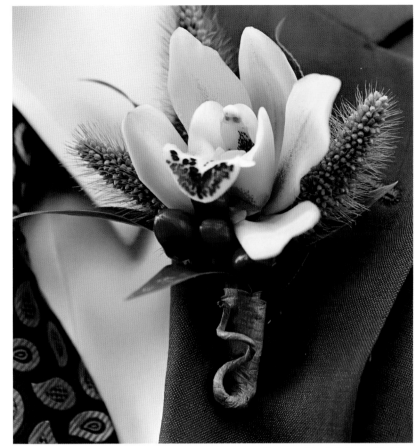

Photograph by Olive Juice Studios

Photograph by Kelly Brown Weddings

Photograph by Adrienne Page Photography

Photograph by Wendy Woods Photography

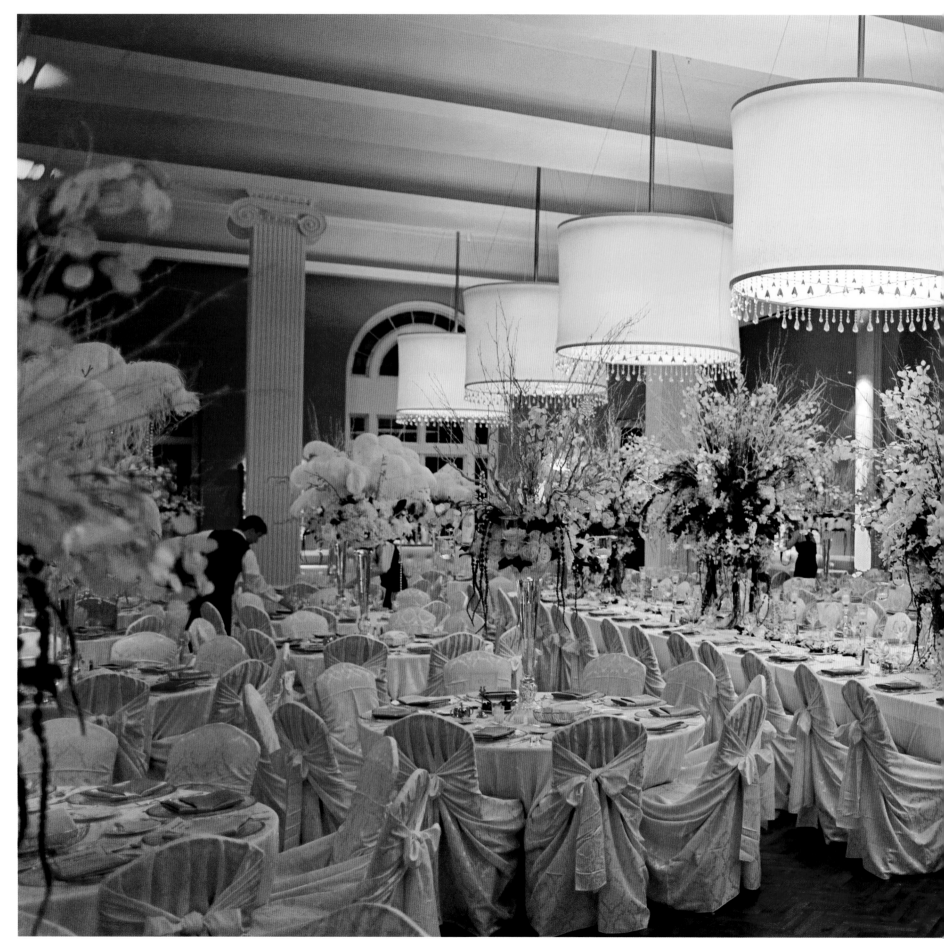

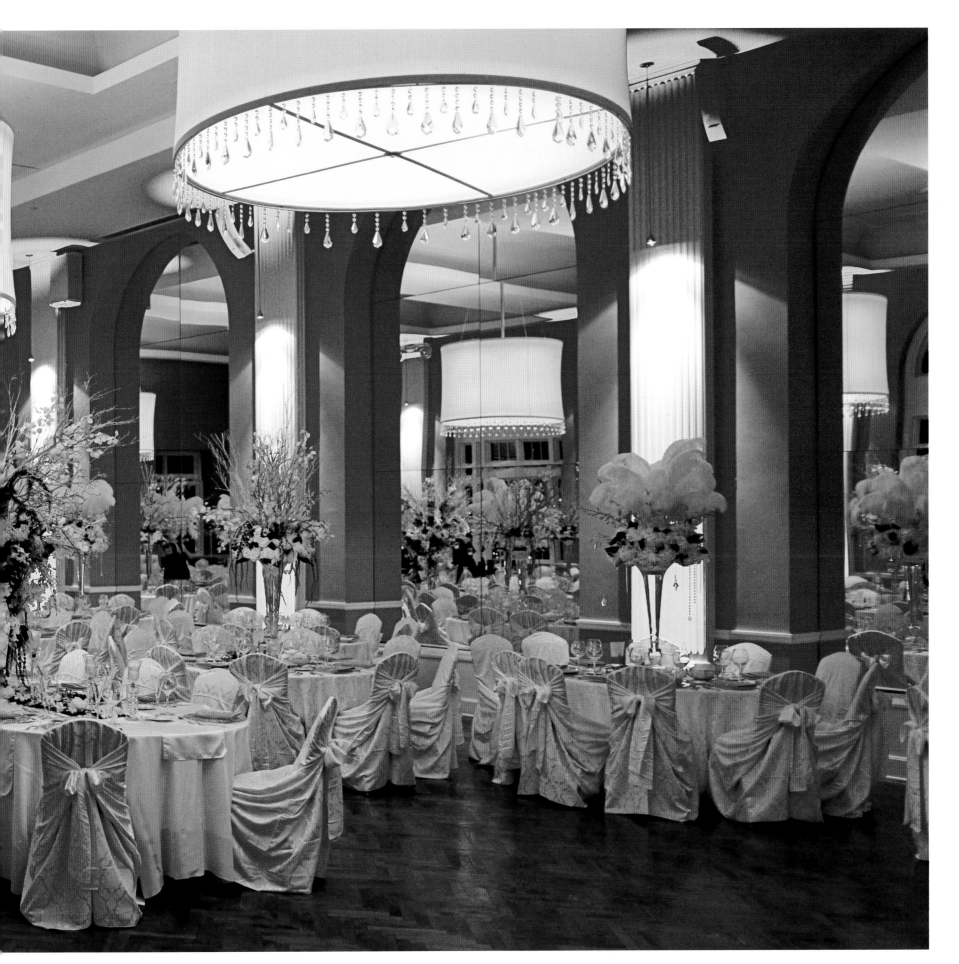

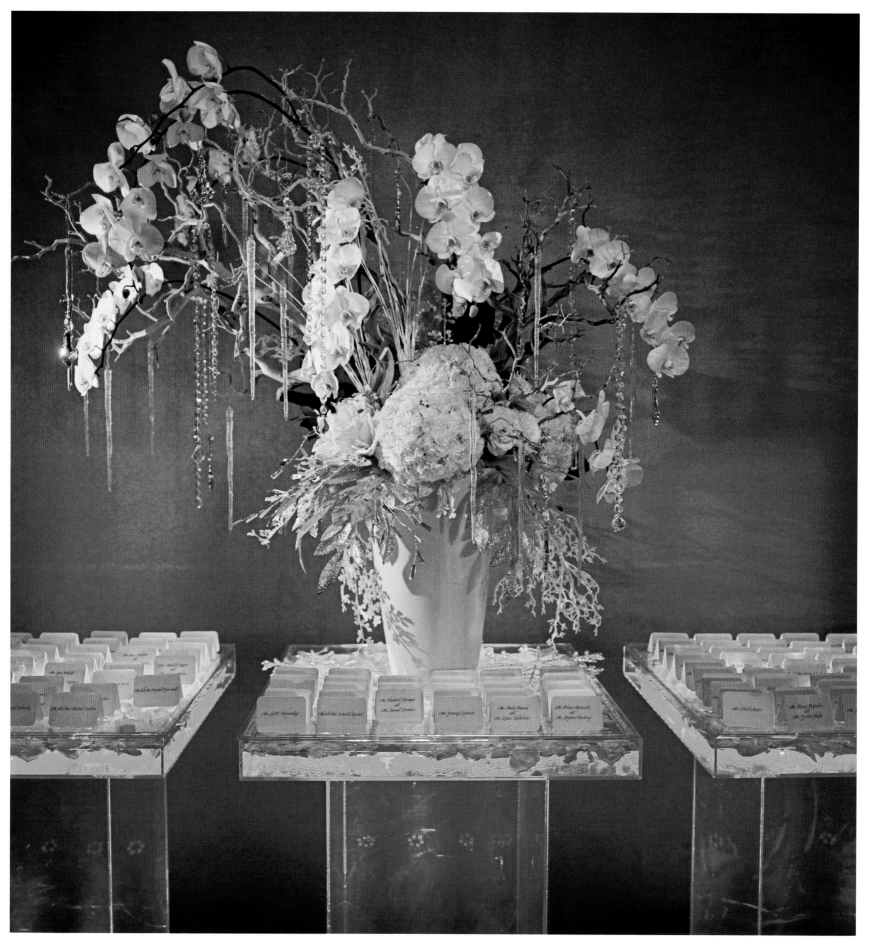

Photograph by Matt Blum

"Start with a great-quality product—it will inspire you and fire you up. Then come up with a dynamic design. The more challenging the project, the more psyched you'll be about it."

—Russell Toscano

Right, facing, and previous pages: A florist's dream come true—a bride who wanted a winter fantasy wedding, dramatic and over-the-top! To generate a feel of driving down a tree-lined street with freshly fallen snow, we coordinated the wedding aisle's "branched" arches with the lighting designer. As the wedding was mid-December, we also strove to keep the theme separate from Christmas holiday. Weeks of preparation and staging plans were required to execute the sophisticated, impressive look. The placecard table featured a dramatic floral centerpiece highlighted by hanging crystals and lighting. The head table and guest tables boasted lavish florals, crystals, branches, lunaria, feathers, and lighting. The head table arrangements, seven feet tall, required four people to lift them onto the table, plus extra bracing below to support the weight.

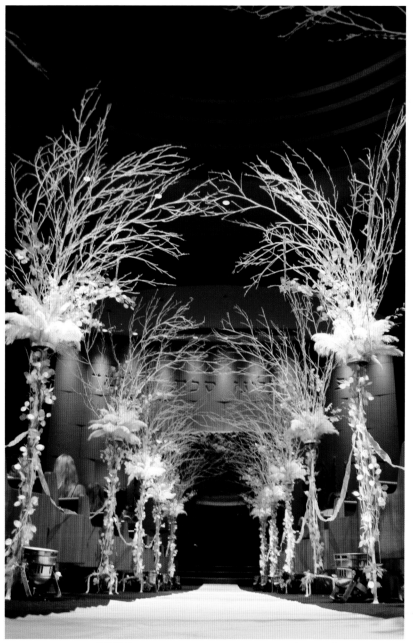

Photograph by David Hyman

views

Seek a florist whose sole goal is not just to satisfy but to completely wow you. The right team will keep in mind that they are creating something for you alone—and will blend their integrity, personal pride in their work, and desire to surprise you. Truly innovative arrangers take flowers people have seen before and combine them in a fresh way to create uncommon, original results.

Partytime Productions

JIM GALLAGHER | GEORGE TOMA
CHICAGO, ILLINOIS

A true rags to riches tale: Partytime Productions has evolved from a teenager's business run out of his parents' basement to one of the Midwest's premier tent installation specialists. Jim Gallagher, once a high-school boy setting up tents at graduations and barbecues, is now a seasoned professional sharing ownership of his full-fledged, 1985-established company with chief financial officer George Toma. Together they have transformed the Chicagoland and Midwest tent provider markets.

Jim and George credit their success to nothing less than sweat equity and hard work. Jim's tent installation business grew steadily as he moved first into his parents' garage and then—after they "kicked him out"—into a place down the road. He purchased more tents and equipment, hired additional workers, and soon realized that he was unwittingly tapping into a relatively un-mined piece of the market—high-quality, high-end tenting, and flooring installation. That advantage has allowed him to populate Partytime with seasoned event planners from the special events industry. Today the company freely collaborates with other local luxury vendors to create events flawless in execution of theme.

Partytime lives by the customer service philosophy "of course"—as in, "Of course we can do that. No problem." The team strives to accommodate any whim and tackle any challenge. In fact, you could say the business grew organically in accordance with demand, and can now bask in its status at the forefront of the industry.

We love getting the chance to show off everything we can do—not just tenting but flooring, lighting, and fabric design too. A tailor-made tent installation awaits a wedding party arriving by boat to a private residence. We constructed custom stairs to accommodate the dock party's entrance, and had to build the tent floor up to eight feet off the ground in some areas due to the slope of the yard.

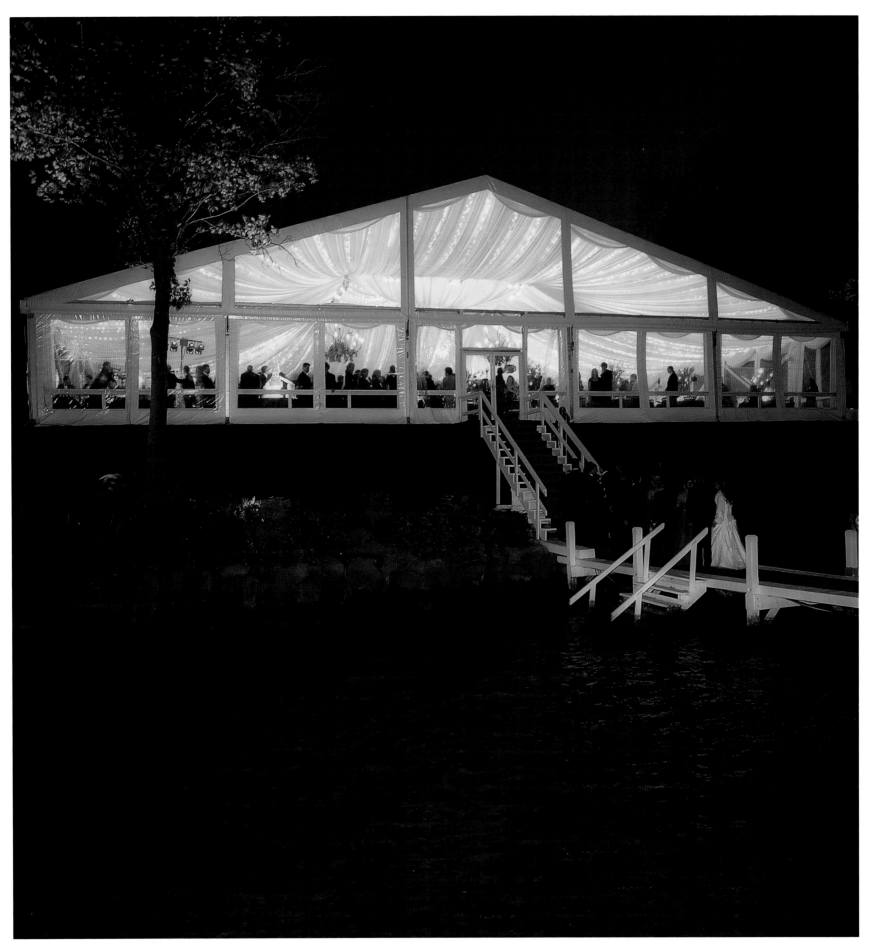

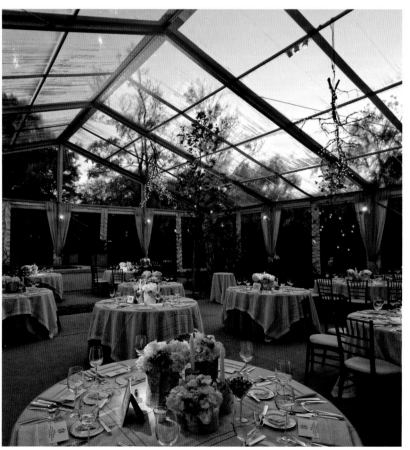

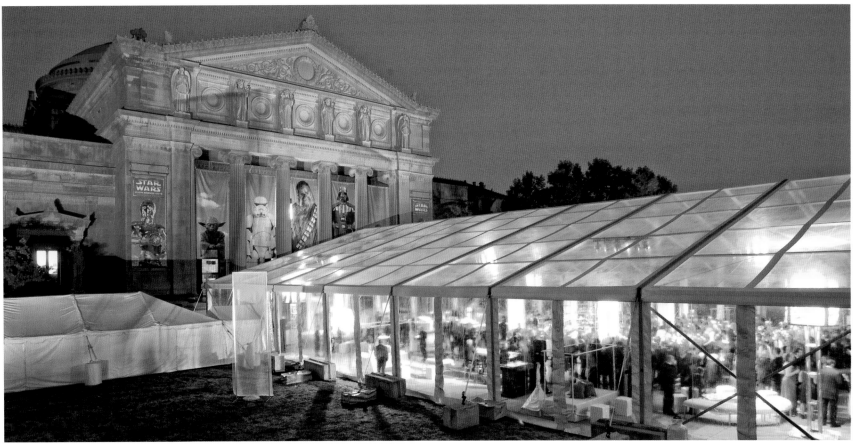

Photograph courtesy of Partytime Productions

Whether a host needs traditional opaque tenting for a corporate or social event, special anchoring for a tented beach party, or a clear-top tent for a high-end wedding, we can pull it off. At a fundraiser held at the Museum of Science and Industry Chicago, we utilized a tent with an all-clear top and sides to allow full view of the museum during the event.

"I love the satisfaction of knowing we made a difference and brought our host's dream—and the coordinator's vision—to life."

—Jim Gallagher

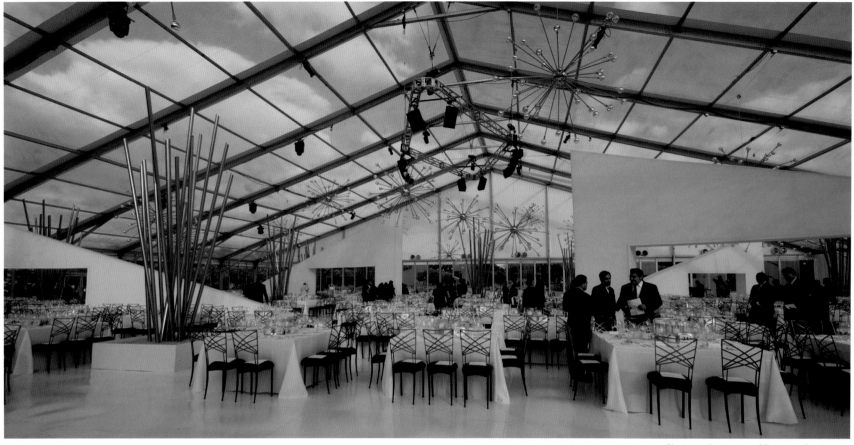

Photograph courtesy of Partytime Productions

Clear-span versus pole structure, opaque versus translucent material—it's a matter of aesthetic preference and functional requirement. For The Art Institute of Chicago's gala to celebrate the grand opening of its Modern Wing, maximizing floor space and showcasing views of downtown were the main considerations that led us to the clear, pole-free structure. We do quite a few corporate and city events, which are great because the hosts' vision is always well-defined, but it's equally rewarding to introduce people to the wide world of tents and help them come up with a plan that works perfectly for the event and its unique site. Our computer-aided design work is great for helping people conceptualize the possibilities of design, layout, and flow.

Photograph courtesy of Partytime Productions

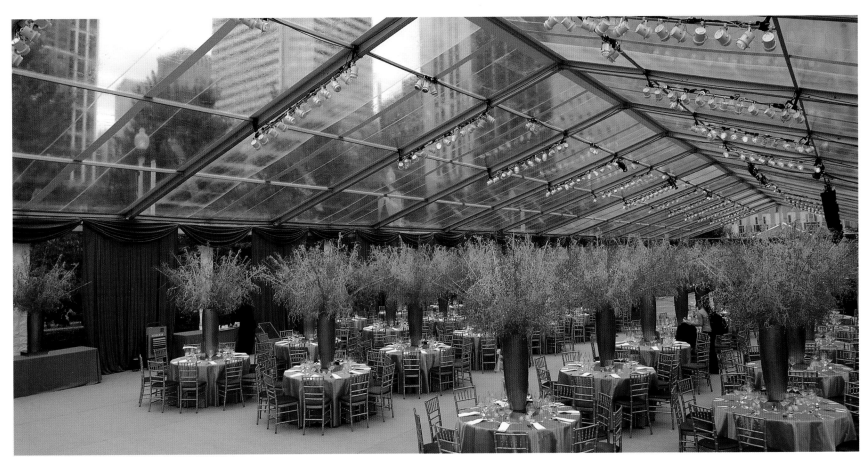

"Can we walk on water? No. Can we tent over it? Absolutely!"

—George Toma

Photograph courtesy of Partytime Productions

Photograph courtesy of Partytime Productions

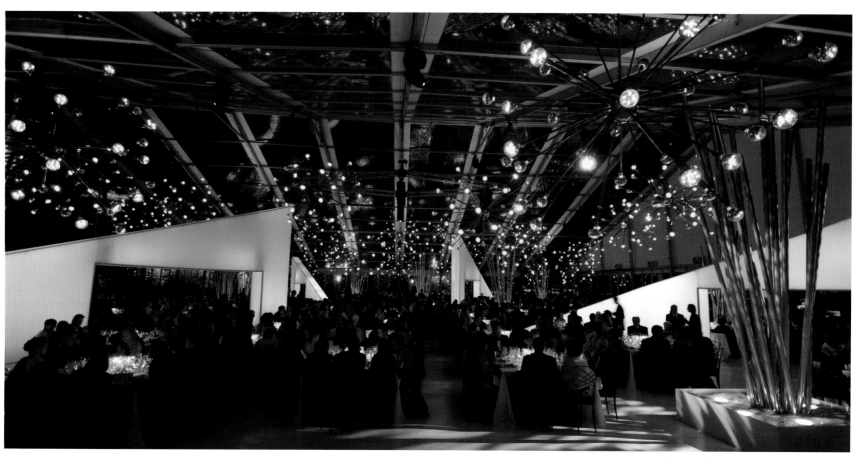

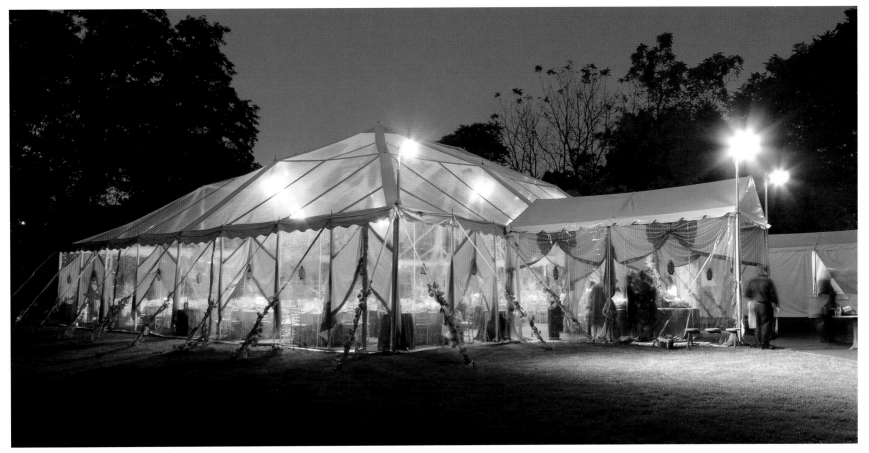

Above, right, and facing page bottom: When circumstances allow, we're partial to clear-sided or open-air tents because they allow the event to become part of the landscape.

Facing page top left: Being able to tent downtown Chicago's Millennium Park ice rink proves that every project is indeed entirely custom. The terrain dictates our process—if we're on concrete, water, or ice, we can use a variety of aboveground anchoring systems, whereas rustic settings allow belowground techniques.

Facing page top right: Because our tent inventory is modular, we're nimble to respond to special requests and unique challenges. For the debut of the Museum of Science and Industry Chicago's "Harry Potter" exhibit, we erected a one-of-a-kind tent; the exterior peaks imply poles, but once inside, guests realize that there are no poles to speak of—the effect is magical.

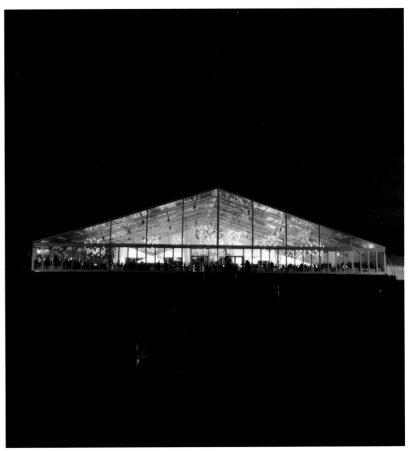

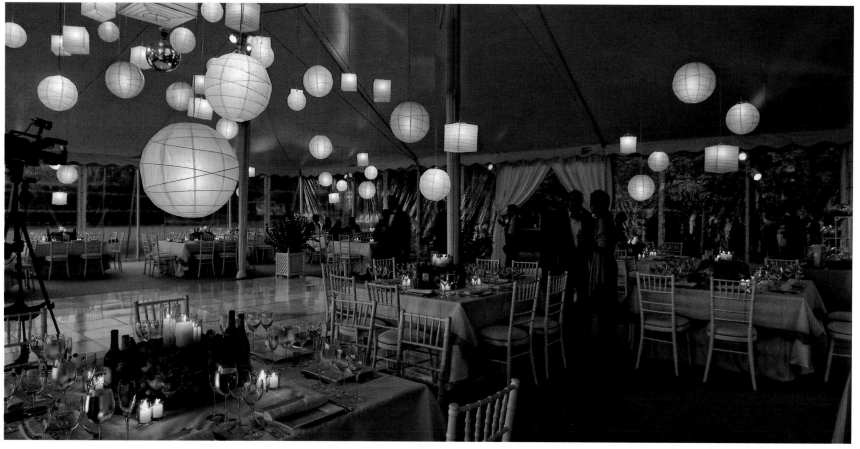

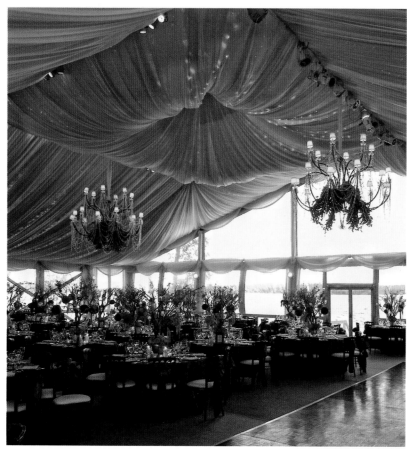

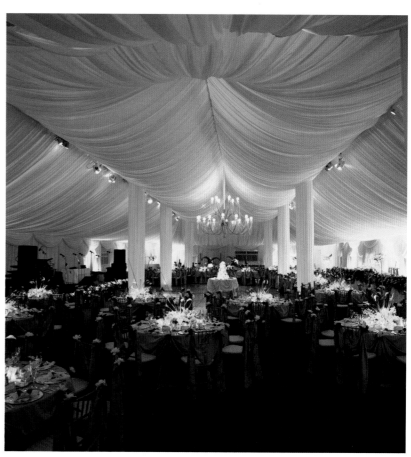

"The venue is everyone's first and last impression of the event, so logistics have to be seamless."

—Jim Gallagher

Right: A clear-top, clear-span structure was erected in Millennium Park to capture the Chicago skyline, connected by marquee walkways to valet tents. There was also a traditional pole tent constructed in front of the park's *Cloud Gate* sculpture popularly known as "The Bean."

Facing page: Dynamic lighting and fabric design bring about amazing transformations within our tents.

Photograph courtesy of Partytime Productions

views

Look for a tent installation specialist who will come equipped with an arsenal of alternate proposals to implement should any element pose a challenge. You want someone who has not just a Plan B but also plans C through Z already laid out well before the day of your big event. You'll also know you've found the right person when they view your every request and vision as a fun challenge and gladly work with you to make it happen.

HELLO DARLING

NATALIE WALSH
CHICAGO, ILLINOIS

As a child, Natalie Walsh spent endless hours planning and designing elaborate Barbie cocktail parties in ways most little girls would never begin to imagine. She turned side tables into elegant lounges, decorated with homemade furniture, dramatically lit fabric treatments, and offered creative accessories. Precocious and driven, Natalie began her work with flowers as a young teenager and studied photography throughout art school. While continuing to work in the floral industry, she began shooting fine art, fashion, special events, and interiors in some of Chicago's most respected addresses.

Natalie took her passion for flowers and special event decor to a whole new level with the opening of Hello Darling in 2005. Emphasizing the often-lost details of organic beauty, Hello Darling immediately received rave reviews for its exceptional floral styling. For Natalie, the flowers themselves inspire an entire event. Combining the elements of color, texture, and light, she highlights the personality of the hosts while captivating their guests. A true creator, Natalie realizes the importance of the big picture while bringing together the details that breathe life into every event.

I worked closely with the hostess to create a look that reflected her singular style, steering away from ostentatious and fussy designs to arrive at an elegant, lush setting that made for a stunning event. A long tablescape revealed sculpted boxwood hedges, silver cubes packed with soft hydrangea bouquets, and tall fluted urns with roses, lisianthus, delphinium, French tulips, camellia foliage, and hydrangeas.

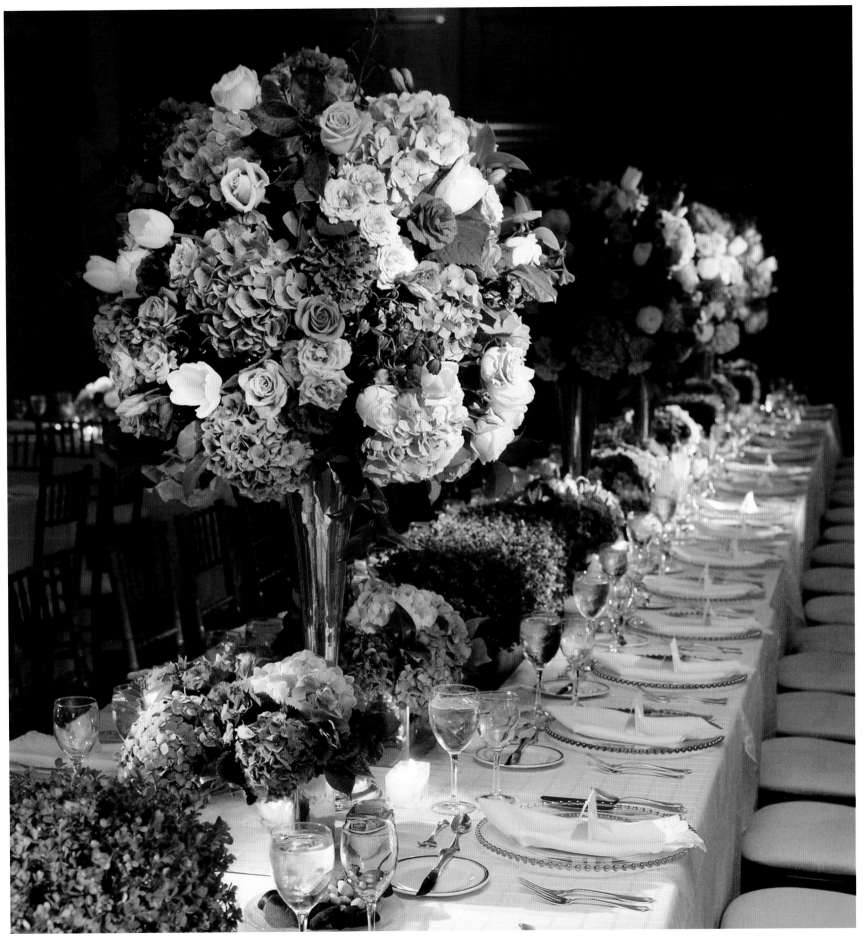

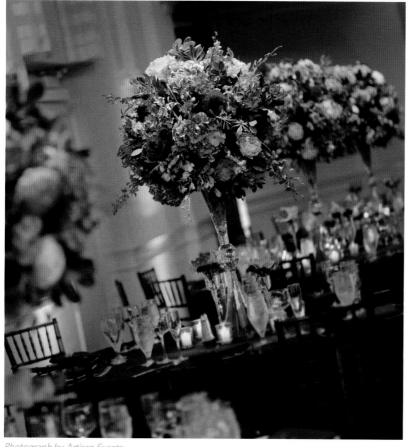

"The beauty of flowers goes beyond the visual. Close your eyes and you can sense the air refreshed by their presence."

—Natalie Walsh

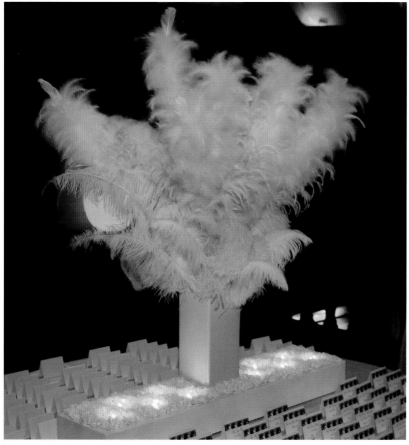

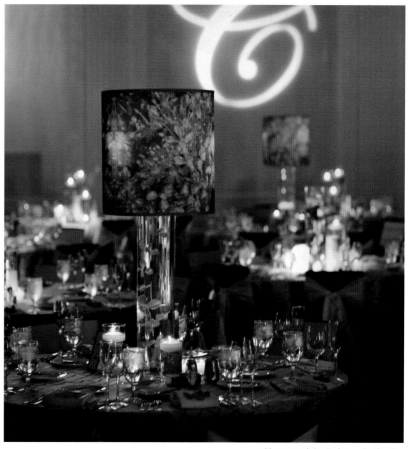

Above and right: I wanted to capture the creative, modern spirit of a fabulous bride. Her purple and lavender color palette, custom printed lampshades, submerged orchid arrangements, and ostrich plume placecard table encompassed all of her favorite elements in modern yet romantic designs.

Facing page: To create a couple's vision of a romantic summer garden wedding, I brought together the bride's favorite soft vintage blooms in jewel tones using rich dahlias, draping jasmine, fresh lavender, exotic orchids, fluttery gloriosa lilies, soft hydrangeas, and fragrant peonies. Indian-inspired accents of gold-painted lanterns, parasols, and sari fabric paid tribute to the groom's Eastern heritage.

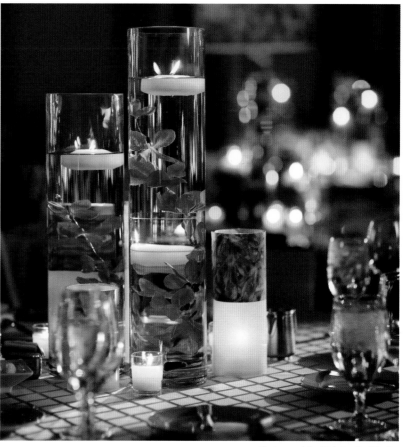

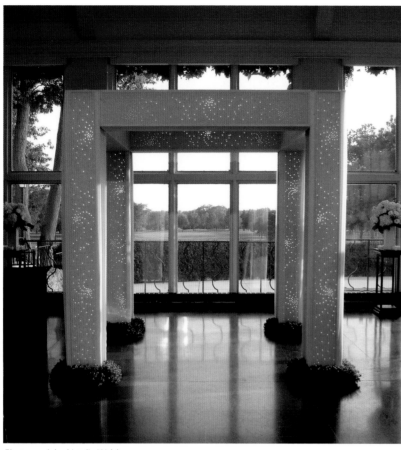

Photograph by Natalie Walsh

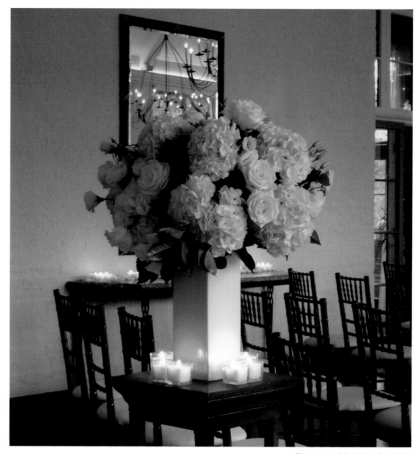

Photograph by Natalie Walsh

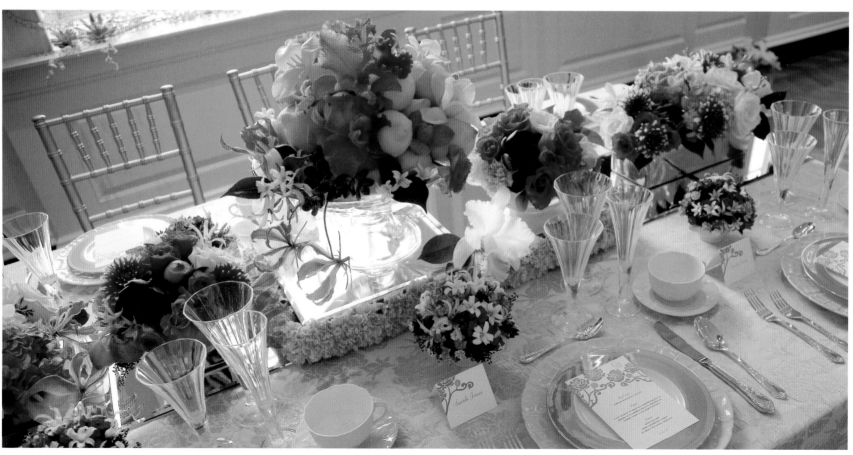

Photograph by Gerber + Scarpelli

"Nothing brings life and warmth to a room like flowers, absolutely nothing."

—Natalie Walsh

Right: I used a rehearsal dinner's invitation as my inspiration for an occasion. Chocolate brown zebra print in an orange-lined envelope, the invitation captured everything the hostess wanted to convey in this modern hotel setting. Warm and autumnal without becoming cliché, the fall theme was striking: We draped the table in orange bengaline linens and lined it with a graphic collection of candlelit manzanita arrangements, rustic lanterns, and ghostwood branches draped in sculptural calla lilies, orchids, and succulents.

Facing page top: For a bride who grew up attending events at a quintessential North Shore country club, the comfort of the familiar surroundings provided the perfect backdrop for the sentimental occasion. From the bride's inspiration of a decorated Manhattan scaffold covered in vines and twinkling lights, we created a celestial huppah design echoing a clean architectural style. The glowing pattern of white light offered a dreamy feel that complemented the romantic blooms of the garden theme.

Facing page bottom: Custom damask linens, feminine place settings, vivid colors, and a strong rectangular table presented an antique-chic style for a friend's event. With the aesthetic of a high-end tea party, the display featured fresh, graceful details: I used a large footed bowl filled with lemons, tulips, gloriosa lilies, and cattleya orchids, and included personal floral arrangements at each place setting.

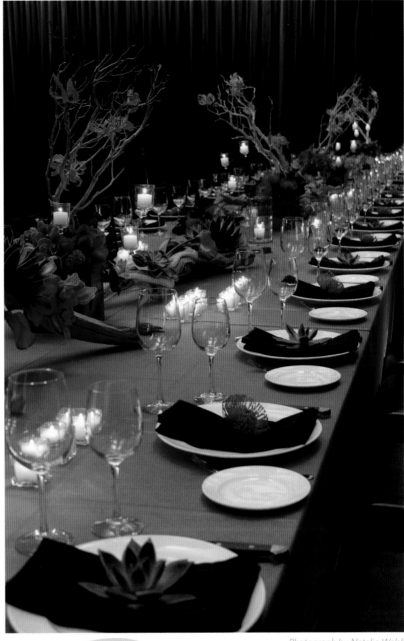

Photograph by Natalie Walsh

views

The most important detail of any event is a happy host, so discuss your ideas openly until you find the designer you trust, and allow them to blow you away with the beautiful results.

PETALS GALORE FLORAL ART

SANDRA KOHLER
ST. LOUIS, MISSOURI

Like most creative professionals, Sandra Kohler found it difficult to be confined to a desk. Although her background in business and fashion marketing originally led to a career as a buyer for a major department store, Sandra missed the daily interaction with the store's clientele. As a creative outlet, she began to design permanent arrangements for model homes. Her designs were so well-received that Sandra started her own high-end floral design company in 1999, where she segued into fresh floral design—Petals Galore Floral Art.

For Sandra, the decision to start her own company was based on passion and her "over-the-top type A" personality. In a business where flying by the seat of your pants is a daily occurrence, Sandra relishes the unpredictability each event brings. As event florists, Sandra and her lead designer, Stephanie Stempf, create stunning bouquets, centerpieces, and countless other floral collections for nearly 80 events each year.

The soul of Petals Galore lies in its creativity. Sandra's vast knowledge of flower types and expertise in selecting just the right—and sometimes unexpected—bloom to complete a design results in creations remembered for their elegance, drama, and originality. Nothing is off limits, and commonly overlooked items such as pumpkins can sometimes wind up as the inspiration for gorgeous centerpieces. Sandra's energy and organization guarantee that she and her staff come well-prepared for any unexpected situation. From extra centerpieces to replacement stems, Petals Galore has anticipated every wrinkle that could arise during the set-up of an event. Sometimes, according to Sandra, that's when creativity is needed the most.

Floral design isn't always limited to flowers. When the setting is an automobile museum and the décor includes large floating moons, you have permission to make the centerpieces equally memorable. Inspired by Fred Astaire and Ginger Rogers in the classic Hollywood film "Top Hat," we filled oversized lighted vases with a combination of cellophane, water, and acrylic ice to replicate the look of tall, cool drinks. To replicate Ginger Rogers' iconic feather gown, we topped the lighted bases with dozens of white ostrich feathers. This was also a nod to the bride, who wore a vintage gown with feathers in her hair.

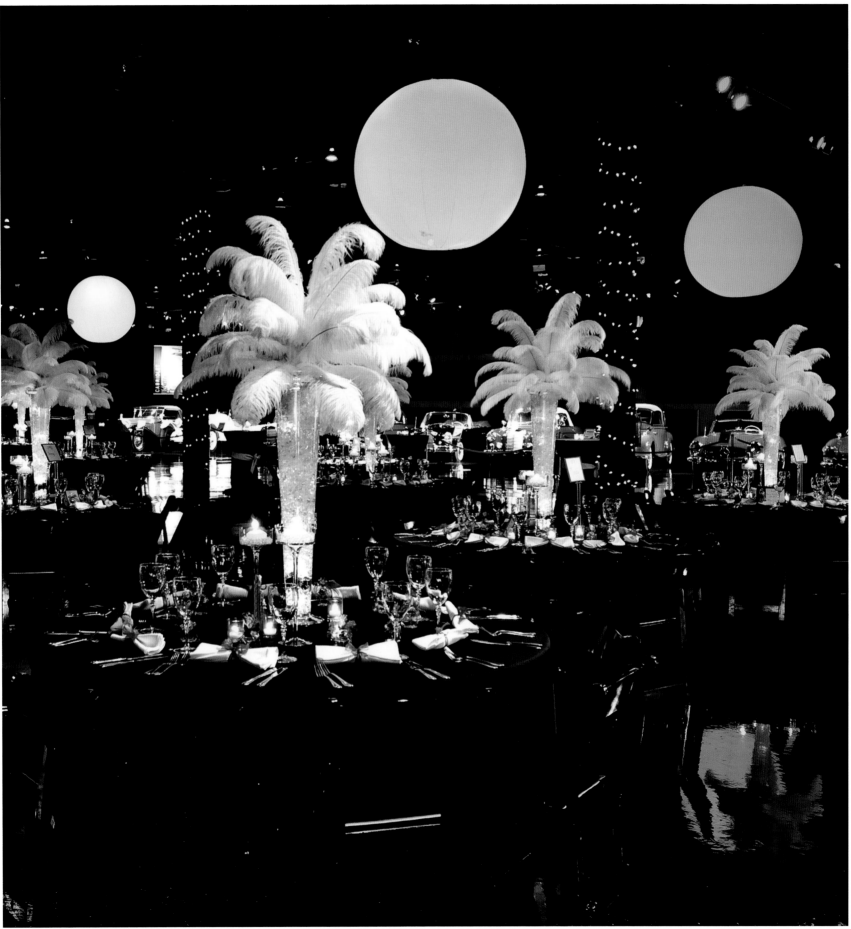

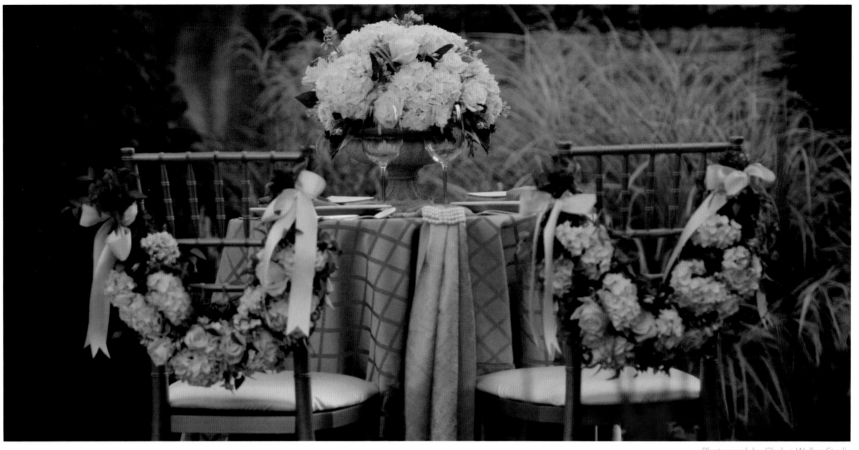

"With this job, you have to be one hundred percent perfect, one hundred percent of the time. There is no room for failure. This is a very high standard, but one that we must aspire to."

—Sandra Kohler

Right: Transforming a casino lounge into an elegant wedding space was a feat for all involved, but I took the opportunity to reflect the bride's fun and whimsical personality in the centerpieces. A combination of apple green—literally—and shocking pink was balanced by hundreds of candles casting a soft, flickering glow around the room.

Facing page top and bottom left: When designing floral art, it's always important to take your surroundings into account. For a natural outdoor setting with powdery blue accents, the flowers have to equal the softness and not be too overpowering. If the design includes something bolder, like graphic black-and-white linens, the flowers need to pack a punch or run the risk of being overlooked. By mixing traditional roses with unexpected fuzzy coxcomb and spindly gloriosa lilies, the result is playful and memorable.

Facing page bottom right: A common hurdle is the request for flowers that aren't in season or wouldn't work with the rest of the design. A bouquet made entirely of mums, for example, would not have the visual excitement of one that also combined green goddess calla lilies, yellow cymbidium orchids, and red hypericum berries. And the mums may not turn out to be mums at all, but roses with the centers cored out and the poms nestled inside.

Photograph by Kelly Park Photography

"Timelines and backup plans are a necessity, but the ability to make a decision on a moment's notice in this industry is imperative."

—Sandra Kohler

Every host is unique, and some are more involved than others. I was provided with champagne ostrich feathers and a gorgeous mix of mercury glass vases for an August wedding. The color palette chosen by the bride was simply red. Together, we worked hand in hand to blend her vision and my creativity. Besides being very heavy, these centerpiece designs presented us with a challenge. Normally designs this large are completed on-site, but these had to be completely assembled prior to transport; otherwise we would not have been able to adhere to the strict timeline. Incorporating the feathers into an oversized signature piece was a chance to bring in complementary accents, like the red hanging amaranthus and Black Magic roses, and for something unexpected, I added a vintage-style brooch to the stem wrap of the bridal bouquet.

Photograph by Kelly Park Photography

views

When you first visit your floral designer, come prepared with photographs that reflect the things you love. Whether it's a whole design style or just a color, it helps give the designer a sense of who you are. Also be willing to open your mind and listen to the designer; by working together, your flowers can turn out even more spectacular than you ever imagined.

RICHFIELD FLOWERS AND EVENTS

GREG NJOES | MARILYN WEIS | DAVID BORNOWSKI
MINNEAPOLIS, MINNESOTA

During a theatrical performance, cast members guide the audience through a metamorphosis from their everyday lives into a new world; those in attendance are whisked away into a foreign land where they can inject themselves into the story for a brief time. Greg Njoes of Richfield Flowers and Events sees himself and his team as cast members of sorts. They bring the same imaginary transformation to many of their events—not necessarily through an enthralling storyline but through a production that encompasses lighting, drapery, flowers and greenery, props, and table décor.

Armed with a valuable team of specialists who have worked with him for decades, Greg and his seasoned staff have perfected the art of deciphering the event's purpose and translating it into fantastic elements that awe guests. At the foundation of this magical work is the company's hesitancy to say no; they research every avenue available to accomplish the goals while simultaneously staying firmly grounded in reality.

The transformations executed by the exceptional team members accommodate a wide range of styles and events. From beginning to end, it's clear that Richfield Flowers and Events takes charge of the big-picture vision and simultaneously attends to the most miniscule aspects of each event—all for the ultimate conversion of a location into an outstanding party.

Lighting is extremely important for an event's success. To create a special glow, we enhanced the gold color palette with overhead twinkling lights and candles at several levels. Bouncing light reflected off the crystals on the decorative gilded branches, and lighting patterns textured the space with designs of trees and organic shapes.

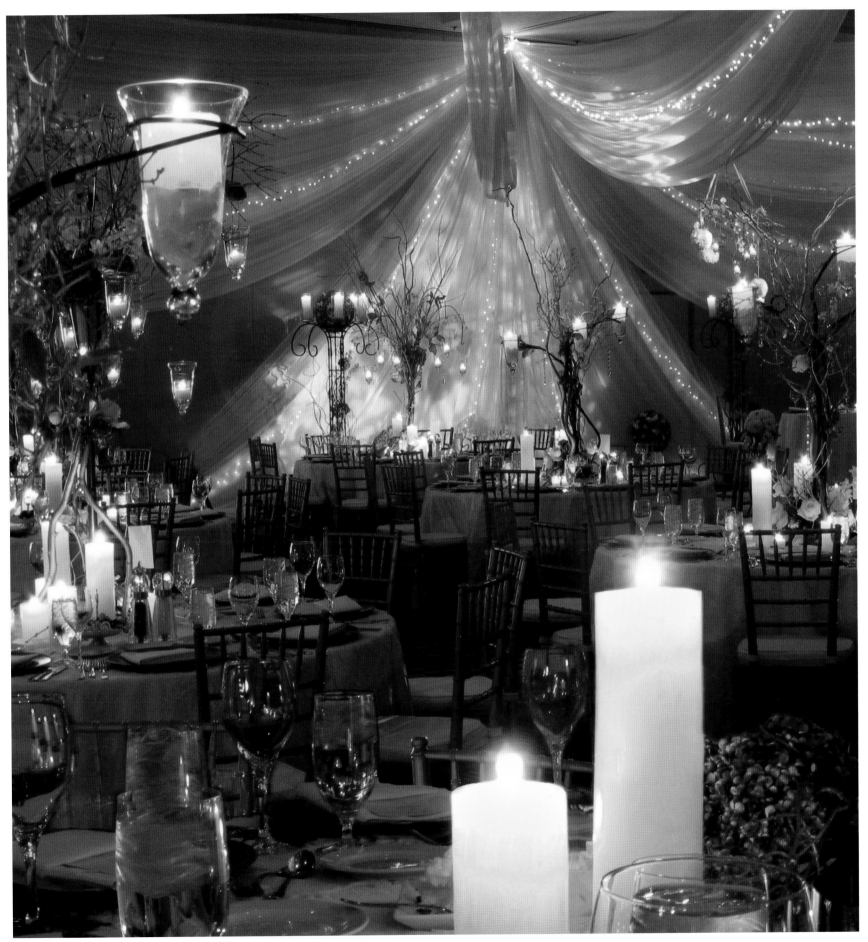

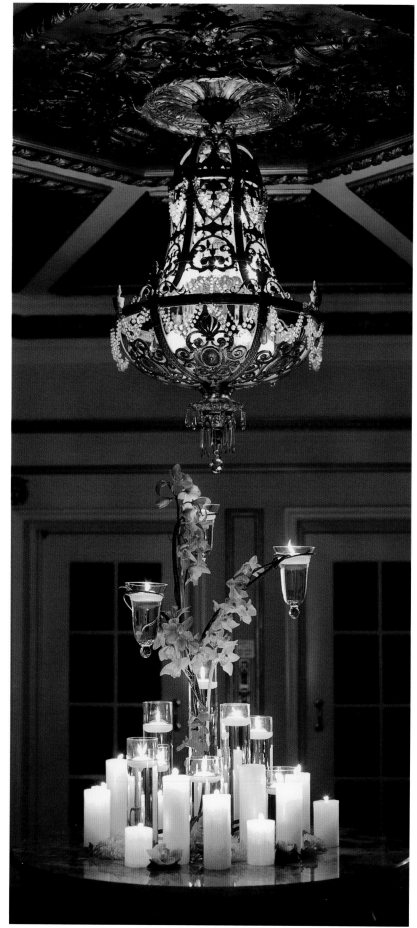

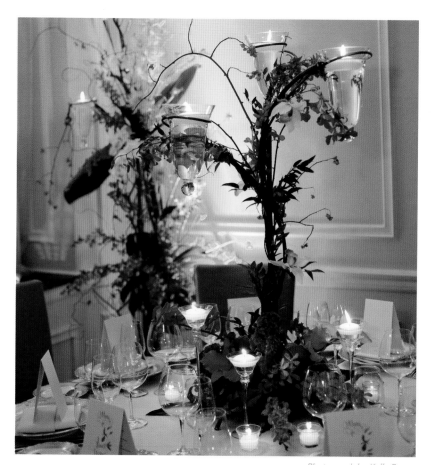

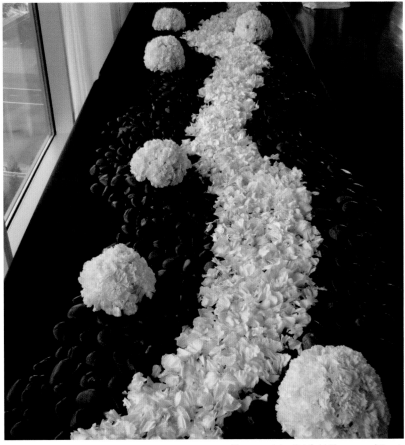

Above and right: Occasionally, circumstances allow the space to meld beautifully with the celebration. In a hotel's art gallery, we picked up the contemporary vibe and added organic texture, as with the natural river stones and flowers that served as the foundation for the placecards.

Facing page: The classic Art Deco style of a condo in the Twin Cities provided the perfect backdrop for a glamorous prenuptial dinner featuring a myriad of orchids in vivid colors and exotic varieties.

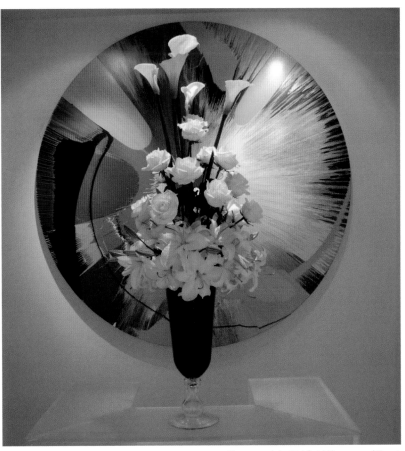

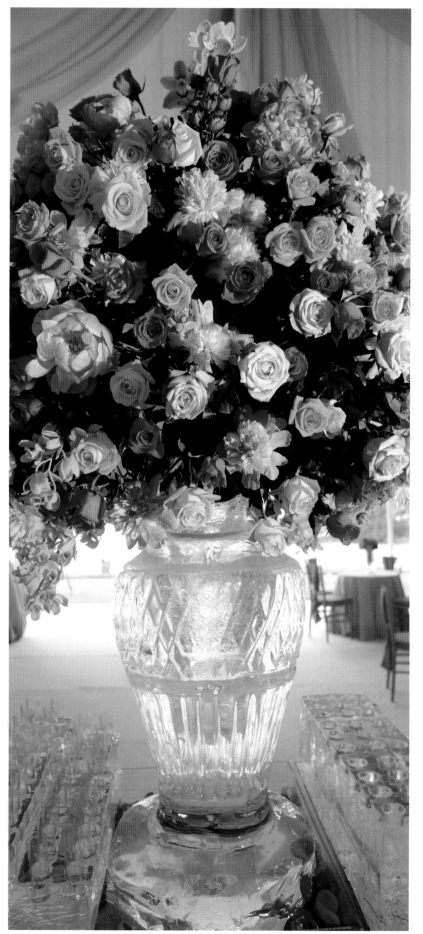

"Just like a play needs an outstanding opening scene to hook the audience, so does every event need a wow factor to intrigue and capture the guests' attention."

—Greg Njoes

Right: Fabric can dramatically transform a room, whether it's used to hide elements that don't work well with the vision of the event—as with the medieval chandeliers that we covered and then colorfully lit for a contemporary, romantic event—or to enhance the existing space—which we did in a six-floor atrium to make the beautiful room feel more intimate.

Facing page: Don't underestimate the power of a good color scheme, especially in the daytime when lighting doesn't have quite as big an effect as at night. We went full steam ahead with yummy sherbet colors for a tented reception and delivered quite a stunning visual punch. Roses, peonies, and orchids gave a full measure of color in both traditional and nontraditional places—vase centerpieces, an ice sculpture accent piece, and the tabletop for the champagne glasses.

views

When working with a limited budget, choose a theme to complement the colors and style of the venue. It gives you a better value. When budgets are not a concern, consider totally transforming the space with surprising colors and designs.

SADIE'S FINE FLORAL DESIGN

SADIE GARDNER
MINNEAPOLIS, MINNESOTA

When Sadie Gardner set out to begin her career in floral design, she didn't intend on changing the face of Midwestern events—but that's precisely what she and her team of designers are doing. Bringing a new look to the world of events, Sadie's energetic approach gives parties what they need to become full-blown galas.

Inventive, bold, and always elegant, Sadie's Fine Floral Design has steadily grown into a five-designer operation and does upward of 80 events a year. The team's design work spans to Minnesota, North Dakota, and Iowa, where they consistently bring a fresh boutique approach to events like weddings, charity galas, and public tours. How do they do it? The team remains focused on what each host or hostess wants—down to the tiniest detail—never pushing or rushing for decisions. And by keeping a constant eye on trends of the industry, this all-female team knows exactly how to take Sadie's Floral to the top.

When the host of a corporate event wanted to wow his guests at Minneapolis' W Hotel, he envisioned something contemporary. We achieved his vision by playing off the venue's strengths: light and décor. Tall, elegant centerpieces give off a glowing warmth while purple tones appear in each arrangement to pull in the colors of the space.

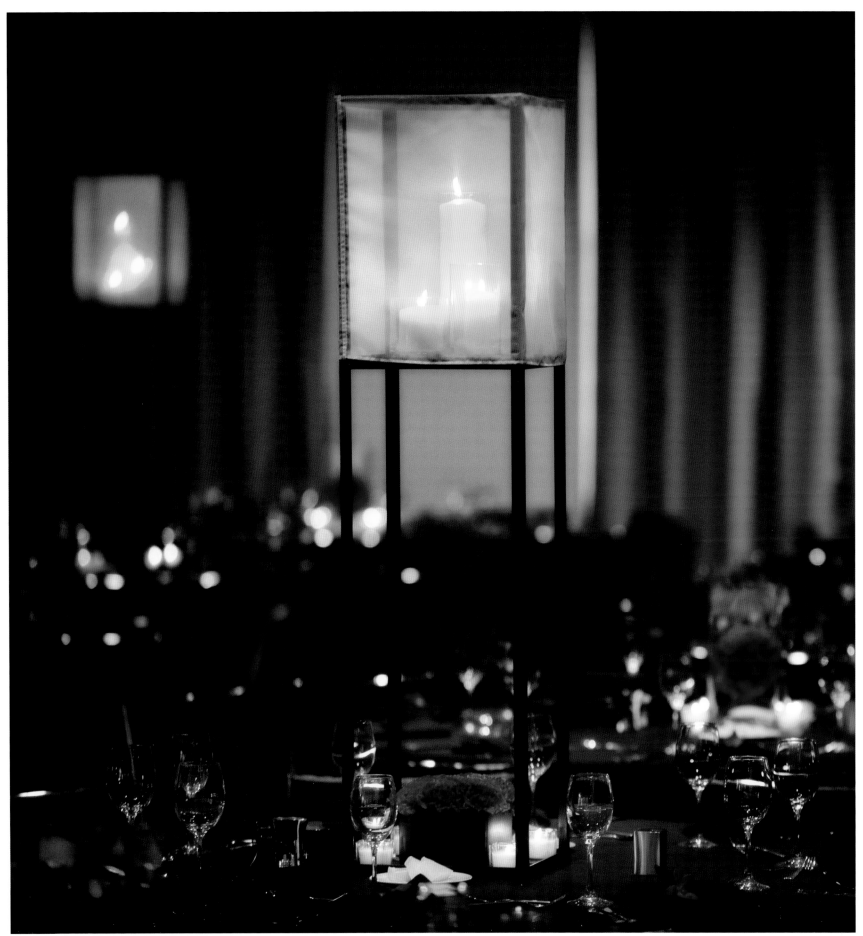

Above and facing page left: The traditional colors of autumn are always stunning, so we utilized them for a fall ceremony and created the exact look the bride wanted. We incorporated fruit into the arrangements to add a lush, vibrant feel. The Calhoun Beach Club in Minneapolis provided the perfect venue, bringing together modern and classic style.

Facing page right: Clad in a red gown, a daring bride chose colors as bold as her personality. Yellow, orange, and red hues made for an elegant, contemporary event. Placed at varying heights to add interest, the table arrangements included eye-catching orchids.

"Inspiration can come from anywhere. Look at colors, photographs, even items in your home. Find out what really appeals to you."

—Sadie Gardner

Photograph by Jennie Sewell, Sewell Photography

Photograph by Noah Wolf Photography

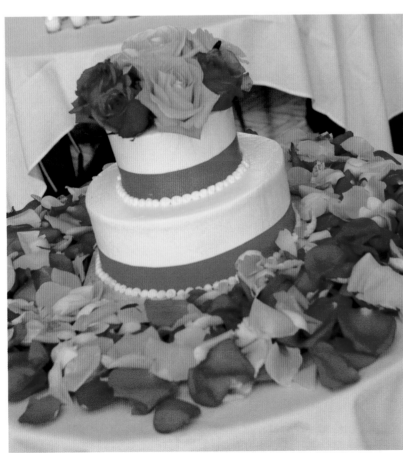

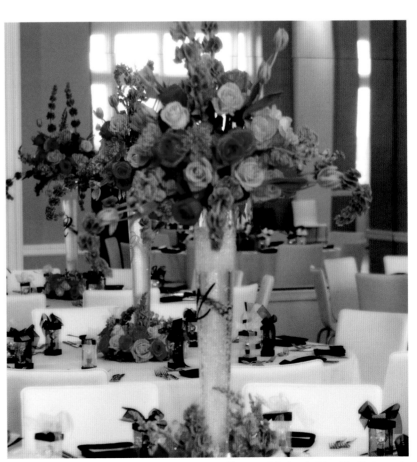

"Fresh, innovative, and vibrant—
that's what every event should be."

—Sadie Gardner

Right: We made a New York couple feel right at home when they returned to their native Minneapolis to tie the knot. Set at the modern Graves 601 Hotel, the event showed off white and silver décor with tall crystal and candle pieces wrapped in white floral wreaths at the base.

Facing page: Newly remodeled, the Calhoun Beach Club featured large white drum candelabra with dangling crystals. We pulled that element into the head table arrangement and used tons of orange flowers for the vivid, luxuriant look that the bride wanted. Her favorite color—orange—carried over beautifully to the wedding cake. The guests' centerpieces featured orange and hot pink, situated with two different settings. Half of the arrangements stood tall and held floral pieces above the vase and at the base; clear water beads and submergible LED lights illuminated the vases in the evening. The remaining centerpieces were three-foot-by-one-foot mounds of hot pink or orange roses with crystal candleholders on either side.

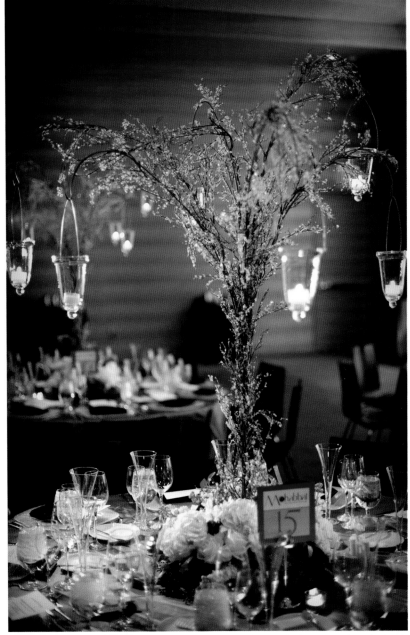

Photography by Marc Andrew, Studio 306

views

Communication is key. When working with an event team, don't be afraid to speak up if you don't like something. We're professionals—it won't hurt our feelings. As a floral designer, I have a library of thoughts, ideas, and patterns that could work for any personality. I'm here to provide those options and make sure the flowers look exactly as desired.

ACME Corp. Production Resources

MARK MISKIMEN
MILWAUKEE, WISCONSIN

When the lights come on, rooms come to life, space is defined, events are shaped, and our eyes are opened to wondrous sights. In the hands of the professionals at ACME Corp. Production Resources, events are exquisitely lit, ensuring that guests are both entertained and enchanted. Let there be light!

Lighting's most basic function is illumination, but the artists at ACME create highlights, patterns, and elements of décor with light, thus redefining a space and creating a new sense of place. Lighting should always follow some form of logic and ACME achieves this through the use of color washes, projected patterns, or highlighting of features such as columns, floral arrangements, and drapery.

When ACME designers first meet with prospective hosts, they focus on the overall design for the event, the architecture of the venue, and the power capabilities. The designers begin every commission by listening to people describe their vision and the feeling they wish to achieve for the event. They know they have succeeded when the lighting they place in a room elicits an emotional response.

Our lighting design—complete with chandeliers—achieved a dramatic, classy, and stylish look
for the event in Bartolotta Catering's event tent at Pier Wisconsin.

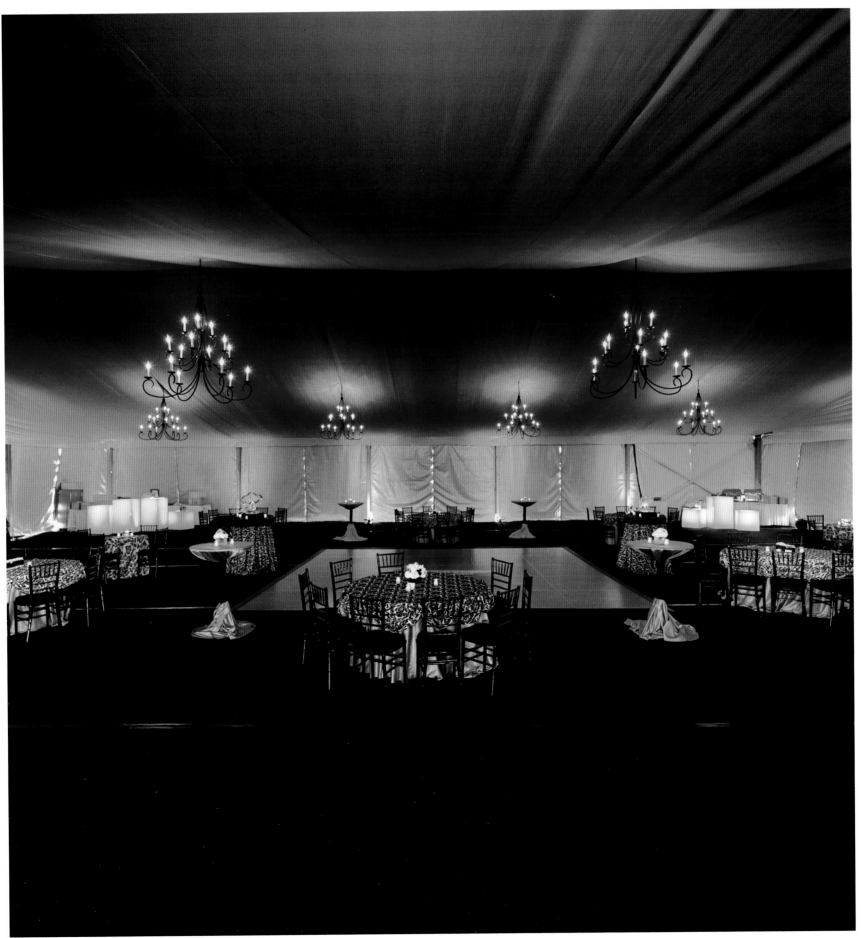

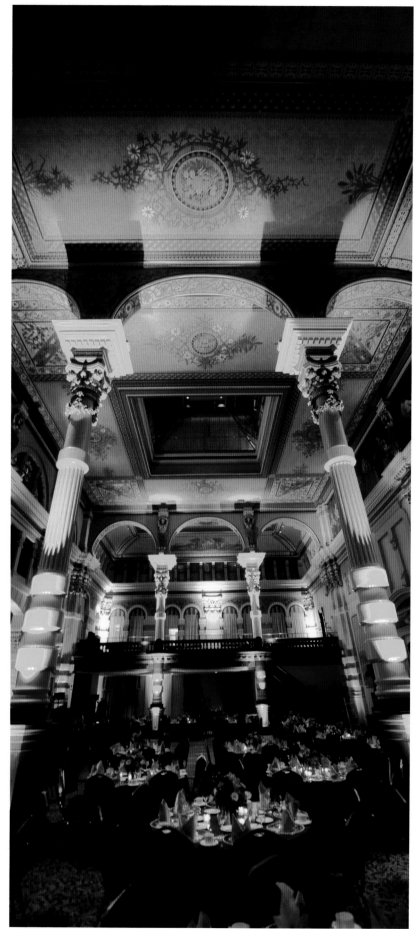

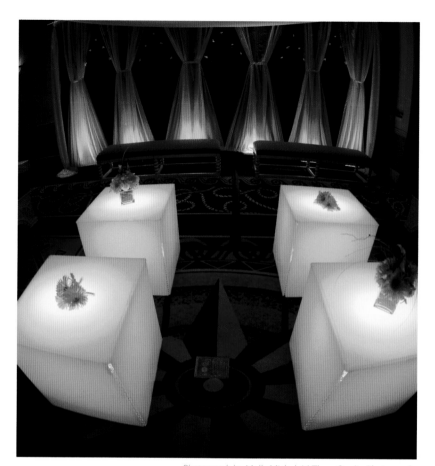

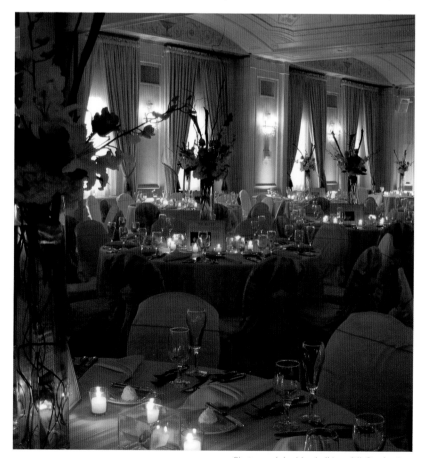

"Lighting as part of the décor can change the color, look, and feel of a room. The vision is more important than the equipment."

—Mark Miskimen

Right: Gobo patterns can be an effective lighting tool to define a space and create décor. Standard patterns, company logos, and custom monograms are available.

Facing page left: We highlighted the architectural columns and the height of Bartolotta Catering's Grain Exchange by placing uplighting at the base of each column to enhance the architecture without taking away from the beauty of the space.

Facing page top right: To define separate areas of the ballroom and create a different ambience for each while keeping the event as a whole looking stylistically consistent, we used glow tables that echoed our lighting on the draping around the walls.

Facing page bottom right: A color wash on the walls and ceiling enhanced the overall décor despite the challenge of space limitations and low power availability.

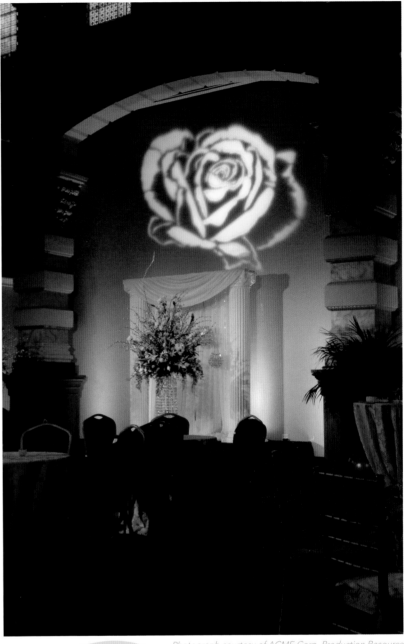

Photograph courtesy of ACME Corp. Production Resource

views

Lighting can completely transform a room and is an essential element in creating an event that makes a first and lasting impression. When carefully integrated with floral, drapery, table covers, and other elements from the beginning, lighting accentuates the beauty of the room and directs guests' attention. Lighting should never be considered an afterthought, but rather an essential ingredient in creating a spectacular event.

Après Party and Tent Rental

CHARLIE FELDBAUM
MINNEAPOLIS, MINNESOTA

Traditional is simply not in the Feldbaum family's vocabulary. Although they have been devoted to making Après Party and Tent Rental a family passion over the past two decades, the company is not about simply repeating what has worked in the past. They are about setting the trends. With an unparalleled line of décor and equipment rental, they work to create a unique atmosphere at each event.

Whether the celebration is a gala fundraiser, a corporate meeting, or an informal family party, Après offers superior products, custom options, and eco-friendly practices. Color, quality, texture, and atmosphere are considered for each event's design, while the event host can be involved to any degree with the planning process.

In such a diverse and constantly evolving industry, Après strives to reflect the latest trends from both the East and West Coasts and combines them with Midwestern sensibility and Twin Cities style.

In reality, the staff at Après Party is the secret to their success. Many staff members have worked with the company for more than 10 years; some have even recruited their own family members to join the team. This collective enthusiasm is evident from the first moment a host steps into the showroom and continues until the last item is retrieved from the site. The entire Après team is available throughout the event, ready to help coordinate a fantastic experience from beginning to end.

Tall botanical centerpieces draw the eye upward in the tented reception as mahogany Chiavari chairs lend a vintage look. The interior of the tent is completely lined in white sheer fabric, which envelops the beaded crystal chandeliers that light the space.

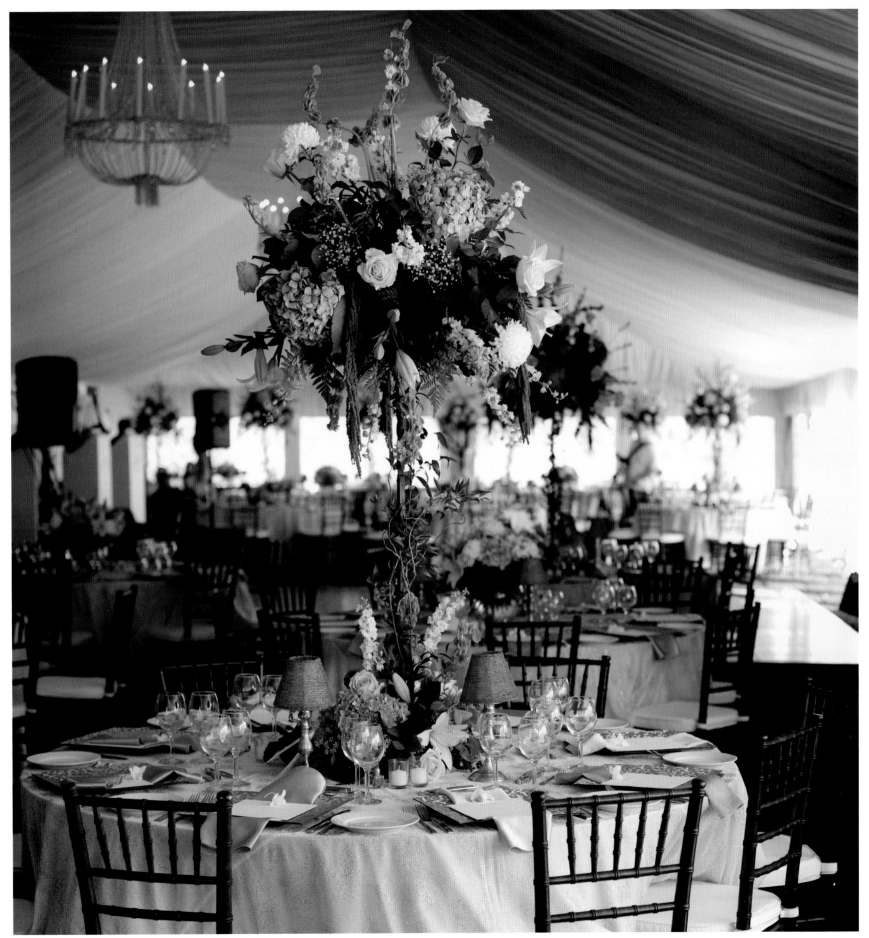

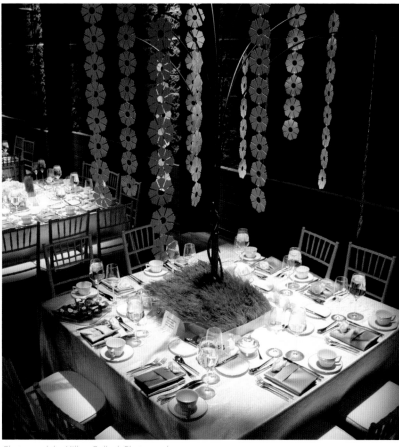

Photograph by Hillary Bullock Photography

Photograph by Coppersmith Studios

Photograph by Jenn Barnett Photography

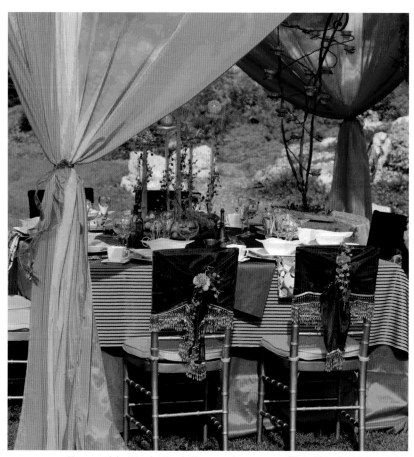

Photograph by Wendy Woods Photography, courtesy of Twin Cities Bridal Association

"Strive to create something unique and unusual. By showcasing the unexpected, hosts can provide a remarkable experience for their guests."

—Charlie Feldbaum

Right: Vivid hues featured on long, rectangular tables create instant glamour for arriving guests at a reception at the Graves 601 Hotel.

Facing page top left: Lighting is an important element that should not be overlooked. Pin spotting tables from above offers a more modern aesthetic that coordinates well with square tables and hip décor.

Facing page top right: Dreamy, blue-lavender hues evoke feelings of a fairytale buffet setting highlighted by a ballerina.

Facing page bottom left: LED lights glow throughout a clear tent to create a cool, lounge atmosphere at a corporate welcome for Republican National Convention delegates.

Facing page bottom right: Natural sunlight plays against the bold colors of a summertime park luncheon.

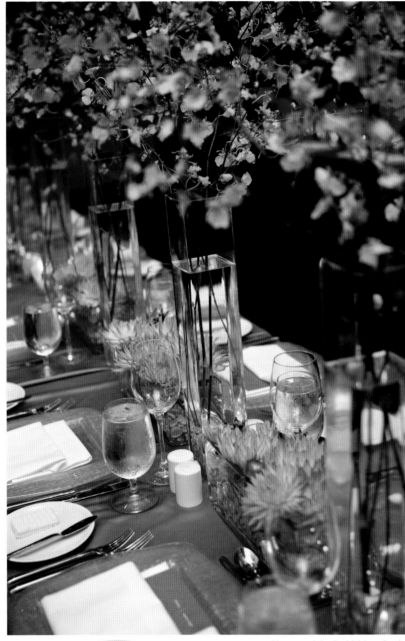

Photograph by Red Ribbon Studio

views

Experienced event professionals will always work tirelessly to achieve the host's vision for the event. The very best do so while offering realistic advice based on what is attainable without sacrificing safety, quality, or budget.

Art Below Zero

MAX ZULETA | JEANNE ZULETA
MILWAUKEE, WISCONSIN

Who would have thought that one of the world's leading ice sculptors, a veritable pioneer in his field, hailed from a tropical land? Venezuelan-American Max Zuleta carved out a niche as a talented ice sculptor in his home country, then translated that success to the United States and abroad.

Max taught himself to sculpt ice from an old book he found while working for a catering company in 1989. As he absorbed the basics, it became a fun hobby. Then other catering companies got wind of him and began making offers; he received three in total. Instead of choosing one, he opened his own ice sculpting company—the first in Venezuela—and ran it for 12 years. Once or twice a year, he would travel to the U.S. to pick up new tools and techniques at sculpting competitions, winning prizes and medaling in many. He met his future wife Jeanne at one in Chicago, and before long she had become an integral part of his business. Freelance work took the couple all over the world—from France and Belgium to Alaska and Canada—but they have long considered the Midwest home.

In 2003, demographic research led them to Zion, Illinois, situated about midway between Milwaukee and Chicago, as the ideal place to settle down and begin a new ice sculpture enterprise. Art Below Zero's inventive approach to ice sculpture has garnered it attention and steady business, as well as an established spot in both urban markets and everywhere in between. Jeanne, a chef, inspires Max to approach ice sculpture as a multipart, thorough process. She also creates clever ice designs that Max then finds a practical application. Their reputation for originality is such that people trust their aesthetic sensibilities, and instead of requesting a swan or a swordfish, they simply state a few keywords and let the company run with it. The extensive portfolio more than testifies to this creative success.

At a Milwaukee Art Museum wedding, the venue's architecture informed the design, as did the French essence and direction provided by David Caruso of Dynamic Events. The hosts wanted a mélange of ice vases and chose nine designs from the 20 sketches we showed them. Our sculpture is a functional decoration element and showcases a fusion of ice and flowers, design diversity, and pristine presentation.

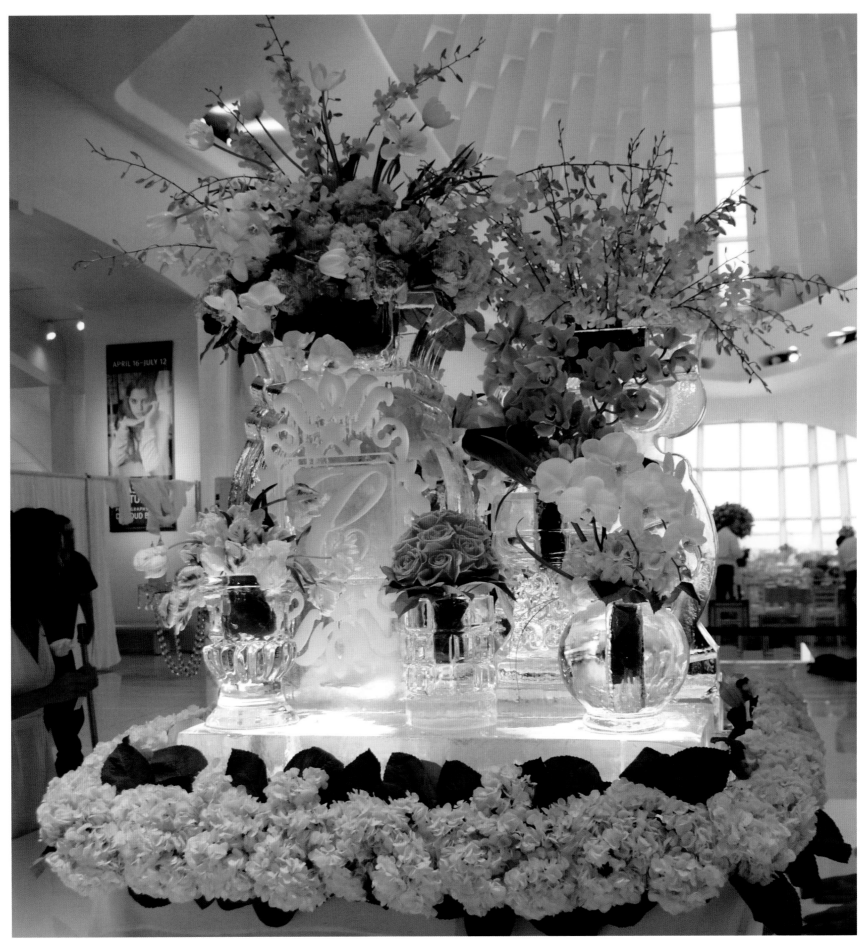

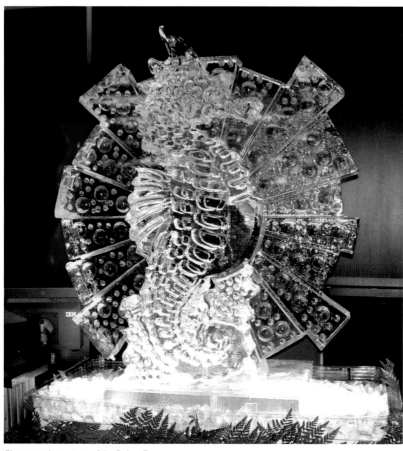

"When you're in a creative field, your brain is never off. I get ideas from my travel photos of sunsets and art, online image searches, my book collection, and even my kids' coloring books."

—Max Zuleta

Right: Born out of my lifelong dream to be a performer and the joy I got out of public ice carving demonstrations, the Art Below Zero Ensemble is a live show that combines ice sculpting, music, and humor. Multimedia visuals, theater, costumes, and originally composed music performed by skilled musicians coalesce to create a performance that is designed to travel worldwide—from the Midwest to Hong Kong—with anything from a Chapman Stick to chainsaws.

Facing page: From an abstract-realist fusion sculpture decorating a spring opening event to a functional, minimalist vodka flume luge to a seafood table at an outdoor wedding to a versatile piece sculpted on-site at a live ice performance, our sculptures aim to possess both utility and beauty.

views

A successful ice sculptor views ice as a medium for creating art, focusing not only on aesthetic beauty but also functionality and interactivity. As ingenuity is key in ice décor, seek someone who has a good relationship and exchange of new ideas with other ice companies overseas.

BOTANICALS~A BRANCH OF HM DESIGNS

CASEY COOPER
CHICAGO, ILLINOIS

A proud member of the HM Designs family of event experts, Botanicals has an impressive array of inventory and resources at its fingertips. Its designs have been featured in *Elle Décor*, *Glamour,* and *InStyle* magazines, as well as on numerous TV programs. Most notably, Botanicals designed and produced Oprah Winfrey's most intimate 50th birthday party.

The vision began while Casey Cooper was studying to become an actor and received a valuable piece of advice: learn a marketable skill. She chose working with flowers, and in 1993, at the urging of her husband John, she founded Botanicals. Bidding on events and creating dramatic environments reminded her of theater, and her improvisational training proved invaluable.

As the company grew, so did the staff and workspace, culminating in a 6,500-square-foot state-of-the-art design studio and a team of wildly talented and intensely passionate experts. The company enjoyed the national spotlight in 2007 when Casey co-authored the book *What's Your Bridal Style?* with wedding expert Sharon Naylor.

As an HM Designs company, Botanicals has the freedom to concentrate on what made it famous in the first place: boundless creativity, admirable integrity, and impeccable quality.

It is possible to be rustic and elegant at the same time! By focusing on the combination of textures instead of a "theme," we were able to create a table that mixed elements like polished wood, steer horns, and cowhide with buttery calla lilies and canary-colored orchids.

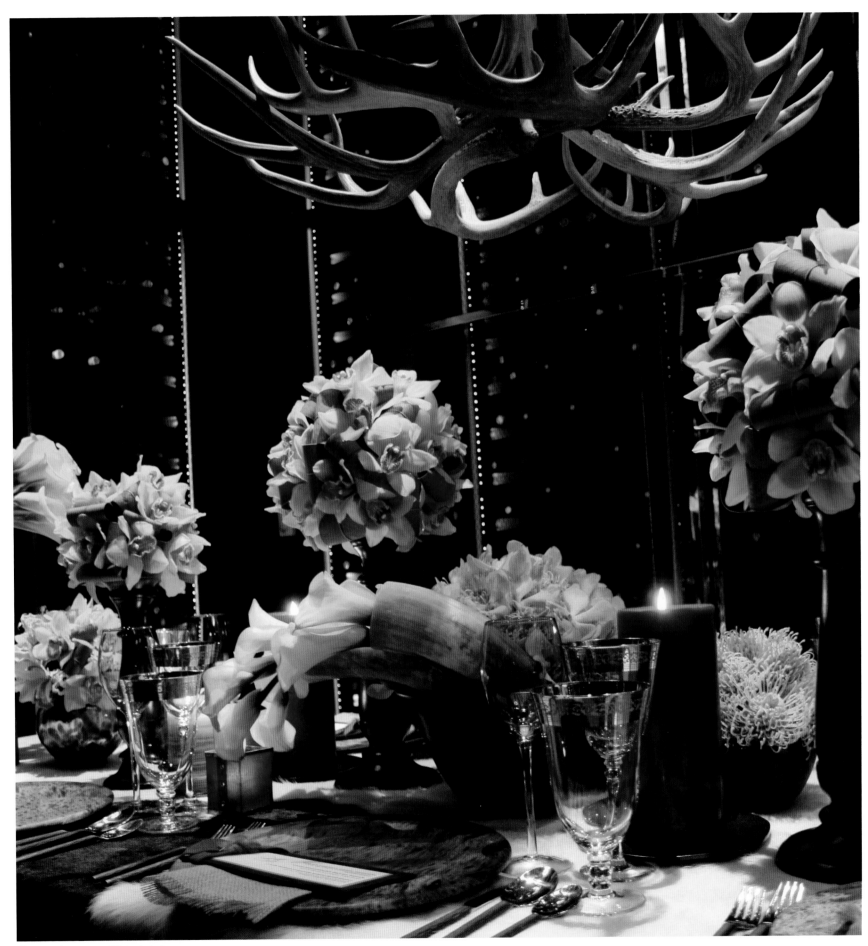

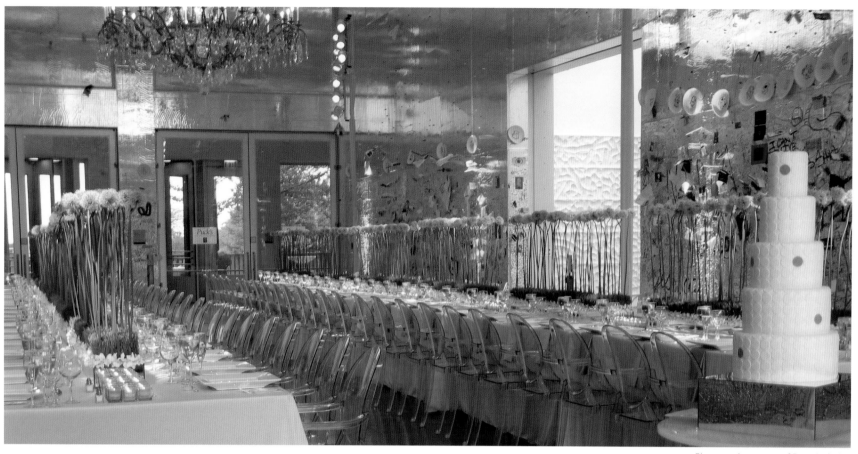

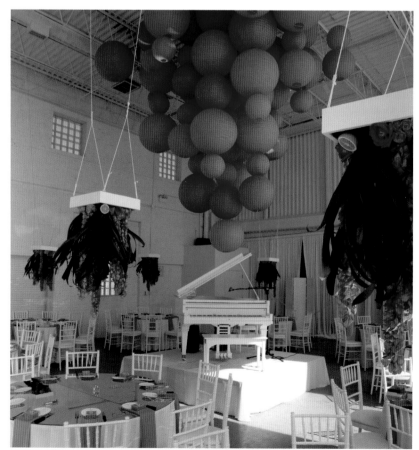

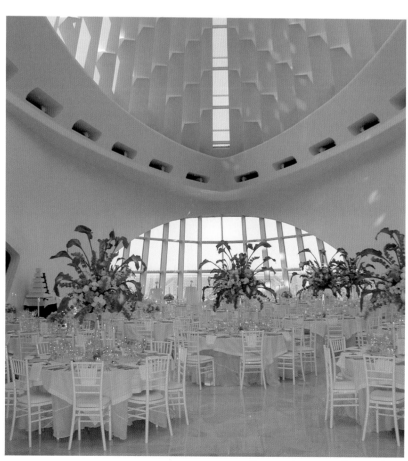

"The best design is rooted in nature."

—Casey Cooper

Right: The inset space under the glass top of a custom-built table allows for many different avenues of creativity. A white fabric underlay fortified with batting created a quilted effect, while green Kermit poms formed an architectural pattern.

Facing page top: A graffiti exhibit was scheduled during a wedding reception at the Museum of Contemporary Art Chicago, so we played up the contrast between chaos and precision with a streamlined runner of wheatgrass, white orchids, and allium.

Facing page bottom left: Hanging floral arrangements lowered the ceiling of a cavernous space while a colorful paper lantern "chandelier" matched the room's scale. As visually interesting as the flowers were from the sides, guests could use the mirrored tabletops to gain a better view of the intricate patterns hidden within.

Facing page bottom right: Everything about the Milwaukee Art Museum is clean, pristine, and architecturally stunning, so keeping the décor white except for the densely formed displays of green goddess calla lilies provided incredible contrast.

Photograph courtesy of Botanicals, Inc.

views

We've found that the most interesting events are born when there's a clash of style. Finding a way to create a cohesive design around disparate tastes often means you end up with a more nuanced, quirky, and individual look. Searching out those contradictions stretches the imagination of both the designer and host, leading you down paths you might not have explored otherwise.

CRESCENT MOON PRODUCTIONS

GRANVILLE ASHLING
MINNEAPOLIS, MINNESOTA

A Chinese proverb states that if you find a job you love, then you will never work a day in your life. Granville Ashling has found this to be true for his life. After falling in love with set design and live events during junior high school, he founded Crescent Moon Productions, a full-service live event design and production company. Crescent Moon Productions works on events of all sizes and offers production management from concept to completion, with lighting design, audio, and video services for permanent installations as well as one-night events.

Creativity, innovation, and a willingness to go the extra mile are cornerstones for how Granville runs his business; he loves the challenges that every week and job bring. Upon learning the objectives and purpose of an event or installation, Granville and his team of experienced designers and craftsmen bring together the requisite tools and equipment. Whether they have six months to research and complete a project, or only 10 to 12 hours to have a show set up and running for a three-hour production that will be seen by thousands, Crescent Moon is ready.

Living Word Christian Center wanted a cutting-edge venue for its Sunday night service that uses the latest technology incorporated into the church experience. The challenge was to portray religious text in a pleasing, respectful, non-showy manner.

Photograph by Rick House

Photograph by Jake Kvanbeck

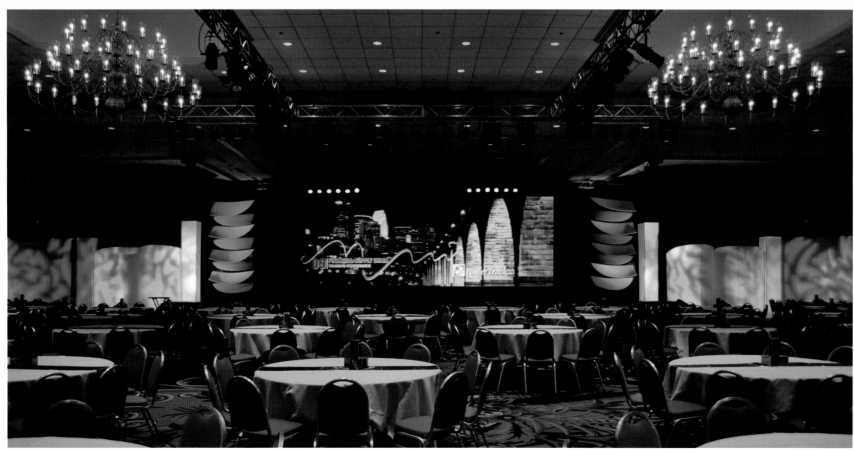

Photograph by Dan Pearson

"Using the right technology in the best way can minimize an event's carbon footprint without sacrificing a bit of the design aesthetic."

—Granville Ashling

Right: I was the lighting designer for a weekend youth event with the band Dutton. After listening to the band's CDs, I created a lighting design that I thought would match their music. We used a 60K rig and a dozen robe fixtures for the event.

Facing page top left: We had only eight weeks to conceptualize, design, and install the project. Two years later it is still running. The church has taken over the role of production manager of the service, a title I held for the first year and a half, and now I strictly focus on the lighting design.

Facing page top right: The challenge in designing Grace Church's Christmas show was properly illuminating the performers—sometimes 75 feet from the stage, in the audience space—so that live images could be clearly shown on a 30-by-60-foot screen.

Facing page bottom: The inspiration for the Power Track event for US Bank Corp. was to capture the mood and look of the four seasons of Minnesota while maintaining a high-class business environment.

Photograph by Jake Kvanbeck

views

Lighting should not be a last-minute thought. It is critical for creating a mood and an emotional response in the audience.

FOOTCANDLES

MICHAEL MURNANE
MINNEAPOLIS, MINNESOTA

It's no surprise that many in the event industry hail from the world of theater. Dramatic flair lends itself exceedingly well to the precise staging and sweeping creativity necessary to execute a wondrous soirée. Footcandles is no different. Run primarily by lighting wizard Michael Murnane, who naturally first began lighting stages in high school for school theater productions, the business is well-known in the Midwest and nationwide as one of the best in bringing unique visions to life—and to light.

During his school days, Michael chose theater as his extracurricular pursuit, and it was backstage with a technical crew that he learned the skill of lighting design. Though he cannot explain why, he's felt an affinity toward lighting ever since the age of two. In 1981, working as a freelance lighting designer, Michael's clientele solidified and he was able to form Footcandles as his base company. Apart from the help of seasonal staff and his wife Deirdre, he's been running the show independently since and is blessed with numerous dedicated patrons. The name Footcandles—deriving from the term used to describe a fixed measurement of light—had been in his head since high school.

Michael views his vocation of lighting design as a craft: a craft that helps illuminate what needs to be seen or shown. Whether lighting an opera, dance, rock concert, gala, architecture, television, or corporate event, he receives inspiration from the intended mood of the affair and then brings the emotional tone of the design alive.

A fundraising gala for the Rape, Abuse and Incest National Network—RAINN—played up themes of security and protection in the form of umbrellas against the rain. I was given creative control of the design, and wanted the guests to feel safe and sheltered.

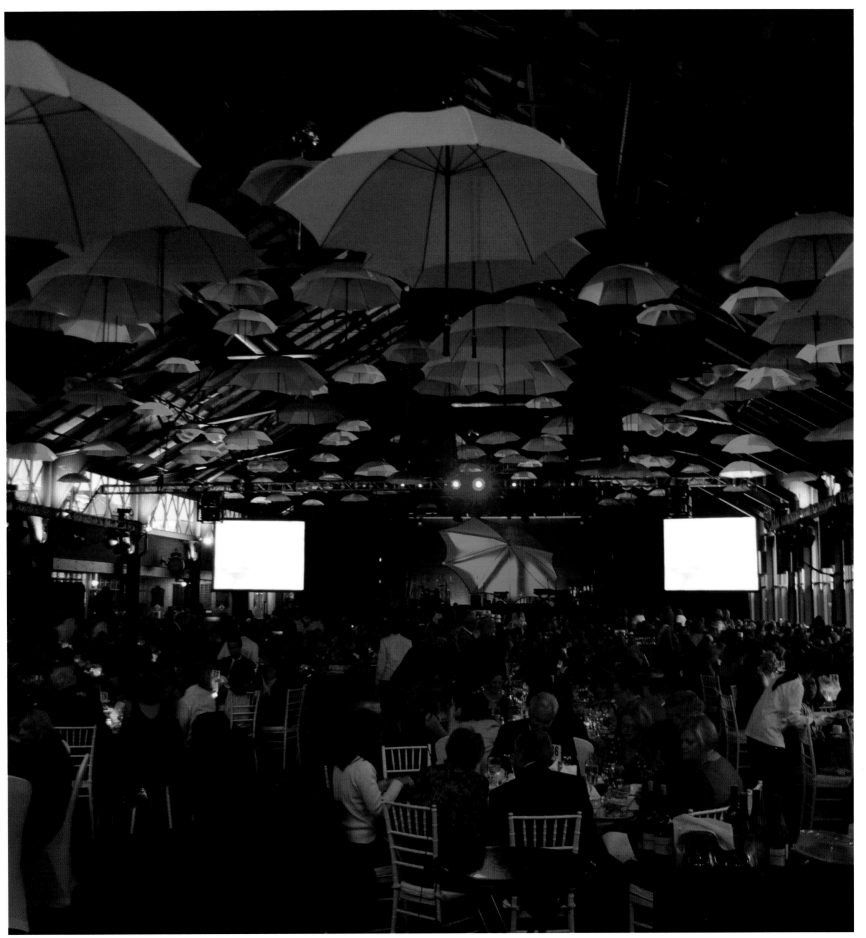

"Lighting should illuminate first and foremost, and then decorate."

—Michael Murnane

Right: In collaboration with David Stark Design for the Minneapolis Institute of the Arts Expansion Gala, I lit a tent with gorgeous pastel hues.

Facing page: Whether lighting the Macy's Glamorama rooftop afterparty or the Target Holidazzle electrical parade float, the space defines the mood and atmosphere forged by the lights. I'm often inspired by music and love to play with how much of the lighting is décor and how much is illumination alone.

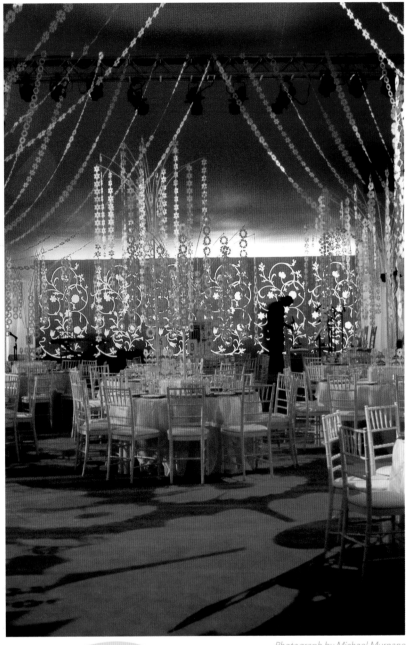

Photograph by Michael Murnane

views

❖ A good lighting designer listens carefully and responds well to all the needs of the production.

❖ The more a lighting designer is included in the creative process, the more he can bring to the table with his skills and experience.

FREESTYLE PRODUCTIONS

DALE KIVIMAKI
MINNEAPOLIS, MINNESOTA

Lights, camera, action! Arguably one of the greatest innovations at large events and shows is the installation of giant video screens that stream live footage of the action onstage, allowing up-close viewing for those in even the farthest seats from the stage. Such an ingenious invention has proven essential to large shows—and the companies that produce it even more so. Minneapolis-based Freestyle Productions is eminently capable of providing not just that but much more, including sound, staging, lighting, scenic elements, and, of course, cameras, projectors, video recorders, and screens.

Through its many years of experience, Freestyle has amassed an impressive portfolio that speaks to the quality and the reliability of its work. Big productions, goes the company motto, require big experience. Founded in 1990, Freestyle began as a video production and editing company, but soon expanded to live event video. The company often partners with sound, light, décor, and design firms for a fully integrated, streamlined experience. Extra perks like a graphics package to tie the entire look together and live video webcasts are readily available. No matter what special request you have, Freestyle will make it happen—effortlessly.

It's only fitting that a company so skilled at facilitating interpersonal communication—by allowing everyone in the audience to read the facial expressions of the speakers and performers onstage—should also be excellent at listening and intuiting its event hosts' needs when approached about a prospective production. An engaged, mutual dialogue is the secret. And the team regularly updates and evolves along with the technology, remaining on the cutting edge of the latest industry developments.

At a formal, black-tie induction ceremony, an ordinary stage turns into something truly special in compliance with the host company's specific guidelines and rigid formula for the annual event. The video, part of the stage set, had to be just right.

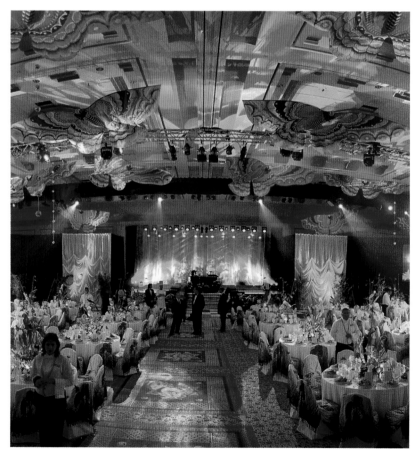

"Anyone can purchase equipment and gear, but it's the people who know how to use them that forge the human connection between your message and your audience."

—Dale Kivimaki

Right: An outdoor event, whether a show at Razorback Stadium with LED screens surrounding and on the stage or a corporate affair on Ellis Island with New York City as a stunning backdrop, poses its own unique set of challenges. Meticulous planning ensures that it will all still go off without a hitch.

Facing page: The ability to fulfill unusual requests, such as providing curved screens—with no video going out of focus—and lighting at an auto show, regularly thrills hosts. And from lighting paper butterflies for a night under the stars in Puerto Rico to providing a full suite of production services to imbue a plain room with a warm, relaxed ambience for a charity fundraiser, it's all about transforming spaces.

views

A computerized inventory system is one of the secrets to success. This includes checking the list multiple times to ensure everything required is on board, and then packing extra items that may be necessary—just in case. Whether operating at home in Minneapolis or in New York or Los Angeles, anticipating hosts' needs is key.

HARVEST PRODUCTIONS

RON DAVIS | BOB DITSCH
KANSAS CITY, MISSOURI

Every major media-inclusive event—from wedding receptions with slideshows to corporate affairs with presentations—needs excellent audio-video coordination. It has the ability to effortlessly elevate any event to one that lingers in the memory, unforgettable. For years Kansas City event producers and designers have been turning to Harvest Productions to bring quality and dependability to churches, venues, and event facilities all over the city.

Bob Ditsch and Ron Davis were technicians who had gotten their feet wet touring with bands and assisting church worship services when they officially founded Harvest Productions in 1986. The company began providing sound reinforcement for the Kansas City Symphony and Starlight Theatre, while also performing audio, video, and lighting installations for small churches. Word of mouth spread—thanks in part to a team committed to high standards—and Harvest now enjoys a diverse clientele and numerous designers from a wide range of backgrounds in its employ.

Some events are performance-based, viewed from a virtual fourth wall, and some are event-based and more all-encompassing. Harvest has designers that specialize in each type, so every audience is satisfied with the experience. The development process works backwards, by asking the host what the audience should be saying, thinking, and feeling when it's all over. From there, the team hammers out the needs of the event—an energizing morning session, a midday attention-grabber, or an evening reinvigorator? This method allows the team to stay focused on the primary objective, while also trimming off any unessential elements. Above all, the business is about serving people—a philosophy that allows Harvest Productions to truly reap the fruits of its labor.

It's exciting to work at the Starlight Theatre because it has a lot of technical infrastructure without much built-in décor. In accordance with event designer Ellyn Bold's design concept, we produced a ceiling, backdrops, and background that brought to life an airy, bright garden feel with topiaries.

Photograph courtesy of the Kansas City Symphony Orchestra

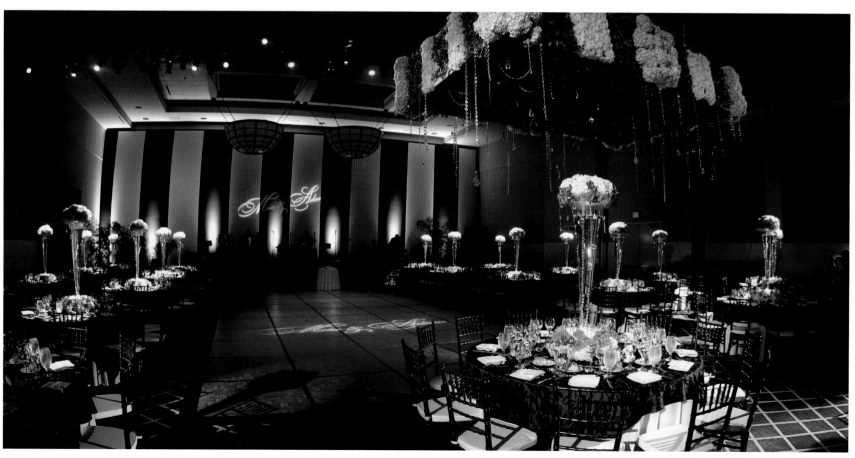

Photograph by Wirken Photography

"We believe in offering results that garner praise and remarks—we call it remarkable service."

—Ron Davis

Right: Commissioned by event designer Ellyn Bold who envisioned a contemporary, edgy feel in the Starlight Theatre, we laid out a dance floor in the center with dinner tables along the sides. Bright, artistic windows lined the walls and space between served as a focal point drawing people and activity into the middle.

Facing page top: At a giant—50,000 people—celebration at Union Station, we produced an experiential lighting, audio, and visual experience that changed throughout the evening. Natural light gradually evolved into illuminations as night fell, culminating in a grand fireworks display.

Facing page bottom: In a traditional ballroom setting, our job was to relate designer Ellyn Bold's color palette to the space, adding splashes of color to the dance floor and setting a lighting and ambience focal point. We continually strive to keep our vision consistent even from a distance. These events should, quite naturally, be positive and celebratory as they turn our hosts' and designers' ideas into reality.

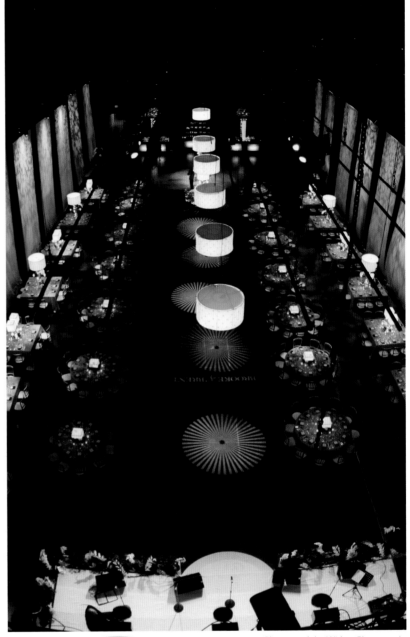

Photograph by Wirken Photography

views

We train our associates to view these events as a forum through which our hosts are exposing themselves to all their most influential peers, everyone that's important in their lives—this is going to be a soul-baring experience.

Eat, Drink & B

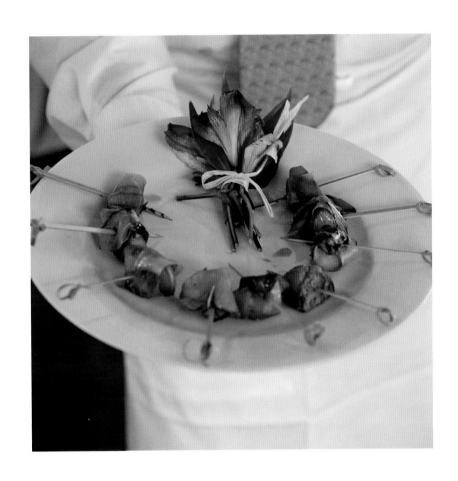

Merry

Lon Lane's Inspired Occasions

LON LANE
KANSAS CITY, MISSOURI

Every party should tell a story. The initial concept sets the stage. The story begins with the invitation and the tale is intricately woven as the party unfolds from the signature cocktail through to the parting gift for guests. All elements of the event must support the storyline.

At Lon Lane's Inspired Occasions, the storyline is paramount and is the inspiration when crafting exciting proposals, preparing unique food, and designing unforgettable events. Founder Lon Lane and his team of "storytellers" create celebrations designed specifically to the tastes and preferences of the hosts, making dreams come true.

Known for innovation in menu design and an ability to breathe excitement into the process, Inspired Occasions produces unforgettable parties and sets trends that lead the industry. How do they do it? Every person on staff has at least one thing in common: a passion to ensure all of the pieces coalesce for an experience that tells the complete, remarkable story from beginning to end. Lon's passion for quality cuisine and unparalleled ambience requires him to approach each event as if it's the only one. Every event host must feel as if he or she is the most important one and that the corresponding "story" will be the best and most remembered.

A home built in the 1920s prompted a speakeasy theme, which was carried throughout the décor and cuisine. We created a Georgian tablescape with antique silver and designed a menu reminiscent of the Prohibition era. Whole smoked salmon and in-house, dry-aged whole Kansas City strip steak carved tableside were the stars. An array of creatively prepared and displayed vegetables and dips completed the main table. Dessert was a reflection of the bustling cities of that era, offering Chicago-style, New York-style, and Miami-style cheesecakes.

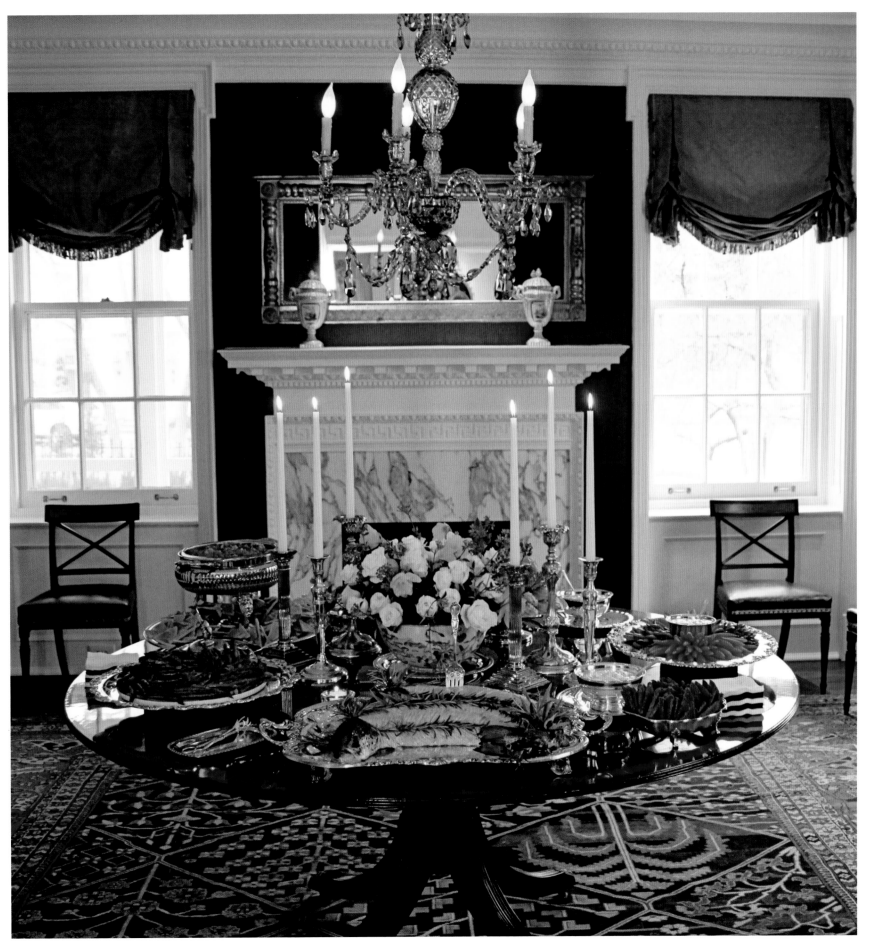

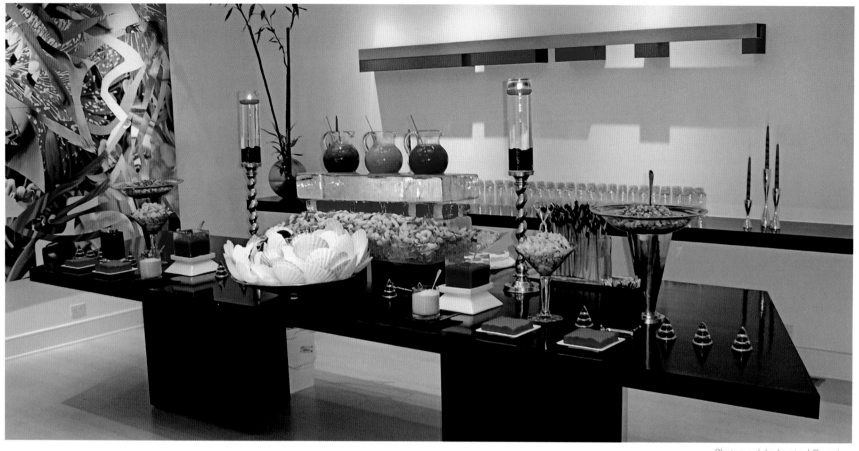

"Planning an event is a discovery process, beginning with uncovering the host's dreams, then creating and delivering an experience beyond expectations."

—Lon Lane

Right: A reception of ivory, gold, and white at Kansas City's Union Station really popped against the existing black and ivory marble. Since the groom was a train buff, we designed the first course to arrive via seven rolling Caesar salad buffets in a train-like procession down the center aisle—where the chefs tossed and customized each guest's salad tableside.

Facing page: Color plays a spectacular role in the presentation of the food. From the primary color scheme in an art collector's home—where the hors d'oeuvres and ice creation mimicked the sculpture on the wall—to the brilliant, fresh hues in a bridal bouquet salad or a tri-color gazpacho display, every element can be incorporated to complete the central storyline.

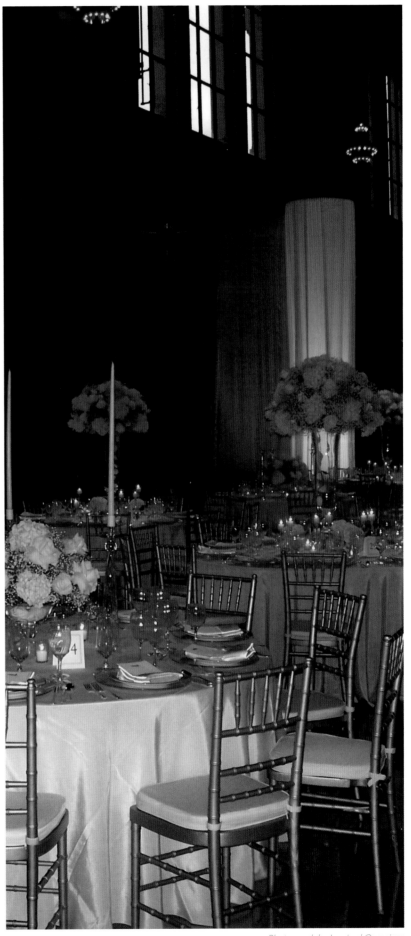

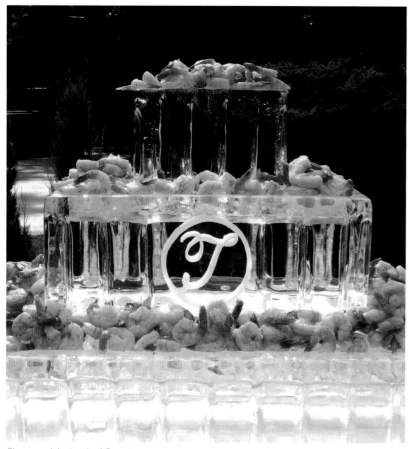

"An event is not just about the food, flowers, music, or decorations. It's about the experience."

—Lon Lane

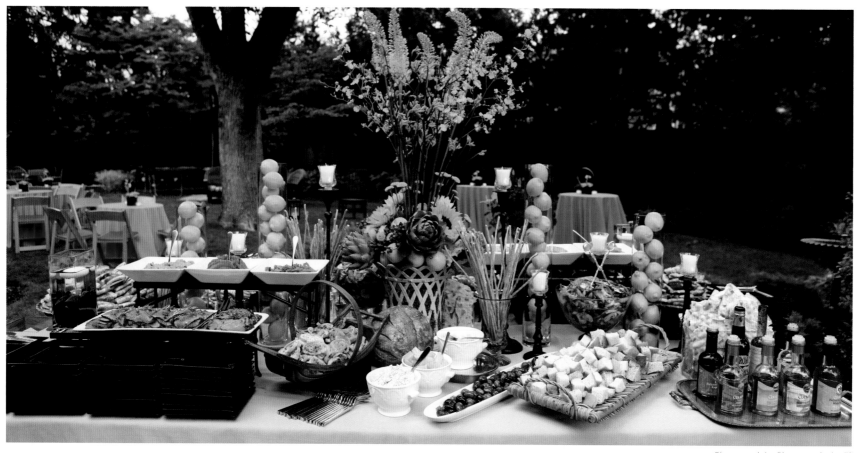

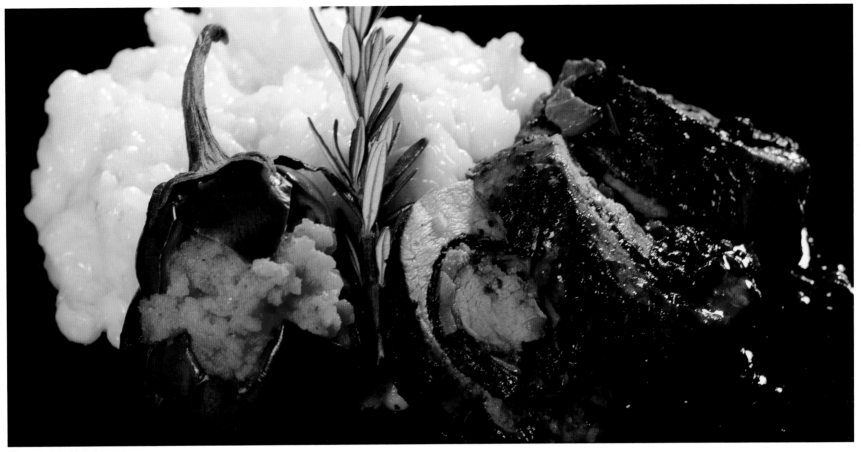

Photograph by VML Advertising

Above: For an upscale plated dinner party, stuffed veal tenderloin, Thai eggplant filled with carrot purée, and white corn risotto was the featured entrée.

Right and facing page: We create excitement and appeal through innovative presentations. An ordinary dish can be transformed with an extraordinary appearance, whether through a stylistic display of sandwich wraps, a beautiful ice carving that doubles as a serving piece, or a tapas-themed buffet with breadsticks, lemons, artichokes, and sunflowers.

Photograph by Inspired Occasions

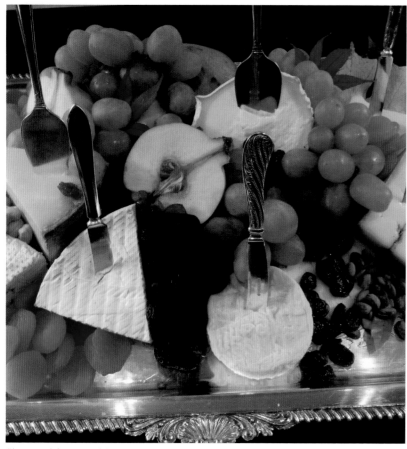

Left: Our inspiration often comes from within as we draw ideas from our own passions or from the need to creatively solve a problem—such as allowing guests to more easily eat crudités by placing them in a cone filled with dip.

Facing page top: A Middle Eastern salad station featured a distinctive arrangement utilizing a green and white palette. Leaves, Nile grasses, and breadsticks allowed the eye to be drawn up vertically.

Facing page bottom: Much to the guests' delight, place settings were set on an angle for a more contemporary, unconventional approach. To start off the evening, the amuse-bouche was a pan-seared sea scallop placed on a mother of pearl plate atop a bed of white lentils, simulating pearls.

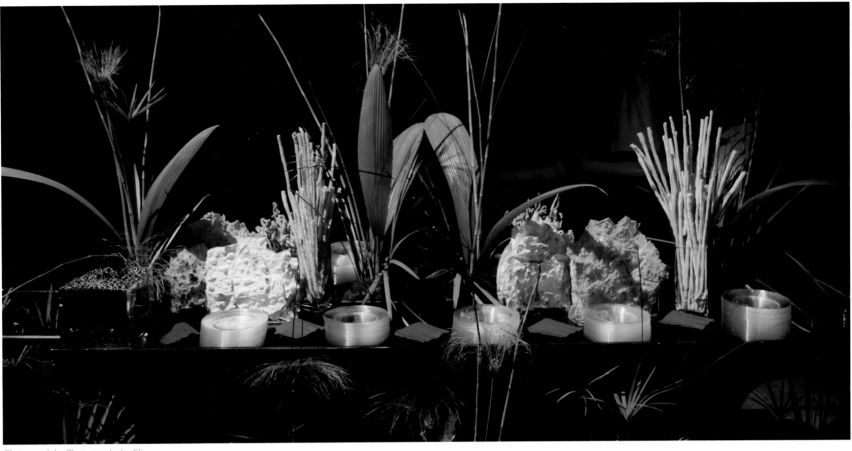

Photograph by Photography by Eli

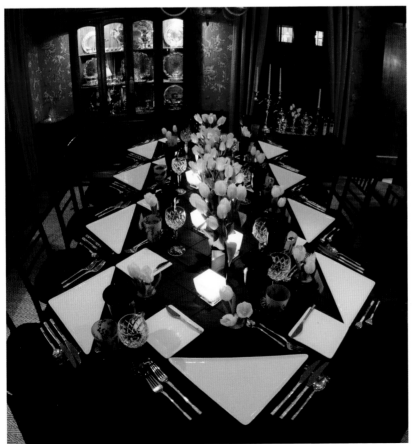

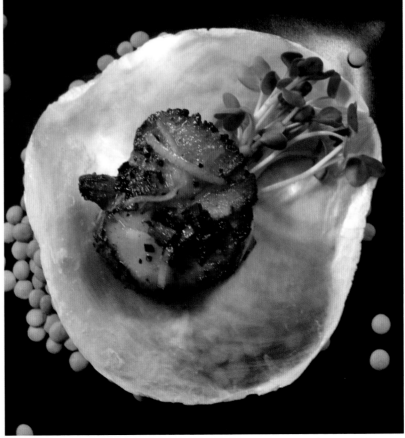

Photograph by VML Advertising

Photograph by Inspired Occasions

Photograph by Inspired Occasions

Photograph by Inspired Occasions

Photograph by Brian Ousley, Boom Multimedia

"Cooking is a creative outlet for the spirit and the soul."

—Lon Lane

Right: The opening of a world-class, modern wing at Kansas City's premier art museum prompted us to serve high tea with a contemporary twist. Chilled cantaloupe and honeydew melon soups, various gelée desserts, lemon and raspberry parfaits, and chocolate-dipped fruit, all set in acrylic containers or on silver forks, showcased cool colors and clean lines.

Facing page: Commonplace elements can be elevated to a more memorable use, often by changing the presentation. We love to utilize chef-attended stations for dishes like grilled bruschetta, where guests can choose a variety of olive oil flavors and toppings for the ultimate appetizer. Other avenues to refresh a traditional dish are unique ways of serving the food or by turning the food or beverage into a professionally lit work of art.

Photograph by Spaces Magazine

views

When planning your event, develop and tell the best story you can. You are limited only by your imagination. You can make your wildest dreams come true. It's all about working with your event team to maximize your resources. Surely you have a story that needs to be told, so let's tell it!

BLUE PLATE

CHICAGO, ILLINOIS

No one knows exactly what Chicago wants like a true native; thus, when Jim Horan began cooking for friends and neighbors in the early 1980s, his food was an immediate hit. Starting small with plenty of passion, Jim's part-time hobby took off after a few catering jobs with the Chicago film industry. With just himself, a van, and tons of delicious fare, Blue Plate began.

Over the years, the company has grown dramatically, feeding and serving the city with its 500-plus team in some of the country's most famous venues. A one-stop shop for event planners and hosts, Blue Plate offers a wide range of services to pull off the hottest events with the most attentive service. Chef-driven and always exciting, the cuisine reflects creativity and freshness. Menu selections like pan-roasted Mannin Bay Irish trout with Guinness butter sauce or blackberry bombe on pistachio shortbread give event-goers a restaurant-quality experience that leaves a lasting impression on the palate. As the menus expand and the company matures, the Blue Plate team knows its roots. The distinct Chicago personality that existed when the company first began will always pervade, giving a close-knit boutique feel to the booming operation.

We used elegant centerpieces and blue-and-purple-toned swirl patterns to set the mood at a family-style sit-down dinner, post-nuptials. A tented event, the dinner took place at Northerly Island.

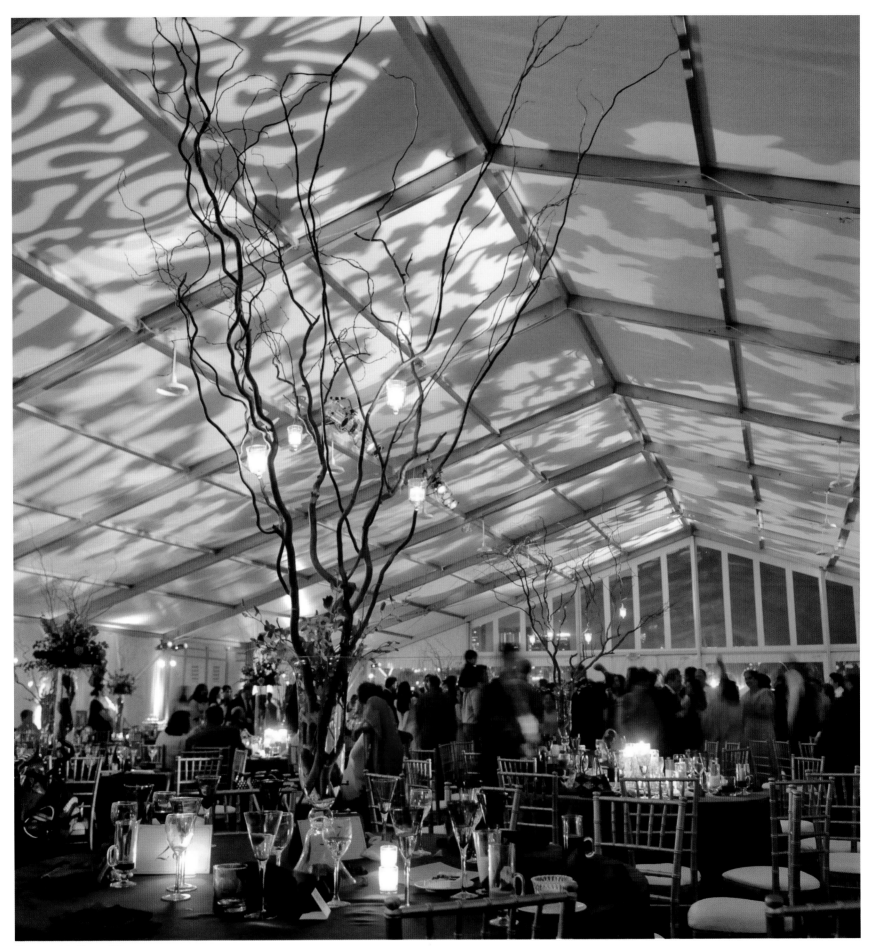

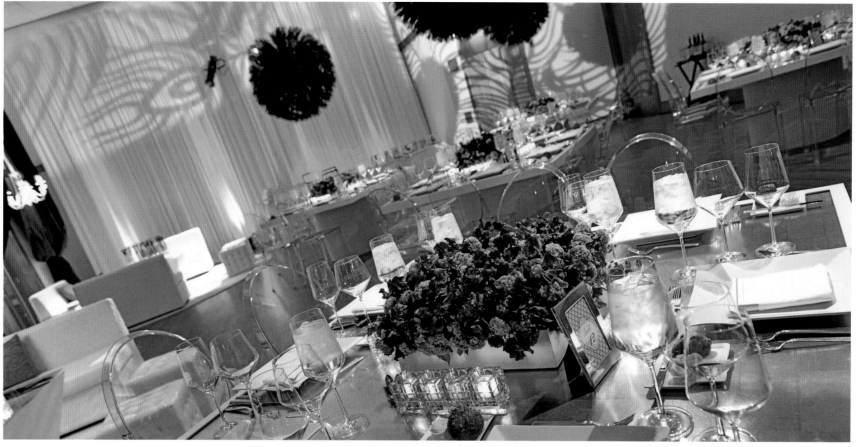

"It's the small things that make an event memorable. The more customized the better."

—Jennifer Perna

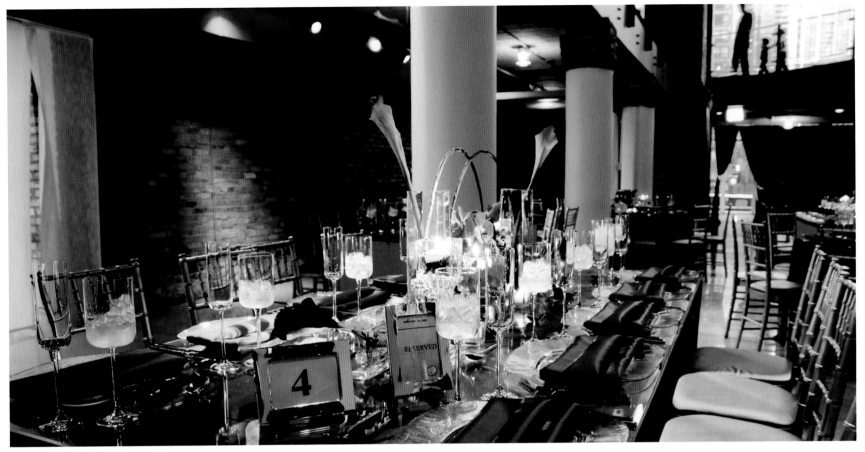

Above: The River East Art Center worked as a dramatic venue. The exposed brick, columns, and theatrical lighting made for the perfect setting.

Right: By using intense flavors on a menu, we can highlight the feeling of excitement at an event: pea-mint grapefruit salad served in hollowed grapefruit rinds offers a refreshing burst.

Facing page: Infused with a glamorous feel, an event in Chicago's Ivy Room displayed peacock feathers and peacock accessories dangling from the ceiling. For starters, we served delicate salmon biscuits with caviar.

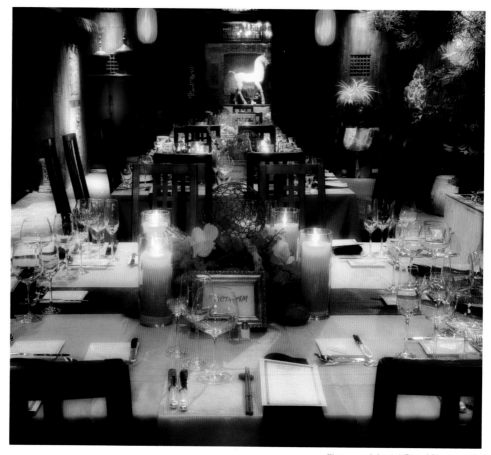

"You eat with your eyes first. Anyone can put food on a plate, but if it looks amazing, people notice. Artistry and aesthetics are such an important part of our business."

—Paul Larson

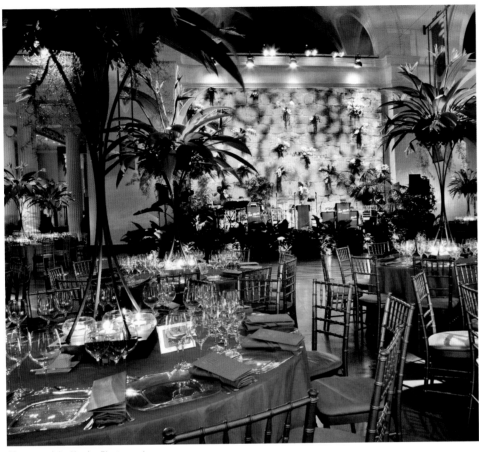

Above left: The Field Museum was transformed to give guests the distinct feeling of dining in an enchanted forest.

Above right: The vivid green from the Brussels sprouts gives chicken with peanut sauce a beautiful presentation. Incorporating splashes of color lends an eye-catching effect to the plates.

Facing page left: We love combining classic ingredients with an unexpected twist. Thai chili and lemon aioli added modern flair to Alaskan king crab.

Facing page right: For a minimalist, Asian-inspired event at The Golden Triangle in Chicago, we used Eastern ingredients throughout the menu.

"If the chefs and the servers aren't the best in the business, no amount of planning will matter. Solid team members make it happen."

—Jim Horan

Right: Private residences can be just as fun as extravagant venues. For a baby shower, we transformed a home with vibrant pinks and oranges.

Facing page: Our dishes reveal the talent of our chefs, training and working in the top culinary schools and restaurants around the country. Raspberries with cheese on mint leaves, gargouillou, crispy pan-seared skate wing, and lobster ceviche skewers taste as good as they look.

Photograph by Jai Girard Photography

views

Hosts and hostesses often take on too much stress during the planning of an event. To curb that, let go of some of the responsibility and place it into hands you trust. If you hire professionals, let them do their job. Relinquishing a little control and putting confidence in the people around you will make for a much more enjoyable evening.

ENTERTAINING COMPANY

WENDY PASHMAN
CHICAGO, ILLINOIS

Food has always meant far more to Wendy Pashman than the simple act of drawing nourishment. Beginning with the multicultural dishes her mother served when Wendy was a child, she has always gathered inspiration from diverse cuisines and the cultures from which they came. From visits to New York as a child to travels around the world as an adult, she has associated delicious ethnic food with the smells, textures, history, and traditions of people from every region of the globe.

Wendy launched Entertaining Company in 1992. Her love of ethnic cuisine and global culture has been the point of departure for event and menu planning at Entertaining Company for the past two decades. Wendy steered the focus to planning globally inspired, multicultural events with the goal of celebrating each event host's unique background.

Wendy's vision went far beyond the food typically served at catered events. She sought veteran restaurant chefs and sophisticated waitstaff. As a result, Entertaining Company's upmarket menus rival the finest restaurants in complexity and quality but also in the cleverness of each dish's presentation. Whether they are preparing a casual dinner with a minimalist style or an elaborate Indian celebration, Wendy and her staff carefully plan and consider the appearance of the food and the surrounding décor, down to the smallest details. Entertaining Company's vibrant events create a sense of wonder in every guest.

Our miniature donut sippers are a popular treat. The donuts are made fresh and decorated on-site with colorful glaze, sprinkles, and toppings. We like to set up our donut station so that guests can dip and dunk for themselves. We often make up bags of donuts as to-go favors or pass them on mini demitasse cups of our signature coffee for an after-dinner sweet surprise or a late-night dip-and-sip treat.

Photograph by Rachel Schwanz

Above: For a boardroom dinner, we used our signature savory cones nestled in colorful lentil to serve smoked salmon with lemon aioli. Black rocks and flowers added an Asian feel and created a balanced masculine and feminine look. The functional nature of the cones meshed well with the artistic presentation and made for a delightful meal.

Facing page: We developed a luscious mango cocktail recipe for an Indian reception that we've since used for several other lively, colorful events. We use a few surprising elements to keep it fresh—a savory flavor instead of the expected sweet taste, an unusual red pepper garnish, and a gin base instead of vodka.

"The culinary arts should marry artistry and practicality."

—Wendy Pashman

"Savoring culturally diverse food is like embarking on a worldwide traveling expedition."

—Wendy Pashman

To accommodate Indian traditions and create a beautiful presentation, we combined Western-style service for the fish, lamb, and potatoes with traditional family-style service of the side dishes. In addition to the cuisine, we also designed and executed the décor. Tablecloths made from Indian silk with sari fabric adorn the corners, lighting with patterns copied from the invitation set the mood, and napkins made from New Delhi beads add a vibrant, customized look to the room's ambience.

Photograph by Chris Cassidy

"Every tabletop is a stage."

—Wendy Pashman

Right: Instead of a traditional cake, we favor individual desserts, such as mango mousse. The individual portions lend themselves to dramatic presentations.

Facing page: A large focus of each catering event should be on styling the presentation of the food and drinks. Whether the event has a modern, relaxed atmosphere with tandoori grilled tofu presented in clay pots or a traditional feel with a classic menu of steak, fries, and salad, the cuisine should appeal to the eyes first.

views

To create an event with a cohesive look and feel, combine the host's desired ambience with the purpose of the occasion; then make food and beverage selections that complement the décor and reflect the host's personality.

J&L CATERING

TED GRADY | KEVIN KELLY
CHICAGO, ILLINOIS

When a large company with resources and expertise in spades feels small and intimate, that's the perfect balance between capable planning and personalized, exceptional service. For over 20 years Chicago's J&L Catering has given its clients focused attention while an array of chefs and planners bustle away behind the scenes.

Founded in 1989 by John Chavez and Lisa Gershenson—J&L—as a small, boutique-style catering firm, the business has been built up by years of success. With a longstanding stellar reputation, both within the industry and from a loyal clientele, J&L Catering is now run by Kevin Kelly and Ted Grady after John and Lisa passed on the torch in 1998. J&L is a caterer first and foremost, but also provides complete, personalized event planning to ensure the entire party is consistent, thoughtfully designed, and united. With a team of eight experienced event designers, J&L helps hosts create completely customized menus for any style of event. One of the firm's most unique aspects is its staff of more than 135 waiters, bartenders, chefs, delivery personnel, and managers—all trained in-house with an average time of more than five years with the company.

J&L prides itself on its versatility, with a diverse culinary team representing several countries and the ability to produce authentic, healthy, thoughtful food. From casual dining to globally inspired menus and upscale 12-course meals with exquisite wine pairings, J&L remains on the cutting edge of culinary design in the Chicago catering arena.

Our in-house pastry chef, a skilled candy maker, crafts the majority of our pastries and sweets from scratch daily, including our famed truffles in a variety of flavors and styles.

Photograph by Shawn-Erik Toth

"Whether we work with a bride, a social organizer, a corporate head, or a gala committee, we forge a true partnership."

—Ted Grady

Photograph by Shawn-Erik Toth

Above, right, and facing page: From a Mediterranean salad amuse-bouche to New Zealand baby lamb chops with risotto timbale to a champagne display at a garden party on the lake to wild Alaskan halibut on couscous with market herbs, our creations are capable of tempting even the hardest-to-please palates.

Previous pages: We pride ourselves on our non-traditional buffets, such as the Asian-inspired vignette at a wedding held at A New Leaf in Chicago. Organic spinach salad, spicy Asian long bean salad, house-made sushi, rice stick noodles in clever to-go boxes, and scallion biscuits adorned the tantalizing and creatively displayed array.

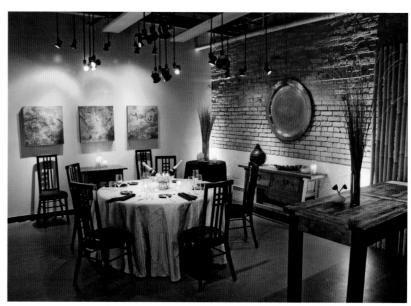

"Each bite of food should be lovingly made into something special."

—Kevin Kelly

Right: Our fare served nearly 800 people at the annual Dance for Life held on the rooftop of the Harris Theatre for Performing Arts.

Facing page: We regularly collaborate with our host and the florist for elegantly synthesized tabletop designs. An amuse-bouche featuring a bite of fish in an Asian bowl is an excellent appetizer choice, and our private tasting room on Chicago's Goose Island can be dressed up to give our hosts a glimpse of their event to come while doubling as a small event space of its own.

Photograph by Shawn-Erik Toth

views

If the executive chef planning and cooking your meal is also the co-owner of the company, you know you're in excellent hands. Work with caterers and chefs who truly care about the outcome of your event and food, and you have an experience that's guaranteed as delicious as it is satisfying.

BERGHOFF CATERING

CARLYN BERGHOFF
CHICAGO, ILLINOIS

Well-appointed catering requires style, flair, and passion. A dash of family tradition doesn't hurt either, and Berghoff Catering founder Carlyn Berghoff has all that and more. A successful caterer in her own right—running her business Carlyn Berghoff Catering since 1986—she took over her parents' popular 107-year-old Chicago restaurant The Berghoff in 2006, combining the roles of caterer and restaurateur into one winning recipe.

An on- and off-premise caterer, Berghoff Catering enlivens venues all over the city that range in feel from modern to classic—with the company's own Berghoff Restaurant home base falling on the latter end of the scale, with its Old World charm and storied history. Carlyn has pursued a love of food her entire life, and she attended the Culinary Institute of America to understand everything about food in order to work with it. Her affinity for catering—Carlyn's "first love"—is directly related to its inherent demand for creativity and poise, with each event and venue different every time. The menus and recipes are constantly reinvented and tweaked as new information gleaned from books, publications, culinary trends, travel, and even store windows and catalogues informs the collective expertise of the Berghoff team.

Fresh, local ingredients are essential to create Berghoff's innovative and contemporary cuisine, and in fact often inspire it. Carlyn has been similarly inspired by her daughter's celiac condition to educate her team on how to handle special dietary restrictions—which also equips her to better serve hosts' needs. Specific requests are no problem for the team, who listen intently and then collaborate intensively to make a host's vision a reality. Berghoff thrives on the essential role it's played in its patrons' histories for over a century now.

We always prefer fresh, seasonal, and local components for our recipes, as in the case of our artfully arranged halibut marcona.

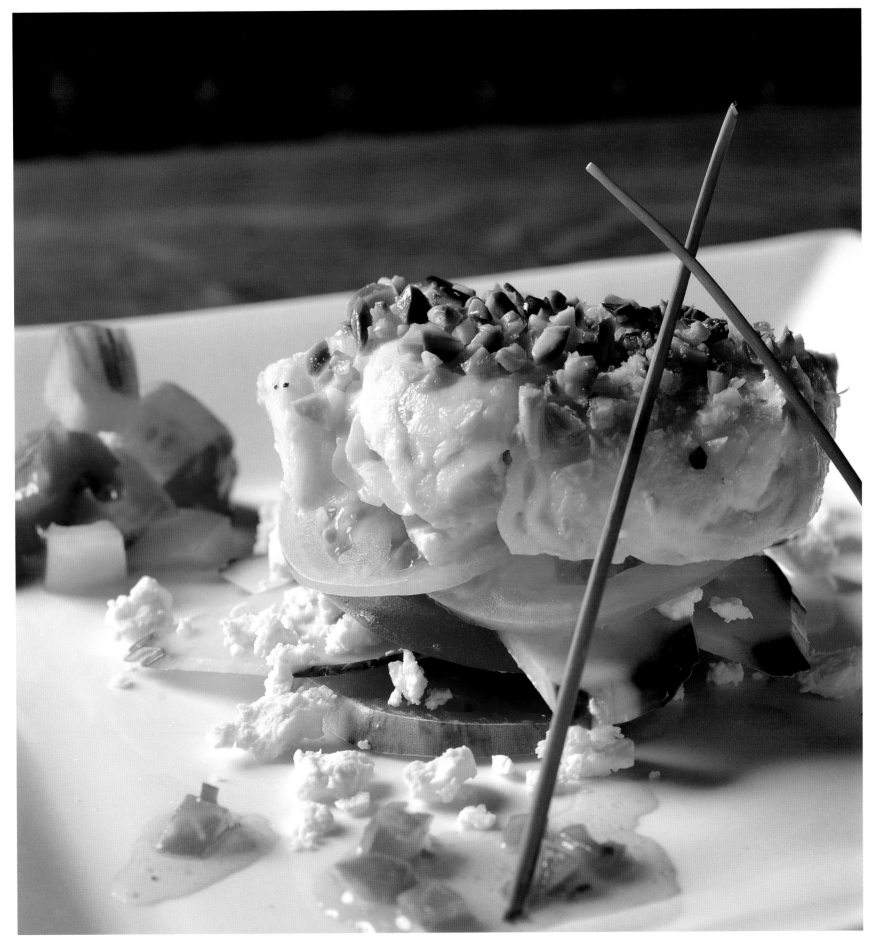

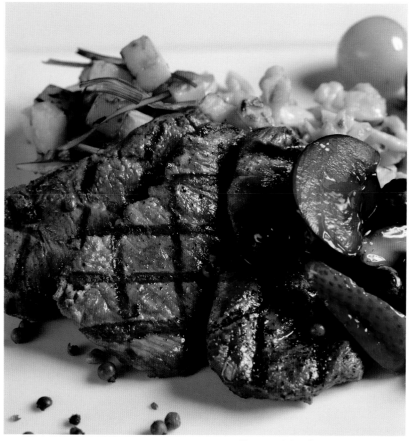

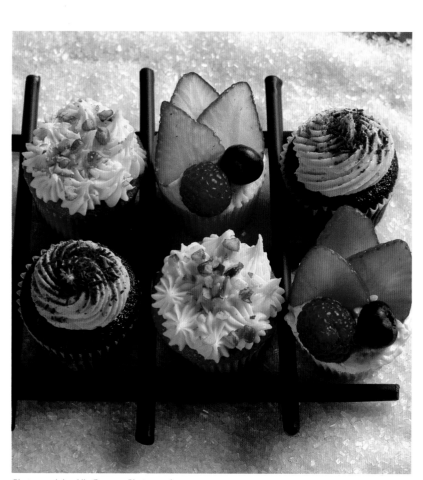

Photograph by Gerber + Scarpelli

"A passion for perfection is absolutely essential in catering."

—Carlyn Berghoff

Top right: An almond wedding cake—we're unique in that we have an in-house pastry chef—with crème brûlée and chocolate mousse stands out against an origami backdrop.

Bottom right: The Berghoff Restaurant's historic Century Room remains an elegant and classic choice.

Facing page: Creative, appetizing presentation is key. We play up the freshness and the texture of our food for maximum appetizing effect, from Humboldt Fog chèvre salad to venison with plum compote and German spätzle to assorted cupcakes—available gluten-free—to apple lollipops dipped in caramel.

Photograph by Ally Gruener Photography

views

Formulating a strong operation plan is like air traffic controlling. We think of the sales, operations, service, and culinary divisions as four pieces of the catering pie. The pie can't be whole without all four slices, even though there will be times when there is less of one or the other. All four must work together throughout the entire planning process. Inventories, floorplans, operational meetings, and timelines are crucial.

BON APPÉTIT MANAGEMENT COMPANY AT THE MINNESOTA HISTORY CENTER

ST. PAUL, MINNESOTA

As an on-site restaurant company with catering at its roots, Bon Appétit Management Company complements its culinary expertise with a tradition of seamless service and event execution. The chefs create food that is alive with flavor and nutrition, prepared from scratch using genuine ingredients. Bon Appétit operates according to a philosophy of providing food services for a sustainable future, and started practicing eco-friendly methods long before they became trendy.

Bon Appétit Management Company supplies museums, corporations, and colleges with delicious, authentic, and sustainable fare. Founded in 1987 by Fedele Bauccio and Ernie Collins, the pioneering company has expanded its commitment to sustainable practices over the years and remains devoted to sourcing and preparing only the highest-quality foods. All of its cafés source food from regional farmers and artisans, and trained chefs create new menus every day based on seasonal availability.

Events held at Bon Appétit venues, such as The Minnesota History Center where Michelle Kirkwold presides as general manager and director of catering, are far from ordinary. Each menu is custom-made according to the host's desires, and with both food and venue controlled by one company the celebration is seamless in theme and execution.

Our affairs can be dressed up any number of ways, such as the early spring cocktail party with tables draped in stunning platinum linens, accentuated by a view of St. Paul's Minnesota State Capitol.

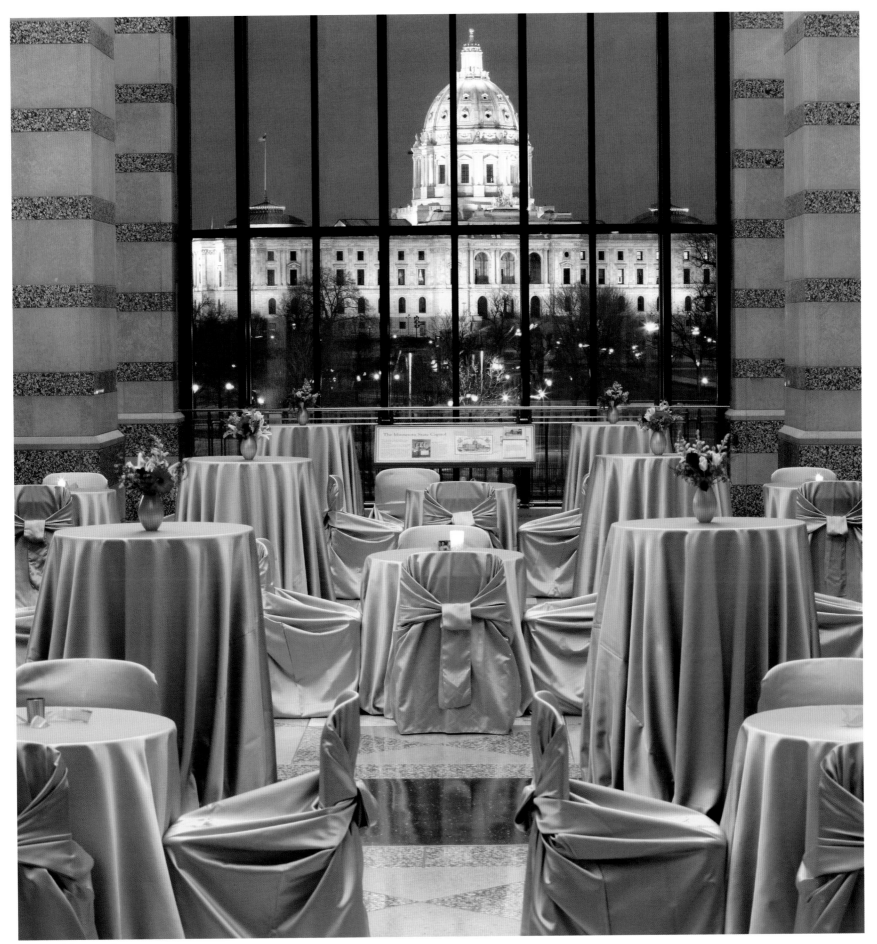

Photograph by Coppersmith Photography

Photograph by Olive Juice Studios

Photograph by Coppersmith Photography

Photograph by Coppersmith Photography

"A well-orchestrated event with beautifully arranged food and intuitive service delights and rewards the guests and the caterer alike."

—Michelle Kirkwold

Right: At a social dinner event for 250 guests we brought in deep aubergine shades and rustic centerpieces. Made of grasses and wheat picked from a local prairie, the decorations echoed the locally sourced menu. Together, the food and décor paralleled our position as a caterer marrying upscale cuisine with the basics of nature.

Facing page top left: A refreshingly non-traditional dessert reception after a wedding featured plates of papaya crème brûlée paired with a buttery French dessert wine and an edible orchid. The splashy colors of gold, brown, and fuchsia result in a vivid visual impact.

Facing page top right: We believe food presentation encompasses texture, shape, color, and flavor standpoints. A quinoa polenta cake with fresh crab garnish was passed as a light and multihued hors d'oeuvre at a corporate function.

Facing page bottom left: At an intimate cocktail event, a curried brook trout appetizer with chutney and melon relish is more than just a creative flavor explosion—it illustrates our commitment to sustainable ingredients, as the fish was caught nearby. All of our seafood is purchased according to the Monterey Bay Aquarium's Seafood Watch guidelines.

Facing page bottom right: Another selection at the dessert reception enticed guests with a hand-crafted dark chocolate truffle and sliced strawberry paired with deep red dessert wine.

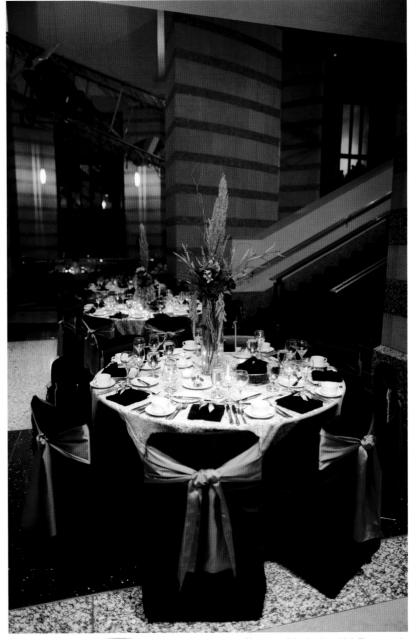

Photograph by Andrew Vick Photography

views

Choose a caterer who will use a multipronged approach to pull off a flawless event—and make sure it's someone who's truly passionate. Steady communication between host and caterer, pre-planning and organization, accessibility the day of the event, and worry-free problem-solving capabilities are all qualities to seek in your caterer. The right company will be so thoroughly prepared that any demand or want you have will be accommodated.

BUTLER'S PANTRY

RICHARD L. NIX JR.
ST. LOUIS, MISSOURI

The most successful enduring businesses today often have the humblest of origins—and retaining that humility through success is an excellent way to ensure continued prosperity and patronage. St. Louis-based caterer Butler's Pantry has that covered, as despite the company's status as a leader in its field, the team remains intensely dedicated to crafting an intimate, personalized experience for every host and event, big or small.

Richard and Anita Nix founded Butler's Pantry in 1966 with the desire to furnish St. Louis with the most innovative and creative catering company around. They began by providing small hors d'oeuvres at minor events, aiming to offer simple entertaining in original, inventive ways, and eventually expanded into full-service catering. Son Richard Jr. has carried on his parents' legacy and grown the business exponentially. Thanks to the combination of his drive and the hard work put in over the years by the founders and their committed team, it's now one of Missouri's largest and finest full-service catering companies.

Team members constantly challenge and inspire each other. The menu development process is especially inclusive. On a biweekly basis, the entire staff—not just the chefs—sits down for "idea hour," and a dynamic brainstorming session ensues. Suggestions are culled from the expertise all team members constantly hone by reading food magazines, attending conventions, eating at a variety of restaurants, and visiting a range of event spaces, ensuring the firm's freshness and relevancy. And when faced with the chance to sample and serve such delectable fare, you'll absolutely find every reason to celebrate.

Showcasing our focus on seasonal, fresh food from local farmers' markets and simple, elegant presentation, balsamic grilled peach wrapped in prosciutto and fresh basil tempted guests' palates at a cocktail reception for the BMW Championship.

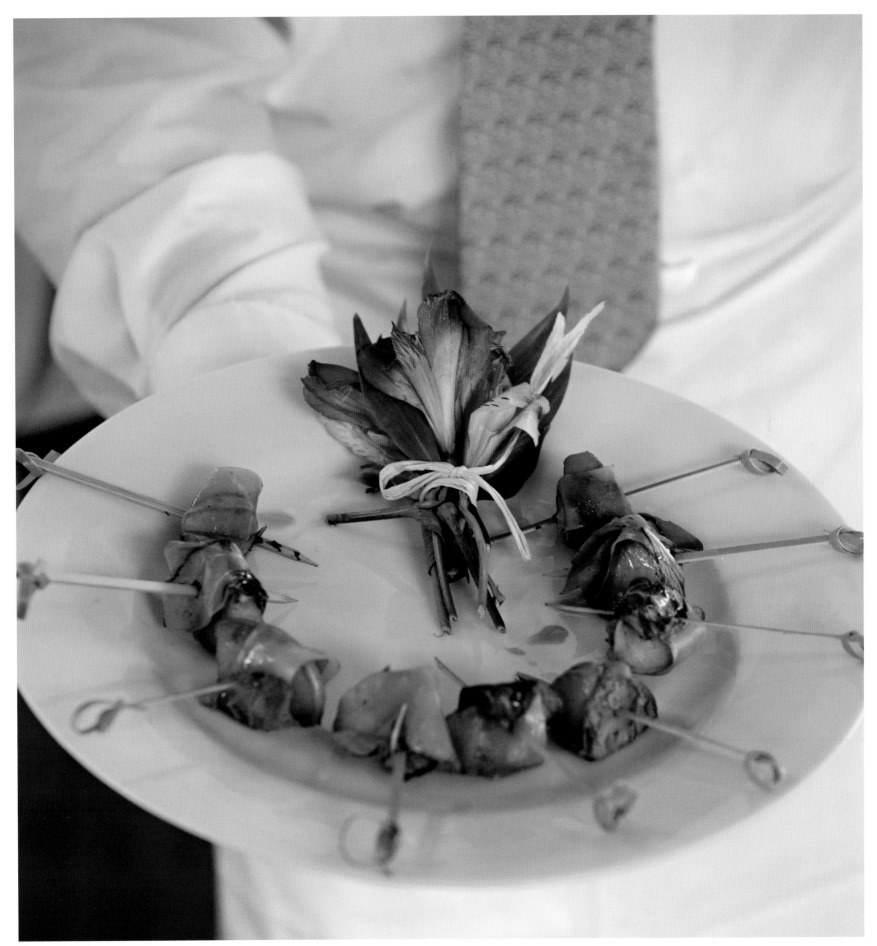

"We love to surprise our hosts by serving something unexpected yet fitting, like a parting gift of saltwater taffy as an homage to a beach engagement. It's all about adding a personal touch in relation to the event."

—Richard Nix Jr.

Right: An open-air, Napa Valley-themed 50th birthday party featured a buffet of artisan cheeses, hand-crafted of the highest quality ingredients and paired by sommelier with Napa wines. Components of the cheese course included goat with fennel, Piave, a wheel of Parmigiano-Reggiano garnished with honeycomb, fig chutney, balsamic strawberries, champagne grapes, assorted olives, and salted marcona almonds.

Facing page top: Daunting heat and an outdoor tent for prep space presented a challenge indeed at a 300-guest plated affair. But thanks to our team's dedication and cleverness, we were still able to effortlessly present dishes such as seasonal berry and blood orange pavlova with raspberry coulis and mint, and grilled lemon shrimp and summer chopped salad.

Facing page bottom: Whether at the grand opening of an organizational store where we served soup shooters from the store's own products or a late summer outdoor cocktail party with oyster mignonette, we strive to present the freshest ingredients in the most unique way.

Photograph by Joanna Kleine Photography

views

Hallmarks of a good caterer include loyal service staff—a history of more than 20 years for some workers is an excellent sign—that frequent patrons recognize, foresight in predicting potential issues and taking proactive steps to counter them, and the ability to work with hosts on any budget as long as goals are clear.

CATERING BY MICHAEL'S

STEWART GLASS
CHICAGO, ILLINOIS

Eating a meal is more than just nourishment for the body; it is a social time for people to share their lives together. In essence, it is a nourishment of the soul. For special events, this concept is magnified. Not just an everyday meal, the food at a celebration becomes one of the centerpieces on which the entire experience hinges.

With this knowledge forefront in his mind and a love of cooking firmly entrenched in his heart, Stewart Glass began offering grill catering in 1980. He has since expanded from his humble-as-pie beginnings into Catering by Michael's, which has become a household name in Chicago with over 250 employees. The large size doesn't equate to a lack of service or quality, though. On the contrary, the staff is comprised of people who are passionate about food and who strive to bring a little sizzle and flair into their work. Partnered with their methodical processes, the abundance of staff ensures the food is prepared à la minute, guaranteeing guests receive the freshest and most flavorful food possible.

Whether Catering by Michael's is serving for a corporate function, a comfortable picnic, an elegant reception, or dropping off food for a business lunch, the dedication to quality cuisine is sure to please even the most discerning palates.

At a multicourse Thanksgiving meal in a private home, we combined plated courses with a buffet. Inspiration centered on presenting seasonal comfort foods in a simple, elegant way. A maple crème brûlée with candied bacon, hazelnut brown butter cake, and cinnamon gelato reflect the colors and flavors of fall.

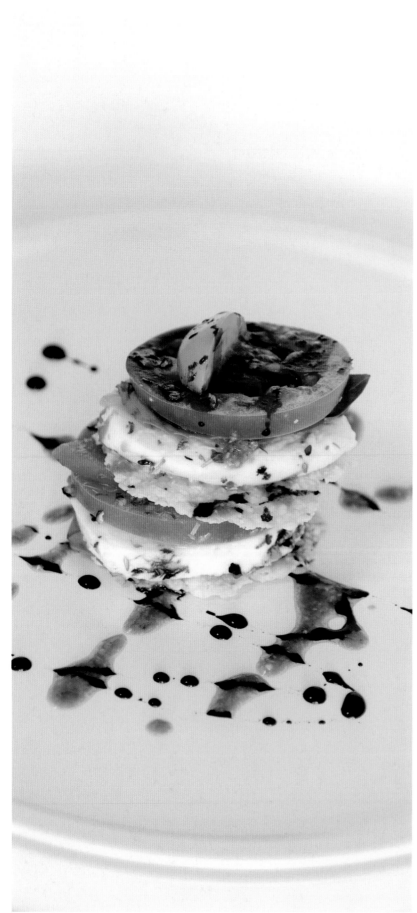

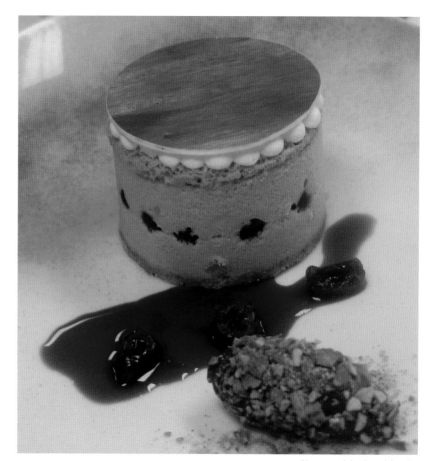

"Caterers shouldn't just provide food, they should provide confidence."

—Stewart Glass

Spring and summer are perfect for fresh, bright dishes. We translated seasonal visions into homemade mozzarella atop refreshing tomato slices with parmesan frico discs and a custom, airbrushed plate featuring a white chocolate cherry pistachio gâteau. Warm weather is also conducive to small plates, often served in sets of three for a single course. In one instance, we paired the rectangle serving pieces with square tables in a venue that reflects many other geometric surfaces. The visual effect was stunning.

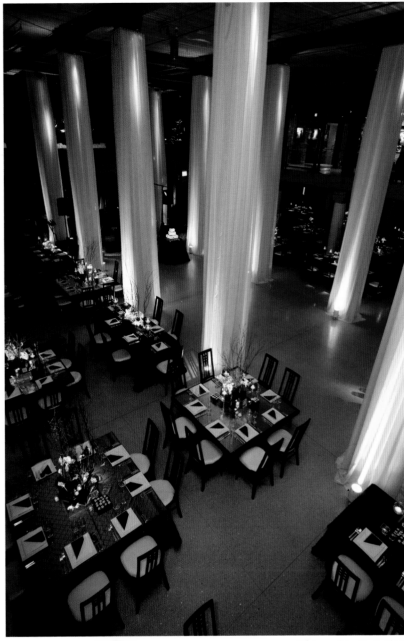

Photograph by StudioThisIs

views

❖ Ask for the details when looking at a proposal so you can be sure to compare apples to apples.

❖ If you must cut back on one part of the food budget, don't skimp on the service. Even delicious food will leave a bad taste for guests if they were treated poorly.

D'AMICO CATERING

RICHARD D'AMICO | LARRY D'AMICO
MINNEAPOLIS, MINNESOTA

Since 1982, one name has been synonymous with culinary excellence and innovation in the Twin Cities: D'Amico. Experience the inimitable D'Amico approach to hospitality at any of the company's award-winning restaurants, or leave it to D'Amico Catering to produce an artful celebration, a memorable expression of creativity and style.

Regardless of where you entertain, D'Amico sets the standard—at their place, yours, or anywhere in between. Exclusive access to the D'Amico family of restaurants and other local venues allows the team to accommodate virtually any request. Using the most delicious natural ingredients, locally sourced from quality artisans, their chefs create elegantly presented and impeccably served food that tempts the eye and delights the palate.

D'Amico Catering delivers the level of detail and commitment you'd expect from a family-owned company. Exceptional staff and intelligent planning mean D'Amico can handle anything from drop-off box lunches to a VIP dinner at a five-star restaurant to a home holiday party. No matter what the gathering, guest list, or theme on the menu, D'Amico Catering excels at bringing visions to life.

Our delectable creations and seamless service are the hallmark of signature events such as Minnesota Public Radio's annual "Rare Pairings" food and wine gala, held in the Atrium of Minneapolis' International Market Square. The event design was by Bungalow 6.

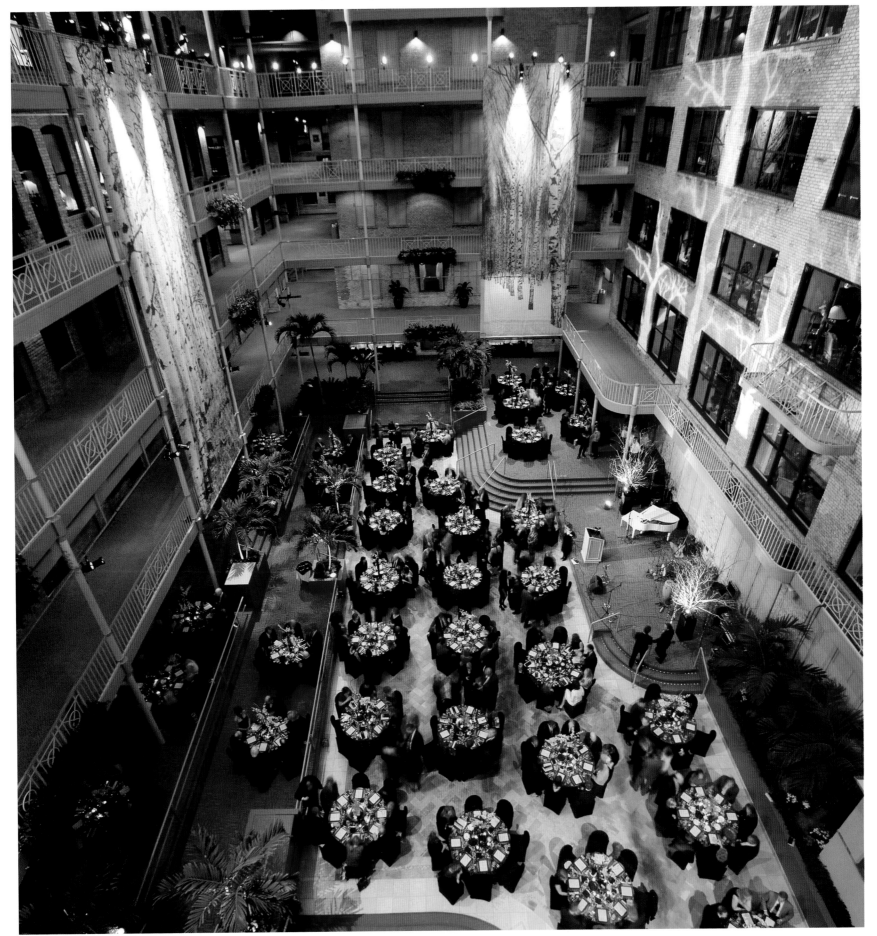

"A great food experience is when everything comes together—with an exquisite sense of precision, passion, and style."

—Richard D'Amico

Right: We love inventing explosions of color and flavor, such as grilled ahi tuna with ponzu sauce on skewers.

Facing page top left: Gazpacho with a twist: a plate of lobster salad with microgreens, cucumber gelée, and tomato water was a bright complement to the meal.

Facing page top right: Inventive martini luges featured chilled orange rinds.

Facing page bottom left: Assorted Sweet Endings confections lent a decadent edge to the dessert tray.

Facing page bottom right: Vietnamese duck egg rolls in dipping sauce made a perfect passed hors d'oeuvre.

Photograph by Noah Wolf Photography

views

Choose a caterer who can accommodate any idiosyncrasy or demand. A good team will think nothing of dreaming up a customized menu centered around a specific theme, budget, or request. The right company will possess a unique versatility and depth and come highly recommended by the community.

DESIGNING CHEFS

JEFF KEIL | HEIDI HALLER
ST. LOUIS, MISSOURI

Not many professions allow you to create a full-size animal from a massive block of cheese, or offer an opportunity to create an edible centerpiece, but that is exactly the profession that partners Jeff Keil and Heidi Haller—co-founders of Designing Chefs—enjoy. Sometimes creating as many as 18 events in as little as 12 days, Jeff and Heidi stay more than busy, which is fine by them since they absolutely love what they do.

Both Jeff and Heidi have culinary degrees and foodservice backgrounds, but Heidi concentrates on the food and menu preparation while Jeff focuses on the event design and front-of-the-house services. Designing Chefs is much more than just a catering service: it's a team of trained, creative individuals who take care of everything from the table linens, floral arrangements, and place settings to the delicious foods that grace the plate. The presentation and platter display of the cuisine is an integral element of the service the team provides.

Jeff and Heidi consider themselves problem solvers, whose goal with every event is to exceed expectations in terms of food, presentation, and service. Based on someone's vision, Jeff and Heidi are able to provide practical suggestions of what will work so the event goes off without a hitch. In every case, Jeff and Heidi go above and beyond to provide the best event possible from stemware to shrimp skewers.

For a tropical-themed dinner party catered in a private home, we put together a fun and interesting centerpiece as an amuse-bouche. We toasted coriander and cumin to crust the shrimp, which created a wonderful aroma. This centerpiece activated the senses of sight, smell, and taste and looked as good after it was eaten as before.

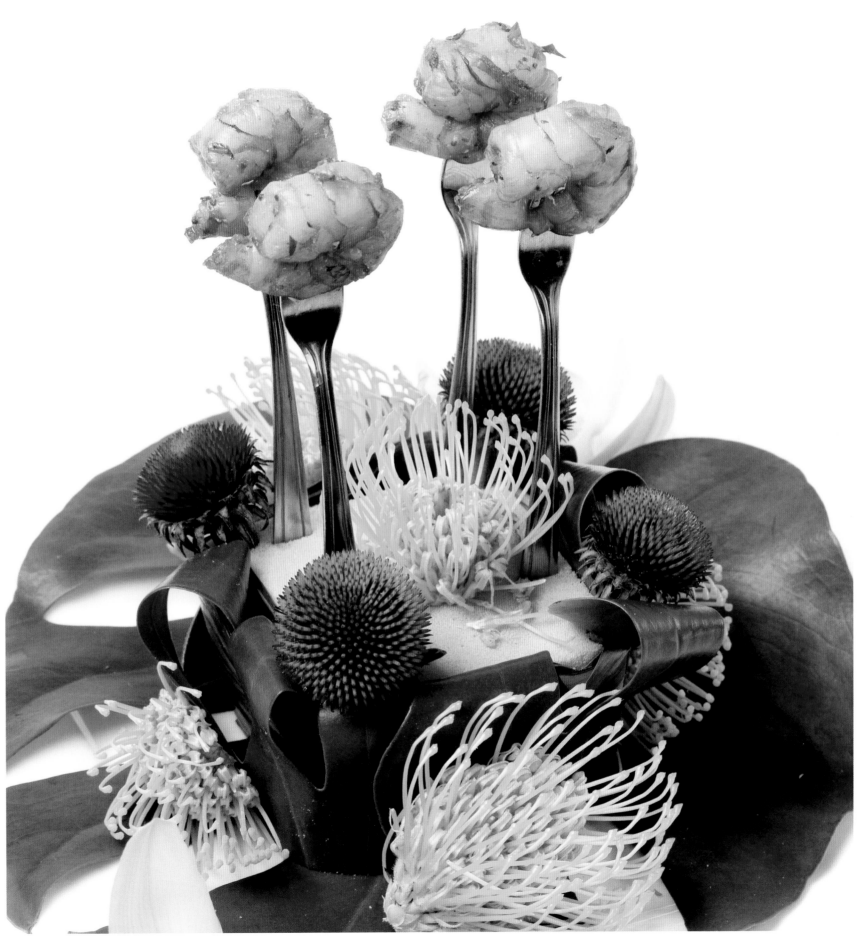

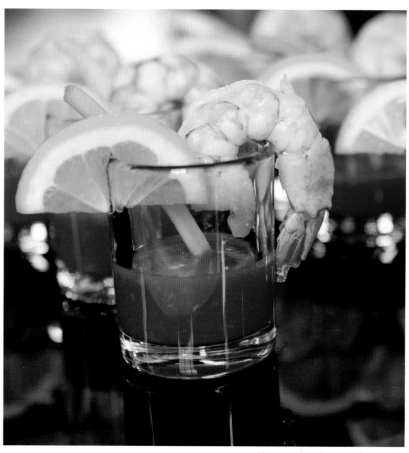

"It's the chef's job to touch upon everyone's sense of sight, smell, and taste. Those three elements need to be there in a bold way."

—Jeff Keil

Right: The St. Louis Zoo held its biannual fundraiser with a sea lion theme. We used a 40-pound block of cheddar cheese carved into the shape of a sea lion and placed it within an ice sculpture designed as ice cliffs with fruits and vegetables used to form the water and other elements. The biggest challenge of the night was having food for the 2,700 guests who attended the event and keeping everything fresh through a five-hour evening.

Facing page top: It's always important to consider color and texture when putting together a dish or menu for an event so that all of the elements complement each other. For a caprese salad we used a summer bounty of locally grown ingredients whose vivid colors matched perfectly with the setting. We can create everything from individual appetizers, such as flirty and fun Bloody Mary shrimp shooters, to entire event menus.

Facing page bottom: Creating a cocktail buffet that is compact, visually pleasing to the eye, and still works in a garden setting is a challenge we enjoy taking on. Encouraging conversation and exploration, our signature Carolina crab cakes are definitely a crowd-pleaser. The presentation intrigues guests, and when they figure out what to do with the interactive appetizer, a bright burst of citrusy vinaigrette squirts from the pipette into their mouths, mingling brilliantly with the soft, traditional crustacean flavor.

Photograph by Jeff Keil, Designing Chefs

views

It's important to always be flexible with expectations. While it's good to have an idea of what you want, don't set it in concrete. Give the information and vision to your professional caterers and let them paint the picture for you.

FABULOUS CATERING

DAWN DROUILLARD | EDEN FITZGERALD
MINNEAPOLIS, MINNESOTA

The idea of catered food often comes with the stigma of being average or just edible—rarely do guests at a special event rave about the cuisine. For Dawn Drouillard and Eden Fitzgerald, owners of Fabulous Catering, the notion of boring, ordinary food was exactly what they set about to change—and change they have.

Dawn, who trained under some of the best chefs in the Midwest, opened Fabulous Catering in 1999 and enlisted longtime friend and occasional co-worker Eden to help full-time when Fabulous Catering was selected as one of three caterers for the 2008 Republican National Convention. This prestigious selection confirmed that Dawn's goal of providing food and service to rival the quality of fine dining was successful. Eden's addition to the team, with her management and event planning experience, stepped the level of quality up even more.

With the philosophy that they are hosting the party along with those who hired them, Dawn and Eden first and foremost assist in making the event special. Dawn's plan involves soulful preparation—no set menus, just a custom plan for each event that centers on fresh, high-quality ingredients used to create scrumptious meals from scratch. Eden adds to the customization by hand-selecting the event staff, based on the host's personality, serving style, and event goals, to ensure every aspect of their catering goes beyond the average. By using their creativity and experience, Dawn and Eden create cuisine that reflects the stunning scenery and friendly people of the Midwest.

An assembly of 15 varieties of grilled, roasted, and raw vegetables creates the perfect substance for a lavish presentation. We often suggest that the event host not include a floral centerpiece but utilize loose florals that are integrated into our buffet because the food creates its own aesthetic.

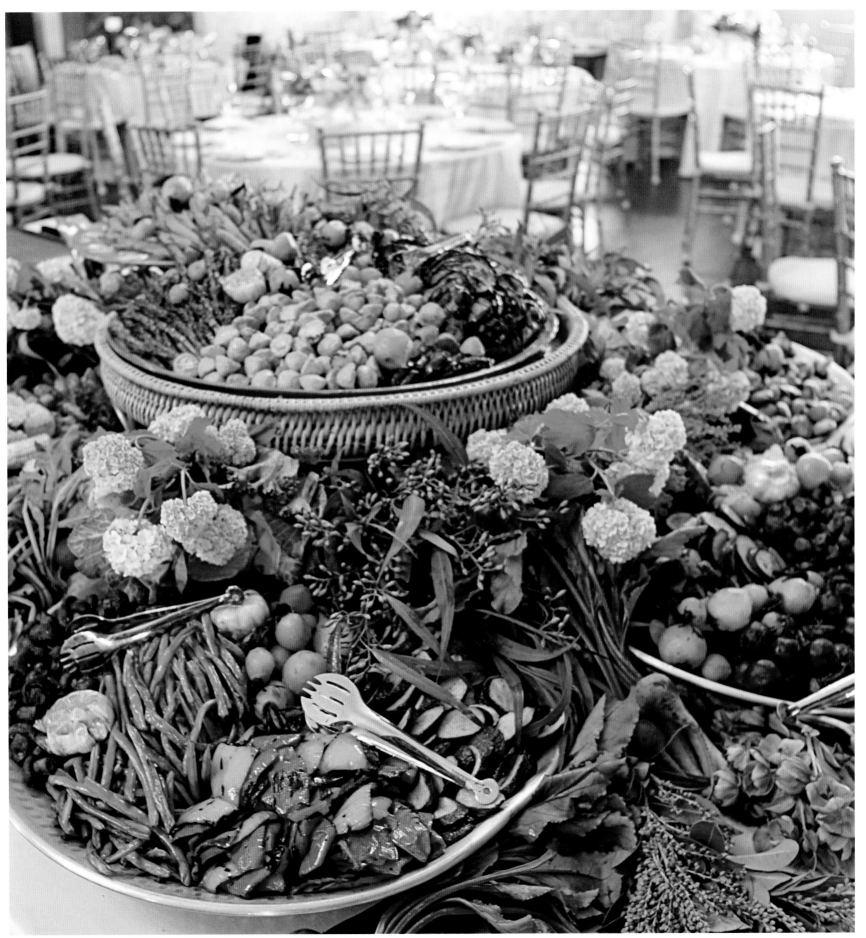

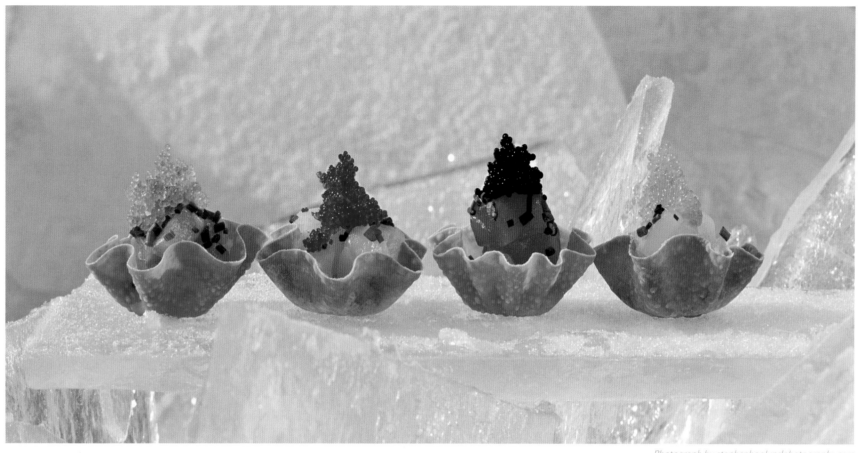

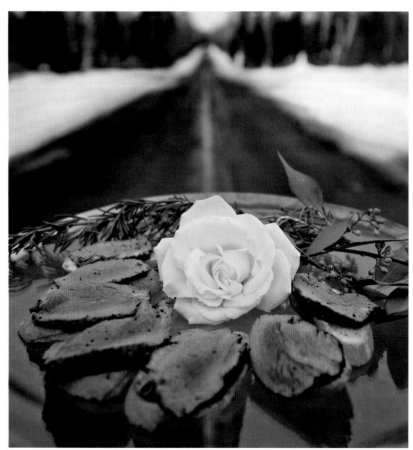

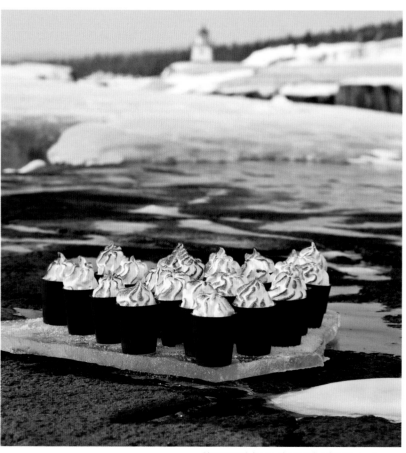

"Just let the food be itself."

—Dawn Drouillard

We are inspired by our surroundings, especially since the Midwest has such a beautiful environment and distinct seasons. Whether it's a winter event that calls for warm and hearty flavors and elegant appetizers or a summer celebration that takes advantage of fresh fruits and vegetables and melt-in-your-mouth mozzarella, we creatively design a presentation that adds flair to the cuisine.

views

❖ Be honest with yourself about how involved you want to be and how much responsibility you want to have for your event.

❖ Money is well-spent on hiring professional serving staff for the event. It makes the food taste even more scrumptious and ensures everything runs smoothly when the details are well-attended.

CHRISTOPHER ELBOW ARTISANAL CHOCOLATES

CHRISTOPHER ELBOW
KANSAS CITY, MISSOURI

The perfect parting favor for event guests is often something sweet and wholly unique. If you're seeking a gift that will truly enchant your guests and seal a positive lasting impression, look no further than Christopher Elbow Artisanal Chocolates.

Christopher Elbow spent years honing his restaurant management skills in high-end eateries helmed by acclaimed chefs in Kansas City and Las Vegas before opening his own chocolate shop in 2003. While a pastry chef at Kansas City's American Restaurant, he began pursuing his creative urges and crafting not mere chocolates but true works of art in miniature. After offering limited quantities to select markets, high demand necessitated that he start his own business to accommodate it. Today his chocolates are available at the flagship Kansas City shop, online, and at select retailers in San Francisco, Chicago, and Washington, D.C.

Inspired by exotic flavors he encounters in foreign marketplaces and restaurants during travels abroad, Christopher takes ingredients like Venezuelan chocolate, French lavender, Japanese *yuzu* citrus fruit, and Scotch whiskey and hand-crafts them into single, tiny pieces of gastronomic perfection that look and taste equally delectable. After all, his mantra is never to compromise on quality. He and his team of 12 employees work with event hosts to customize boxes of two or four chocolates with initials, logos, color-matched ribbons, and flavor selection—and he even runs a chocolate bar at large corporate or charity events.

It's instantly gratifying for me to work from my Kansas City store and witness firsthand the delighted smiles of the people tasting my creations. We work in small batches so we can control the quality, and each individual chocolate is a melding of culinary artistry and handmade craftsmanship.

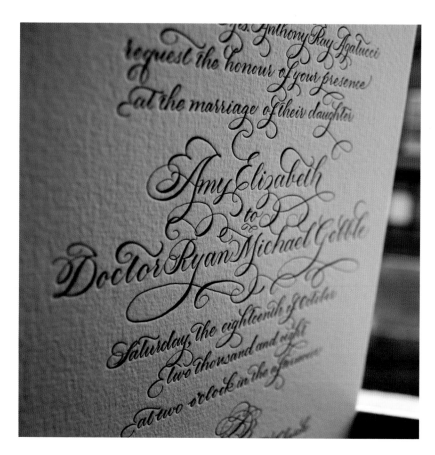

Penn Avenue

...request the honour of your presence
at the marriage of their daughter

Amy Elizabeth
to
Doctor Ryan Michael Gottlie

Saturday, the eighteenth of October
two thousand and eight
at two o'clock in the afternoon

It's All In the ...

thank you
for being a part
of this special day

Stephanie & Alex
August 8, 2008

chant Greenwood

Arthur

Details

A MILESTONE PAPER COMPANY

SARAH GLAD
MINNEAPOLIS, MINNESOTA — ST. PAUL, MINNESOTA

From the moment guests receive invitations through the use of menus and placecards at the event, A Milestone Paper Company desires to create an ambience that cannot be overlooked. Although the guests' arrival is often considered the start of an event, Milestone regards the opening of invitations as the beginning because this initial contact sets the tone and expectation for the entire celebration.

Sarah Glad began Milestone because she loved design and enjoyed helping people celebrate. During her own wedding preparations, she realized the importance of custom paper goods in creating a well-integrated event that guests would remember. She now uses that desire to craft paper products that complement and enhance the other elements in an event, including the floral arrangements, attire, décor, linens, and even the music.

Each of Milestone's custom products is carefully crafted only after an in-depth consultation with the event host and a presentation of three to five examples with the event information included. The event host can then see a more accurate representation of a final design and can choose various elements for incorporation in the end result.

Through innovative use of color, style, texture, and materials, Milestone creates stunning paper goods that are often breakthrough designs and unexpected but perfect combinations. With a willingness to venture into uncharted territory and a strong desire to generate excitement for the celebration, Milestone guides the event host to the perfect custom design.

The inspiration for the fall celebration was a luxurious, warm, elegant feel, so I used the deep copper and chocolate colors with the satin and gold accents to embody the tone for the entire event. The classic monogram and the elegant fonts continue the theme on the menu.

SALAD

Bibb lettuce flower
with candied marcona almonds, roasted red and gold beets, shaved
breakfast radishes, white balsamic vinaigrette & mango avocado salsa

ENTRÉE

Crab cake with Meyer lemon confit & goat cheese
Filet of beef tenderloin stuffed with boursin blue cheese
Potato terrine wrapped in brik pastry and garnished with tomato jam
Giant asparagus and heirloom carrots bundled

DESSERT

Wedding Cake
Fresh almond praline & chocolate truffle fudge
with white chocolate mousse frosting

Audrey and Matthew

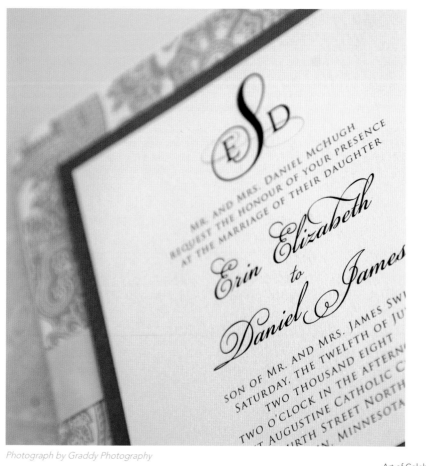

E S D

MR. AND MRS. DANIEL McHUGH
REQUEST THE HONOUR OF YOUR PRESENCE
AT THE MARRIAGE OF THEIR DAUGHTER

Erin Elizabeth

to

Daniel James

SON OF MR. AND MRS. JAMES SW
SATURDAY, THE TWELFTH OF JU
TWO THOUSAND EIGHT
TWO O'CLOCK IN THE AFTERN
T AUGUSTINE CATHOLIC C
URTH STREET NORTH
N, MINNESOTA

Penn Avenue

Photograph by Graddy Photography

"It's not just about conveying information. Each piece expresses the tone, feeling, and personality of the celebration."

—Sarah Glad

Combining potentially contradictory tones in paper products produces a fun challenge when creating new designs. One couple desired an elegant feel but with a natural, woodsy element, so I created table cards from dark-stained wood and added elegant fonts. Another couple liked a few designs but just hadn't found "the one." They imagined a balance of antique charm with a chic, modern twist. As soon as I suggested a weathered, rustic gold motif with a more formal calligraphy-style font and bright orange color, they instantly fell in love. One of my favorite designs is the invitation in the metal tin with the personalized, laser-cut monogram. All of the elements—the textured linen cardstock, acrylic, smooth pale green cardstock, and aluminum—fit perfectly with the modern, art-inspired venue.

Photograph by Graddy Photography

views

Guests will notice the continuity and the execution of a coordinated event. Early in the planning stages, consider how to tie everything together. Use this continuity to convey a theme and incorporate that feel into the save-the-dates, invitations, menus, and placecards. Allow the paper products to add to the ambience of the event.

BENNETT SCHNEIDER

DOROTHY FISCHER | JOELLEN BAX
KANSAS CITY, MISSOURI

Selecting the right invitation for your upcoming event can be overwhelming, especially if your wedding is the first major event you've ever put together. The sheer amount of options is often confusing. Fortunately, Bennett Schneider is here to help. The shop began life in the early 1930s as a popular bookstore and soon became a Kansas City institution. Over time, the focus shifted from books to stationery, and in 2004 mother-and-daughter pair Dorothy Fischer and JoEllen Bax seized the opportunity to purchase the store and go into business together. While ready-made products are carried, the emphasis is undoubtedly on custom pieces—Bennett Schneider serves as a liaison between customers and designers, a way to have the custom-made DIY experience without the hassle.

The neat, well-organized, colorful shop, nestled within a line of high-end stores, has a studio feel. When patrons arrive—the majority already familiar with the shop and its proprietors—they work with either Dorothy, JoEllen, or store manager Bryan Griffin, who chat with them about objectives, help narrow the options down to a few suitable designers, collect design preferences, send the information to the designer, and orchestrate proofing.

Bennett Schneider exclusively works with designers that Dorothy and JoEllen have an excellent personal relationship with—reputable, high-quality stationers with a classic, timeless, and flexible style. And they know that high quality doesn't have to mean high cost: there is a wide range of prices represented, and they are willing to work with anyone no matter the budget. Above all, what's most important is to ask the right questions—What do you want this invitation to feel like when someone opens it? Do you want it to be about color, typography, names, the date?—and let patrons know they are in eminently capable hands.

We hosted an open house at the store for our 5/80 anniversary, celebrating five years of ownership and 80 years of business. One of our customers loaned us an amazing collection of vintage engraved stationery for the occasion.

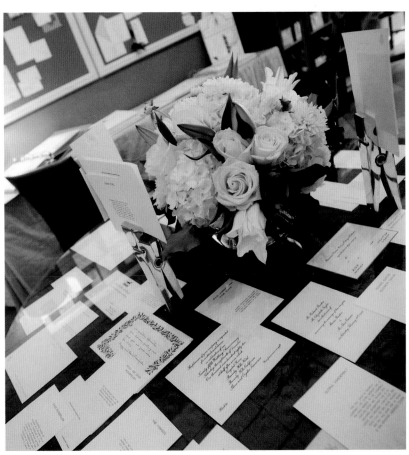

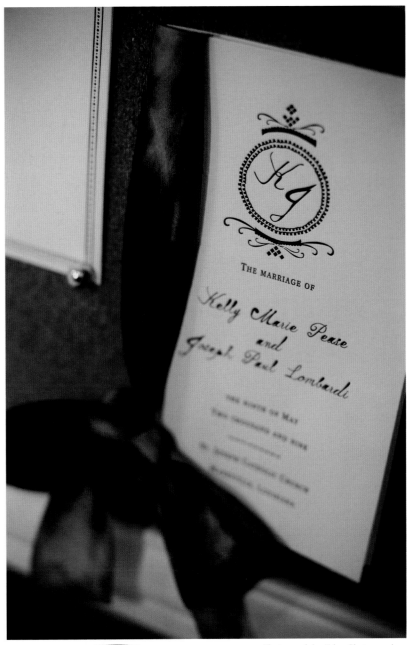

Photograph by Kdog Photographers

"The invitations impart the very first impressions of the party and set the mood for the celebration like nothing else can."

—JoEllen Bax

From wedding programs with hand-dyed silk ribbon to letterpress stationery and invitations to favor boxes—all made-to-order, naturally—the products we furnish our patrons with are so dynamic and distinctive that we're not surprised to hear feedback like, "I sure hope the event lives up to the invitation!"

views

❖ A relaxed, easy shopping experience with expert advice streamlines the stationery and invitation selection process.

❖ Designs shouldn't be forced—they should always be exactly what patrons want and need.

❖ When you have a regular stationer who knows your name, taste, and style, things are so much simpler.

THE BLOOMING QUILL

DEBI ZEINERT
MILWAUKEE, WISCONSIN

Some view calligraphy as a lost art, but not Debi Zeinert. It's her passion and something that comes quite naturally to her. In fact, she's entirely self-taught. A natural artist all her life, Debi has always loved letters—and when she discovered calligraphy as a child, she knew she'd hit on something both fulfilling and, eventually, gainful. Her left-handedness made any other form of learning except self-teaching impossible, and soon she was dreaming up her own unique designs derived only partly from the styles in calligraphy books.

All Debi has to do is sit down with her pen to draw up a new style belonging to her alone. Her designs are so original they've even been made into fonts, used exclusively by New York-based letterpress shop Boxcar Press for its Smock invitation line. The shop also incorporates Debi's hand calligraphy into many of its wedding suite designs for its invitation line Bella Figura.

It made all too much sense for Debi to turn her forte into a business, and that's exactly what Debi's personal venture The Blooming Quill is. Headquartered in Wisconsin but with business conducted mainly online and with clients all over the country, the Blooming Quill's star calligrapher can address or design any form of stationery. She relishes working with brides, enjoying the opportunity to take a bride's vision all the way from save-the-date cards to place settings at the reception. She finds that once people have calligraphy, they want everything in calligraphy—and that's fortunate indeed for her!

Smock and Bella Figura letterpress stationery often use my calligraphy in their designs, such as the yellow-and-white invitation suite. The companies take my calligraphy that I write for them and incorporate it seamlessly into their concepts.

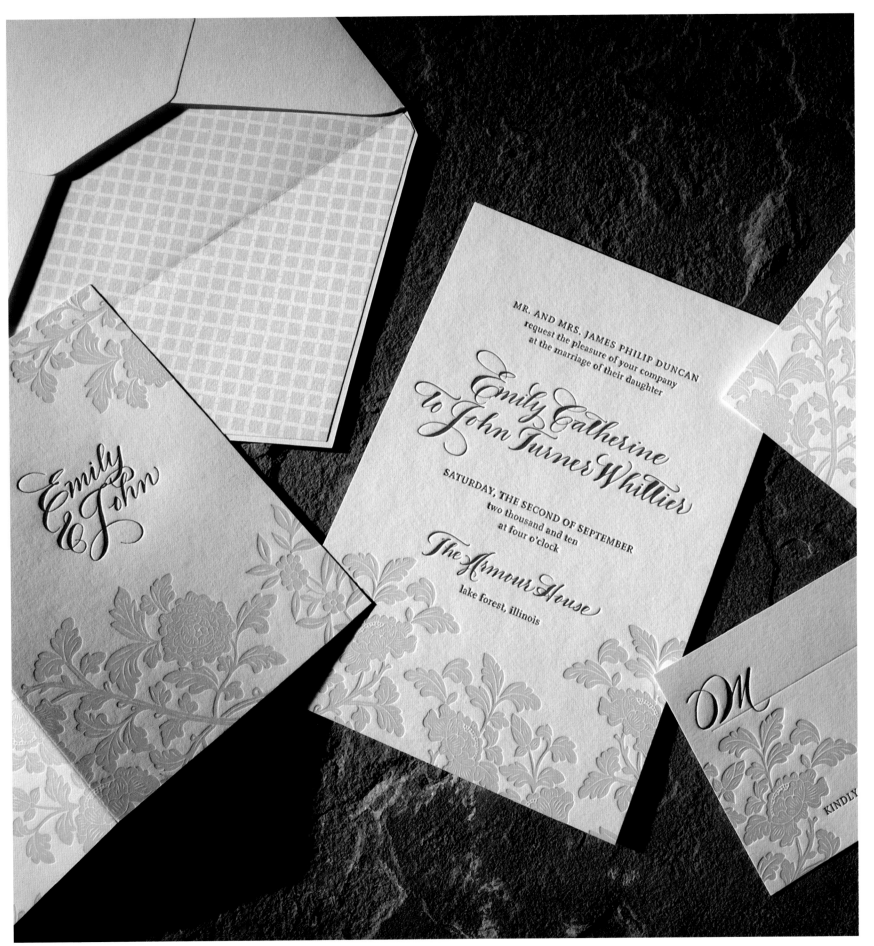

MR. AND MRS. JAMES PHILIP DUNCAN
request the pleasure of your company
at the marriage of their daughter

*Emily Catherine
to John Turner Whittier*

SATURDAY, THE SECOND OF SEPTEMBER
two thousand and ten
at four o'clock

The Armour House
lake forest, illinois

Emily & John

OM

KINDLY

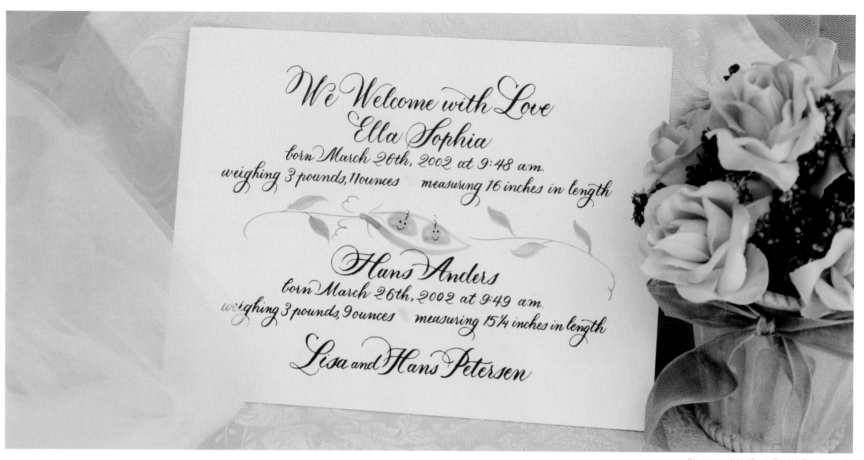

We Welcome with Love
Ella Sophia
born March 26th, 2002 at 9:48 a.m.
weighing 3 pounds, 11 ounces measuring 16 inches in length

Hans Anders
born March 26th, 2002 at 9:49 a.m.
weighing 3 pounds, 9 ounces measuring 15¼ inches in length

Lisa and Hans Petersen

Photograph by Scott Patrick Photography

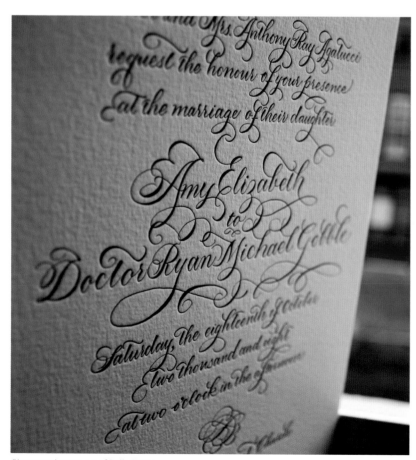

and Mrs. Anthony Ray Agalucci
request the honour of your presence
at the marriage of their daughter

Amy Elizabeth
to
Doctor Ryan Michael Gottle

Saturday, the eighteenth of October
two thousand and eight
at two o'clock in the afternoon

Raspberry Margarita

1 ¼ OZ LEMON JUICE
1 OZ SIMPLE SYRUP
3 OZ RASPBERRY PURÉE
1 OZ TRIPLE SEC
1 ¼ OZ WHITE TEQUILA

SHAKE ALL INGREDIENTS WITH ICE,
STRAIN INTO MARGARITA GLASS,
GARNISH WITH LEMON SLICE.

Photograph courtesy of Bella Figura

Photograph courtesy of Bella Figura

"Infusing a page with love and warmth through every stroke of the pen adds a personal touch that no printed font can match."

—Debi Zeinert

Right: I treasure the chance to make each page unique and individual, as when I hand-paint artwork on every invitation. I'm an artist at heart and love to draw and paint, so the chance to combine that with my calligraphy is priceless to me.

Facing page: Whether the resulting invitation is entirely calligraphy or integrates art or graphic design, I put painstaking care into every aspect of it. For a birth announcement for twins featuring artwork of two peas in a pod, I offset print the calligraphy and then hand-painted each one with the art. Other times the result will be 100-percent calligraphy or a design by another stationer that includes my lettering

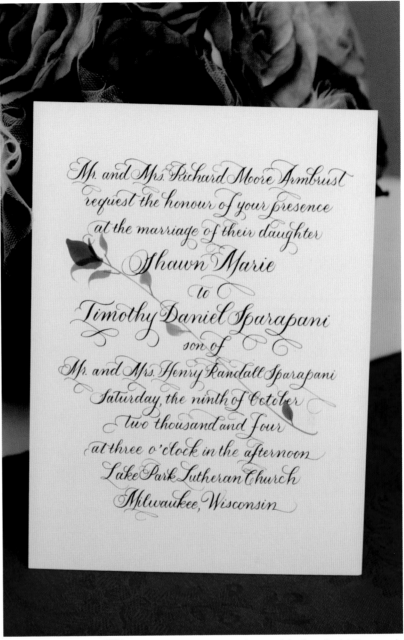

Photograph by Scott Patrick Photography

views

❖ When seeking a calligrapher, prioritize quick yet pretty service.

❖ Look for someone who's original and free-thinking.

❖ Peruse website samples to get a feel for the style you want.

❖ Don't be afraid to ask for special, personalized details.

PEN & INK

ROB BOISVERT
MINNEAPOLIS, MINNESOTA

The art of personalized letters has been lost on a generation that is raised on the iPhone, Twitter, and Facebook, but Rob Boisvert knows the beauty and satisfaction that comes from an invitation, menu, or placecard when it is hand-crafted. For the last 10 years, Rob has created customized works of art for corporate and private clients through his company Pen & Ink, restoring an age-old tradition into a modern-day art form.

From shopping for paper and decorative items with a client to personally applying hundreds of decorative appliqués, Rob offers services that big printers won't. He is fascinated by the craft he works in and spends many hours studying materials and inks he can use beyond the standard fare—velvet or metallic inks, for instance. He is always experimenting and expanding his craft, thus providing truly one-of-a-kind items.

A perfectionist and an artist, Rob sees the world with an artist's eye, but being color blind, he also sees the world with a completely different palette than most. Being color blind has not hindered Rob whatsoever, and he feels no boundaries or barriers, enjoying the ability to experiment in ways that others may not think to.

Because of how closely he works with people on each project, he naturally takes great pride in his work.

Simulated calligraphy and hand addressing find uses in a diverse number of applications. For The Minneapolis Institute of Arts the challenges were to help the museum's event invitations and other high-level communications stand out with elegance and have the appearance of being done by hand without being cost-prohibitive.

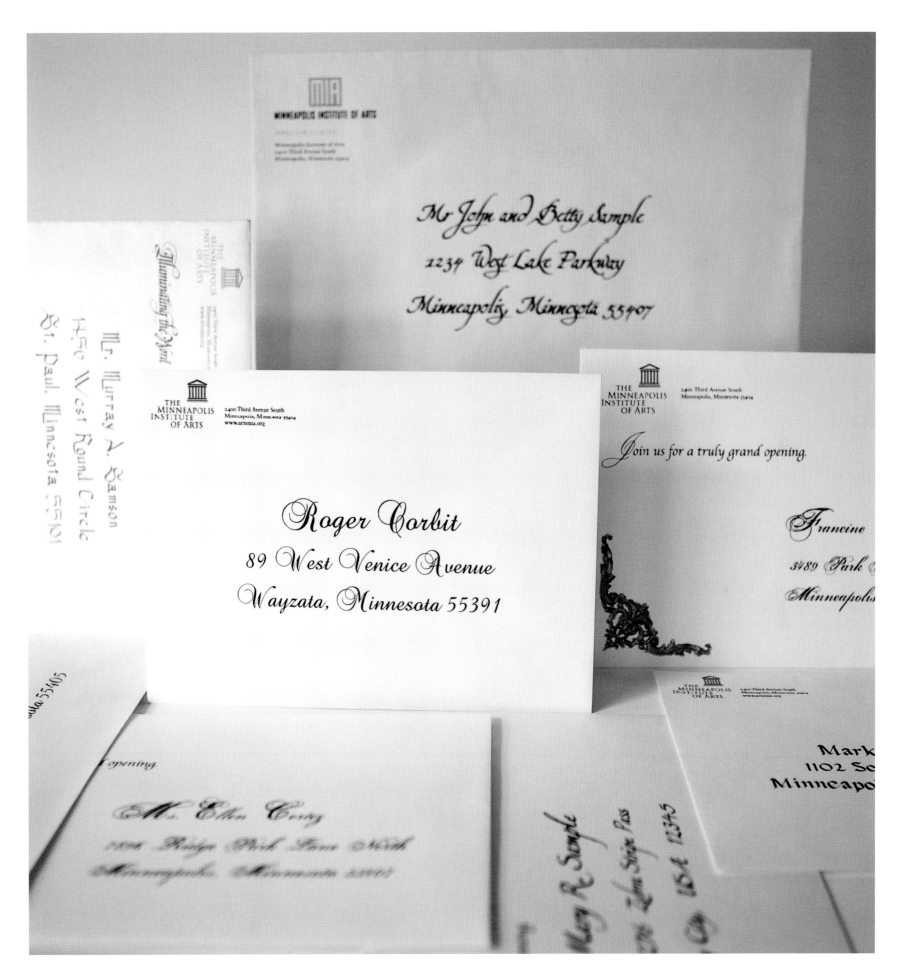

"Customization does not have to be costly, it just means unique."

—Rob Boisvert

Right: Anything, from save-the-date card to printed menu, can be personalized for an elegant presentation.

Facing page top left: Metallic certificates with simulated calligraphy are part of my diverse repertoire. Because we're flexible to changing needs, personalizing 200 certificates the day before Seagate's event was not a problem.

Facing page top right: For a large wedding, the invitation inspiration was the bride's dress, which was adorned with Swarovski crystals; we hand-affixed jewels to all of the invitations.

Facing page bottom left: The invitation was for the opening of the "Illuminating the Word" exhibit at The Minneapolis Institute of Arts. I have started offering a calligraphy font that looks very much like it was hand-done but is easier, quicker to complete, and less expensive.

Facing page bottom right: The range of work I do is extremely broad. There truly are no limits. Dimensional items such as jewels, stars, or appliqués of any kind can be added to placecards, invitations, and more. The ability to personalize any item with odd and dimensional materials can make for very unique elements for an event.

Photograph by Noah Wolf Photography

 views

Invitations that are elegantly designed and printed using the finest paper and inks deserve more than a label that was printed and affixed to the envelope. If you are going to spend $30,000 on the room and food and beverage, then do not skimp on the details that tie an event together. Using an elegant calligraphy font or having invitations done by hand is not a significant expense, and taking the time to carry an event's look and feel to every detail makes a big impact.

SUGAR RIVER STATIONERS

HEATHER RAFFEL
MADISON, WISCONSIN

How often do you receive an invitation so beautiful you almost want to frame it as artwork? At Sugar River Stationers, owner Heather Raffel blurs the line where invitation meets art.

During a personal interview with prospective party hosts, Sugar River designers ask questions aimed at unearthing interests and passions that could form the basis of a particularly creative, outside-the-box invitation design. While grooms are often turned off by the level of overwhelming femininity attached to wedding planning details—more fanciful invitations included—they are delightfully surprised by Sugar River's inclusive approach. For example, a shared interest like hiking or a favorite vacation spot could be pared down and interpreted stylistically to become a truly innovative theme. And it's not just weddings—the stationers are happy to dream up similarly fresh, beautiful invitations for any type of special event, corporate affairs included, honoring Heather's roots in visual branding, marketing, and graphic design.

Sugar River's innovative printed materials are celebrated for perfect balance of text and graphics, an aesthetic quality that proves an irresistible lure for those who crave ingenuity.

We always draw inspiration for our wedding invite suites from something personal about the couple. A Korean-American bride induced us to pull elements of her heritage—the peonies letterpressed for a watercolor effect, the character signifying "double happiness"—while the groom selected the green color. The "MW" symbol resembling two hearts represents the couple's initials, a theme of duality further emphasized by the two colors of green and pink.

wanda lau and michael rappel
491 s. ninth street, apartment m-302
quakertown, pa 18951

since we met, we haven't stopped smiling.

please join us when
wanda w lau and **michael james rappel**
unite in marriage with the blessings of our parents

saturday, the third of may
two thousand and eight
five o'clock in the afternoon

silver garden of southfield
southfield, michigan
reception to follow

thank you

kindly respond
by the first of april

○ accepts
○ declines

wanda and michael

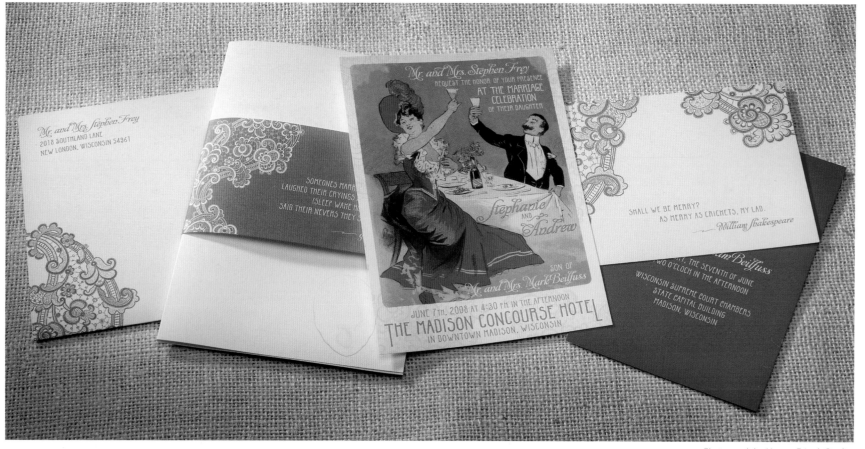

Photograph by Harper Fritsch Studios

"Going green with printed materials is easier than you might think."

—Heather Raffel

Right: "Wouldn't it be cool to do this?" That sort of thinking often drives our design. For an invitation to a Caribbean-style event, we created an Art Nouveau frame with a foil stamp bordering detail, then made the whole thing look antique. We really raised the bar on ourselves with the vintage-style pink letterpress response card.

Facing page: Our style is constantly evolving and we're not afraid to test out new techniques, like incorporating vintage ephemera and patterning, or adding small details. Whenever we attach special elements like a ribbon or a string, there's always a functional component— sometimes the booklet simply needs to be held shut, but the requirement is an opportunity to do something inventive. This isn't just a simple card, it's part of a cohesive package, and maintaining a high level of presentation is key.

Photograph by Harper Fritsch Studios

views

❖ Seek designers that believe printed materials can attain the level of art.

❖ Let your designer translate your tastes into a streamlined representation of your personality.

❖ Go green with recycled stock paper products, which lend credibility.

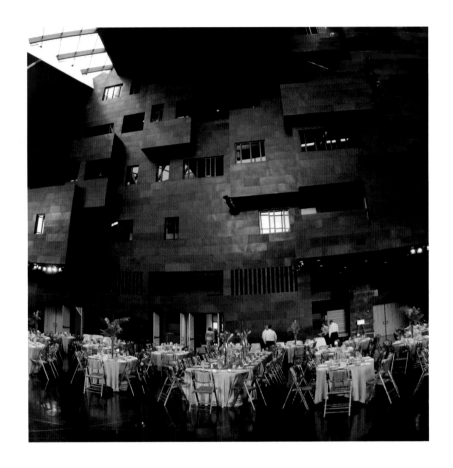

Capturing the Mo

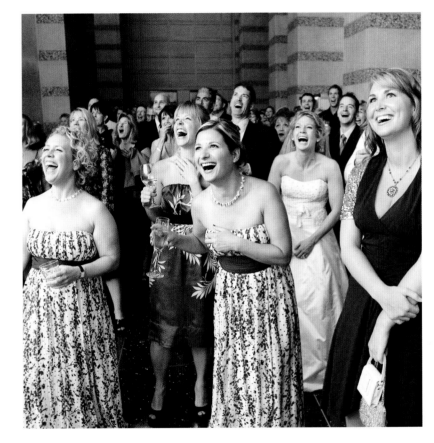

ment

Coppersmith Photography

MATT COPPERSMITH | AMY COPPERSMITH
MINNEAPOLIS, MINNESOTA

For Matt and Amy Coppersmith of Coppersmith Photography, having a camera in their hands and taking photographs has been a lifelong passion. Both have had an interest in photography since they were young kids, and when they realized they could make a living at it, their career choice was set. Matt's career began in commercial photography while Amy's was in portraiture and fine art. They have combined their passion and talents to become award-winning event photographers.

Photographing weddings, corporate or charity events, fashion shows, and industrial parties puts Matt and Amy in the middle of celebrations where everyone is happy—and that happiness is contagious. The couple strives to make every image a work of art through their great attention to detail. Capturing moments that may only last a second is an art and a science, and Matt and Amy have learned to constantly be moving using their finely tuned situational awareness to gain a feeling for a room and the people in it, so they can be in the right place at the right time. Coppersmith Photography's focus is always on pleasing the people who have commissioned the photographs, whether for memories, print advertising, or public relations. Matt and Amy maintain a full-service operation, from managing large corporations' expectations to teaching couples how to slice cake in a camera-friendly fashion.

Lighting and linens can have a dramatic effect on a room. For a bridal fair ceremony on the basement level of the Minneapolis Convention Center, we chose a high angle to capture the scene and gain as much coverage as we could in the short amount of time we had available.

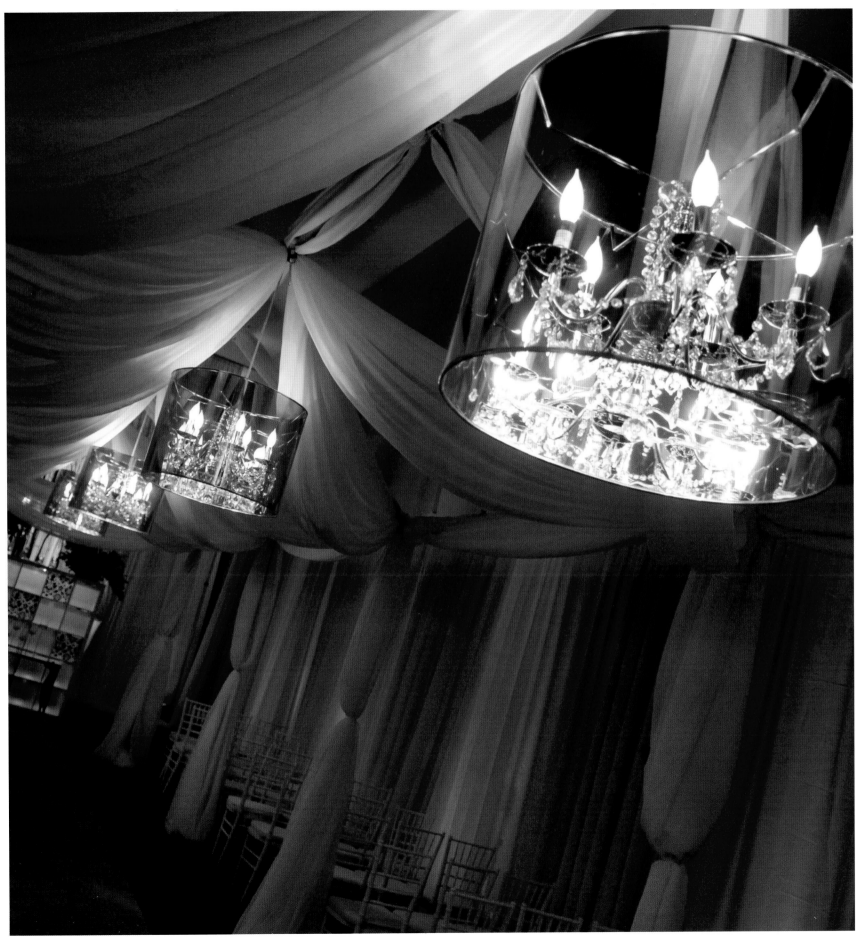

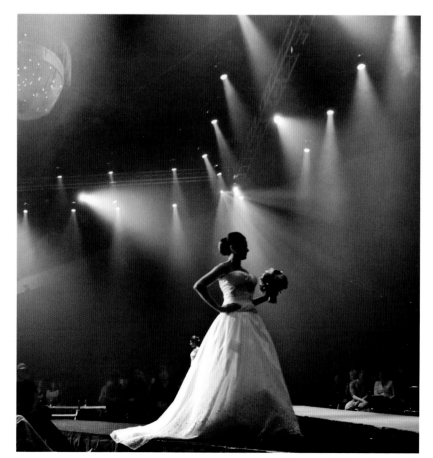

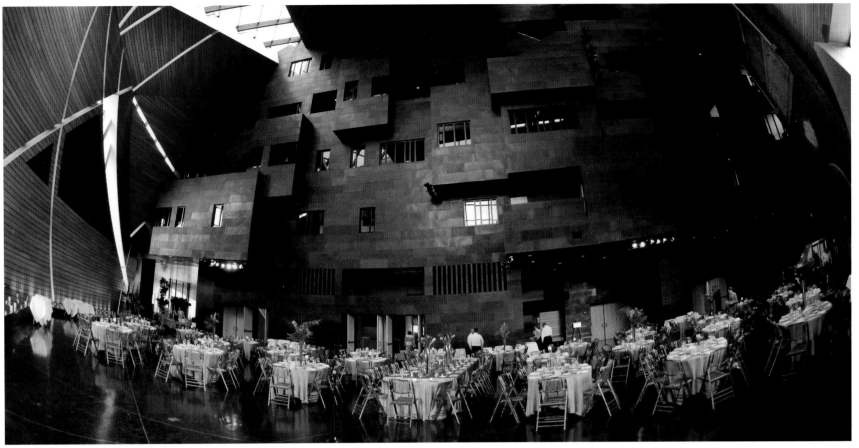

Photograph by Amy Coppersmith

Above: Ambitious wide shots reveal the full effect of the room setup for a wedding reception dinner, along with the architectural elements of the space in relation to where dinner would be served. The dramatic, dark copper wall had to be exposed properly to see the detail in it. We used a high aperture setting to keep the room's decorative details in focus.

Right: We wanted to show the preparation of food and beverage, along with the type of wine served, for the awards banquet. Small details are just as important as the larger ones, for they add to the ensemble of photographs describing the event.

Facing page left: The challenge of the bridal fair dance stage was clearly capturing the couples dancing while showing the whole detail of the draped fabric. We wanted the scene to look like it was at a fancy event, not surrounded by tradeshow booths and casual attendees. The dramatic fabric draping was a wonderful framing device.

Facing page top right: For the reception, we wanted to capture the detail of guests lifting their glasses in a toast to the couple's life together. The complexity in getting this shot is that you don't know when people are going to lift their glasses, and when they do, how few seconds you have to capture it before they lower their glasses. It's a difficult photograph to get in focus as well as properly framed.

Facing page bottom right: We photograph the fashion show at Minneapolis Bridal Fair for the Twin City Bridal Association without a flash so we don't distract from the lighting effects that are in place.

Photograph by Matthew Coppersmith

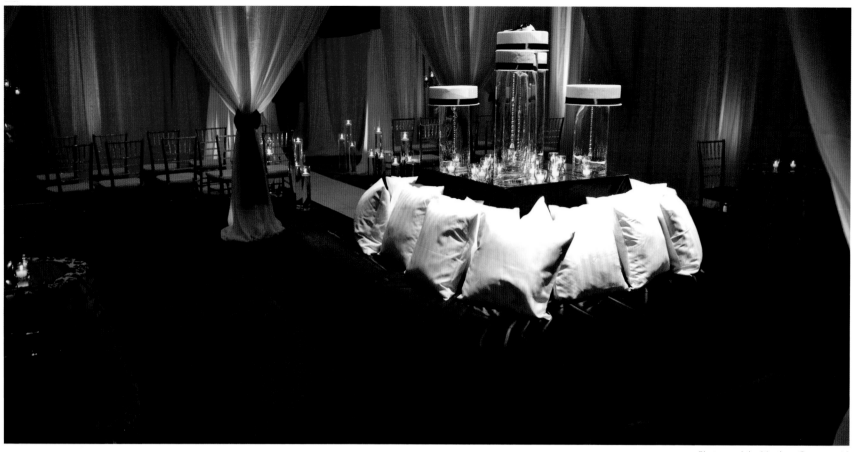

"Our goal is to capture every detail, emotion, person, and moment, at every event we photograph, leaving nothing forgotten."

—Matt Coppersmith

Right: At the ISES Awards banquet afterparty, the people who decorated wanted us to photograph every detail while preserving the artistic feel of the event. To enhance the character of one of the themed rooms, we used a fisheye lens and shot from a low angle.

Facing page top: We needed to showcase the room in one image that would display what the décor company could do to a small space. We needed to portray what a company could expect to see at its event. The photograph also needed to show how large the space would still feel, so we used a wide fisheye lens to capture the effect.

Facing page bottom left: Color, texture, and styling were very important to the hosts of the artistic affair. We wanted to showcase the event's color scheme as well as the flowers and the styling used to decorate the space.

Facing page bottom right: For the Twin City Bridal Association's Trend Wedding in Minneapolis, we captured the fine dining aspect of the room décor. There were three tables set up in the dining room, each around 50 feet long. We wanted to show an angle of the tables that would illustrate the idea of length while revealing some of the tabletop decorative details.

Photograph by Matthew Coppersmith

views

If you want to remember your event, the photographer is the key. When the wedding or corporate meeting is over, all you will have left are the photos. The flowers will wilt, the food will be eaten, the wedding dress will be boxed and put away, but photos will last a lifetime, so do not skimp on the photography.

KRAKORA STUDIOS

MICHAEL KRAKORA | HEATHER KRAKORA
MADISON, WISCONSIN

Imagine a photography team made up of two best friends who complement each other perfectly and collaborate seamlessly. Too good to be true? Not for husband-and-wife photo partners Michael and Heather Krakora, who together comprise Krakora Studios.

The two spouses were strongly drawn to photography initially, yet never dreamed it could be a career. Heather and Michael met in college while both were taking photography classes as they each pursued other career paths—dental school for him, graphic design for her. However, Michael's passion for photography proved undeniable and redirected him toward professional photography. A happy accident led him to discover a surprising affinity for wedding photography over his original commercial focus. And after a career as an art director and the birth of their second child, Heather began taking pictures again. Once she did, Michael knew he'd found his new business partner.

Together, they're an unstoppable team. At weddings, Heather works with the girls capturing the behind-the-scenes energy, while Michael's gregariousness and humor make him great with groups. They build on their relationship with the couple—begun months before the day of the wedding—to create a relaxed, fun environment where genuine shots come naturally. They're so un-intrusive that couples often tell them later, "We had no idea you were there!" But of course they were—the fact that the entire day was documented perfectly and beautifully through two sets of lenses is proof enough.

At a wedding for a musically inclined family, the groom's niece and nephew hit the dance floor before the reception had even begun. We really wanted to capture their larger-than-life personalities, which represented the feeling of the whole reception.

Photograph by Krakora Studios

"Enthusiasm is contagious and puts people at ease—and that's when the best images are captured."

—Michael Krakora

Above and right: We love drawing attention to the little things that really express a couple's personality and identity. Hands, shoes, and feet are particularly expressive, and also very intimate. If there's great light, we want to use that to showcase especially unique elements, like a personalized billboard sign or a taxi limo.

Facing page: You have to be prepared at any time to grab those spur-of-the-moment, spontaneous shots that wind up perfectly capturing the day, and fortunately we are always on the lookout. The combination of a long veil and a windy day created a happy accident and a fun image after one wedding ceremony. At another wedding we captured a serene Buddhist monk shepherding the youngest attendants around the gardens.

"We're focused on capturing our couples' best moments. The last thing we want to do is make any of this about us—we've already had our wedding!"

—Heather Krakora

Right: We love to have fun with our couples and take advantage of gorgeous light when we get it. We always seek to capitalize on every moment we can find and shoot many different things—it usually results in amazing, dramatic images.

Facing page: Sometimes we're like kids in a candy shop with so many facets of the event to photograph. Small details are wonderful for showcasing the couple's style, from handmade signs and vintage props to sendoffs—a rarity nowadays—in horse-drawn carriages.

Photograph by Krakora Studios

views

❖ Find a photographer who emotionally engages you. When that connection is there, you'll reveal more of yourself for truly honest moments.

❖ The right photographer will keep things lighthearted, fun, and goofy, so subjects are put at ease and even say, "That was fun!"

❖ Hiring a photography partnership or team means the entire event will be documented—they won't miss a thing!

NOAH WOLF PHOTOGRAPHY

NOAH WOLF | KERRY WALLACE
MINNEAPOLIS, MINNESOTA

True partnerships maximize each person's strengths and prove that two can accomplish more than one. The team behind Noah Wolf Photography is a shining example: Noah Wolf and Kerry Wallace, who work together to pull off exceptional photography.

For Noah, photography is all he's ever done—he knew he wanted to be involved in it since age 12. And when she was 11, Kerry received a camera for Christmas which sparked her passion. Both love photographing people above all, with portraiture and wedding photography as personal favorites. Upon establishing Noah Wolf Photography together, Noah and Kerry discovered that their work together grew organically, with fluid roles. All the studio duties are essentially shared, and each spouse takes a sincere interest in the other's projects. Genuine love for what they do has led to a flourishing business grown largely through word of mouth.

The husband-and-wife team's thorough dedication to getting great shots under any circumstances always proves impressive. Party hosts are thrilled to be able to view the entire event, including the parts they didn't witness, and corporate patrons are downright stunned at the level of detail and beauty found in such documentary-style photography.

Some events emphasize décor and ambience more heavily than others. In those cases, we want to go beyond capturing the visuals to create a piece of art as well. We look at any detail in 360 degrees if we can, and provide a stylistic image for every straightforward one. At the finale party for the Republican National Convention at Walker Art Museum, many suspended crystals hung from the ceiling as part of a pre-existing art installation, then illuminated azure to fit with a blue-themed room.

Above and left: It's all about constantly keeping an eye out for those great poignant moments. We covered Barack Obama campaigning in Minnesota and enjoyed staking out prime locations for the best emotional shots. At weddings, we love when we happen to catch especially touching, intimate moments—like a fun-loving couple's photo booth strip placed into the album at a wedding.

Facing page: We relish the chance to capture spontaneous, expressive reactions, whether it be Henry Kissinger making the rounds of a room at a Republican National Convention event or wedding guests watching and laughing at the reception slideshow. We never get bored; we know that there has to be genuine emotion happening somewhere. Our job is to find it, observe it, and record it.

Photograph by Noah Wolf Photography

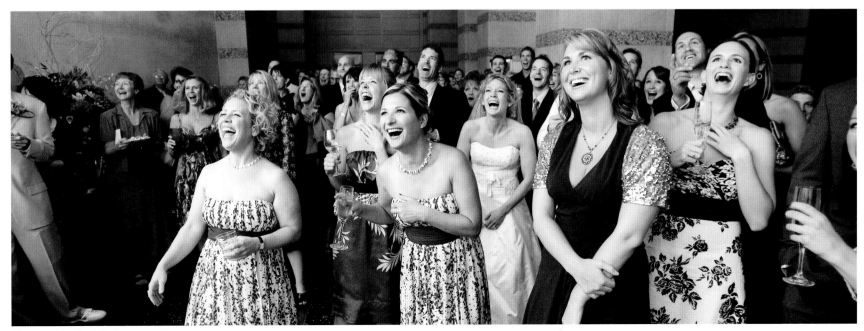

Photograph by Noah Wolf Photography

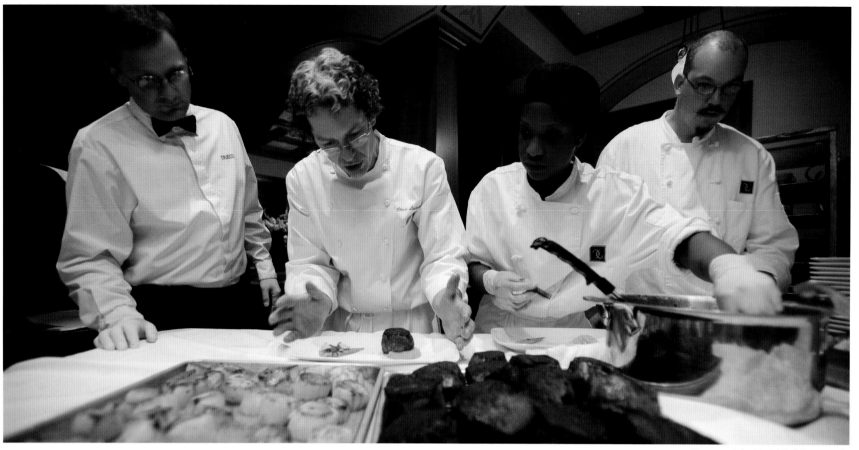

"People get hooked on good photography."

—Noah Wolf

Right: A large-scale, high-end event celebrating the opening of a new wing to the Minneapolis Art Institute completely transformed the space. In cases like these, we make sure that our images encapsulate that ethereal ambience.

Facing page: Focusing on the elements of the celebration most important to the hosts is essential. For a bridal couple serious about good food, we captured an exclusive glimpse of the chefs working their magic behind the scenes. And at an annual 200-person dinner for Minnesota Public Radio, the central role played by food and wine necessitated that we pay close attention to cataloguing those details.

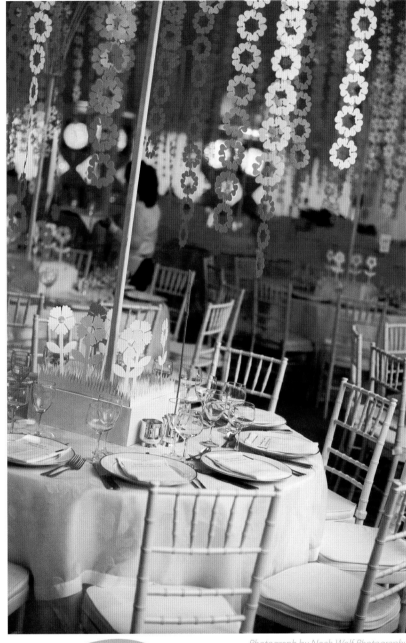

Photograph by Noah Wolf Photography

views

Ensure that the photographer you choose is prepared to create great images under any circumstances—rain or shine, light or dark. Seek someone who possesses mastery of light, excellent time management skills, and the ability to keep subjects calm. A good photographer's goal should be to always exceed expectations, no matter what.

CONTEMPORARY PRODUCTIONS

STEVE SCHANKMAN | SAM FOXMAN
ST. LOUIS, MISSOURI

There are few companies in the United States specializing in talent specifically tailored for entirely unique celebrations. When you pair that with a heritage of over 40 years, you've got a one-of-a-kind entertainment institution in Contemporary Productions.

Contemporary has been booking bands and producing shows since 1968. The firm remains one of the only entertainment companies to regularly produce national talent and regional bands, playing special events in venues from ballrooms to ballparks nationwide. The agency books performers including Jay Leno, The Temptations, Lionel Richie, Counting Crows, and Michael Bublé, just to name a few, while also managing a roster of the most sought-after regional entertainers. These include the Fabulous Motown Revue and the Steve Schankman Orchestra—both led by company founder Steve Schankman.

Some hosts want big names, some want local talent—Contemporary's job is to recommend the right entertainment to complement the celebration. From the Princess Hotel in Scottsdale to the Waldorf Astoria Hotel in New York City to the most elite country clubs across the nation, Contemporary can fill any venue—and any dance floor—with toe-tapping, crowd-pleasing music.

The Fabulous Motown Revue performed an energetic, glitzy show at The Pageant in the Delmar Loop, St. Louis.

Photograph by Peter Wochniak

Photograph by Libby Farmer Papineau

Photograph by Libby Farmer Papineau

Photograph by Bentley Studio

"The event barometer is the dance floor. If your guests are dancing at midnight and screaming for more when the lights come on, you've accomplished your mission!"

—Steve Schankman

Right: The Steve Schankman Orchestra plays for both public and private events and often headlined at Finale, a St. Louis jazz club. The American Songbook, played frequently with Sinatra-style vocalists, is among the band's repertoire.

Facing page: The Fabulous Motown Revue performed at several events during President Barack Obama's 2008 campaign. During the final days of the campaign tour, the band warmed up a crowd of more than 100,000 at an Obama rally under the Gateway Arch in St. Louis. This event was the largest rally for a presidential candidate in the history of the country. In January 2009, the 16-piece group was invited to entertain guests at the Midwest Inaugural Ball in Washington, D.C.

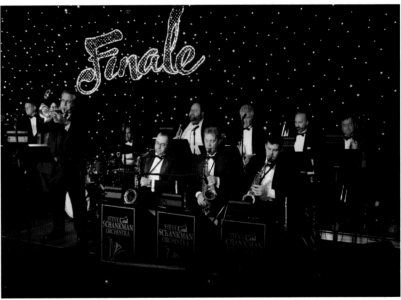

Photograph courtesy of Contemporary Productions

views

Recognize that you can get big music without a big name, and the right talent consultant will work with you to select the best choice for your celebration. Look for someone who will listen to what you want, then add a personal touch—and you'll get a great night that has guests dancing into the wee hours.

RICK AGUILAR STUDIOS

RICK AGUILAR
CHICAGO, ILLINOIS

When a bridesmaid needs an emergency bobby pin or a gentleman requires assistance tying his bow tie, the photographer isn't usually the one to swoop in and save the day. Yet with more than 20 years' experience photographing some of Chicago's chicest people and events, Rick Aguilar has picked up an extra skill or two along the way.

By expecting the unexpected, Rick Aguilar Studios is able to capture dramatic, playful, and touching moments without ever resorting to stiff smiles or trite poses. Rick is a master at settling nerves and coaxing out emotions even amid the frenzied swirl of a party. A hallmark of Rick's work is the extensive personal consultations he conducts beforehand, guaranteeing that the film he shoots later on will not only be creative and fun, but also tell the story of the day. His interest in fashion and experience photographing for the reality television shows "Hitched or Ditched" on the CW and VH1's "My Big Fat Fabulous Wedding" contribute to his urban appeal. It's not unusual to find Rick in an alleyway, conducting a gritty fashion shoot with an edgier-than-most bride.

Having a studio located in the city offers options for more than just the big day, including test shots and portrait sessions. Rick's hometown of Chicago, with its fabled architecture and celebrated landmarks, provides constant inspiration for the photographer and his assistants.

People tell me all the time that they don't photograph well or that they're uncomfortable in front of a camera. It's my job to not only put them at ease, but to also snap some pictures quickly, when they're not expecting it. Candid shots can end up being some of the best! Another trick I use to get a large crowd excited is to instruct them to shout, jump, or cheer. If it's a wedding, it's a special treat for the bride and groom to feel all the love and energy in the room directed at them and then have it captured on film.

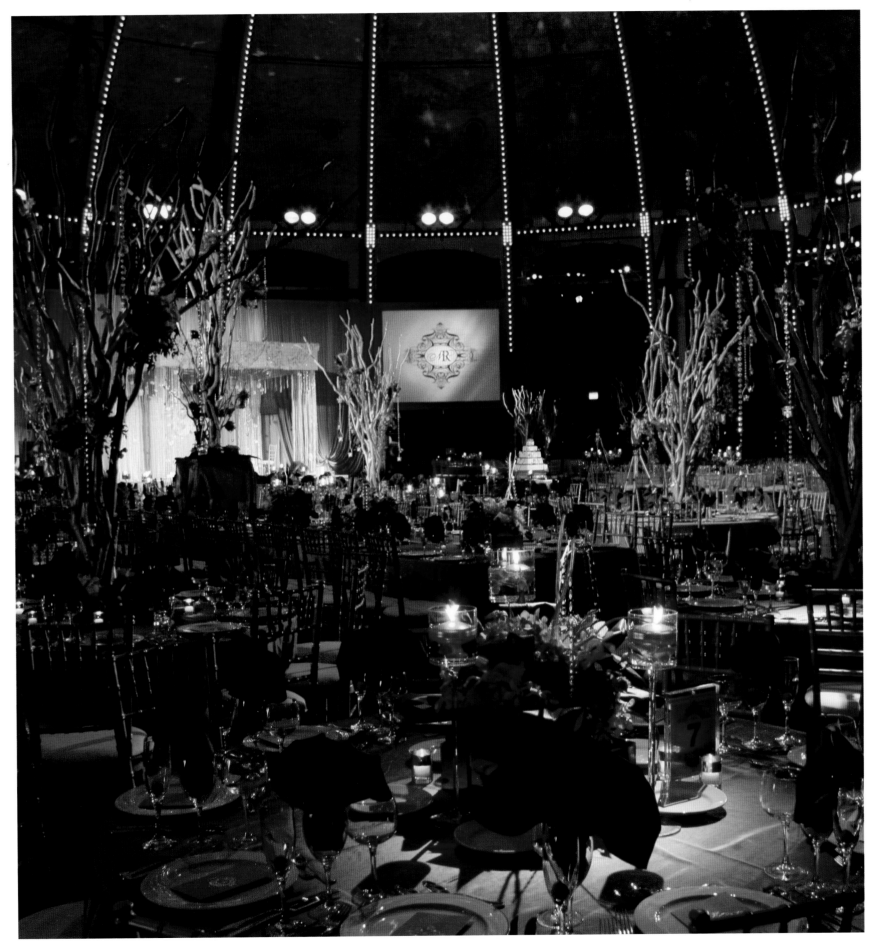

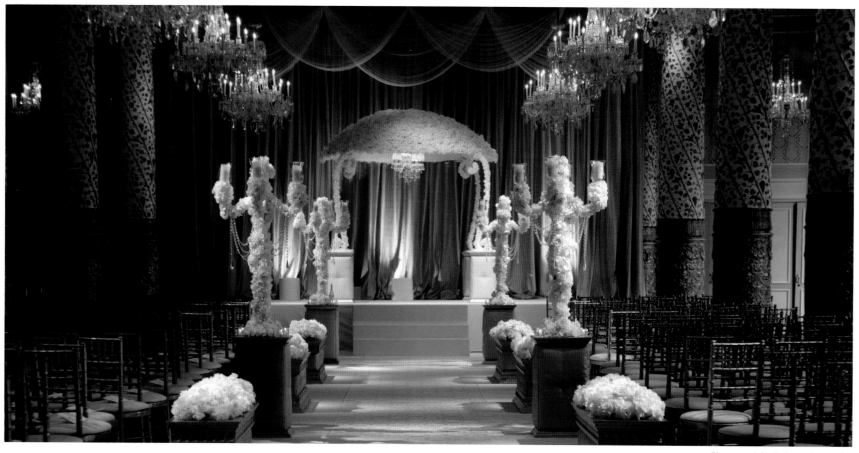

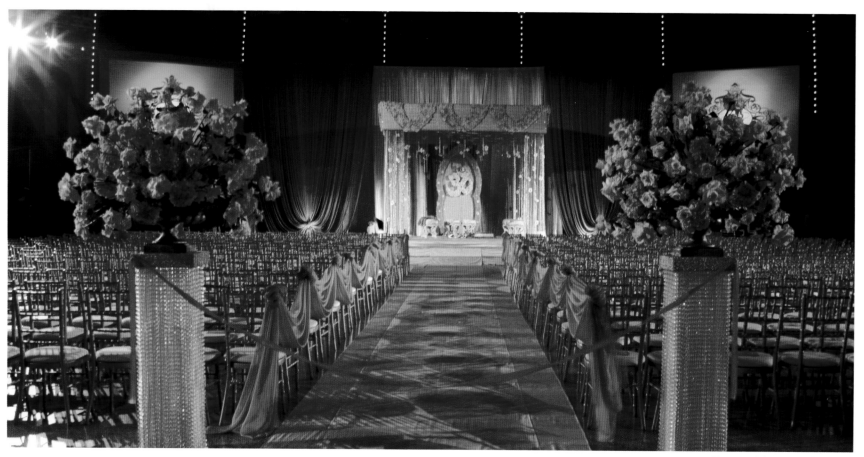

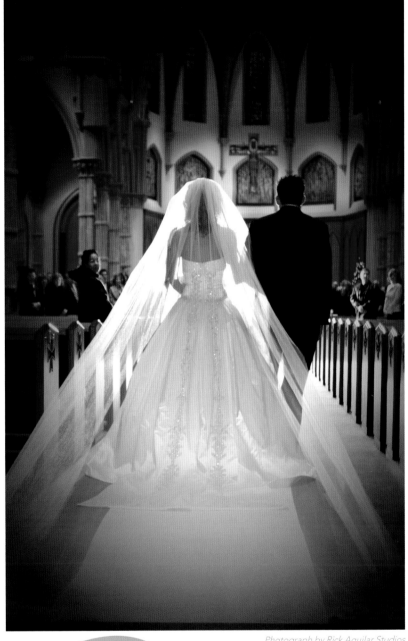

"I love the idea that I am creating images that will last a lifetime and be part of a family history."

—Rick Aguilar

Every wedding presents a different opportunity to focus on beauty. Regardless of religion or beliefs, the splendor of this one perfect day is always breathtaking. We shot an Indian wedding that was incredible: five days, five parties, 800 guests, multiple costume changes, and a horse! The wedding day alone lasted 18 hours. That was a true test of endurance, not only for myself but, I'm sure, for the guests as well.

Photograph by Rick Aguilar Studios

views

When looking for a photographer, you want to select someone not only professional, but someone who makes you feel comfortable too. You need an ally with so many hectic things going on, and often the photographer is the only person who's with you the entire day—more than your friends, even more than your parents. You have to find someone who is on your side.

Rajtar Productions

JOHN RAJTAR
MINNEAPOLIS, MINNESOTA

The most gorgeous, artfully arranged images feature components that appear to have materialized out of nowhere and orchestrated themselves into perfect photographs of beauty and creativity. At least that's how it seems. In reality there's a mastermind behind the magic—photo stylist, prop master, and art director extraordinaire John Rajtar of Rajtar Productions.

It evolved quite naturally. After traveling all over Europe, John returned to the United States and, in search of work, happened upon a tiny flower market. There he quickly absorbed the technical knowledge, synthesized it with his fine arts background, and soon rose in the ranks from floral designer to head of flower productions for events. Before long he was propping, styling, and producing for photographers, then hired by one of the top advertising photography studios in town. Today he owns a successful photo styling business—Rajtar Productions.

John Rajtar has a good eye. It's his job as photo stylist to brainstorm a photo shoot's needs. Prop settings and other elements fuse together for breathtaking shots that translate his visions into strikingly beautiful reality. John's large array of props provides whatever is required, from a banquet table to a harvest cornucopia. Both organization and spontaneity are key for his profession—he researches in advance and arrives at each location with an abundant supply of props and imagination, wholly prepared for anything.

According to John's philosophy, passionate work is all play—and he relishes the ability to do what he loves and create thoughtful, beautiful images on a daily basis.

Every photo arrangement showcases my versatility, creativity, and attention to detail. The magic happens when, drawing on my artistic life experiences, I combine elements from my extensive prop collection and numerous other prop sources to generate stunning effects—and give way to the extraordinary.

Art of Celebration

CHICAGO & THE GREATER MIDWEST TEAM

ASSOCIATE PUBLISHER: Heidi Nessa

GRAPHIC DESIGNER: Paul Strength

EDITOR: Sarah Tangney

PRODUCTION COORDINATOR: Drea Williams

HEADQUARTERS TEAM

PUBLISHER: Brian G. Carabet

PUBLISHER: John A. Shand

EXECUTIVE PUBLISHER: Phil Reavis

PUBLICATION & CIRCULATION MANAGER: Lauren B. Castelli

SENIOR GRAPHIC DESIGNER: Emily A. Kattan

GRAPHIC DESIGNER: Kendall Muellner

MANAGING EDITOR: Rosalie Z. Wilson

EDITOR: Anita M. Kasmar

EDITOR: Jennifer Nelson

EDITOR: Lindsey Wilson

MANAGING PRODUCTION COORDINATOR: Kristy Randall

PROJECT COORDINATOR: Laura Greenwood

TRAFFIC COORDINATOR: Jane Lardo

ADMINISTRATIVE MANAGER: Carol Kendall

CLIENT SUPPORT COORDINATOR: Amanda Mathers

PANACHE PARTNERS, LLC
CORPORATE HEADQUARTERS
1424 Gables Court
Plano, TX 75075
469.246.6060
www.panache.com
www.panachecelebrations.com

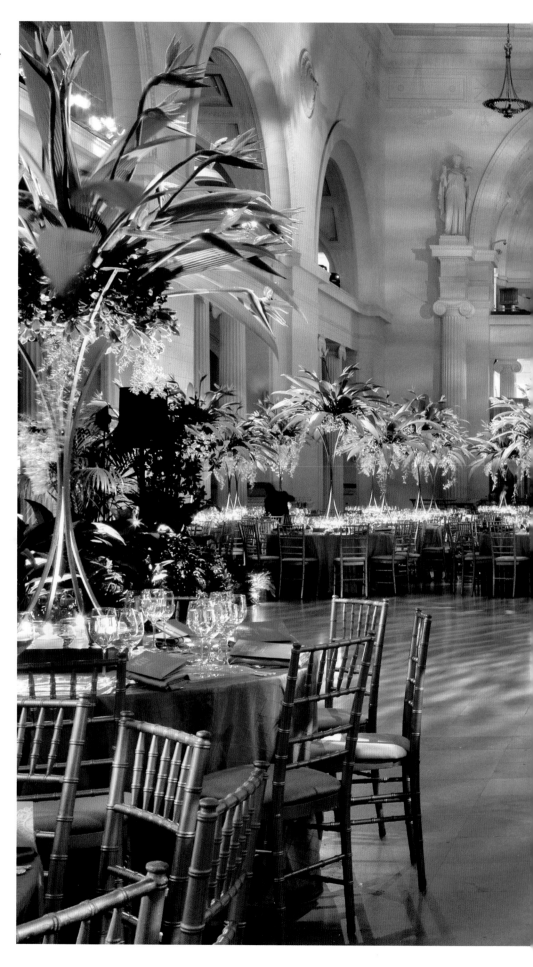

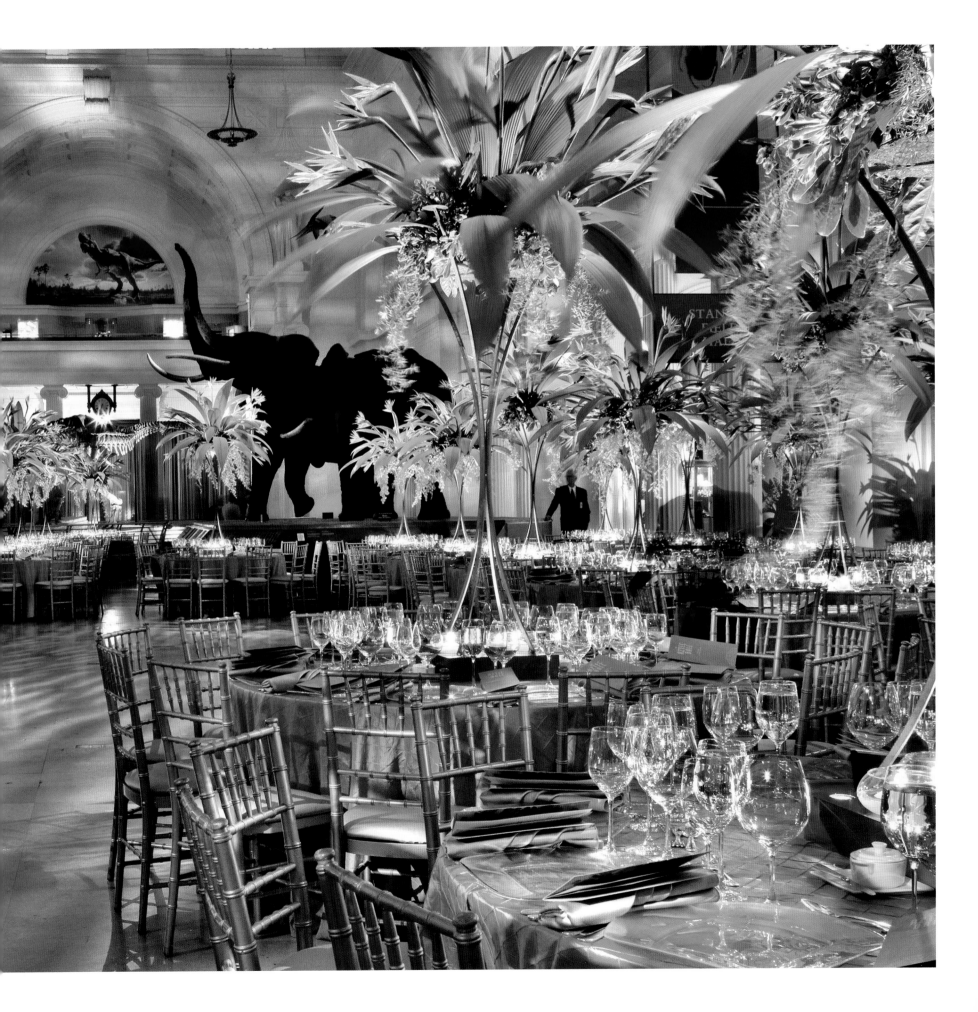

INDEX

THE PANACHE COLLECTION

CREATING SPECTACULAR PUBLICATIONS FOR DISCERNING READERS

Dream Homes Series
An Exclusive Showcase of the Finest Architects, Designers and Builders

Carolinas
Chicago
Coastal California
Colorado
Deserts
Florida
Georgia
Los Angeles
Metro New York
Michigan
Minnesota
New England

New Jersey
Northern California
Ohio & Pennsylvania
Pacific Northwest
Philadelphia
South Florida
Southwest
Tennessee
Texas
Washington, D.C.

Spectacular Homes Series
An Exclusive Showcase of the Finest Interior Designers

California
Carolinas
Chicago
Colorado
Florida
Georgia
Heartland
London
Michigan
Minnesota
New England

Metro New York
Ohio & Pennsylvania
Pacific Northwest
Philadelphia
South Florida
Southwest
Tennessee
Texas
Toronto
Washington, D.C.
Western Canada

Perspectives on Design Series
Design Philosophies Expressed by Leading Professionals

California
Carolinas
Chicago
Colorado
Florida
Georgia
Great Lakes

Minnesota
New England
New York
Pacific Northwest
Southwest
Western Canada

Art of Celebration Series
The Making of a Gala

Chicago & the Greater Midwest
Georgia
New England
New York
South Florida
Southern California
Southwest
Toronto
Washington, D.C.
Wine Country

Spectacular Wineries Series
A Captivating Tour of Established, Estate and Boutique Wineries

California's Central Coast
Napa Valley
New York
Sonoma County
Texas

Specialty Titles
The Finest in Unique Luxury Lifestyle Publications

Cloth and Culture: Couture Creations of Ruth E. Funk
Distinguished Inns of North America
Extraordinary Homes California
Geoffrey Bradfield Ex Arte
Into the Earth: A Wine Cave Renaissance
Spectacular Golf of Colorado
Spectacular Golf of Texas
Spectacular Hotels
Spectacular Restaurants of Texas
Visions of Design

City by Design Series
An Architectural Perspective

Atlanta
Charlotte
Chicago
Dallas
Denver
Orlando
Phoenix
San Francisco
Texas

PanacheCelebrations.com
Where the Event Industry's Finest Professionals Gather, Share, and Inspire

PanacheCelebrations.com overflows with innovative ideas from leading event planners, designers, caterers, and other specialists. A gallery of photographs and library of advice-oriented articles are among the comprehensive site's offerings.

Panache Partners, LLC 1424 Gables Court Plano, Texas 75075 469.246.6060 www.panache.com

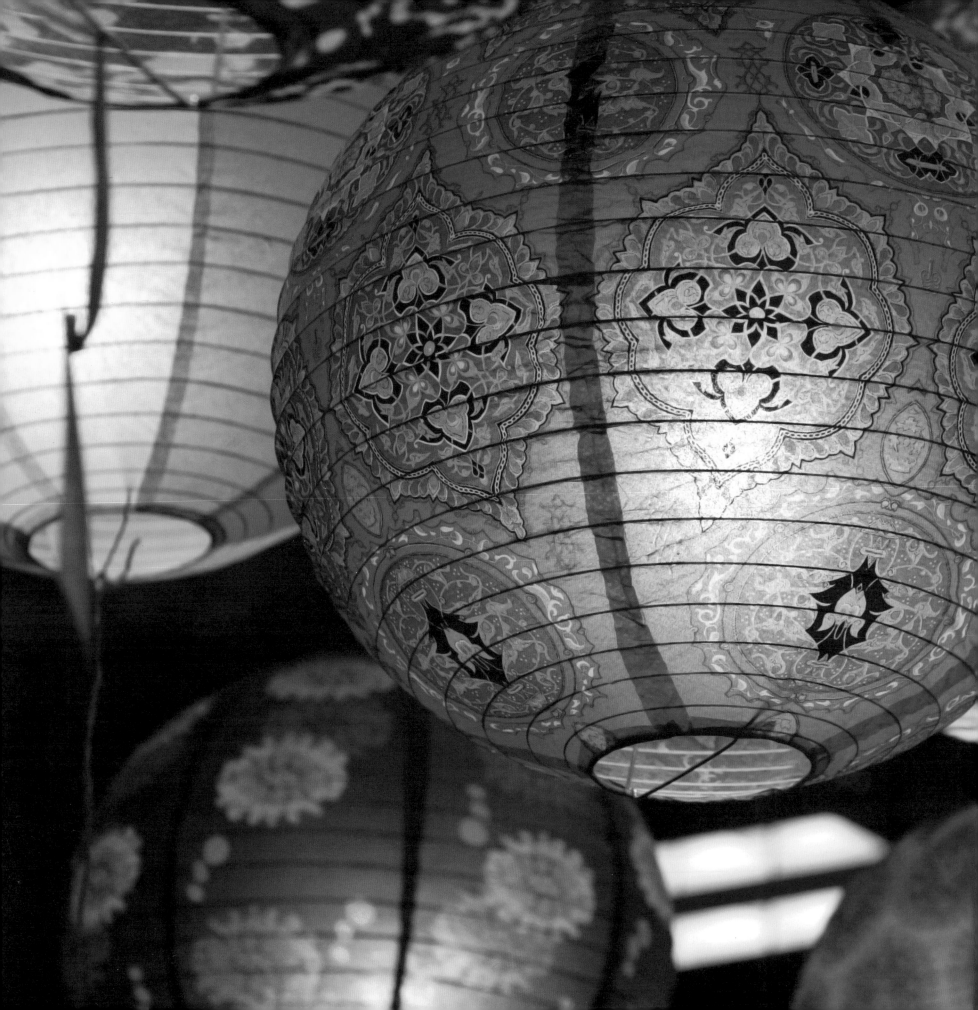